Defining the Renaissance *Virtuosa*

Leonardo, Raphael, and Michelangelo are familiar names that are often closely associated with the concepts of genius and masterpiece. But what about Sofonisba Anguissola, Lavinia Fontana, and Irene di Spilimbergo? Their names are unfamiliar, and their works are literally unknown. Why?

Defining the Renaissance "Virtuosa" considers the language of art in relationship to the issues of gender difference through an examination of art criticism written between 1550 and 1800 on approximately forty women artists who were active in Renaissance Italy. Fredrika Jacobs demonstrates how these theoretical writings defined women artists by linking artistic creation with biological procreation and by asserting a connection between an artist's sex and her style. She also examines the ambiguity of these women as both beautiful objects and creators of beautiful objects. Jacobs's study shows how deeply the biases of these early critics have affected both subsequent reception of these Renaissance *virtuose* and modern scholarship.

Defining the Renaissance
Virtuosa

WOMEN ARTISTS AND THE LANGUAGE OF ART HISTORY AND CRITICISM

Fredrika H. Jacobs

Virginia Commonwealth University

CAMBRIDGE
UNIVERSITY PRESS

PUBLISHED BY THE PRESS SYNDICATE OF THE UNIVERSITY OF CAMBRIDGE
The Pitt Building, Trumpington Street, Cambridge, United Kingdom

CAMBRIDGE UNIVERSITY PRESS
The Edinburgh Building, Cambridge, United Kingdom http://www.cup.cam.ac.uk
40 West 20th Street, New York, NY 10011–4211, USA http://www.cup.org
10 Stamford Road, Oakleigh, Melbourne 3166, Australia
Ruiz de Alarcón 13, 28014 Madrid Spain

First published 1997
First paperback edition 1999

Printed in the United States of America

Typeface Centaur 12/14 [CRM]

A catalogue record for this book is available from the British Library

Library of Congress Cataloguing-in-Publication Data
Jacobs, Fredrika Herman.
 Defining the Renaissance virtuosa : women artists and the language of art history and
criticism / Fredrika H. Jacobs

 p. cm.
 Includes biographical references and index
 ISBN 0 521 57270 3 (hardbound)
 ISBN 0 521 64496 9 (paperback)
 1. Feminism and art – Italy. 2. Women artists – Italy – Biography – History and
criticism. 3. Art, Italian. 4. Art, Renaissance – Italy. I. Title.
N72.F45J33 1997
704′.042′09450903 1–dc21 96-37798
 CIP

ISBN 0 521 57270 3 hardback
ISBN 0 521 64496 9 paperback

For Paul and Jessica

But, what shall I say to them now,
 Our women, who assume this profession,
 Who adopt paint, pen, chalk
 And then explain the flight of their fame?
 — Giulio Cornelio Gratiano,
 Di Orlando Santo vita, 1636

I say that even later someone will
 Remember us . . .

 — Sappho

Contents

Illustrations

Acknowledgments

A number of years ago I taught a course on aesthetics and art criticism. After about two-thirds of the semester had passed, several women in the class asked a simple and logical question. When, they wanted to know, would we be discussing critical writings on women artists? That question was the catalyst for this study. And so I thank my students for seeing what I had overlooked.

The endnotes to this study make clear my indebtedness to the scholarship of many, but especially that of Elizabeth Cropper, Mary Garrard, and David Summers. I am further grateful to Mary for her critical reading of an early version of this study and for her unfailing encouragement of this project.

I also thank Angela Federico, who spent a long weekend with me searching Naples for evidence of Mariangiola Criscuolo's paintings, and Fernando Magrini, who aided my search in Pistoia for Suor Plautilla Nelli's altarpiece for Santa Lucia. Although these efforts proved futile, the quest for Isabella Parasole's illustrated book of lace patterns was successful, thanks to the assistance of Sonia Giacopani at the Biblioteca Angelica, Rome.

My attempts to grasp the nuanced meaning of neo-Petrarchan verse and translate it fairly would not have been possible without the significant assistance of Mary Gallucci. I am most grateful to her for her knowledge and patience. My thanks also go to Liana De Girolami Cheney and Ingrid Rowland for their advice concerning the translations of several passages.

Finally, I thank Lynette Bosch and Bette Talvacchia for their encouragement; Carolyn Brown for helping me to cope with the computer age;

Camilla Palmer and Christie Lerch for their invaluable editorial expertise (and patience with my deficiencies in this area); my parents Frederick and Lucy Herman, who have always prompted me to look and encouraged me to question; my brother Bernard L. Herman, whose scholarly example I admire and whose opinion I treasure; Julian and Bettie Jacobs, for keeping the home fires burning during my absences to search for evidence of Renaissance women artists; and Martha and Becky for everything. Above all, I thank my husband Paul and daughter Jessica. Their support and loving encouragement made this book possible.

CHAPTER ONE

Introduction

A COLLAGE of voices, past and present, informs us that "the woman of the Renaissance is many women — mother, daughter, widow; warrior, manager, servant; nun, heretic, saint, witch; queen, martyr, seeker."[1] She is also an artist — painter, sculptor, engraver, embroiderer. Broadly speaking, this book is about Italian Renaissance women artists — who they were and what they did. More specifically, it is about what early modern writers say they were and about how the works they produced are described. It is, therefore, a study concerned with the critical language of art — the terms used to differentiate the artistic productions of women from those of men, the methods by which the female capacity to create was distinguished from that of the male, the syntactic strategies employed to draw a likeness between the female as maker and model, and the organizational principles used to delineate a history of art monopolized by *pittori* and *scultori* and visited only marginally by *pittrici* and *scultrici*. The intent here is not simply to identify Renaissance *virtuose* but to illumine the definition of the *virtuosa* as constructed in the early art historical discourse.

Today the names of Renaissance women artists are largely unfamiliar, their identities often unknown. But to their contemporaries they were worthy of recognition. Thus, in sixteenth- and seventeenth-century art and civic histories, biographies, and poems we find the names of *virtuose* recorded, their varying achievements assessed, and praise grudgingly or generously accorded them. Sadly, few of the works they created remain. Approximately half of the forty women artists discussed in this book survive only as a name on a printed page. In a significant number of cases, we have no images to associate with a name, no way to evaluate an artist's style, and no visual means of assessing critical pronouncements

about a woman's artistic abilities. This lack of visual evidence determined the focus of this book. Texts, not images, are scrutinized. Rather than analyze how an artist depicted her subject, this study examines how the writer represented his, which is, of course, her.[2] The extreme but by no means unique example of Irene di Spilimbergo demonstrates the necessity of this methodological approach. Celebrated for her fluency with the pen and the brush by more than one hundred forty poets in more than three hundred Italian and Latin poems, Spilimbergo is unknown today as a painter. Therefore, if we are to appreciate this woman as a *virtuosa* we must turn to the texts that commemorate her. Only by this method can we understand who this Venetian *pittrice* was, and, more importantly, discover what the Renaissance *virtuosa* was and how she came to be.

An artist's inclusion in this study depends upon her having been active in Italy during the sixteenth century. This criterion is flexible only to the degree that her activity extended into the seventeenth century, as happened, for example, with Sofonisba Anguissola and Lavinia Fontana, or in the event that an artist's only known work date to 1600, as is the case with Isabella Parasole. (See Appendix One for a list of the artists and the relevant sources.) The sources utilized dates primarily from the sixteenth through the eighteenth century, though a few from the nineteenth century provided unique information.

The historical and geographical frame of this study is similarly the product of authorial intent. Art history as we know it has its origins in sixteenth-century Italy.[3] It was there and then that painting and sculpture ceased to be regarded as crafts and became *arti nobilissimi*. More to the point, it was during this era that the modern concept of the artist was forged. Not only did the *artisan* become the *artist;* he became the *virtuoso,* a man so outstandingly gifted that, to quote Vasari, "one can claim without fear of contradiction that . . . [such artists] are not simply men but, if it be allowed to say so, mortal god[s]."[4] Among the many artists privileged by this status was the sculptor Antonio Rossellino. Vasari's description of him paints a portrait of a man of "rare virtue." The description also illustrates the contextual elasticity of the word *virtù* as it relates to the definition of the *virtuoso*.

It has ever been a truly and laudible and virtuous thing [cosa virtuosa] to be modest and to be adorned with that gentleness and those rare virtues [rare virtù] that are easily recognized in the honorable actions of the sculptor Antonio Rossellino, who put so much grace into his art that he was esteemed by all who knew him as something much more than a man and adored almost as a saint for those supreme qualities that were united to his talent [virtù].[5]

When this and similar passages in Vasari's *Le vite de' più eccellenti pittori, scultori, ed architettori,* 1568, are read in conjunction with Gian Paolo Lomazzo's *Trattato dell' arte della pittura, scoltura, et architettura,* 1584, which contains chapter titles such as "Della virtù del colorire," "Della virtù del lume," "Della virtù della prospettiva," the Renaissance concept of the *virtuoso* comes into focus. Ideally, but not necessarily, he is an ethical man who unequivocally possesses both inherent and learned artistic abilities.[6] He exhibits virtuousness in his demeanor and virtuosity in his art.

So what is a *virtuosa?* Early texts present us with several options. Giorgio Vasari's and Fra Serafino Razzi's writings about Plautilla Nelli, "a revered and virtuous sister [veneranda e virtuosa suora]" and a competent if unexciting *pittrice,* imply that a *virtuosa* is a pious painter. Descriptions of Marietta Robusti by Raffaello Borghini and Carlo Ridolfi replace piety with physical beauty and musical talent: "it is apparent that she combines many virtuous qualities (si vedero unite molte virtuose qualità)." Scores of writers recognized similar qualities in Irene di Spilimbergo. In fact, so great was her loveliness of body, manner, and voice that the virtuosity of this *virtuosa* was of little consequence. Almost all of the more than one hundred contributors to the memorial volume of poems written in her honor, *Rime . . . in morte della Signora Irene,* fail to mention her artistic abilities. Properzia De'Rossi, a *virtuosa* with "capricious talent (capriccióso ingegno)," is an intriguing variant. A beautiful and accomplished dancer, she was "excellent not only in household matters, like the rest of them, but also in many sciences."[7] She was, moreover, daring. Challenging tradition, this *virtuosa* reached for the chisel, a tool presumed to belong to the *virtuoso.* In De'Rossi's case, a *virtuosa* is, at least to some degree, a transgressor of gender barriers.

Although it can be argued that the *virtù* of the *virtuoso* included (in

3

addition to artistic virtuosity) good looks and munificence,[8] the virtu-
ous demeanor expected of the *virtuosa* challenged those who would praise
her to put a square peg into a round hole. In sixteenth-century Italy, the
terms "woman" and "artist" simply did not go together. In fact, the
"feminine" virtues desired of one were the opposite of the "masculine"
virtues expected of the other. Woman, by reason of being female, should
be silent, passive, and private. But if the *virtuosa* acted in accordance with
these standards, she could not fully engage in a profession that is all
about expression and public exposure. Early writers found a twofold
remedy to resolve the dilemma posed by the opposition. On the one
hand, they divided stylistic virtuosity into two different and readily
discernible types: masculine and feminine. On the other, they defined
the *virtuosa* as a distinct and exceptional category of the larger class
"female." Together, these strategies permitted that which is masculine
(if not always male) to maintain a position of superiority, while still
acknowledging something what could not be ignored: some women were
artists.

Because the designation *virtuosa*, like *virtuoso*, appears fairly infre-
quently in early critical writings, understanding what the term signifies
requires understanding what constituted, for these writers, feminine and
masculine creativity and style. Organized around several themes, this
book is designed to carefully consider conventional topoi, analyze the
contextual meanings of aesthetic terms like *ritrarre*, *imitare*, *invenzione*,
fantasia, and *grazia*, and illumine the classical and contemporary writings
that informed concepts of *artiste femminile* in general and that of the
virtuosa specifically.

Chapter Two, "Problems of Praise and Pythagorean Contrariety,"
establishes the theoretical frame within which diverse concepts of art,
the artist, and aesthetic evaluation can be examined. It is within this
frame that a definition of the concept of *virtuosa* is put forth. This
chapter also considers the development of the history of art and wom-
an's place within that history as established by certain conventional
analogies or comparisons. Chapter Three, "(Pro)creativity," looks at the
language of artistic production, considers the conventional assumption
that it resembles biological generation, and examines how Renaissance
criticism reflected this comparison, to the detriment of women artists.

But concepts of (pro)creation provided only a partial picture of what was thought to constitute creativity. Chapter Four, "Melancholia," fills in the missing details. A hallmark of genius, the melancholic temperament came to be recognized by writers of the Renaissance to Romantic eras as the defining trait of the divinely inspired mind. Yet, like all else, melancholia was gendered and subdivided into two kinds: productive and unproductive. In contrast to the potential for heightened and enlightened creativity associated with male melancholia, the feminine variant of the condition, defined as erotic melancholia, was thought to lead to depression and stasis. Focusing on, but not restricted to, three and a half centuries of writings about the Bolognese sculptor Properzia De'Rossi, Chapter Four demonstrates how this form of differentiation was advanced and to what effect.

Chapters Five and Six, "*La Donnesca Mano*" and "Misplaced Modifiers," shift the focus from the process of artistic production to the aesthetic evaluation of the produced image. In contrast to concepts of artistic creativity, which were defined primarily on the basis of sex, issues of style — "the feminine hand [la donnesca mano]" — reflect expectations based on culturally constructed notions of gender. Criticism of women's work is rife with terms such as "diligence," "sentimental," "affected." Often these terms are qualified — "feminine affectation [femminilità affettiva]," "womanly grace [donnesca grazia]." Here, as elsewhere, categories of classification derived from the dualist scheme of Pythagorean contrariety place woman and art in dialectical relation to one another. They do so by stressing experiential difference and feminizing both practice and style.

Chapter Six carries the examination of aesthetic language in another direction. Whereas Chapter Five concentrates on the relationship of style to practice, "Misplaced Modifiers" looks at the relationships between artist, model, art object, and viewer, using the term *grazia* as a point of departure. While several art and literary historians have considered this issue in relation to conventionalized neo-Petrarchan descriptions of feminine beauty and portraits of unknown beautiful women, this study looks at the specific rather than at the generic, at the identified woman who produces objects rather than at the unknown woman who herself is the object. As a woman and as the maker of art,

the Renaissance *virtuosa* provided early writers with the perfect vehicle for blending the conflicting definitions of each. By sleight of pen, critics left intact an aesthetic that associated stylistic *grazia* with masculine mastery of the medium. In this chapter the female response to such verbal messages is examined in women's self-portraits or, as the case may be, a woman's refusal to fulfill a man's request for such a self-image.

Chapter Seven, "*Femmina masculo e masculo femmina*," borrows its title from Mario Equicola's *Libro di natura d'amore*, 1526. Returning to the structure of Pythagorean contrariety, this chapter considers concepts of the woman artist as belonging to an intermediate, or exceptional, class of being that falls between a pair of opposites.

To the extent that it is possible, Renaissance critical commentary is juxtaposed with representative images by each artist. In some cases these images are familiar. In others, such as the lace patterns and botanical illustrations by the Roman *intagliatrice* Isabella Cattani Parasole, the images have not appeared outside of their original texts (1600, 1614, and 1628). But, as noted, matching image to artist and art historical text is not always possible. Thus, we must make use of what we have: texts, art, civic, and church histories; treatises on the ideal woman; eulogies; *canzoni* and *rime*. We must do so with the express goal of acquiring what Michael Baxandall has called "the period eye," an adjustment of our views to past visions. Only in this way can we understand the definition of the woman artist and the perception of feminine style that has been passed on to us. To this desired end, the writings about artists and art in Appendix II as well as those appearing throughout the study enable early authors to speak for themselves. The images illustrating the text allow the artists to respond. Although the book provides commentary on the dialogue, it is left to the reader to assess the eloquence of each.

Obviously, the best scenario is when the artist through her own work speaks for herself. This, however, is now possible for less than 50 percent of Renaissance *artiste femminile*. No works, for example, can be attributed to Lucrezia Quistelli, who, says Vasari, "learned to draw from Alessandro Allori, the pupil of Bronzino."[9] We do not fare much better with Plautilla Nelli, prioress of the Dominican convent of Santa Caterina da Siena, Florence. Although she, like Sofonisba Anguissola, enjoyed international fame, she and her works, unlike Anguissola and

many of her paintings, have all but been lost to the vagaries of time. Despite early recognition and regardless of the considerable appeal of her paintings among Florence's nobility, as reported in the sixteenth century by both Vasari and Francesco Bocchi, only two of her images are, to my knowledge, extant. As for the images and objects produced by Nelli's "discepole" — Prudenza Cambi, Agata Trabalesi, and Maria Ruggieri — none have been identified, even though Razzi recorded their popularity throughout Italy.[10]

Sadly, detailed descriptions of paintings and specific references to their locations do nothing to help revive a memory or assist in the rediscovery of an oeuvre. Santa Lucia in Pistoia was, we are told by Vasari and Razzi, the home of Nelli's Madonna and Child with Saints Thomas, Augustine, Mary Magdalene, Catherine of Siena, Catherine of Alexandria, Agnese, and Lucy. Today this "chiesetta" is a small apartment building identified as Via de'Rossi, 3, and distinguished only by its brimming flower boxes. One can only guess what happened to its contents. They — or at least Plautilla Nelli's painting — did not make it into the parochial church of Santo Spirito or into the collection of the Museo Civico di Pistoia. The same fate befell Mariangiola Criscuolo's *Assumption of the Virgin*, reported by Bernardo de Domenici in 1742 to be in a lunette over the door leading into San Giuseppe Maggiore in Naples.[11] When the church was demolished in 1934, its contents were destroyed or dispersed to places unknown.

Although (or possibly because) there is so little artifactual evidence to counter critical commentary, the desire to "correct" the art historical record is great. But to do this would be to replace one filtering voice for another. Thus this study, while not attempting to speak for lost images in order to celebrate their makers, admits to speaking on their behalf. It does so by critiquing the language of the critics, by examining how context defines a word like *virtuosa,* and by examining how analogical and metaphorical associations establish otherness as secondary.

CHAPTER TWO

Problems of Praise and Pythagorean Contrariety

> L. Paulus Aemilius and not a few other Roman citizens taught their sons painting along with the fine arts and the art of living piously and well. This excellent custom was frequently observed among the Greeks, who, because they wished their sons to be well educated, taught them painting along with geometry and music. It was also an honor among women to know how to paint.
>
> —Leon Battista Alberti

Giorgio Vasari's *Le vite de' più eccellenti pittori, scultori et architettori,* 1568, is variously described as "a forerunner of the most common genre of modern art history," the book that "form[ed] a canon that was long unquestioned."[1] Among its parts — a preface to the work as a whole; biographies of Renaissance artists, beginning with Cimabue and ending with Vasari's account of his own life; and prefaces preceding each of the three eras or stages into which the biographies are grouped — the second and third prefaces are said to be "probably the most famous texts in the entire history of art."[2] It is here that the idea of rebirth (*rinascita*), which is referred to at the conclusion of the first preface, is ingeniously developed. Paraphrasing a passage in Cicero's *Brutus,* evoking another in Aristotle's *Poetics,* and citing a well-known litany of names in Pliny's *Natural History,* Vasari sketches a tripartite history of art that parallels the three-stage development of the individual — from infancy, to childhood, to adulthood. Putting aside, for the moment, the biological implications of this metaphor, the analogies illustrating the rebirth of the visual arts are of critical importance to the definition of *virtuosa.*

Implicit in the concept of rebirth is that of lineage, an idea conveyed

by Vasari's designation of the great modern painter or sculptor as the "new Apelles" or the "new Lysippos." The significance of an appellation of this kind becomes apparent when considered in the context of the historical sequence described in the prefaces to the *Vite*. If Apelles and Lysippos were at the pinnacle of ancient artistic achievement, then their modern counterparts logically may be understood as occupying a similarly lofty position in the *rinascimento*, since, as is argued in the preface to Part II of the *Vite*, artists of Apelles' caliber produced works of art "perfect in every detail."[3] This approach raises two questions for the present study: (1) Are the analogies advanced in early writings in art gender specific? (2) To borrow Plutarch's phrasing, "If . . . we asserted that painting on the part of men and women is the same, . . . would anybody reprehend us?"[4]

Although Renaissance answers to Plutarch's question are implicit in the analogies put forth to define the Italian Renaissance as a *rinascita*, a clear understanding of the concept of artistic virtuosity as it relates to gender requires us to acknowledge four things. First, the traditional etymology of the Latin term *virtus*, meaning moral goodness, or goodness of anything in its kind and efficacy, traces it to the word *vir*, meaning "man." Second, the different meanings of the Latin *virtus* carried over to the sixteenth century, thus allowing the Italian word *virtù* to refer to both virtuous behavior and virtuosity with the brush or chisel. Third, the classical texts informing Renaissance concepts of artistic virtuosity were not restricted to those about the visual and literary arts. Treatises on *virtus* in the sense of moral goodness also came into play.[5] Vasari's alternating use of the word *virtù* to connote moral goodness and/or artistic excellence points to this double signification. Finally, virtue had long been described as being of two types. In accordance with the Pythagorean system of classification, which defines one thing in contrast to its opposite, virtue, as some aspect of human personality, was described as being of two distinctive kinds: masculine and feminine.[6] This brings us back to Plutarch's query and the implications of analogical constructs. If *virtù* as moral goodness is gender specific, then it follows that *virtù* as goodness of anything in its kind, such as artistic virtuosity, is also gender specific. At issue is whether one type of *virtù* (moral goodness) can be separated from another kind of

virtù (goodness of anything in its kind) and, if such a division is possible, whether it is permissible to praise the *virtuosa* as the equal of the *virtuoso*. In grappling with these issues, writers of the *rinascimento* considered the opinions of their ancient forebears. Among the more influential texts affecting Renaissance thought was Plutarch's *Mulierum virtutis*, a book dedicated to commending and commemorating exceptional women for acts of valor.

Like the hero, the heroine is worthy of public recognition, or so Plutarch argues in his moralizing essay. In order to defend this ideological position, Plutarch changes the criteria according to which women are praised. He does so, however, without disturbing a deeply entrenched value system that recognized the masculine as superior to the feminine.[7] Rather than define the virtuous woman as the chaste and attentive wife or honor her as the good mother who dutifully minds the home and nurtures her husband's children, Plutarch designates as worthy of praise the female, Cloelia for example, as one who demonstrates "strength and daring as above that of woman."[8] For him a virtuous woman is one who acts like a virtuous man. Conversely, less than meritorious males, such as the Argive men, are those who slide into behavioral patterns perceived *in genera* as feminine. Accordingly, Plutarch commends the young women of Argos for defending their city against Spartan invasion but mocks the cowardly retreat of their male compatriots. "Even to this day," he observes, the Argive victory is celebrated as "the 'Festival of Impudence,' at which they clothe the women in men's shirts and cloaks, and the men in women's robes and veils."[9] Admittedly, the cross-dressing of the "Festival of Impudence" makes this more of an example of gendered role reversal than one of encomiastic parity, yet it is precisely for this reason that it makes clear Plutarch's position on two fundamental issues. First, to be masculine, if not male, is better than to be feminine. Second, in deed, if not body, women can rise above the condition of their sex.

Although Plutarch's *Mulierum virtutis* was not the sole classical source informing the Renaissance about the presumed nature of woman, it was one of the texts most frequently and prominently cited by sixteenth-century authors of *discorsi, dialoghi,* and *difesi* written for and about women.[10] Among the many writers commenting on the ideas espoused by Plutarch was Torquato Tasso.[11] In his *Discorso della virtù femminile e*

donnesca, 1582, Tasso reaches conclusions much the same as those of the Roman writer, albeit for different reasons and only after making a qualifying distinction between "feminine virtue" and "womanly virtue." Faced with the undeniable fact that females, like males, demonstrate "lofty talent [altezza dell'ingegno]" and confronted by a plethora of texts advancing myriad reasons why this should not be so, Tasso explains the anomaly by dividing women into two types and separating their virtue into two kinds. On the one hand, there is the *cittadina,* the *gentildonna privata,* and the *industriosa madre di famiglia.* On the other, there is the woman "born of imperial and heroic blood." Women belonging within the second of these two categories, because of the ameliorating qualities of their noble blood, possess, says Tasso, "the masculine virtues of their glorious ancestors [le virili virtù di tutti i suoi gloriosi antecessori]." Unlike their plebian sisters, who can do no more than evince "proper modesty [pudicizia proprissima]" and other female virtues *in ratione et modo,* these exceptional women, are, as it were, men by virtue of their birth. Having established this difference, Tasso distinguishes them as "womanly" rather than "feminine" "ne più si usi il nome di femmina, ma quel di donnesco]."[12]

Plutarch's celebration of and Tasso's explanation for exceptional women acknowledge what was, even by the second century and certainly by the sixteenth, already a long-lived idea. Virtues are not only subject to gendered expectations; when placed in a sexual context, they involve oppositions. They are, in other words, as oppositional as male and female. Man is to be eloquent, yet woman should remain silent. He is to be active, but she should be passive, and so forth. Given the oppositional method by which a thing is often defined, it perhaps could be no other way. Right, for example, is understood by its not being left, high by its not being low, and so forth. The problem comes when, as must inevitably happen, shades of gray are seen between black and white, or, to use Tasso's example, when the *donna donnesco* is perceived as being midway between the female and the male. To recognize gray (or "womanly" virtue as contrasting with feminine or masculine virtue) presents a problem in how any specific thing is to be defined. It also – and this is the critical issue – challenges the structuring principle for the order of reality that Aristotle claims, on more than one occasion, was adopted by

all of his predecessors. This principle is known as "Pythagorean contrariety." According to Aristotle, it is composed of ten paired opposites:[13]

Limited (or definite)	Unlimited (or indefinite)
Odd	Even (as in numbers)
Unity	Plurality
Right	Left
Male	Female
At rest	Moving
Straight	Curved
Light	Darkness
Good	Evil
Square	Oblong[14]

Although these categories of classification are presented as pairs, they are not put forth as symmetrical and equal principles. Ignoring notions of moderation that would allow a component of any pair to be evaluated contextually, Pythagorean polarities were ordered into a hierarchy.[15] First, a positive or negative value was ascribed to each pole. Next, these values were comparatively ranked. The positive pole thus becomes valued as higher, the negative as lower. Within this hierarchical evaluative scheme the category which includes "male," "good," "limited," "odd" (one, three), and "unity" is made superior to the category that includes "female," "evil," "unlimited," "even" (two, four), and "plurality." Although lists of oppositional pairs were not uniform (Alcmaeon, for example, includes "white" and "black," and "sweet" and "bitter"), contrarieties were consistently expanded through the practice of linking other ideas to each core pair. By this means "female" came to be associated not only with "darkness," "unlimited," and other qualities, but with a cluster of related and similarly positioned concepts, such as the formless, the potential, the passive, and matter.

Although Pythagorean contrarieties were conveyed to the Renaissance by Aristotle, there was no dearth of authors emending the list, since this method of establishing the order of things lent itself to Patristic explanations of the relation of Eve, the privative, to Adam, the positive, as well as to the explanation of the relation of soul to body and form to matter. In large measure the relation between these pairs reflects the unification by writers of the first centuries of Christianity of Plato's

dualist beliefs with the Pythagorean system. In contrast to the sets of opposites that pre-Socratic philosophers and Hippocratic writers used to explain their theories of the order of a single world of reality, Plato introduced a different type of opposition, one that distinguishes between two distinct worlds. On one side there is the world of the "divine and immortal and intelligible and uniform and indissoluble and ever constant and true to self." On the other there is the world of the "human and mortal and manifold and not intelligible and dissoluble and never constant nor true to itself."[16] The oppositional pair of Adam ("male") and Eve ("female") was easily inserted into this scheme. Created by God and therefore participating in His divinity or Idea (Pythagorean "oneness" or the Platonic "divine"), Adam exists fully and eternally (Pythagorean "unity" or Platonic "immutable"). Having been made from Adam's rib, Eve ("female") is not only derivative (Pythagorean "plurality" or Platonic "manifold"), she is relegated to the realm of matter. "Put in terms more appropriate to the Patristic tradition, man is spirit or soul formed directly by God . . . while woman partakes of the body in which inheres, again, the principle of division."[17] Considering both the position of "female" in this polarizing scheme and the point of both *Mulierum virtutis* and *Discorso della virtù femminile e donnesca*, both Plutarch and Tasso, depending on how they defined the exceptional woman, must either defy or accept the essentialism that is the infrastructure of Aristotelian thought. If they define the exceptional woman as just that — exceptional — then the status quo remains. If, however, they suggest that the qualities in her are latent in all women, then the physiological basis on which ethical assumptions were founded is rejected.[18] Both writers chose to assume the former position.

Admitting to differences between individuals — "Achilles was brave in one way and Ajax in another" — Plutarch still draws a distinctive line between males and females, and between females and exceptional females.

It is not possible to learn better the similarity and difference between the virtues of men and of women . . . than by putting lives besides lives and actions besides actions, like great works of art . . . For the fact is that the virtues acquire their own coloring, as it were, due to varying natures, and they

take on the likeness of the customs on which they are founded, and of the temperament of persons and their nature and mode of living.[19]

As the title of Tasso's *Discorso* implies, he agrees. Although the first duty of the woman "born of imperial blood" is to act in accordance with her noble status, she is not given leave to behave in a way not sanctioned by contemporary customs and current modes of living. But if in the end both Plutarch and Tasso kept woman in her subordinate place, they nonetheless revealed the flaw in the Pythagorean system. Clearly, exceptions are contradictions.

Tasso, more than Plutarch, grappled with this problem. His resolution was to establish a third category. By doing so, Tasso throws into question the viability of the age-old binary system. He was not the only sixteenth-century writer to do this. Several years before the publication of *Discorso della virtù femminile e donnesca,* Jacopo Zabarella (1535–89) published his *Tabulae logicae.* A corpus of diagrams that illustrates the relationship of the specific to the general, *Tabulae logicae* at once recalls and refutes Pythagorean oppositions by establishing a third, or intermediate, position between polar pairs.[20] I am not suggesting that Tasso's "womanly woman," an individual who cannot be classed exclusively with either component of the male–female pair nor defined strictly in accordance with the qualities associated with each sex, sprang from Zabarella's ideas about dualism and intermediates. Instead, I am suggesting that the established order, based largely on fictive presumptions and having evolved into a complex web of associations and implications, was forced to confront observable fact. One such visible fact, as Tasso's treatise discloses, was the all-too-conspicuous politically powerful woman. Another, as the writings of sixteenth-century critics, theorists, historians, and poets make clear, was the unprecedented number of women entering what, in the case of painting, Annibale Caro called in 1559 "the profession of gentlemen" and, in the case of sculpture, Francesco da Sangallo claimed in 1546 to be without question an exclusively male preserve.[21]

Whether or not the rejuvenating Tuscan air that Giorgio Vasari credits with having revived the visual arts at the end of the dugento had, by the beginning of the cinquecento, wafted over all of Italy, the atmo-

sphere was one permitting extraordinary achievement. One of the more extraordinary occurrences was the phenomenal appearance, as well as the literary recognition, of women in visual arts professions. Vasari's explanation for the flourishing of the arts in general is as viable as any other explanation for the dramatic increase in the number of *artiste femminile.* To claim that popularly held perceptions of women changed, all of a sudden, around 1500 is simply inaccurate. As for the willingness of writers to deal with female artists and their works, several possible reasons can be advanced. The first is a simple case of numbers. Cinquecento critics could not deny the female presence in visual arts professions, any more than Tasso could ignore the woman evincing "altezza dell'ingegno." The second goes hand in hand with the first. If one of the motives behind the birth of art history was the critics' desire to prove the miraculous nature of the Renaissance, then surely a celebration of *artiste femminile* as "miracoli" and "maraviglie" helped to prove the point.[22] The third possibility, which is neither generous or benign, is that these writers realized that the pen could control by describing, and thereby defining, what the cultural climate could not contain. If Vasari was right, then "the ravening maw of time" would take a higher toll on images than on texts. This, in turn, would leave unassailable the declarations of critics.[23]

As fate would have it, Vasari was correct. Frequently we have verbal descriptions of works of art and critical assessments of Renaissance artists but lack the paintings and carvings that would allow us to check word against image. Although this holds true for works by many artists, both male and female, it is more often than not the unfortunate case where Renaissance women artists are concerned. In fact, histories, biographies, theoretical treatises, dialogues, epitaphs, and neo-Petrarchan verse tell us what artifactual evidence does not. Nearly forty women were active artists in Italy during the sixteenth century. They were painters, engravers, embroiderers, and sculptors. A majority were the wives and daughters of artists. A few were the children of notaries and noblemen. Others were nuns who produced devotional images and God-fearing upper-class ladies who wove portraits with colored silks and embroidered liturgical vestments with gold threads. One was a wanton and lawless woman who wielded the chisel and her fists with equal zeal.

These women painted large-scale altarpieces, small devotional panels, still lifes, and portraits. They illustrated scientific tracts written by men and designed lace patterns for ladies. They carved portal reliefs for major churches and modeled clay images of saints and angels for chapel altars. A few were the beneficiaries of royal patronage. Most had to be content with minor commissions from the lesser nobility. Some enjoyed international fame. Others survive only as nameless daughters of talented and celebrated fathers. A select few had the luxury of turning away a patron or, as the case may be, having their fathers say no on their behalf. They were active throughout Italy: in Venice and Milan in the north, Naples in the south, Rome on the western Tyrrhenian coast, and Ravenna on the eastern Adriatic shore. All of them emerged during a time that has come to be regarded as the formative period of modern concepts of art, the artist, and art history, for it was during this era that, despite earlier resistance both in the intellectual order and in the popular imagination, the craftsman (*artigiano*) became the artist (*artista*), and academicians collectively promoted a unified theory of the arts.[24] With the acquisition of theory, the value of a work of art — and hence the merit of its maker — lay not merely in the image itself but in the language with which it was described. Thus, the choice of words used by *conoscenti* to translate the visual into the verbal was, art historically speaking, as important as, if not more important than, the image itself. Indeed, as centuries passed and art works disappeared, the word was inevitably privileged over the image.

The publication in 1550 of the first edition of Vasari's *Vite*, a collection of 142 Renaissance artists' lives, marks the victory in a battle waged in earnest since Filippo Villani wrote *De origine civitatis Florentiae et eiusdem famosis civibus*, 1381–2.[25] The victory — the inclusion of artists on lists of the illustrious — was achieved largely but not exclusively through the effort and example of two men and as a result of a methodological impasse then plaguing the discipline of history. In response to the last of these factors, historians fused the two formerly independent disciplines of history and biography into another form of historical discourse: biographical history. Of the various professions providing suitable subjects for this new genre, the arts emerged as the most amenable. The great masters had done their part in making this

possible. Leonardo da Vinci asserted that "the knowledge of the painter transforms his mind into the likeness of the divine mind," while Michelangelo, through his promotion of Leonardo's aphorism on auto-mimesis — [ogni dipintore dipinge se]" — established the rightness of the selection of art and artists as the proper subject for the new discipline.[26] The result was the birth of art history. Along with it was born the concept of the *artista*, a man in possession of a cluster of humanistic traits signifying excellent moral character (virtue) and/or intellectual and artistic accomplishment (virtuosity).[27] In a word, a man of *virtù*.

As the historical record shows, early writers took note of Renaissance women artists. Indeed, one of the artists, the Bolognese *scultrice* Properzia De'Rossi, was among the 142 "valiant men" included in the first edition of Vasari's *Vite*. She is, moreover, identified in that text as a "virtuosa" and, accordingly, placed in the company of other women who proved meritorious "in all kinds of virtue and activities": Corinna, as a writer of verse; Zenobia, as a warrior; Cassandra, as a seer; Ceres, as a cultivator of crops. Given the traditional etymology of *virtus* from *vir*, and considering Tasso's equation of "womanly virtue [virtù donnesca]" with "masculine virtue [virili virtù]" it is not unreasonable to ask if Vasari's *virtuosa*, like Tasso's *donna donnesco*, demonstrates the same "altezza dell'ingegno" as the *virtuoso*, and thus similarly holds an intermediate place in the Pythagorean scheme of contrariety. In asking this question I am, I confess, changing the focus of Tasso's discussion from a consideration of the consequences of class to those of profession. Such a shift is, however, justified on two counts. First, Plutarch had already proposed the topic, when, in the introduction to his discussion of virtue in *Mulierum virtutis*, he used the following rhetorical query as the frame on which to structure his discussion of female versus male virtue. "If, conceivably, we asserted that painting on the part of men and women is the same, and exhibited paintings done by women of the sort that Apelles, or Zeuxis, or Nicomachus has left us, would anybody reprehend us?"[28] Second, whether consciously or not, Renaissance writers provided answers to this question, which Plutarch himself never answered directly. Paolo Pino, for example, disliked the whole comparative idea. Speaking specifically about classical women painters, in other words

those very artists whose works Plutarch would have us exhibit side by side with those by Zeuxis and Apelles, one of the interlocutors in his *Dialogo di pittura*, 1541, says, "It displeases me to hear the woman compared to the excellence of the man in virtuosity, and it seems to me that art is denigrated by doing so. Art draws the feminine species away from that which is proper to it." But it is not the response of Pino's character that is of greatest interest, rather it is his statement that women artists, those who take up "the occupations of men [partecipavano dell'uomo]," remind him of tales told about hermaphrodites.[29]

Pino's choice of analogy is insightful. Not only does it define painting as a masculine vocation, it defines the woman painter as not quite male, not quite female. This puts her in a very uncomfortable – and sometimes unpopular – position. Certainly, that holds true of Vasari's Properzia De'Rossi, a *"giovane virtuosa* not only in household matters, like the rest of them, but also in sciences without number, so that all men, to say nothing of the women, were envious of her."[30] But his combination of knowledge and abilities does more than put the *scultrice* in an enviable place. De'Rossi's wielding of the chisel, a tool associated in 1546 by Francesco da Sangallo exclusively with men, positions her as an intermediate between a Pythagorean oppositional pair. And so we come to the problem of praise. How is something or someone – such as a female sculptor – to be defined if she does not fit into the established order? The obvious answer, and the one both Pino and Vasari propose, is to define her as a *miracolo*. Yet labels, whether "miracolo" or "donnesco," demand justification and require refinement. Early writings on the nearly forty sixteenth-century women artists supply both.

We can do no better than guess whether or not Plutarch considered painting on the part of men and women to be the same. Although he allowed the examples of heroic acts by women in his text to speak to the issue of male versus female virtue, he was mute on the topic of male versus female virtuosity. His silence is deafening. So, too, is that of Cicero and Quintilian, two of the three classical authors who wrote brief histories of art, which in their cases are corollaries to more protracted discussions of developments in the art of oratory.[31] The third

voice, that of Pliny the Elder, resounds with clarity. Having as its principal function the chronological tracing and critical assessment of stylistic developments in the arts of painting and sculpture, Pliny's survey of art history in *Natural History* provides the reader with a plethora of artist's names, dates, and works. It is in this history of ancient art that information necessary to answer Plutarch's query is found, for it is here that we discover, to use Pliny's words, that "women too have been painters." Six, to be exact: Irene, Marcia, Timarete, Aristarete, Olympias, and Kalypso.[32] Here, too, we learn that inclusion in an art historical text is not synonymous with incorporation into the progressive history that is the subject of that text. Appearing as they do in a perfunctory paragraph lacking references to historical place and following page after page of a chronologically ordered survey of the achievements of more than two hundred male painters, women artists are relegated to the status of an afterthought, an endnote.[33] Thus, to find an answer to Plutarch's question, we need only consult the ancient art historical record. To assert that painting on the part of men and women is the same was, it seems, inconceivable.

Sixteenth- and seventeenth-century writers on art convey a concept of female virtuosity that, though significantly expanding upon Pliny, parallels Plinian notions of art history and the position of women artists in that history. Pliny's influence takes two forms. The first is fairly temperate, because it is restricted to a recitation of information from the *Natural History.* When, for example, Giovambattista Adriani, Raffaello Borghini, and Giulio Cornelio Gratiano review the history of art in antiquity, they remain faithful to their source. As Pliny had done, they describe a succession of male artists inventing techniques and refining style. This accomplished, they pay brief tribute to Irene, Marcia, Timarete, Aristarete, Olympias, and Kalypso. The second form is virulent, being both long-lived and far more encompassing in terms of whom it affects. As is well known, Renaissance writers took great pride in their repossession of the past. For academicians formulating the new discipline of art history, repossession had special critical import. Notions of artistic rebirth established a comparative canon of excellence. Although the relationship between ancient and Renaissance perceptions

of art historical progression have been discussed at length, it is useful to review how the latter was structured on the former in order to advance a standard of artistic excellence.

Despite differences in authorial intent, length of text, and extent of detail, the histories of Cicero, Quintilian, and Pliny share the same organizing premise. From rude beginnings, the arts develop through successive periods of technical invention and stylistic refinement. Thus, Cicero "applaud[s] Zeuxis, Polygnotos, Timanthes, and others for their design and for their skill in the representation of details" yet maintains that "it is in [the works of] Aetion, Nicomachus, Protogenes, and Apelles that we behold, at last, the complete fulfillment of our desires."[34] Quintilian and Pliny concur. For Quintilian the evolution of style toward perfection in painting began with Polygnotos and Aglaophon, was advanced greatly by Zeuxis and Parrhasios, and reached its zenith in the works of Protogenes, Pamphilus, and Apelles.[35] For Pliny "the grace of [Apelles'] art remained quite unrivaled," while in sculpture Lysippos won the laurels of highest excellence for having exploited to perfection the possibilities of statuary first revealed by Phidias.[36] Within this evolutionary process an artist's individual characteristics of style or newly devised means of visualizing a concept becomes an agent of change. Timanthes' "representation of details," for example, makes possible Apelles' stylistic grace. Together, these artists effect collective advancement.

Renaissance writers made this historical scheme their own. The prefaces to Vasari's *Vite* plot a similarly progressive evolution of events for the history of Renaissance art. Broadly speaking, the three-stage evolution he charts corresponds to three successive centuries. It begins with Cimabue and Giotto in the trecento, continues through advances made by Masaccio and Donatello in the quattrocento, and attains perfection with Leonardo, Raphael, and Michelangelo in the cinquecento. Tracked stylistically rather than chronologically, works produced during "the first and most ancient age of these three arts (that is, the era that begins with Cimabue and Giotto) are seen to have been very distant from their perfection." Although judged by Vasari to be "good," the artists of this first age made images lacking in refinement. Their style was "dry." "In the second [era], it is manifestly seen that matters much improved, both

in the inventions [inventioni] and in the use of more design [disegno], better style [maniera], and greater diligence in their execution." Consequently, "rudeness and disproportion . . . were swept away." Although he does "not yet call them perfect," Vasari nonetheless declares this second generation of artists to be "better" than their immediate forbears. It is the painters, sculptors, and architects of the third age who receive his greatest accolade. Having mastered *regole, ordine, misura,* and *disegno,* these artists are designated "the best."[37]

Ever cognizant of classical precedent and dedicated to incorporating its example into the emergence of his own age, Vasari goes on to summarize the contents of Cicero's, Quintilian's, and Pliny's histories of ancient art and then to advance parallels between the past and the present.

If we can put faith in those who lived near those times and could see and judge the labors of the ancients, it is seen that the statues of Canachus were very stiff and without any vivacity or movement . . . Then came Myron, who was not a very close imitator of nature, but gave so much proportion and grace [proporzione e grazia] to his works that they could reasonably be called beautiful [belle]. There followed in the third degree Polykleitus and the other so famous masters, who, as it is said and must be believed, made them entirely perfect [perfette]. The same progress must also have come about in painting.[38]

Most importantly, this progress not only recurred, giving the *rinascita* its name, it positioned Renaissance artists well ahead of the progression-toward-perfection game. Because they stood on the shoulders of giants, Renaissance artists had a distinct advantage over their ancient forebears. Their task was to nurture and harvest the seeds of excellence already sown by Zeuxis, Timanthes, Apelles, and others. This, according to Vasari and other sixteenth-century critics and theorists, is exactly what they did. Raphael "enriched the art of painting with that complete perfection which was shown in ancient times by the figures of Apelles and Zeuxis; nay, even more," while Michelangelo vanquished "even those most famous ancients who without a doubt did so gloriously surpass" nature.[39]

References like these function in several ways. They acknowledge a debt. "The men of this age, which is at the topmost height of perfection, would not be in the position they are in if those others had not

been such as they were before us."[40] This debt is one of lineage. Thus, implicit in the designation of an artist as a "new Apelles" or a "new Zeuxis" is an assignment of historical place. But this is not just any place; it is a place at the top of the critical heap. A "new Apelles" is the modern paragon replacing the ancient paradigm. In other words, while analogies between the ancient past and Renaissance present reenforce the ties that bind together these two eras, they also assert a qualitative difference between them. That difference was understood as the besting of the best.

This view of the history of art altered its course. The strictly linear progression mapped by Cicero, Quintilian, and Pliny was now reconfigured to form a circle, or, more accurately, something that may be described as a figure eight. The lower circle charted the course of the arts through the ancient and medieval periods. It began in antiquity at the base, moved upward through a succession of artistic inventions followed by a series of stylistic refinements, until it reached the top of the curve. Then, during the Middle Ages, it slid back down to the point of its rude beginnings. Perceiving a rupture in history, the Renaissance designated its own origins not at the base point where the medieval period ended, but at the place where the classical period had reached its greatest height. This necessarily credited a "new Apelles" or a "new Nicomachus" with a style well above the critical mean. Equipped with an authoritative list of names provided by the three authors of ancient art histories, sixteenth-century critics and theorists structured their history of art as a complex web of critical comparisons with canonical import.

Gian Paolo Lomazzo's poetic "Discourse on Ancient and Modern Painters," 1587, recognizes the likeness of eras and follows a conventional pattern in advancing the comparative canon.

> Furon già sette gl'antichi Pittori
> Cinti la fronte d'immortal alloro
> Come soprani à gl'altri, e in mano loro
> Altre corone havear di verdi allori.
> Per i nostri adornar c'havean i cori
> Conformi à loro, e suoi emuli foro.
> Onde da Apelle primo in tanto choro

Fù cinto Rafaello in grandi honori.
Da Parrasio fù ornato il Bonarotto.
Da Protogene il Vinci illustre e chiaro.
Polidor da Anfion fù coronato,
Da Aristide Titian, dàl saggio & dotto
Sclepidoro il Mantegna; & doppo il raro
Gaudentio da Timante; & fui svegliato.[41]

[There were seven ancient painters, the laurel of immortality encircling their brows, for they are above the others, and in their hand are other wreaths of green laurel. In admiration we conform our voices in emulation. So it is that Apelles, the first in this great chorus, was joined to Raphael in the highest honors. Buonarotti was adorned by Parrhasios. From Protogenes Vinci was made illustrious and bright. Polidoro was crowned by Anfion {Antiphilos?}. From Aristedes Titian was made wise and learned, Mantegna made a second Sclepidoros {Elasippos?}, and Gaudenzio was Timanthes reawakened.]

It can be argued that Lomazzo's decision to include Gaudenzio Ferrari (ca. 1475–1546) and Polidoro da Caravaggio (1490/1500–1543) in his analogical "Discorso" had as much, if not more, to do with civic pride than aesthetic evaluation. The same can be said of the poem "De la Signora Caterina Cantona." Here, Caterina Leuca Cantona (d. 1605), the Milanese embroiderer whose works reportedly graced more than thirty churches in and around her native city and who made portraits that could be viewed from either front or back, is compared analogically to Aristarete, Timarete, Marcia, and Irene, four of the six female classical painters Pliny cites.

Trovai à caso frà le antiche carte
Le feminil pitture alte & reali,
Che sgradate non fur da i principali,
E de i lor nomi ne lessi gran parte.
Fra l'altre celebravasi Aristarete,
Con Timarete, & Marcia, che l'ali
Spiegaro al ciel eterne & immortali,
Alcestine, & Irena con lor arte.
Di Propertia scoltrice à tempo nostro,
D'Europa; Sofonisba, e lor sorelle,
Lessi di Rè pittrici et di Signori.

Ma de la gran Canona i chiari honori,
In ricamar effigie ornate e belle,
Avanza ciò che può dirne ogni inchiostro.[42]

[I found by chance among some old papers, lofty and regal feminine pictures, which were not displeasing among princes, and I read a great number of their names. Among those celebrated were Aristarete, with Timarete, and Marcia, who unfold their wings in the eternity and immortality of heaven with their art, as do Alcestine and Irene. Of Properzia, a sculptor of our time, of Europa and Sofonisba and their sisters, I read they were the painters of the king and of gentlemen. But treasured honors go to the great Canona. In her weaving of ornamental and beautiful effigies, she put forth everything that one could say with pen and ink.]

The issue of civic pride aside, what is striking about Lomazzo's second poem is the narrow scope of its focus. Not only is Cantona separated from her fellow Milanese, Polidoro and Gaudenzio, she is associated only with other women artists. Moreover, she, like the other named sixteenth-century *artiste femminile*, is made the artistic heir of Pliny's coterie of talented ladies. The existence of two poems – one about male artists, the other about females – and the gender-specific analogies in each make clear Lomazzo's answer to Plutarch's query. Works of art produced by women are not the same as those made by men.

Lomazzo's segregation of artists by sex can be seen as a sixteenth-century updating of Pliny's relegation of female painters to a textual place with no historical significance. Although it is true that his citing of Aristarete, Timarete, Marcia, and Irene supplies Caterina Cantona, Properzia De'Rossi, and the Anguissola sisters with a professional genealogy, it is also true that this genealogy carried little positive weight. To be the heir of someone without historical place is to assume a like position.[43]

Other writers apparently felt this strategy was a viable one. Taking advantage of a likeness in name, Federico Frangipane observes that Irene di Spilimbergo is the "true exemplar of her ancient namesake" (Appendix Two, Section 6a). But the convenient happenstance of same name was not a criterion for forcing women into a homologous group in which sex rather than style is the essential defining characteristic. In

1603 Lutio Faberio put Lavinia Fontana in the company of Timarete, Marcia, Irene, "and others already regarded highly in this marvelous art" of painting.[44] For Giulio Cornelio Gratiano, writing in 1636, Spilimbergo, De'Rossi, Anguissola, Campaspe Giancarli, and Marietta Robusti follow in the footsteps of Timarete, Irene, and Artistarete (Appendix Two, Section 5). Carlo Ridolfi agreed. Having cited in the introduction to his "Vita di Marietta Tintoretta Pittrice, Figliuola di Jacopo" the valorous accomplishments of Zenobia and Tomyris and the literary achievements of Corrina and Sappho, among others, he notes that, "over and above the honors granted Timarete, Irene, Marcia, and Aristarete in ancient times," Fontana, Robusti, and Spilimbergo should be celebrated for demonstrating clearly what "womanly perspicacity" [perspicaccia donnesca] can achieve when conjoined with "erudite studies" [erudita negli studii].[45] A century later Bernardo de Domenici recited a similar litany of names when speaking of Mariangiola Criscuolo. He does so, moreover, by noting that this requires him to suspend momentarily his historical survey. "If I want to record the great number of illustrious women who practice the arts of design, I must be able to interrupt the narration."[46]

Yet not all writers designated Renaissance women artists as the lesser other through the subtle implications of association. Some were openly critical, even though they used dialogues to mask (albeit transparently) their criticism. As noted, one such critic was Paolo Pino, who allows his interlocutor Lauro, in *Dialogo di pittura*, to play the role of devil's advocate by stating bluntly his dislike of any suggestion that men and women have comparable talents.[47] Lomazzo, in both his *rime* and *Libro dei Sogni*, was less strident but equally eloquent. In the *Libro*, an anachronistic dialogue between Leonardo da Vinci and Phidias, the Renaissance painter first marvels at the list of ancient women artists recited by the classical sculptor, then explains the effects of a historical reality. Social convention made it impossible for women "to practice like men."[48] Boccaccio described the situation this way: "in antiquity figures were for the greater part represented nude or half nude, and it seemed to [Marcia] necessary to make men imperfect, or, by making them perfect forget maidenly modesty."[49] For Lomazzo's Leonardo, such prohibitions inevitably meant that women did not make the "marvelous and wondrous

things" produced by men. There were, however, exceptions to the rule. Interestingly, they are identified in the context of past–present analogies.

The seventeenth-century critic Carlo Cesare Malvasia simultaneously follows and breaks convention. Like many before him, he introduces a woman artist by citing her professional genealogy. Thus, he begins his life of Elisabetta Sirani (1638–65) by invoking the memories of Properzia De'Rossi and Lavinia Fontana.[50] But he also recalls a host of male painters: "i fratelli Aspertini, i tanti Passerotti, i tanti Procaccini, i tre anzi quattro Carracci, quali dierono l'ultima mano alla perfetta pittura." This raises a serious question. With whom is Sirani to be classed? Malvasia provides the answer. Elisabetta's style, he says, is "manly [virile]." In contrast to the *artiste femminile* he has just named, she "never [left] in her work a certain timidity and flattery which is characteristic of the weaker sex [non lascio mai una certa timidità e leccatura propria del debil sesso]." This puts Sirani in the company of her seventeenth-century male peers and not in that of her sixteenth-century female forebears.[51] More to the point, it defines her as one of those exceptional females Tasso dubbed a *donna donnesco,* a woman blessed with "le virili virtù." More than a century later, Francesco Maria Tassi proved more liberal regarding the question of who was to be admitted to this select group. The Bergamese painter Chiara Salmeggia, also known as La Tapina, he says, is like "the ancient Timarete, Marcia, Kalypso, 'Lula Cesena Vergine Vestale' and those of more modern times, Sofonisba Anguissola, Artemisia Gentileschi, Lavinia Fontana, Elisabetta Sirani, Marietta Robusti, the most celebrated Rosalba Carriera . . . and those many others who, in their desire to study painting, left behind their inherent weakness and vanity [le naturali debolezza e vanitadi]."[52] Still, Tassi's liberality had its limits. Overcoming feminine weakness does not win woman the right to be classed with man. What was true for Plutarch remained valid for Tassi. To claim that paintings by men and women are the same is inconceivable.

CHAPTER THREE

(Pro)creativity

The man of genius possesses, like everything else, the complete female in himself.

—Otto Weininger

G ENDER permeates the metaphorical language of art, a language largely devised by Renaissance theorists and based on ancient philosophical precepts.[1] Nowhere is this more evident than in concepts of creativity and notions about the relationship of form to matter. In the Pythagorean scheme of things, form is associated with the positive and higher pole "male," leaving matter allied with the negative and lower "female."[2] The two come together when, during the creative process, matter receives form or, to put it another way, the generative idea transmutes into a tangible work of art. Since antiquity, biological procreation has been employed as a metaphor to explain the creation of images. Artists produce art works, just as parents generate children. Obviously this necessitates a merger of contrarieties. It does not, however, require equity in contribution or influence. Although matter is as essential to form in the creative process as is the female to the male in procreation, matter, like Aristotelian woman, is designated the indeterminate and receptively passive partner. Determinancy resides in form, just as potency resides in semen.

For Aristotle, bronze casting exemplifies the relationship. Bronze, like female matter, becomes a statue only when it is given form by the male sculptor.[3] The painting process is similarly described by Pietro Aretino. Brush in hand, the male painter actively manipulates passive pigment.[4] Taken to its logical conclusion, the (pro)creation metaphor made the woman artist an oxymoron, for man, to quote John Ruskin, "is emi-

nently the doer, the creator."[5] The protagonist of Henry James's unfin-
ished tale of a portrait painter points to the constancy of an ancient
idea redeployed by Renaissance writers and encapsulated by Ruskin. As
the preeminent creator, man assumes the procreative capacity of woman.

In the fall of 1895 Henry James entered in his Notebooks the first of
six notations that he would collect under the subject heading "The
Child." It was to be a story about the artist's power to create, a power
unbound by limitations of medium and one that draws on the fertile
wellspring of the imagination in order to create life itself. Initially James
envisioned a "woman who wants to have been married — to have become
a widow," who approaches a painter for a portrait of the husband lost
or never had. Then in 1900 the author significantly altered his story
line. The mateless woman is made a childless mother. Now "a young
couple come to a painter and ask him to paint for them a little girl (or a
child *quelconque*), whom they can have as their own — since they so want
one and can't come by it otherwise." Although the story remained
unfinished at the time of James's death in 1916, the author's intentional
equation of artistic creativity with biological procreativity is unequivocal.
The barren wife enters the painter's studio and assesses her surround-
ings; "things on easels, started, unfinished, but taking more or less the
form of life." Obviously aware of the artist's power to breathe life into
the imagined and inanimate, the young woman implores the painter to
"form a conception" of a child for her. In so doing, she acknowledges
his power to do what she cannot. The artist, it seems, can create life.
(The story was eventually published in its entirety in the *New York Times
Magazine*, Oct. 26, 1986.)

If, even in its unfinished form, Henry James's "The Child" may be
seen as one of literature's most pointed and poignant examples of the
equation of two disparate creative acts, the story is by no means singular
in advancing a similitude between the distinctively different ontologies
of making art and making children. In fact, a likeness between the
propagation of ideas and the procreation of children had long and
repeatedly been acknowledged. Aristotle, for example, asserted, "that
which desires form is matter, as the female desires the male."[6] Galen,
associating more clearly the male with the artist and the female with the
material shaped by the artist, concurred. "In the same way [the sculptor]

Phidias possessed the faculties of his art before touching the material, . . . so it is with the semen."[7] Thomas Aquinas followed suit. "In the arts the inferior art gives disposition to the matter to which the higher art gives form, . . . so also the generative power of the female prepares this matter, which then is shaped by the active power of the male."[8] These and similar statements paved the way for later writers, like James, to grant the artist creative powers extending far beyond the limits of the pictorial frame or marble block. But as Aristotle's, Galen's, and Aquinas's association of the artist with that which is male and the artist's material with that which is female suggests, defining the creative process in terms of contrarities was also a shared conceptual concern. For ancient and medieval writers the question was not whether the male is the principal generative agent but rather how secondary is the female role in the process.

Plato expressed his ideas on the subject in *Theatetus.* Here, Socrates claims to have inherited his mother's gift of midwifery. As she assists mothers in the delivery of their children, so Socrates, by his interrogative technique, aids men in bringing forth their ideas. Although the analogy suggests a likeness between these acts of assistance, the participants and products of each are different:

So great, then, is the importance of midwives, but their function is less important than mine; [although] . . . my art of midwifery is in most respects like theirs; [it] differs from theirs in being practiced upon men, not women, and in tending their soul in labor, not their bodies . . . Now I have said all this to you at length, my dear boy, because I expect that you, as you yourself believe, are in pain because you are pregnant with something within you.[9]

Although Plato's Socrates assumes skills associated with women in order to assist the "dear boy" who is pregnant with thoughts and in the throes of a decidedly female birthing experience that will result in the forma-tion of as yet unrealized ideas, he nonetheless distinguishes male from female, mind from body, and concept from matter.[10] He does so, moreover, in accordance with the asymmetry of the Pythagorean scheme of contrariety. Clearly, the creative male intellect is superior to the fecund female body. But what is most remarkable about this passage is the gender of the process itself. From start to finish, the form of

creativity in which Socrates participates is revealed to be essentially one of male self-generation.

Plato's view of creativity has been echoed through the centuries. In the second book of *Trattato di Architettura*, for example, Filarete explains to a patron the conception and nine-month gestation of an architectural design in procreative terms: "First the building is conceived and then, in a manner similar to the way a mother gives birth to a child after nine months, it comes into existence [l'edificio prima si genera, per similitudine lo potrai intendere, e così nasce si come la madre partorisce il figliuolo in capa di nove mesi]."[11] Similarly, Leonardo exploits biological analogies to the production of a work of art, using not only the verbs *partorire* ("to give birth to"), *nascere* ("to be born, come into the world") and *generare* ("to procreate") but also *creare* ("to make, create, invent") in this sense.[12] In a like manner but in reference to a different art form, Philip Sidney describes himself as "great with child to speak, and helpless in my throes," while Shakespeare's Richard II, separated from his wife and isolated in prison, creates a world populated by people as diverse as his thoughts.

> My brain I'll prove the female to my soul,
> My soul the father, and these two beget
> A generation of still-breeding thoughts,
> And these same thoughts people this little world,
> In humors like the people of this world.
>
> (V.v.1–2)[13]

Although Plato's position continued to have its proponents, accepting female participation in the (pro)creative process while relegating it to a necessary but decidedly inferior role was the norm.[14] This may be seen as a logical concession, since, if nothing else, acknowledging the female presence in the creative process was a recognition of the obvious. After all, it is an unassailable fact that that which is generated issues from *her* body. Yet acknowledging the undeniable did not result in participatory equity. Although it is necessary to recognize at least to some degree the procreative capacity of the female, necessity could be and was made the mother of invention. More specifically, woman was made the mother of man's invention. The principal spokesman for this point of view was

Aristotle, the first to present an explicitly epigenetic theory and the main author of *De generatione animalium,* the primary text cited in debates on embryology through the fifteenth century and one that continued to affect ideas on the subject during the sixteenth century.[15]

Aristotle maintained that four interdependent causes, or factors, are necessary for something to come into being; (1) the efficient cause, or the impetus to the making of that thing; (2) the formal cause, or that which gives form to matter; (3) the material cause, or matter that receives the form; and (4) the telic cause, or goal it endeavors to reach.[16] Three of these four causes (formal, efficient, and telic) he credits to male *sperma.* Only the necessary but least important material cause, or matter that receives the male engendered form, is viewed as a female contribution. Whereas the material cause, or *katamenia,* contributes to the growth of the embryo, it does not generate life, for if, as Aristotle contends, "the male stands for the effective and active, and the female, considered as female, for the passive, it follows that what the female would contribute to the semen of the male would not be semen (or what we understand as the ovum), but material for the semen to work upon."[17] But the difference between male *sperma* and female *katamenia* went beyond their respective associations with active and passive, and form and matter. For Plato the essential difference centered on "the principle of soul," which Aristotle defines as "the power of making the sensitive soul."[18] *Sperma* possesses this power. *Katamenia* does not. While the latter is similar to the former, it is "not pure, for there is only one thing that [katamenia] does not have; the principle of soul."[19]

This suggests that women are impotent, for, as Aristotle argues, "if the sensitive soul is not present, either actually or potentially, . . . it is impossible for face, hand, flesh, or any other part to exist; it will be no better than a corpse." It is man, therefore, who literally breathes air (*pneuma*) into inert matter, giving it life. Indeed, *pneuma,* which mediates between soul and body, accrued over time the power to mediate not only between the conceptual and the material, but also between person and image.[20] It became the *spiritus* that inspires the artist, the *anima* that animates what he conceives. *Pneuma* or *spiritus* was the verification of all of this creative *potenza.* "Other pictures may be said to be pictures,"

31

Vasari wrote, but "those by Raphael life itself, for in his figures the flesh trembles, the very breath [lo spirito] may be perceived, the pulse beats and the true presentment of life [vivacità viva] is seen."[21]

Aristotle, like Plato, saw parallels between physiological and artistic creation, but whereas Plato illustrates the likeness metaphorically, Aristotle explains it theoretically. The production of a work of art, he claims, is also "a state of capacity to make . . . [and] is concerned with coming into being, with contriving and considering how something may come into being [formal and telic causes], . . . and whose origin is in the maker [efficient cause] and not in the thing made [material cause]." This allows him to conclude that the processes of production and reproduction are "identical." This assumption necessarily gendered, and thereby qualified, each of the four ontological causes. As one of the four interdependent causes, the material cause was understood to be proximate matter. Within it form, but not soul, is said to exist potentially, for it is "that out of which something existing becomes."[22] In order for this latent form to be actualized, passive and malleable matter must be acted upon by an active source. In procreative terms this source is the male, for "the male, as male, is active and the principle of movement comes from him."[23] In creative terms this source is the intellective soul, the "form of forms," or, as Federico Zuccaro was to describe it at the beginning of the seicento, the "*concetto* of all *concetti*, form of all forms, Idea of all thoughts."[24] It is, in other words, the faculty enabling man to conceive in the abstract.[25] Only after this active agent has acted upon the passive material will the fetus or art object acquire its predetermined form and take on the defining character, or style, of its creator.

Aristotle's conception theory, at least on its most basic level, is an elaboration of older epigenetic notions. In Aeschylus's *Eumenides*, for example, Apollo says, "The mother is not the parent of that which is called her child but only nurtures the newly planted seed that grows. The parent is he who plants the seed."[26] In *Orestes*, Euripides employs the same furrowed-field analogy.[27] In doing so, he reenforces the association of female with matter. But ancient authors were not of one voice on this issue. Confusion concerning who contributed what as well as the degree of influence exerted by that contribution reflects the difficult task of delineating Aristotle's theory and underscores the inconsistencies in

De generatione animalium that point to more than one author. For example, Galen, who makes mention of the problem of authorship of *De generatione animalium* in his treatise *On Seed*, advocates a dual-seed theory that gives a more substantial role to the mother. Noting discrepancies in the Aristotelian text and using the artisan model, he describes a generative process more complicated than the peripatetic position that held the male responsible for either all or most of the relevant causes necessary for bringing something into being.

> For everything following [Aristotle] shows that, as from wood and the crafts-man the bench arises, in the same manner from the *katamenia* [female fluid] and from the motive principle in the male the fetus is established. Therefore, he says, some animals do not even discharge semen, but merely give a share of psychic heat . . . The female . . . receiving . . . the power that shapes and gives to shape its form.[28]

Galen's reading of Aristotle may be understood in one of two ways. First, generation is a more prolonged event during which the female material cause can affect the final outcome by literally "filling out" the male preformed concept. Second, the material and efficient causes are linked kinetically through the formal cause yet remain chronologically secondary to the telic cause. In either case, the female adds something to the sperm. Even if this addition is nothing more than nutrients, it changes the function of matter so that it is no longer wholly passive and receptive. In the case of the craftsman, the material (the type of wood chosen) affects the workings of the formal cause (the motions of the axe and drill). Nonetheless, both are subject to the desired effect (such as shape relative to function) that has been predetermined by the artisan. Thus, regardless of which teleological explanation one opts to accept, female (material) participation only completes what the male has essentially already done.[29]

Because medieval writers were heirs to several reproductive theories, they used ancient terms like *semen* so flexibly that it is not always easy to place them squarely in the camp of Aristotle or that of Galen, but they had no problem accepting the positive and negative values of Pythagorean contrarieties that inhere in classical preformation theories. Indeed, as these theories passed through the complicated maze of Christian interpretation, questions concerning male and female roles in reproduc-

tion as they relate to sex difference and familial resemblance became subplots to woman's overall inferiority to man. Ancient authors assisted medieval writers in this endeavor. In classical texts medieval writers found confirmation of their assessment of woman, who, as the descendant of Eve, is secondary, derivative, and inherently bad (Genesis 2:21–3). Pliny, for example, follows Aristotle in seeing male semen as the animating principle.[30] He then goes on to describe at length the ill effects of female semen, or *katamenia* – not upon woman but upon the world at large. Female fluid, he claims, can cause wine to sour, make mirrors grow dull, and kill bees. By conflating the destructive Plinian female with Eve's inherently sinful issue and by then placing this hybrid within the hierarchical scheme of Pythagorean contrariety, woman was made an even greater source of malignancy. "You are," Tertullian charged, "the devil's gateway: you are the unsealer of that [forbidden] fruit: you are the first deserter of the divine law: you are she who persuaded him whom the devil was not valiant enough to attack."[31] For these inherited sins, woman had recourse to salvation by one of two means. Because, as Cornelius a Lapide explains, woman "is granted to man . . . to help him procreate children," she could submit to man's will and bear the pains of childbirth.[32] The alternative was to submit to God's will, serve Christ, abstain from sex, and thereby rid herself of her "worldly body [and] the gender of [her] body."[33] Whether she opted to do the former or chose the latter was of no real consequence. In the final analysis, her choice changed nothing. Whether she submitted her body to man or to the Son of God, Eve's daughters remained secondary. Echoing the often repeated polarities set forth by Pythagoras, Saint Jerome summed up the situation: woman "is [as] different from man as body is from soul."[34]

The discovery, transmission, and assimilation of ancient texts in the later Middle Ages propelled classical conception theories and assumptions about gender difference into the Renaissance. Ever conscious of incorporating the antique into the present and conditioned to seeing women as intellectually and spiritually deficient beings, Renaissance writers accepted without hesitation the (pro)creation analogy, replete with all of its male–female polarizing associations. Certainly, it carried with it the authoritative principles of thought that structured ancient

systems of classification. It also harmonized the most revered of these principles. Not only did it leave intact the Pythagorean-Aristotelian contrariety of male as the positive and superior opposite of female, it accommodated Plato's division of reality into two distinct worlds: the "divine" and "intelligible" and its opposite, the "human," or earth-bound, and "not intelligible" or sensible material. Challenges to these polarizing schemes were not forthcoming from writers in either the medical or liberal arts disciplines. Indeed, although Renaissance medicine may be distinguished from the medieval discipline because of the work of humanists who produced the great editions, indexes, and commentaries on classical texts dealing with spermatology, hysterology, and the science of humors and physical change, and also because of the growth of experimental anatomy and an increase in clinical *consilia*, a long-lived belief in male *potenza* remained current. Before 1600, as Giovanni Marinello's *Delle medicine partenenti all'infermita delle Donne*, 1574, demonstrates, consensus held the hot male sperm, fueled by the "vapors" of the womb (*matrice*), to be "the instrument generating every creature."[35]

As Renaissance academicians incorporated terms like *concetto*, which comes from the Latin verb *concipere*, meaning "to lay hold of entirely," "to absorb" (as liquid), "to catch" (as fire), and "to conceive" (as a child), and *genio*, from *genius, gigno, gignere*, meaning "to beget," "to bear," "to bring forth," and "to produce," the (pro)creative metaphor came increasingly into play.[36] In fact, the notion of likeness may be said to have come of age during this era of rebirth. Not only was each of these creative processes deemed indispensable to its counterpart as the ideal means of explaining the other; each was viewed as the ontological model from which the other took its being. Certainly, it takes little perspicacity to see how the metaphor works. Ideas, like children, are often said to have been conceived during the heat of passion, which, at its greatest intensity, is wholly absorbing. This intensity is the *fuoco, furia*, and *fierezza* of creative inspiration, the *calor genitalis* of male seed, the *logos spermatikos*, which the Stoics regarded as *the* cosmic procreative force. Because it is a peculiar nature of the visual arts that the *concetto* is actualized in a tangible and frequently figurative form, the metaphor could be and was extended beyond the process to the actual product.

A work of art, like a child, has a genetic relationship with its creator. In the work of art we recognize the relationship as style; in the child we call it familial resemblance.[37] This makes the artist's mind a matrix or womb. Indeed, as the locus of generation and as the mediator between the imagined and the real, as well as art and nature, form and material, and soul and body, the creative mind is a matrix in the fullest sense of the word. Here, as Leonardo argues, the postsensory and prerational faculties of memory, cogitation, and fantasy come together.[38] Like so many threads woven into a distinctively patterned cloth, myriad sensible things apprehended, remembered, and imagined are compounded, transposed, and augmented as the conceiving mind's eye fashions the desired form. Initially this form is abstract concept, a kind of mental embryo. In a process which, as Filarete observed, is like gestation, it is fertilized by the creative imagination and shaped by reason and critical judgment. Finally it is given material form, as if it were a kind of progeny. Federico Zuccaro recognized this when, proceeding from Aristotle's dictum, he defined in 1607 a work of art as a *composto,* a union of matter and form organized on principles of *misura* and *ordine.*[39] In this respect, an image can be compared to a person, a union of body and intellectual soul. Earlier, in 1575, Juan Huarte acknowledged this likeness. Calling attention to "engender" and "generate" as the root meaning of *ingegno,* Huarte credits *ingegno* with dual powers. On the one hand, it is a physiological power man shares with beasts. On the other, it is a conceptual power enabling man to participate in the spiritual through intellect.[40] But embedded in the perceived parallels between the act of generating offspring and that of producing works of art was the well-established division of procreative responsibilities, a division giving men but denying women full (pro)creative capacity. Here the operative word is "full." That the female participates in the procreative process is undeniable. That women also participate in creative arts professions had become, by the second half of the cinquecento, equally undeniable. I believe the difference between *his* versus *her* participation in the second of these processes can be seen as the difference between creating and making. Although this semantic distinction is my own, it is based on the metaphorical language of sixteenth-century texts.

In the *Due Lezzioni,* 1549, Benedetto Varchi claimed, "*disegno* is the origin, source, and mother" of painting and sculpture.[41] A year later and again in 1568, Giorgio Vasari switched the gender of the generative parent. Painting and sculpture, he says, are as "sisters born from one father, through a single, simultaneous birth [un sol parto]."[42] Subsequent characterizations of the originating and subsuming source of the arts suggest that Vasari, not Varchi, gendered the creative process in accordance with generally held truths about procreation. Indeed, Varchi vacillated on the issue. Whereas in 1549 he made *disegno* the "mother" of the arts, in *Lezione sulla generazione del corpo umano,* 1543, he pointed to the father as the principal generative force. Just as medieval writers used the words *semen* and *sperma* flexibly, so Varchi uses the term *sperma* to refer on occasion to both male sperm and "female fluids." Nonetheless, in *Lezione sulla generazione* he concludes that, because male sperm is hot and female "sperma" or "materia" or "uomore" is cool and damp, the man possesses the potent "spirit of movement."[43]

If biological procreation and artistic creation are like ontological processes, then Varchi's vacillation is nonsensical. What is true of one type of creation should, logically, be true of the other. The artist should assume the active potency (*potenza*) of the male. The material (*materia*) he shapes should passively receive his design. Although speaking of the author rather than the artist, Shakespeare perhaps captures best the essence of the relationship when, in *The Winter's Tale* (II.iii) he wittily compares the actions of a love-making couple to the movement of a printing press. Rhythmic up and down motion aside, the process whereby the blank page receives the impression of a male-authored text is not unlike that which enables male form to be impressed on female matter. As the metaphor makes clear, male intellect, like sperm, is the principal agent in all generative acts. Writing in 1633, Galeazzo Landrini agreed. Citing Aristotle as an authoritative voice on the subject and using wax and paper as his examples, he identifies male sperm as that which moves impressionable female matter.[44] Analogical transpositions in writings on art bear out this line of reasoning. Like Vasari, both Anton Francesco Doni and Alessandro Lamo identify *disegno* as "il padre."[45] And, although Benvenuto Cellini designates relief rather than design as

the singular parent, he too invests "il padre" with (pro)creative pow-ers.[46] When all is said and done, Varchi's statement of 1549 stands alone in granting the "madre" the capacity to create.

Logically then, that which is produced by *disegno*, namely works of art, could provide writers with another venue for extending the metaphor. If the processes of procreation and creation are alike, then each results in progeny, the former being composed of flesh and blood, the latter of pigment or stone.[47] Vasari recognized the equation. "When a son of [the goldsmith and painter] Francia as a very handsome young man was introduced to Michelangelo he [Michelangelo] said to him, 'the living figures your father makes are better than those he paints.'"[48] A similar remark concludes Vasari's review of Sofonisba Anguissola. "If women know so well how to make living men, what marvel is it that those who wish are also so well able to make them in painting? [Ma se le donne sì bene sanno fare gli uomini vivi, che maraviglia che quelle che vogliono sappiano anco fargli si bene dipinti?]"[49]

Vasari's comment about Anguissola's (pro)creative capacity is, in the general context of writings about artists' works, not particularly notable. However, in the specific context of critical writings about women artists it is unique. How, then, are we to interpret this curious aside? There are several possible ways to read the remark. First, and speaking generally, Vasari suggests that the woman artist is an oxymoron. This interpreta-tion rests on the synchronization of this passage with popularly held contemporary notions about biological reproduction (and intellectual conception), notions that define the man as *the* creator. Second, and in specific reference to Anguissola, Vasari implies that this *pittrice* can do what other women cannot. If this reading is right, then Sofonisba, whom Vasari commemorates "in memoria della [sua] virtù," is defined as a woman in possession of what Tasso was soon to differentiate from "femminile virtù," namely "donnesca virtù." She has abilities enabling her to act like a man or, in this case, paint like a *pittore*. Finally, the remark can be read as irony. Anguissola, who died childless, never demonstrated a capacity to "make," let alone create, living men. The last of these options is untenable. The publication of Vasari's statement preceded Sofonisba's death by forty-six years. At the time it appeared she was in her thirties, old, by contemporary standards, for childbearing

but not so old as to preclude the possibility. This leaves as viable the first two and not unrelated choices. If, as I will argue, Vasari's comment is a combination of options 1 and 2, then a subdivision in type, which can be defined as an intermediate existing between a Pythagorean contrariety, is established. In other words, Anguissola is an exceptional woman, one possessing Tasso's "virile virtù," a *virtuosa* in the fullest sense.

In the presumed order of things and reflective of the difference between *ars*, which can be taught and learned, and *ingenium*, which originates only with the artist him- or herself, there are artists and there are Artists. These are not the only two categories established in early texts. There are also artists and female artists, a division in type made clear by both the terms for each (*pittori / pittrici*, and *scultori / scultrici*) and by the practice of qualifying the word *artiste* with the adjective *femminile* when the reference is to women. Vasari, it seems, believes there is yet another division. There are *artiste femminile*, and within this group there are *virtuose*, women who distinguish themselves by doing something perceived as masculine. Such an assertion was not difficult to make. Indeed, Vasari could easily carve out a special place for the *virtuosa*, because of the already recognized contradictions within contrarieties, not the least of which were inherent in concepts of ontology.

If medieval notions of woman explain how concepts of masculine and feminine, including theories of spermatology, hysterology, and the science of the humors, came to depend less on academic debates concerning sex difference and more on debates dealing with gender difference, they also underscore the problematical nature of the dislocations within the (pro)creative metaphor. Although to recognize a likeness between the patterns of the propagation of ideas and the procreation of children may be seen as reasonable, the appropriation of the inferior female body by the superior male seems to defy logic. Crediting the female mind with the intellectual capacity to conceive ideas would also have seemed incredible, if for no other reason than a lack of philosophical precedent. There are, however, two possible rational explanations for what appear to be illogical presumptions. The first focuses on the exceptional woman. The second, which subsumes the first, considers

woman as a homologous class and presupposes certain and definitive truths about female subordination.

As Plutarch's *Mulierum virtutis* demonstrates, women could act like men. Such women were wonders or "errors" of nature, as Boccaccio said of Artemisia, queen of Caria, a woman he describes as female in body but one "endowed by God with a magnificent and virile spirit."[50] Error or not, the exceptional woman was increasingly a presence that demanded and got recognition. As Tasso's *Discorso della virtù femminile e donnesca* shows, definitions went hand in hand with this recognition. Invoking the authoritative voices of Plato, Aristotle, Plutarch, and Petrarch, Tasso reviews and accepts the long-lived lists of oppositional virtues ascribed to each sex: men should be eloquent, women silent; men should be magnificent, women modest; men should be liberal, women economical, and so forth. But, he notes, there are exceptions to the rule. Whereas "intellectual speculation [a fundamental principle of artistic creation] does not suit" ordinary women, it is appropriate to the "womanly woman [donna donnesco]," because she is endowed with "masculine virtue [le virili virtù]." In such cases, he argues, the dominant virtue ascribed to one sex may be present in the other. Thus, the exceptional woman can be eloquent, liberal, magnificent, and so forth. Nonetheless, this woman, as female, should simultaneously remain economical, silent, and modest. Putting aside the questionable possibility of reconciling opposing virtues in one person, Tasso's virtuous hybrid opens the door for the appropriation of the characteristics of one sex by the other. She does so, however, without weakening the infrastructure of Aristotelian thought. For all her "virile virtù," this woman is still female.

Did gendered expectations bar women from visual arts professions? Obviously, they did not. Did a woman's sex affect critical assessments of her professional activities? In most cases the answer is yes. And even when, as sometimes and infrequently happened, a woman artist achieved critical parity with her male peers, her singularity served to underscore the deficiencies of all others. Nowhere is this more evident than in discussions of portrait painting.

Beginning in antiquity, writers recognized portraiture as the major

and correct preoccupation of the woman artist. Pliny, for example, observed that Marcia "painted chiefly portraits of women," an observation repeated by Boccaccio. Moreover, of the eight works Pliny cites by subject, five are identified as portraits. That women were viewed as particularly well suited to this art form is evinced further by commentaries on Lavinia Fontana. Fontana began painting around 1570. Although she produced small devotional panels in a manner described as a balance "between a Flemicizing interpretation of familiar aspects of Bolognese culture . . . and a delicate, sentimental accentuation of the religious ideology promoted . . . by Gabriele Paleotti," it was through the painting of portraits that she achieved fame.[51] Looking back at Fontana's career in 1642, Baglione was not surprised by her route to success, for "being a woman, in this kind of painting [portraiture] she did quite well."[52] Fontana's sex also explains her inability to take on the challenging task of painting anything other than "an ordinary painting [un quadro ordinario]." Applying to Lavinia the deficiencies of Aristotelian woman, Baglione assesses her now lost monumental and narratival altarpiece for the basilica of San Paolo fuori le mure in Rome, *The Martyrdom of Saint Stephen*, 1603–4 (Figure 1), by commending her decision to thereafter restrict herself to painting portraits.[53] Baglione's critique of Fontana's abilities as limited by reason of her sex is by no means unique. Without exception, women are never praised for painting historical, biblical, or mythological narratives (*istorie*). Many, however, are commended for their ability to paint portraits (*ritratti*).

Although a significant number of religious compositions are among the works attributed to Fede Galizia, whose oeuvre otherwise consists primarily of still-life paintings, the Milanese had established her reputation as a portraitist by her teens.[54] According to Paolo Morigia, who included the painter in *La Nobiltà di Milano*, 1595, and whose portrait Galizia painted that same year, Fede captured his likeness with "such excellence . . . that no one could desire anything more."[55] That portrait is lost, but a second one of him made in 1596 exhibits the "high degree of naturalism [talmente al natural]" Morigia found so pleasing. Adhering to the tradition of naturalistic portraiture in northern Italy, most notably seen in the works of Giovan Battista Moroni and Moretto da

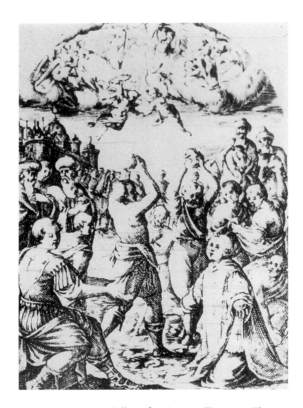

Figure 1. Jacques Callot after Lavinia Fontana, *The Martyrdom of Saint Stephen*, 1603–4, destroyed by fire, 1823. (Photo: author.)

Brescia but also evident in those by Sofonisba Anguissola, whose work Galizia knew, Fede rendered with acute precision her sitter's wrinkled skin, set jaw, and the distorted image reflected in a pair of spectacles.[56]

Morigia is not alone in praising a *pittrice* for her skill in *l'arte del ritratto.* According to Carlo Ridolfi, Marietta Robusti was "particularly skilled in knowing how to make good portraits." Indeed, "molti gentil'huomini e Dame Venetiane," including the famed antiquarian Jacopo Strada, sought her talents.[57] What was true of Robusti holds true for Lavinia Fontana. Fontana, says Malvasia, was particularly popular with the Bolognese patriciate, especially the female members of the Peppoli, Gozzadini, Bargellini, and Boncompagni families, who, desiring both

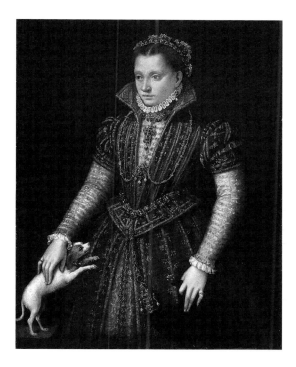

Figure 2. Lavinia Fontana, *Portrait of a Noblewoman*, ca. 1584. National Museum of Women in the Arts, Washington, DC. (Photo: National Museum of Women in the Arts.)

the company and talents of the "virtuosa giovane," asked her to paint their portraits.[58] Numerous extant portraits by Fontana shed light on the cause of her appeal. *Portrait of a Noblewoman*, ca. 1584, plays the quiet reserve of the subject's face against a profusion of detailed jewels and richly embroidered and patterned fabrics (Figure 2). According to one modern writer, "the portrait makes a splendid impression because of the sitter's beautiful clothes and accessories; her wealth and status, not her personality, are its subject."[59] Another modern critic sees the image differently. "In the *Noblewoman* of Washington there is perhaps a note of emergent melancholy in [Fontana's] subtle investigation into the psychological character of the face."[60] Rather than read these statements as

mutually exclusive, they should be taken as mutually supportive testaments to the Bolognese artist's capacity to balance artfully the various elements of portraiture.

Although early writers uniformly praise women as particularly proficient in rendering a sitter's likeness ("specialmente in ritararre"), critical commentary on their works is most notable for what it does not say. Whether the artist whose images were under review enjoyed international prestige, like Robusti and Fontana, or was little known, like Mariangiola Criscuolo and Quintilia Amaltea, several key phrases and terms are conspicuously absent. None of these women is praised for creating images "more alive than life itself [più vivo che vivere]." None is credited with creative *invenzione*. And none is commended for a lively style, a masterful technique that makes the difficult seem "effortless [disinvoltura]." Such omissions draw a qualitative distinction between the created and the replicated, between the animate and the inanimate, between the good and that which is merely mediocre. Giovambattista Armenini enunciated the difference in *De'veri precetti della pittura*, 1587. "Even an artist of mediocre talent [mediocre ingegno] can master this art [portraiture] as long as he is experienced in colors." Indeed, Armenini continues, "I say that we have seen more than once that the more accomplished an artist is in *disegno*, the less he has known how to make portraits."[61]

Keeping in mind that Armenini, like Vasari, Doni, Lamo, and other sixteenth-century theorists, implies a likeness between the propagation of ideas and the procreation of children when he defines *disegno* in one instance as "an idea born in the mind" and in another as "that thing imagined first in the mind and conceived by the intellect and by judgment," his explanation for this division can come as no surprise.[62] Recognizing the constraints placed on creativity that are an inherent part of copying (*ritrarre*), he contends that the truly good artist cannot "endure" the "awkwardness and weakness" found in faces in nature. Thus, rather than simply replicate the faces he sees, this artist will, to varying degrees, invent and thereby perfect a likeness to correspond with his concept of how it should be. He will, in other words, substitute *imitare* for *ritrarre*.

The difference between these mimetic methods is explained most

concisely by Vincenzo Danti. "By the term *ritrarre* I mean to make something exactly as another thing is seen to be; and by the term *imitare* I similarly understand that it is to make a thing not only as another has seen the thing to be [when that thing is imperfect], but to make it as it would have to be in order to be of complete perfection."[63] Vasari agreed. Artistic license (*licenza*) "enables the artist to enhance his work by adding copious invention [*invenzione copiosa*] and, as it were, a certain beauty to what is merely artistically correct."[64] In fact, engaging in "license . . . without creating confusion or hurting order" and endowing a work with "a grace that exceeds measure" leads to an ever *più bella maniera.* Although Armenini concedes that a portrait made in this way is "less of a likeness," he too maintains that its perfection raises it above the "mediocre."

Armenini's division of the art of portraiture into two types was an important hierarchical distinction. On its most rudimentary, or "mediocre," level, a portrait is a record of a person's physical likeness. It does not go beyond the surface. An image of this kind does not require intellectual sophistication on the part of the maker, since copying (*ritrarre*) demands only the coordination of the hand with the eye. It also (and this is of importance for women artists) does not entail any form of impudent observation. But by the end of the quattrocento, portraiture, like other art forms, had become "an expression of conviction . . . reflecting the reawakening interest in human motives and human character."[65] The publication of treatises on physiognomy, like Alessandro Achillini's *De Chyromantie principiis et physiognomie,* 1503, or texts that included an excursus on the subject, such as Pomponius Gauricus's *De sculptura,* 1504, and Lomazzo's *Trattato dell'arte,* 1584, heightened artists' awareness of the challenges of visualizing the invisible.[66] In order for the artist to capture the uniqueness of the human personality he had to go beyond perceptible reality, using the visible only as the starting point from which to reveal what is described in Leonardo's Notebooks as "the motions of the mind [i moti dell'animo]."

The difference between these two methods of painting a portrait, one dependent on perception and tied to the sensible (*ritrarre*), the other born of concept and linked to the intellect (*imitare*), came to be understood as a qualitative distinction between mere technical facility and

technical prowess coupled with creative invention. The idealized perfection, or *le arie del bel viso,* of the latter came to function as a synecdoche for the beauty of the art of painting itself. This beauty had the power to propel the beholder up the Platonic *scala amoris,* or ladder of love. But it could do so only after the painted or sculpted image had acquired the immediacy of a psychological presence. The artist had to give it life, make it appear to breathe, listen, and even speak. In contrast to portraits that do no more than transcribe physical appearance, portraits *più vivo che vivere* demand *imitare,* or coordination between visual perception, intellectual contemplation, and manual dexterity. They require creative *potenza* — "imitazione adopera tutte le potenze dell'intelletto."[67]

Artistic *potenza* may be understood in two distinctive but related ways. On the one hand, it is the capacity to give form to formless matter — the bronze, marble, or paint. On the other hand, it is the ability to reshape imperfect matter — the model — in accordance with a preformed concept of beauty. The Pythagorean opposition of form and matter inheres in both, yet it is in the second type of *potenza,* which necessarily demands the first in order to be actualized, that the creative mind assumes all the mediating powers of the *matrice,* or womb. The imagined ideal is made real as the material receives *anima* from the inspired creator. But because the resultant form is a visualization of perfection generated by the maker's mind, idealization necessarily holds primacy over naturalism. This, Zuccaro maintained, is the essence of *disegno.* Because intellect is always the intellect of someone, it always deals with the particulars of its own imaginings and desires. Thus, while ideas or mental images refer to and depend on external sense (memory), the mind perceives potential and conceives the ideal. This ideal, a vision void of the "awkwardness and weakness" found in nature, is the subject of portraits Armenini praises as being of the highest kind. Such images function as testaments to an artist's *ingegno* as it was defined by Juan Huarte, since they are enlivened by *pneuma, spiritus,* or *aria* in its most complete sense.

Sixteenth-century ekphrastic descriptions of painted images, based on Petrarch's sonnet on Simone Martini's now lost portrait of Laura, capture the *più vivo che vivere* qualities that make the absent vital and present. Baldassare Castiglione's Latin elegy on Raphael's portrait of the author, which moved Castiglione's wife Hippolyta to "caress it," "laugh

and joke with it, [and] speak to it as though it were itself capable of speech; for with an assenting nod it seems indeed to speak . . . your words," Giovanni della Casa's description of the now lost portrait of his mistress by Titian in which the beloved "opens and moves her eyes on living canvas, and speaks and breathes . . . and moves her sweet limbs," and Vasari's detailing of the *Mona Lisa*'s "beating of the pulse" and lips that "seemed, in truth, to be flesh, not colors" are only three of countless examples of portraits said to have been endowed with life by the painter.[68] Without exception, these descriptions refute the inanimate nature of paint by emphasizing the life-giving *potenza* of the artist. They also, almost without exception, describe images of women made by men. If this may be seen as a faithful adherence to the notion that matter is a feminine principle of perfect potentiality and form is a masculine principle of perfect activity, it also throws open to question not only the extent to which the female possesses the capacity to create but also the extent to which women can excel in an art form for which they were said to be well suited.

Following the theoretical lead of Cennino Cennini and Lorenzo Ghiberti, and demonstrating the rightness of Leonardo's aphorism "every painter paints himself [ogni dipintore dipinge se]," Vasari and other sixteenth-century academicians frequently associate an artist with his work, or more precisely, associate his demeanor with that of the figures he produces. Thus, for example, the "infinite grace [seen] in all of [Leonardo's] action" parallels the *grazia* characterizing all of the figures he paints.[69] This is *aria*, the essential and interchangeable characterization of the artist's style with the presence of a person he has fashioned. Such a transposition demonstrates all the creative powers signified by *aria* — conceiving beauty, designing form, shaping material, and, finally, giving it palpable presence. This implies a causal relationship between the creator and the created, a relationship that hinges on issues relating to the soul as a life principle and one that reflects a belief in it as the presumed medium of expression between person and person, and person and image. "The soul itself being invisible, its actions and interactions with the world are made evident to us as expressions and movements of its agent, the body. It was on the bedrock of this idea that one of the

foundation stones of Renaissance art literature was set."[70] The active principle of making begins with "the form in the soul." From this starting point the form develops, at last becoming a "product of art . . . produced from a thing which shares its name."[71] In terms of artistic creation, this is the power to make the invisible apparent and animate, to reveal what Leonardo called *i moti dell'animo*, to vivify what Pliny described as the *animus et sensus hominis* or *perturbationes.* On the most obvious level, the relationship between mind and body is expressed in physiognomy and gesture. People reveal their inner selves through expression and action. But an image of a person, because it is a product of a self that is not its own, must necessarily mirror the principle of soul belonging to its maker. This explains why Leonardo's personal *grazia* is reflected in the works he produces. It also reenforces the notion of *materia* as impressionable and advances the likeness of familial resemblance to artistic style. Here, too, the issue of the female capacity to create comes into play.

The explanations proffered by Aristotle for a child's resemblance to its mother were contradictory and unsatisfactory. To account for this phenomenon, Galen and Hippocratic authors maintained that family resemblance, which includes the sex of the child, must be understood in terms of the generative contributions of both parents. According to dual-seed theories, both parents have male and female seed. In the event that the contributions conflict, "one – not necessarily the son-producing seed or their father's seed – will prevail."[72] For Aristotle, who viewed woman as an infertile male, such an idea would have been out of the question.[73] He argues that semen contains and transmits the same movements that are in the father's blood at the stage when the blood is forming bodily parts. These movements, therefore, must tend to produce in the female matter a soul as well as a form identical with that of the father, since male *sperma* is the "originative source" and that which possesses the "principle of soul."

Although the procreative process in and of itself should insure that a child reflects its father, Aristotle advises each man to bring the "design" of his children under his conscious control. He can do this by engaging in sex at the proper time, during the right weather conditions, and, most importantly, with the appropriate mate.[74] A failure to follow these

prescriptives, or a man's inability to generate the all-important vital heat, which is the source of movement, will result in the creation of a child that is either a deformed male or a female.[75] Renaissance physicians agreed with the philosopher on several key points. Chief among them are the primacy of the male in procreation and the possibility of external influences affecting conception. For example, Jacopo da Forlì, a physician and philosopher teaching and writing in Padua around the turn of the fifteenth century, proposed cold weather, northern winds, the eating and drinking of warm foods and beverages before sexual intercourse, and significant celestial influence as factors that increase the chance of producing a male child.[76] In 1576 the Venetian physician Giovanni Marinello, like Aristotle, would emphasize the importance of choosing the right mate[rial]. He suggests that the prospective father desiring the all-important male heir select a woman with "good coloring and a pleasing disposition, who is not heavy but soft in body."[77] Her softness, which Marinello contrasts with male hardness, makes her impressionable and thus, as Shakespeare's printing press metaphor elucidates, the ideal recipient of his form. But children can and often do resemble their mothers. How does this happen? Once again, the idea of necessity as the mother of invention is invoked. Continuation of the species requires females. But in a process that was argued to be essentially one of paternal preformation, deviation was often explained as the resistance of matter to conceptual form. This "fact," like virtually all aspects of the theory of procreation, found a place in art theory.

Aristotle's ideas concerning paternal design and maternal (as *materia*) resistance fell on fertile theoretical ground. All art, Varchi argues, must culminate in a product fusing form and matter. "What is generated by nature or made by art is neither in the form alone nor only [that is, potentially] in matter, but the whole compounded together."[78] But as Vincenzo Danti reiterates, in order for an artist to realize "the perfect concept composed in the mind [concetto perfettamente composto nell'idea]," the material receiving the idea must be suitable to his intentions.[79] "All the intentional forms of nature are in themselves most beautiful and proportionate, but matter [*materia*] is not always suitable to receive them perfectly . . . Most of the time matter does not receive the perfection of form."[80] Although the male–female opposition is not

stated explicitly, it is nonetheless implicit in the contrariety of conceptual form to material shape. In fact, responsibility for the miscarriage of a concept is laid squarely on a feminine principle (*materia / mater*).[81] The idea of material resistance is conveyed in a statement attributed to Michelangelo by Francisco de Hollanda. If an artist is able to "imagine beautiful and masterly [things], his hand could not be so inexpert as not to reveal some trace of his beautiful desire."[82]

The relationship of the child to its mother goes beyond the female contribution of matter. *Materia*, it seems, is very impressionable, receptive to sense impression as well as conceptual design. What a woman saw during impregnation or during the course of gestation could have a significant impact on the fetus. In Heliodorus's third-century romance *Aethiopian Tale about Theagenes and Charicleia*, Charicleia's pale complexion, "which color is strange among the Ethiopians," was the result of her mother having "looked upon pictures of Andromeda naked . . . and so by mishap engendered presently a thing like to her."[83] Improbable as it may sound, Heliodorus's tale was repeated in variation by writers such as Soranus, found practical application in Renaissance *bambini*, *deschi*, and majolica vessels, and survived well into the nineteenth century as the Venetian saying, "Quel che se fissa, se fa" (What she looks at, she makes), demonstrates.[84]

Recorded in Florentine *ricordanze* between 1450 and 1520 as part of a trousseau, *bambini* were mostly sculpted and richly dressed male babies. Most, but not all, were images of the *bambino Gesù*. Some were the products of master artists, such as Desiderio da Settignano and Benedetto da Maiano. They may have been considered talismanic, transferring magically "virtues and forces from the effigy to its user." "The future mother, in other words, would be impregnated, by visual contemplation, with the power and qualities of the magic object."[85] Paintings were invested with similar pre- and postpartum power. According to Leon Battista Alberti, "Whenever man and wife come together, it is advisable only to hang portraits of men of dignity and handsome appearance, for they say this may have a great influence on the fertility of the mother and the appearance of future offspring."[86] The sixteenth-century Bolognese naturalist Ulisse Aldrovandi was to agree, urging families to hang only images of attractive people in bedrooms "perche

quanto molto importa alla concettione della matrone et quanto alla bellezza della futura progenie."[87] Giulio Mancini repeated the idea. He recommends for bedroom viewing only those images that promote the most efficacious results: healthiness and attractiveness. Beautiful and sexually provocative images "serve to arouse one and to make beautiful, healthy, and charming children . . . not because the imagination imprints itself on the fetus, but because each parent, through seeing the picture, imprints in their seed a similar constitution which has been seen in the object or figure."[88] Juan Luis Vives agreed, recommending pictures of beautiful men, such as Hercules, as particularly appropriate.[89]

Although Mancini's statement illustrates an acceptance of a dual-seed theory, it nonetheless continues to accept male primacy, since his remarks are part of his instructions directing men where to strategically place specific types of images within the home. It seems only fitting that images of children made by men be placed in rooms where "one has to do with one's spouse." There they can augment "designs" of children conceived by fathers and possibly decrease the effects of material resistance. Clearly, the function of talismanic images underscores the susceptibility of *materia* to sense perception, which, in turn, reenforces a belief in woman's limited ability to see beyond the real. She is, at least theoretically, unable to envision the abstract, incapable of animating a soul in either flesh or pigment.

Sofonisba Anguissola is the exception to the rule.

I must relate [Vasari writes] that I saw this year [1566], in the house of [Sofonisba's] father at Cremona, a picture executed by her hand with great diligence [tanta diligenza e prontezza], portraits of her three sisters, . . . who appear truly alive [vive] and lack nothing except speech. In another picture may be seen . . . her father Signor Amilcare [Anguissola], who has on one side one of his daughters, Minerva, . . . and on the other side [his son] Asdrubale . . . [They] also were executed so well that they appear to be breathing and absolutely alive [pare che spirino e sieno vivissimi].[90]

The two portraits are reproduced here as Figures 3 and 4. In the context of sixteenth-century writings on women's art Vasari's recognition of Anguissola's life-giving creativity is unique. Whereas Frangipane claims Irene di Spilimbergo "made many true forms come alive on paper" (Appendix Two, Section 6a), and although Vincentino di

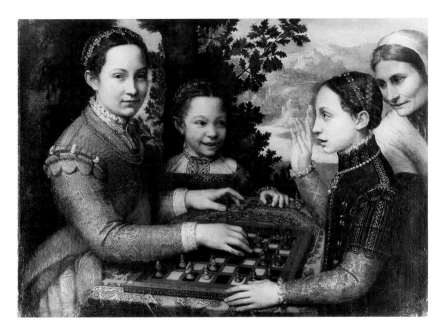

Figure 3. Sofonisba Anguissola, *Portrait of the Artist's Sisters Playing Chess,* ca. 1555. Muzeum Narodowe, Poznan, Poland. (Photo: Muzeum Narodowe, Poznan, Poland.)

Buonaccorso Pitti says Properzia De'Rossi "made the rough stones [she carved] come alive," the comments of neither writer bear comparison with Vasari's praise of Sofonisba.[91] Stated simply, the conventions of poetic eulogy cannot be understood in the same way as art criticism reflecting analytical observation.

When Vasari described portraits by Sofonisba's hand with prose otherwise reserved for paintings produced by *pittori,* he joined what had become an international chorus singing in praise of the Cremonese artist. Escorted ceremoniously by the duke of Alba, Anguissola had arrived at the Spanish court in 1559 to serve as lady-in-waiting to Isabella of Valois. Her duties included the painting of portraits. The images she produced were not mere replications of works already produced by men. In fact, quite the opposite was true. A bill of 1568 records Sánchez Coello as having painted no fewer than six copies of Anguissola's portrait of Don Carlos, Isabella's stepson.[92] She was with-

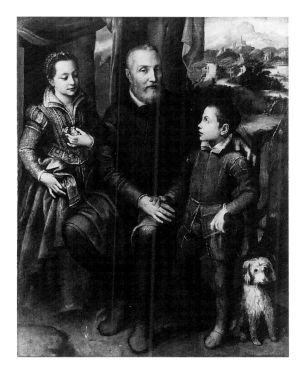

Figure 4. Sofonisba Anguissola, *Amilcare Anguissola with His Daughter Minerva and Son Asdrubale*, ca. 1558. Nivaagaards Malerisamling, Vivaa, Denmark. (Photo: Nivaagaards Malerisamling, Vivaa.)

out question a much appreciated and admired artist, as her dowry, supplied by Philip II and valued at around two thousand ducats, indicates. If Vasari never knew the specifics of her monetary fortunes, he was well aware of her fame. He also recognized what he saw in the Anguissola home in 1566. Sofonisba's portraits convey a familial intimacy, a daring casualness, and an indisputable directness that make them appear "truly alive."

Anguissola's *Portrait of the Artist's Sisters Playing Chess* matches enlivened figures with a lively subject. Captured in the act of playing chess "[in atto di giocare]," these women are anything but static. One of the artist's sisters (Lucia) looks at the viewer. Her movement of the game pieces is

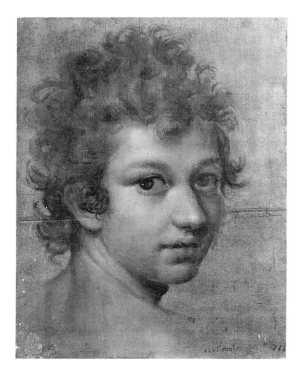

Figure 5. Lavinia Fontana, *Head of a Smiling Boy*, 1606. Galleria Borghese, Rome. (Photo: Ministero Beni Culturali e Ambientali, Rome.)

only temporarily arrested as her hand hovers above the chessboard. Another (Minerva), on the right, with intent anticipation or registered surprise stares across the chess set at Lucia. A third (Europa), in the center, smiles broadly as she awaits the response the move is about to provoke. And, finally, the older woman on the far right focuses on the maneuvering that is the catalyst for all of this animation.[93] Vasari's praise of the figures in this work as "appear[ing] to be truly alive" is a critical recognition of Sofonisba's ability to record the complexities of their actions and reactions — "i moti dell'animo" and "le arie del viso." She was able to master the intricacies of response, in part, by recasting the format of formal portraiture into an informal grouping of figures unified "in the act of playing." If we accept Vasari's definition of

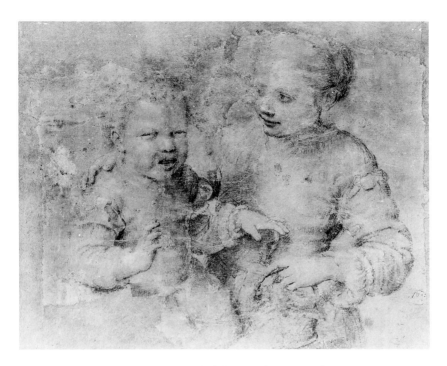

Figure 6. Sofonisba Anguissola, *Asdrubale Bitten by a Crayfish*, ca. 1557–8. Museo Capodimonte, Naples. (Photo: Museo Capodimonte, Naples.)

invenzione as the artful presentation of narrative and the control of the number and appropriate actions of depicted figures, Anguissola's mastery demonstrates not only an ability to "make [living human beings] with paint" but also her command of disegno in its complete sense: the capacity to conceive and actualize *invenzioni*.

Although early critics failed to see these same qualities of individual characterization and animation in the work of Lavinia Fontana, they are, as her tempera and wash *Head of a Smiling Boy* shows, hard to miss (Figure 5). In this image, style and subject are perfectly matched. The impressionistic fluidity of her brushwork augments the turn of her sitter's head, the mass of his carefree curls, the glint in his eyes, and the smile of recognition that vivifies his countenance. If Anguissola created images that breathe and appear on the verge of speaking to the viewer, so did Fontana.[94]

Perhaps the best examples of Sofonisba Anguissola's mastery of *l'arte del disegno* is a drawing of her brother, *Asdrubale Bitten by a Crayfish* (Figure 6). As is the case with the family portraits Vasari saw hanging in the Anguissola home in 1566, in this image he perceived stylistic qualities he and others typically associate with male productions. This moved him to describe her works with words typically reserved for those made by men.

It is no long time since Messer Tommaso Cavalieri, a Roman gentleman, sent to the Lord Duke Cosimo (in addition to a drawing by the hand of the divine Michelangelo, wherein is a Cleopatra) another drawing by the hand of Sofonisba, containing a little girl laughing at a boy who is weeping because one of the crayfish out of a basket full of them, which she has placed in front of him, is biting his finger; and there is nothing more graceful [graziosa] to be seen in that drawing, or more close to truth [più simile al vero].[95]

A letter to Cosimo de'Medici from Cavalieri, dated 20 January, 1562, confirms the gift.

I sent it [Anguissola's drawing] to you with this one [Michelangelo's *Cleopatra*], and I believe that it may stand comparison with many other drawings, for it is not simply beautiful, but also exhibits considerable invention [ancora inventione]. And this is because the divine Michelangelo, having seen a drawing done by her hand of a smiling girl, said that he would have liked to see a weeping boy, as a subject more difficult [più difficile] to draw. After he wrote to her about it, she sent to him this drawing, which was a portrait of her brother, whom she has intentionally shown as weeping.[96]

That Anguissola received guidance from Michelangelo cannot be questioned. Letters from her father to the master verify the relationship and explain how it worked. On 7 May 1557 Amilcare wrote, "I beg of you that since, by your innate courtesy and goodness, you deigned by your advice in the past to introduce [Sofonisba to art], that you will again condescend sometime in the future to guide her again . . . that you will see fit to send to her one of your drawings that she may color it in oil, with the obligation to return it to you faithfully finished by her own hand."[97] This kind of help was not an unusual display of graciousness on the part of the revered master. Beside supplying Anguissola with drawings, Michelangelo also assisted Sabas-

tiano del Piombo, Benvenuto Cellini, Antonio Mini, and Giuliano Bugiardini. But *Asdrubale Bitten by a Crayfish* is neither a copied or completed image. It is Sofonisba's inventive answer to Michelangelo's challenge, an answer that required, as others saw clearly, a capacity to first conceive and then actualize an idea.

Anguissola's drawing of her tearful brother and smiling sister may also be seen as a successful resolution of the problem of differentiating responses that, while generally expressive of opposite emotions, are strikingly similar in their physiognomic manifestations. A topic of considerable interest to sixteenth-century theorists, physiognomic variety had long enjoyed a place in the critical discourse.[98] Alberti's remarks on the subject have particular relevance here.

And who would ever believe, if he had not tried it, how difficult it is if he wishes to paint a face which laughs, to do it so that it is not rather weeping than happy? And who, moreover, could ever manage without very great study to create faces in which the mouth, the chin, the eyes, the cheeks, the forehead, the eyebrows, everything fits together to smile or weep?[99]

Anguissola mastered the difficulty described by Alberti by recording the differences as detailed by Leonardo. "He who sheds tears raises the eyebrows till they join and draws them together, producing wrinkles in the middle of his forehead, and turns down the corners of the mouth, but he who laughs raises them, and his eyebrows are unfurrowed and apart."[100] While this may demonstrate Anguissola's awareness of a formula for depicting physiognomic types, it also shows her ability to sidestep by inventive means the problems inherent in such prescriptions.[101] Here the operative word is "inventive." As Lomazzo was to note in the *Trattato*, physiognomic variety, liveliness of gesture, and invention go together. "All great inventors, for the most part, were extremely subtle investigators into natural effects."[102] *Asdrubale Bitten by a Crawfish*, which is anything but a dry and lifeless adherence to rules, demonstrates Anguissola's creative probing into these effects. As an addendum, it should be noted that Anguissola's side-by-side portrayal of laughing and crying figures was not to be the only image of this subject presented to a Medici duke. According to Baldinucci, Pietro da Cortona depicted with

admirable virtuosity these same oppositional expressions with the hope of impressing Ferdinando II.[103]

In the context of critical writings on art, crediting a woman with such a creative capacity and mastery of means is, to say the least, very unusual. Typically, *artiste femminile* are praised for their ability to replicate the creations of others. Vasari, for example, designates "the best works by [Suor Plautilla Nelli's] hand [as] those she has derived from others [ha ricavato da altri]," specifically "a Nativity of Christ copied [ritratto] from one which Bronzino once made for Filippo Salviati."[104] And for his own *Libro dei Disegni* Vasari chose "some very good drawings by the hand of Properzia [De'Rossi], done with pen and copied from the works of Raphael [fatti di penna e ritratti dalle cose di Raffaello]."[105] In a like manner, Dionigi Atanagi, who praises Irene di Spilinbergo's technical facility – the "particular care" she gave to "measurements and scale, lights, shadows and foreshortened things [misure, lumi, ombre, e cosi agli scorci]" – fails to describe a single work she has invented. Instead, he notes that she "drew a copy of some pictures by . . . Titian."[106] Remarks like these stand in contrast to Cavalieri's and, later, Zaist's comments concerning Anguissola. "As reported by that writer [Vasari], [she] knew not only how to draw, color, and make naturalistic portraits [ritrarre naturale], and copy excellently things by others, but also made things of her own and with proper invention [propria invenzione]."[107]

Vasari had, in fact, stressed this very point. Anguissola "has also executed by herself *alone* [ma da sè sola ha fatto] some very rare and beautiful works."[108] Such critical commendation is significant, since, as Lomazzo, Sangallo, and Armenini argue, *invenzione* has its origin in the fertile mind.[109] In other words, *invenzione* is yet another hallmark of individual stylistic excellence, yet another aspect of the many-faceted *l'arte del disegno*. It is the difference between *ritrarre* and *imitare* and that which separates *mediocre ingegno* from unqualified *ingegno*. Vasari makes this clear. "It is only too true that those who do not possess *grande invenzione* are always poor in *grazia*, *perfezione*, and *giudizio*."[110] And, "when our excellent craftsmen seek to do no more than imitate the manner of their masters . . . and when they study these things only, they may with time

and diligence come to make something exactly the same, but they cannot by these means alone attain perfection in their art, seeing that it is clearly evident that one who ever walks behind rarely comes to the front."[111] Armenini concurred. "One can hardly be said to have a good style [buona maniera] without first being a fine inventor [un bello inventore]."[112] Neither could one be credited with *ingegno*. Invention, Lodovico Dolce writes, has two sources: history, which the artist can choose to represent or which the patron selects to have represented, and *ingegno*, which belongs solely to the maker and from which arises the order of the parts within the whole (*ordine*) and propriety (*convenevolezza*). From this, in turn, comes that which imparts *vivezza*: "l'attitudini, la verità, la . . . energia della figure."[113] Of the nearly forty women discussed in early texts as active artists during the cinquecento, Anguissola is unique in being admitted to the stylistic forefront. Indeed, her ability to overcome the "più difficile" subject of a weeping child with apparent ease (*prontezza*) and with "ancora inventione" prompted Vasari to distinguish her from other *pittrici*. Her works exhibit, he observes, "greater grace [miglior grazia] than those by other women."[114] Vasari's recognition of Anguissola's stylistic *grazia* brings the (pro)creation analogy full circle.

Grazia is a mirrored quality, possessed by the image and existing in the hand that made the object as well as in the mind that conceived it. In the best of circumstances, *grazia* betrays no hint of effort, indeed, "very great is the debt to Heaven and Nature by those who give birth to their works without labor and with a certain grace that others cannot give to their creations either by study or by imitation."[115] But Vasari's praise of Anguissola's ability to impart life and grace to her creations was not without its negative repercussions for other women. If Sofonisba's virtuosity elevated her in the eyes of critics above the condition of her sex, it also confirmed its absence in others.

This is not to say that some aesthetically laden terms, like *invenzione* (creative invention), appear only in reference to the Cremonese painter. Baglione, for example, notes, "Isabella Parasoli Romana was the wife of Lionardo, and she made by her own *inventione* a book of intaglio with diverse forms of lace and other works for women."[116] Similarly, Ridolfi credits Marietta Robusti with producing "opere d'invenzione."[117] Yet these examples have little in common with Anguissola's described dem-

onstration of creativity. In the case of Parasole, *invenzione* is gendered by function. The pattern book of designs for "lace and other women's work" was made expressly for a female audience. In Robusti's case, Ridolfi fails to cite a single supporting example; instead he goes on, as Atanagi had in reviewing the life and works of Spilimbergo, to commend her as a competent copyist. La Tintoretta, he notes, "drew after her father."

The opposition of invention to replication as well as the hierarchical distinction between portraiture and *istoria* is set forth most clearly by Paolo Morigia. Caterina Leuca Cantona was well known for her silk and gold-thread embroideries of liturgical vestments, which imitate "quite wondrously [con stupore] that which is most notable in paintings and miniatures" and, because of their remarkable show of craftsmanship, decorate "more than thirty churches in this city [Milan] and elsewhere."[118] Even more amazing were her embroidered portraits that could be viewed from either front or back. According to Morigia, these images established Cantona as the "honorata Gentildonna con l'ago," or, as Lanzi was to claim later, "the Minerva of her time."[119] But despite this complimentary title, Cantona was not accorded by Morigia the laurels for the highest excellence in this art. A tapestry filled with "nuova inventione," a hunt scene crowded with men, various animals, satyrs, and centaurs for the king of Spain, won Scipione Delfinone "first place [il primo luogo]."[120]

The "nuova inventione" in Scipione Delfinone's hunt scene broadens the scope of *invenzione* to include fantasy and imagination. During the sixteenth century, fantasy came to be regarded as one of the faculties of the soul. In *De imaginatione,* first published in 1501 (with a second edition in 1507), Gianfrancesco Pico della Mirandola argued that *fantasia* stands between sense and soul, between matter and mind between the corporeal present and the conceptual past, present, and future. Several decades later Juan Luis Vives described *fantasia* as "prodigiously unrestrained and free; it can form, reform, combine, link together and separate; it can blend together the most distant objects or keep apart the most intimately connected objects."[121] In other words, *fantasia* is related to the intellective soul and thus to *anima* and *aria.* Whereas *fantasia* had carried since antiquity some negative connotations — the deceptive

phantasms of Plato's cave — Philostratus was one ancient voice elevating the faculty and allying it with creative genius.

There was (beside imitation) another influence pregnant with wisdom and genius. "What was that?," said the other, "for I do not think you can adduce any except imitation (mimesis)." "*Phantasia*," said Apollonius, "wrought these works, a wiser and subtler artist by far than imitation; for imitation can only make as its handiwork what it has seen, but *phantasia* equally what it has not seen."[122]

Like Plato in *Theatetus*, Philostratus draws an analogy between mental creativity and corporeal fecundity. Both perceive the mind as a womb, the locus of both reason and fantasy. Although Aristotle links the higher operations of the *fantasia* to practical intellect, and therefore to art and prudence, medieval and later Neoplatonic writers, including Saint Augustine and Marsilio Ficino, viewed *fantasia* as a seductive path to sin, something uncontrolled by reason, "shadows of the true light of God, accessible only to the intellect, whose intervention alone can prevent or correct our ensnarement in fallacies."[123] But during the course of the sixteenth century it was Aristotle's etymological derivation of *phantasia* from *phaos* (light) and its relationship to prudence that came to the fore, mitigating (if not totally eliminating) the more negative connotations of the word. As a faculty capable of composing a wholly new form from myriad extant forms or, perhaps better still, conceiving of something nonexistent, *fantasia* came to be recognized as that which makes artists copious inventors.[124] Yet such enlightened vision was not without its dark side. In the psychology of art, a capacity to conceive the fantastic was a sign of melancholic temperament as well as creative genius. Indeed, already by the time of Cennino Cennini, the word *fantasia* signified the natural gifts of the painter. But just how "natural" were these gifts?

As an aspect of creativity, *fantasia* was often associated with the womb. By the early cinquecento anatomists had discredited the ancient notion of the uterus as a separate animal whose roamings ceased only when it was impregnated. Nonetheless, in the popular imagination notions of the womb's errancy persisted, explaining female promiscuity and irrationality. At the same time the wanderings of the womb also suggested "comparisons with the idiosyncratic itineraries of fantasies."[125] Such

gendered interpretations and analogical relationships imply a general lack of distinction between corporeal and mental processes while underscoring the Pythagorean opposition of male to female and their respective associations with form and matter. A male womb is a mental matrix filled with *concetti* and *fantasie* that burn to be delivered or realized in form. A female womb, by contrast, is a bodily vessel filled with moist and chilly *materia* that dampens the fire of creative imaginings. But as malleable material, the female womb is susceptible to external impression. These impressions come from one of two sources; concepts of the desired form generated by paternal *potenza*, or images of the type described by Aldrovandi, Mancini, and Vives. The function of the male as opposed to the female womb points to a qualitative distinction in the perceived relationship of physical and psychological male and female humoral disposition.

As Huarte explains, the mind and womb, like the liver and the heart, are connected. "The member which partakes most of the alterations in the belly/uterus . . . is the brain."[126] Gynecological writers agreed that this explains female mental disorders, such as lovesickness and hysteria. It also explains a woman's irrational attachment to her child. Plato makes much of this point in *Theatetus.* Speaking to his protégé who is "pregnant" with thoughts, Socrates informs him, "If, when I have examined any of the things you say, it should prove that I think it is a mere image and not real, and therefore quietly take it from you and throw it away, do not be angry as women are when they are deprived of their first offspring." Here, the oppositions of male to female and intellectual to material are supplemented by an opposition of real, or true, to "mere image," or false. While this points to Plato's denigration of images as *phantasms,* it also looks forward to Aristotle's linkage of the higher operations of the *phantasia* with the practical intellect, a connection that was to enable Gianfrancesco Pico della Mirandola to see fantasy as enlightenment rather than shadows in the Platonic cave. In other words, man, who has soul, can come to know rationally what he cannot see but is able to imagine and conceive.

Sixteenth- and seventeenth-century medical authorities explained this phenomenon physiologically. Bodily heat and dryness are not only qualities constitutive of maleness, they are also qualities associated with

intellect, particularly imaginative creativity. As noted, the verb *concipere*, "to lay hold of entirely," "to absorb," "to catch," and "to conceive," lent itself to this interpretation. Men, it seems, possessed the potency of *concipere* in the fullest sense of the word. They grasped conceptually the unseen and caught and absorbed into their memory the visible. United in intellect, cognition and sense gave rise to visionary ideas, like *fantasie.* This scenario works in reverse for females. As heat and dryness are constitutive of maleness, so cold and dampness are constitutive of femaleness. If heat fires the creative mind, so moisture quenches these inventive fires. Lomazzo's discussion of the embroiderers Scipione Delfinone and Caterina Cantona in the *Trattato* seems to point to this difference.[127] Both are praised for their remarkable abilities, and both are said to have received royal commissions. In Scipione's case they came from kings, in Caterina's from princesses and duchesses. Cantona, a *ricamatrice* who was also a miniaturist, represented the contest between Arachne and Athena and embroidered a scene of the coronation of Philip II, complete with seven personifications and allegorical figures. She also wove "naturalistic portraits [ritratti al naturale]." Delfinone, the *recamatore* whom Lomazzo celebrates elsewhere as "of the highest and most profound talent," made a fantastic tapestry depicting a hunt that, says Lomazzo, demonstrates "bellissime invenzioni" because it includes all sorts of things "che mente d'uomo puo imaginarsi."[128] Although both artists were accomplished in technique, Cantona's physiognomic replications and conventional imagery were no match for Delfinone's creative imaginings.

Melancholia: A Case Study

Females, because of the coldness and humidity of their sex, cannot have profound talent.

—Juan Huarte

F OR her capacity to conceive *invenzioni*, for her ability to reveal *i moti dell'animo*, for her skill in creating figures with paint "so well that they appear to be breathing and absolutely alive" — in other words, for demonstrating masculine virtuosity — Sofonisba Anguissola was admired by all "as a wondrous thing," a *virtuosa*.[1] Like Anguissola, Properzia De'Rossi was lauded as "one of the greatest miracles produced by nature in our time" and designated a "giovane virtuosa."[2] De'Rossi, however, earned the title by reason of her choice of medium rather than because of her masterful style. Although Pomponious Gauricus reported in 1504 that the wife and daughter of the sculptor Guido Mazzoni worked in the family *bottega* and Luigi Lanzi was to claim in 1789 that the Renaissance artist Quintilia Amaltea tried her hand at "carving and painting [scolpire e dipingere]," Properzia's unorthodox decision to grasp the sculptor's chisel instead of the painter's brush was enough to win her unique status in the early art historical discourse.[3]

During the years immediately preceding the 1550 publication of the first edition of Giorgio Vasari's *Vite*, artists debated the relative merits of painting and sculpture by means of the comparative technique known as the *paragone*. The discussion of the rivalry between the sister arts, while reflecting shared theoretical attitudes and a common mythology, nonetheless spawned varied and creative statements and rejoinders regarding the superiority of one art to the other. Proponents of sculpture pointed to God's modeling of man as proof of the primacy of their art. Partisans

of painting countered. God, they noted, had first painted the heavens blue. Undaunted, sculptors tried a different line of reasoning. Detailing the intellectual challenges of their medium, they concluded that their art, rather than that of painters, was *più difficile* and hence preeminent. To solidify this claim, the Florentine sculptor Francesco da Sangallo noted the absence of women from the profession. In what can only be seen as a denigration of female artistic ability, he held that the nonexistence of female sculptors established without equivocation the nonpareil nature of his art. Many women in Flanders, France, and Italy, he observed in his 1546 letter to Benedetto Varchi, "paint in such a way that their paintings are held in high esteem. But nowhere, and at no time has one ever [been] found . . . who worked in marble."[4] Vasari, a critic, painter, and architect but no sculptor, was soon and effectively to challenge Sangallo's contention. For "braving the roughness of stone" and wielding the chisel with her "little hands so tender and so white as if to wrest from us the palm of supremacy," De'Rossi was distinguished by being the only woman among 142 "valiant men [uomini valenti]" memorialized in the first edition of the *Vite*. Although brief critiques of works by several *pittrici* were included in the expanded second edition of 1568, the *scultrice* remained the sole woman privileged with her own biographical entry.[5] Given this singularity in status, it is appropriate that special attention be paid to the critical commentary on her life and work. After all, because she stands alone in a book widely recognized as "probably the most famous . . . in the history of art," she must exemplify the woman artist.[6]

That Properzia De'Rossi performs this defining role is underscored by Vasari's introduction to her life, a survey of no less than forty women "most excellent and famous in no common way." Among the celebrated are the warriors Camilla and Zenobia; the writers Corinna, Sappho, Vittoria Colonna, and Laura Battiferri; the astrologer-magicians Cassandra and Themis; and Isis and Ceres, who were accomplished "in matters of agriculture." The curious and conspicuous absence of artists from this list (especially in the second edition, which contains Adriani's references to five of the six women artists mentioned by Pliny), puts Properzia in the position of standing in for the many. But the most notable aspect of this litany of names is not the list itself but rather the

continued association of the sculptor with one of those cited: Sappho. As Gian Paolo Lomazzo's subsequent placement of De'Rossi in the company of Sappho, Thisbe, and Medea suggests, the reasons for the association had little to do with achieved excellence.[7] The *scultrice*, as Vasari explains and Lomazzo emphasizes by analogy, was incapable of coping with unrequited love, unable to deal rationally with, and thereby overcome, her emotions. Ultimately, the result of these deficiencies, which identify her as a victim of a form of melancholia described best as lovesickness, forced her into a debilitating depression that stilled her hand. Despite the fact that she excelled "in household matters" and regardless of her knowledge of "infinite scienze" and her ability to carve stone, De'Rossi is not remarkable for demonstrating that a woman can rise above the condition of her sex but for proving that she cannot.

The information Vasari provides concerning the life and work of the Bolognese *scultrice* carries the authority of firsthand research. Having fled the political unrest of Florence, Vasari found himself in Bologna for the coronation of Charles V as Holy Roman Emperor on 24 February 1530. This put him in the right place at the right time. Properzia De'Rossi died either in late 1529 or early 1530. If we take Vasari at his word, he was, even at this early date, busy gathering information about artists that would eventually take shape and be published as the *Vite.* It was, he says, "a sort of pastime," a pastime spent collecting information from "various records and writings" and listening to what he describes as "the tales of old men." Clearly, tales of Properzia had reached the author's ever attentive ears. But Vasari's apparent gathering of firsthand information cannot assure us of either his accuracy or objectivity. All too often his penchant for obfuscating anecdotes, propensity for proffering moralizing evaluations about an artist's work and character, and concessions to the Italian novelistic tradition combine to create a portrait of an artist that is part fact, part fiction.[8] As his life of Properzia De'Rossi illustrates, particularly his auto-mimetic reading of her San Petronio relief of *Joseph Fleeing Potiphar's Wife*, the particular spin Vasari puts on the tale he tells can make inclusion in the *Vite* a dubious honor. It is with this in mind that Vasari's *vita* of the artist is considered here in the light of what we know factually about her life.

Figure 7. Properzia De'Rossi, *Grassi fami-ly crest*, ca. 1520. Museo Civico Medi-evale, Bologna. (Photo: Musei Civici D'Arte Antica, Bologna.)

A woman by the name of Properzia De'Rossi, daughter of a Bolognese citizen who was the son of a notary, one Girolamo De'Rossi, lived in Bologna during the first three decades of the sixteenth century. By 1516 she had reached the age of maturity, twenty-five.[9] This places her birth date right where Vasari says it should be, around 1490.[10] As yet no source has been uncovered to shed light on her artistic training.[11] All we know is what Vasari tells us. One of her earliest works depicted "the whole Passion of Christ . . . with a vast number of figures" carved into peach stones — eleven to be exact. These were then set into a silver filigree crest of the Grassi family (Figure 7).[12] But the *scultrice*, who is described by Vasari as "very beautiful," a lady who "played and sang in her day better than any other woman of her city" and a woman endowed with a "capriccioso" intellect, soon tackled the challenges of stone. "By means of her husband" she sought and secured work on portal reliefs for the church of San Petronio in Bologna (Figure 8). Whether she received intervening assistance in this endeavor cannot be verified. Her association with the project, however, cannot be contested. In August of 1524 four artists, including Amico Aspertini, received commissions for

Figure 8. Properzia De'Rossi, portal reliefs, Church of San Petronio, Bologna. (Photo: author.)

decorative portal reliefs illustrating scenes from Genesis. In 1525, several additional artists, including "Propertia de'Russi," were added to the roster. For the next year and a half the name "Madonna Propertia" and "La Propertia" appears in Fabbrica records. On 15 January and 5 April 1526, the Florentine and Bolognese sculptors Tribolo and Alfonso Lombardi were paid for "modelli fatta a la Propertia." Several months later, on August 4, the balance of her account for making two sibyls, at least two angels, and a "picture [quadro]" was settled for 40 lire.[13] It is the "quadro" that captured Vasari's attention and became the revealing centerpiece of her *vita* (Figure 9).

To the vast delight of all Bologna, [De'Rossi] made an exquisite scene, wherein – because at the time the poor woman was madly in love with a handsome young man, who seemed to care but little for her – she represented the wife of Pharoah's Chamberlain, who, burning with love for Joseph, and almost in despair after so much persuasion, finally strips his garment from him with a womanly grace [donnesca grazia] that defies description. This work was es-

Figure 9. Properzia De'Rossi, *Joseph Fleeing Potiphar's Wife,* ca. 1526. Museo di San Petronio, Bologna. (Photo: Alinari/Art Resource, New York.)

teemed by all to be most beautiful, and it was a great satisfaction to herself, thinking that with this illustration from the Old Testament she had partly quenched the fire of her own passion. Nor would she ever do any more work in connection with that building, although there was no one, except Maestro Amico [Aspertini], who did not beseech her to go on with it.[14]

Vasari's allusion to the less than cordial relationship between De'Rossi and Aspertini is confirmed in an unlikely source.

According to records in the Archivio Criminale di Bologna, "Propertia de Rubris" and/or "Propertia de Rossi" seems to have had a temper as hot and irrepressible as her passions.[15] In a series of court hearings beginning on 25 October 1520 and continuing through April of the following year, "Propertiam de Rubris' the concubine of Antonio Galeazzo who lives by the Cappella of San Felice" was accused of entering the garden and destroying 24 feet of vines and a cherry tree belonging to one Francesco da Milano, a velvet merchant. Extant complaints and petitions shed no light on what precipitated the incident. In fact, the evidence that remains is little more than a quagmire of references to who lived where. From these we learn that "Propertiam De Rubris" and Antonio Galeazzo Malvasia were not cohabitating and that her home stood opposite that of the merchant's, separated only by a small bridge crossing the Riva di Reno. Despite her being identified as a "concubine" there is no reason to conclude that she was a prostitute. First, she is never referred to by any of the names associated with the profession. Second, the sixteenth-century laws regulating prostitution in Bologna specify where *meretrice* and *ruffiane* may live. Although the criminal records place the "De Rubris" home in close proximity to one of the prescribed areas, it is not actually within it. On the basis of the partially complete documents in the Archivio Criminale we can conclude only that she was not the "lady" either Vasari or, later, Pompeo Vizani claim she was. This we can do with certainty.

The 1520–1 encounter with Bologna's civil and criminal authorities did not, it seems, dissuade De'Rossi from further violent outbursts. On 23 January and 26 February 1525, "Propertia de Rossi" appeared again in court. This time she was in the company of the painter Domenico del Francia. Both were charged with trespassing and with assaulting an artist, one Vincenzo Miola. According to documents, "de Rossi" specifically was accused of throwing paint in Miola's face and of scratching his eyes. Court records state that the complainant's accusation was corroborated by Amico Aspertini, the envious artist Vasari charges with "speaking ill" of the *scultrice.* Is the "Propertia De Rubris" brought into court in 1520 the same "Propertia de Rossi" who appeared before Bologna's criminal tribunal in 1525? Is one, the other, or are both the "Propertia De'Russi" at work in San Petronio in 1526? The coinci-

dence of dates suggests we are reading about one and the same individual. So what sort of woman was she? Was she the talented, learned, and beautiful Properzia "who succeeded most perfectly in everything except her unhappy passion," or was she a feisty and less than decorous lady? If we, like Lomazzo, credit her with a Sapphic personality, then she is both, for, as Huarte explains, the effects of melancholia, which in women typically takes the form of lovesickness, can rouse its sufferers to acts of aggression as readily as cast them into a depressing malaise.[16]

Vasari's autobiographical reading of De'Rossi's Joseph relief is by no means unique or even unusual in the *Vite.*[17] With its damaged nose, Michelangelo's *Faun*, for example, reflects the sculptor's own disfigurement by the fist of the envious Torrigiano.[18] More to the point, and in keeping with Vasari's view of history as an instructive discipline, it underscores the unfortunate results of misdirected energies. In contrast to the ever munificent Michelangelo, blessed with "la virtù del divinissimo ingegno, industria, disegno, arte, giudizio e grazia," the ill-tempered Torrigiano spent so much *furore* on violent acts that little was left for wielding the chisel. Vasari, however, does not always rely on such juxtapositions to disclose the detrimental effects of bad behavior on the making of art. For example, accepting as fact the story of Castagno's purported murder of Domenico Veneziano, he claims that the "invidioso" and "maligno" Castagno unwittingly "painted himself [in Santa Maria Nuovo] with the face of Judas Iscariot, whom he resembled in both appearance and deed."[19] In contrast to Torrigiano, Castagno's virtuosity seems to mitigate, if not excuse, moral depravity. Vasari described him as possessed of "grandissimo invidia," but nonetheless commended him for demonstrating in his art the "splendor of his virtue." These and numerous similar examples define a work of art as something fashioned by the self and, therefore, revelatory of the emotional intensities of the subconscious.[20]

To some degree, Vasari's commentary on the "quasi disperata" De'Rossi adheres to this pattern of disclosure. Unwittingly or not, Properzia exposes the darker side of her mind in her work. There is, however, a significant distinction between her purportedly auto-mimetic image and those created by her male peers. Whereas the vicious deeds of Torrigiano and Castagno are countered by the virtuous actions of

Michelangelo and Domenico Veneziano, Properzia's uniqueness leaves us without a moral or artistic foil, especially in the first edition of the *Vite,* where she alone must represent the strengths and foibles of the woman artist. Thus, even though she may have exhibited signs of a "nobile ed elevato ingegno," she demonstrated, as her *Joseph Fleeing Potiphar's Wife* reportedly illustrates, even more clearly woman's inability to gain control over her erotic passions. In contrast to the *homo melancholis,* she falls victim to a melancholia of a very different – and decidedly female – kind. Having expressed her sorrow for all to see, she becomes despondent, refuses "ever [to] do any more work in connection with that building," and, completing her tenure at San Petronio, lays down her chisel.

But in fairness to Vasari we should not ignore the fact that his life of Properzia De'Rossi fits a pattern in the *Vite.* The *scultrice* is not the sole artist affected adversely by love. Raphael, who "kept up his secret love affair . . . with no sense of moderation" and with dire consequences, is the ultimate example of the disastrous effects of amorous excess. He is not unique in this regard. Both Domenico Puligo and Giorgione insisted on visiting their plague-ridden lovers. Predictably, both contracted the disease. Other examples, such as those of Alfonso Lombardi and Andrea del Sarto, are more benign. Lombardi, readily seduced by the finer things in life, including women, and easily distracted from his work because of it, played the part of the fool and missed professional opportunities. Andrea del Sarto is a variation on the theme. He, too, "became enamored of a young woman." His mistake was in marrying her, since thereafter he had "much more trouble than he had suffered in the past." These stories, which admit the culpability of both the beloved and the lover, must be seen as didactic warnings against misplaced priorities. Love, like envy, robs an artist of the fire and fury that should rightly be directed toward creative ends.

Vasari's *vita* of Properzia was open to several interpretations. First, it could be read as an acknowledgment of fact. At least one woman, to quote Vasari, "braved the roughness of marble and the unkindly chisels." And, indeed, commentaries on De'Rossi by Raffaello Borghini, Pompeo Vizani, and Giulio Cornelio Gratiano make much of "the virtuosity of this unusual woman [della virtù di questa rara donna]."[21]

A second possibility, and one that associates the life of the *scultrice* with artists whose lives are complicated by love, is to simply read Properzia's story as a lesson on professional versus personal priorities. A reading of this kind, which has nothing to do with gender difference, allows the story to end here, since the message has been delivered. A third and alternative reading – and one that clearly captured the nineteenth-century romantic imagination – not only accepts Vasari's equation of Properzia with Potiphar's wife, but also factors in Lomazzo's equation of the sculptor with Sappho. This reading, I admit, distances Properzia from the sixteenth century and forces us to see her as a literary persona reflecting a nineteenth-century penchant for romances about artists.[22] Nonetheless it is constructive, since it both defines and traces from antiquity to the early twentieth century a type: the creative female.

On 22 June 1830, Antonio Saffi stood before the assembled members of Bologna's Accademia di Belli Arti and called for the revival of the memories of those "cortesi donne" who were painters: "[Lucrezia] Quistelli, [Sofonisba] Anguissola, [Lavinia] Fontana, [Elisabetta] Sirani, and those others who raised the glory of the gentle sex." But, he continued, more notable still was Properzia De'Rossi. It was, he argued, not only rare to find a woman who worked in stone, but nothing less than "exceptional" to find one who both understood and applied the theoretical principles of this "most difficult art" with "perfect success."[23] Saffi's lecture may be properly called a defense. Two years earlier, in 1828, Paolo Costa's *Properzia De'Rossi,* a *reppresentazione tragica* in four acts, had played to enthusiastic audiences in Bologna. The tale Costa tells is, like that of Vasari, a piteous one, a sad story of love and rejection. In response to Romeo Caccianemici's characterization of the artist as a famous and talented yet unhappy woman, Alfonso, a courtier in the service of Charles V, asks, "Despondent? Why?" Romeo's response is concise and to the point. "Per amore." To both illustrate and prove the validity of his assertion, Romeo directs Alfonso's attention to De'Rossi's marble relief of *Joseph Fleeing Potiphar's Wife.* The two figures represented in the panel, he contends, have the features of the artist and those of the young man whose affections she sought but never gained. Like Saffira, the spurned wife of Potiphar, Costa's De'Rossi is deserted by her desired lover. Overcome by rejection, she cannot work and soon

dies.[24] Antonio Saffi found the premise of Costa's play — and Vasari's critique — hard to accept. To suggest that a talented woman ("una donna di quell'ingegno") would stoop to making such a base and public display was both "repugnant" and ridiculous. "There are some who want to see a resemblance between the Egyptian woman and [Properzia], seeing her portrait in the figure of Potiphar's wife and that of her lover in the effigy of Joseph. But I find this demands too much faith and, for my part, I see it as a fable."[25]

"Fable" is an apt description for Costa's *reppresentazione tragica.* Not content with the Properzia–Potiphar's wife analogy, he, like Lomazzo, cast the *scultrice* as Sappho, the paradigm of female melancholics and the poet who proved to be the catalytic impetus behind efforts to associate love with the emotional disturbances of madness. Having explained at the conclusion of Act I the cause of De'Rossi's sadness by pointing to *Joseph Fleeing Potiphar's Wife,* Costa opens Act II with the artist alone in her studio. She has abandoned the chisel and taken up the harp. Singing a sad ode to Sappho, she bemoans her fate. "All is hopeless, hopeless. The only outlet for my sorrow is in the verse of the dejected Sappho! Nature and art no longer give me pleasure!" As the play continues, Properzia tells her friend Beatrice something that Romeo has already explained to Alfonso. Her carving of Saffira's rejection by Joseph is intended to relieve some of her own despair. But even this act, she confesses, can do no more than slightly assuage her sense of hopelessness. It cannot help her overcome the debilitating obstacles of "profonda malinconio." *Joseph Fleeing Potiphar's Wife,* she declares, will be "l'ultimo de'miei lavori." Abandoned and depressed, Properzia is unable to work, and without her work she has nothing left of any value. Destitute in spirit, she dies. Thus, Costa's Properzia, like Lomazzo's, goes the tragic way of other women deprived of the men they so desperately love: Thisbe, who killed herself after discovering her beloved Pyramus dead; Medea, whose desertion by Jason plunged her into insanity; and Sappho, who hurled herself from the Leukadian Rock when she lost Phaon's love.

Whether or not Costa was familiar with Lomazzo's *Libro dei Sogni* is uncertain. Nonetheless, he too recognized the *scultrice* as "quasi disperata" and, with the Sappho analogy, exploited the characterization to its full dramatic potential. In fact, the Sapphic ode sung by his Proper-

zia bears a striking resemblance to Sappho's Fragment 31, a poem in which the author describes the symptoms of her passion.

for the instant I look upon you, I cannot anymore speak one word. But in silence my tongue is broken, a fine fire at once runs under my skin, with my eyes I see not one thing, my ears buzz. Cold sweat covers me, trembling seizes my whole body, I am more moist than grass. I seem to be little short of dying.[26]

Costa's Properzia similarly sings of being unable to speak or see, laments her inability to concentrate, and complains of being plagued by a persistent buzzing in her ears. She, too, is pale and cold yet suffers inexplicably from a subtle but intense heat that courses through her veins. In short, she says, "I am like death" [Morta rassembro]."[27] These are the unmistakable manifestations of melancholia, which, "like water, sometimes is cold and sometimes is hot." Even more, these are the oxymoronic signs of erotomania, an emotional state Sappho described as "bittersweet."

Early physicians and philosophers recognized but were reticent to artic-ulate fully the relation between humoral medicine and pathological perturbations caused by inordinate passion. But the story of Antiochus and Stratonice, especially as told by Plutarch in his *Life of Demetrius*, and Sappho's poems, which speak of love in terms of its somatic side effects, captured the medical imagination and thus sparked the investigative impulse. For Hippocratic writers, health was a matter of moderation and balance. The four elemental humors – blood, phlegm, black bile, and yellow bile – should, ideally, exist in an isonomic state. A predomi-nance of one humor over the others, they said, leads to diseases of the soul affecting the body: mania, melancholy, and phrensis. In cases where black bile (*atra bilis*) is in surplus, pathological symptoms with strong somatic manifestations, such as palpitations, trembling, blurred vision, and stammering, are most apparent.[28] These side effects are those suffered by Antiochus and endured by Sappho's lovers.[29] They are also, as Aristotle notes, the symptoms associated with "all men who have become outstanding in philosophy, statesmanship, poetry, or the arts."[30] If this is the case, then the manic phrensis behind this psycho-physiological state must be of two kinds – one positive, the other

negative. "Certainly, the evidence is strong from an early date on that the poets recognized the capacity for love to bring about pathological conditions affecting both the body and soul."[31] Equally clear, as Plato's *Ion* demonstrates, is the recognition by philosophers that these conditions need not be caused by carnal desire.

Following Aristotle's *Problems*, Arab physicians of the ninth and tenth centuries postulated a melancholy of genius that was a product of cognitive processes. This they distinguished from melancholy caused by excessive love, or *amor hereos*, which Petrarch termed *amor concupiscentiae*. During the medieval period these ideas were conveyed to Europe through the *Viaticum* and the writings of Avicenna. By the end of the sixteenth century this second form of melancholy had acquired the adjective "erotic," thus distinguishing it from the Aristotelian form of the disease experienced by "all men who have become outstanding" in myriad creative and intellective disciplines. Despite the physiological similarity of their symptoms – insomnia, anorexia, depression – the difference between them was as great as that distinguishing health from sickness, hot from cold, exaltation from despair, the celestial from the earthly, creative productivity from debilitating malaise, and male from female. Indeed, while melancholia became the hallmark characteristic of empowered and enlightened genius, erotic melancholy, or what came to be called "erotomania," cast its victims into the dark abyss of ineptitude.

In order to understand how such polarized psychophysiological maladies could be associated, the theories of how erotic and creative melancholy develop must be reviewed. Both begin with sight and sensation, as a passion or motion common to soul and body.[32] Because, as Aristotle explains, "desire coincides with the initial movement of practical intellect," the sight of something beautiful arouses affection. Affection, in turn, radiates from the heart as the vital, principal, and moving force in the form of *pneuma*.[33] In this form, the object of sensation passes through the eyes to the brain's frontal lobe of the anterior ventricle, which is occupied by the common sense (*sensus communis*). The dorsal lobe of the same ventricle hosts fantasy, or retentive imagination (*fantasia* and *imaginatio*). It is only after the object of sensation has reached the dorsal lobe of the middle ventricle, which is the locus of mnemonic

vision and where fantasy, ignited by vivifying heat, comes into relation with the rational soul via cognition (*virtus cogitativa* and *virtus aestimativa*), that the paths of erotic and creative melancholic minds diverge.

if it is what it has been described to be, imagination will be a motion generated by actual perception. And since sight is the principal sense, imagination has derived even its name from light [phantasia/phaos], because without light one cannot see. Again, because imagined objects remain in us and resemble the corresponding sensations, animals perform many actions under their influence; some, that is brutes, through not having intellects, and others, that is, men, because intellect is sometimes obscured by passion or disease or sleep.[34]

Erotomania occurs when intellective powers are obfuscated by passion. Because of this the object of sensation becomes a fixed reality, an obsession polarizing all cognitive activities, and one that dries and chills the brain. Reason is overpowered as carnal desire takes over. But for those with creative melancholia the object of desire transcends corporeal reality. As creative heat intensifies, devitalizing cold is neutralized. This enables the beautiful form within the perceived object to be purified of any residual materiality and thereby regain its innate, dynamogenic power.[35] In other words, the source of sensation is not reduced to *materia*. Therefore it does not become an obsessive infatuation. Instead, it is transmuted into a beautiful and illuminating vision that mirrors aspects of the divine, refracting, as it were, God's image. What can only be seen as a ritualistic articulation of loss and mourning in sufferers of erotomania thus becomes, in the *homo melancholis*, a means of recuperation and celebration. Via inspiration, says Marsilio Ficino, the melancholic man is reunified with his higher self.

All those who have invented anything great in any of the nobler arts did so especially when they took refuge in the citadel of the soul, withdrawing from the body . . . Therefore, Aristotle writes that all outstanding men in any art were of melancholy temper, either born so or having become so by continual meditation.[36]

A self-described melancholic, Ficino may be credited with turning melancholia into a positive virtue and ascribing the disease to the intellectual elite, for it is he who draws the sharp distinction between corporeal loss and transcendental gain. "This is in fact what our dear Plato meant in *Timaeus* when he said the soul, in frequent and intense

contemplation of the divine, grows on such nourishment and becomes so powerful that it departs the body, and its body, left behind, seems to dissolve."[37]

Ficino's platonizing of the *homo melancholis* gave rise to the belief that a beautiful work is the creation of a beautiful soul in quest of knowledge. Michelangelo described this psychological state as "the artist's joy," "La mia allegrezza é la maninconia."[38] There was, in fact, a natural fit between the activities of the mental matrix and those of the artist. The capacity of the mind to conceive *invenzioni*, envision *fantasie*, indeed, Aristotle's understanding of creativity as the soul's "power of making the sensitive soul" underscore a belief in the artist's ability to begin with the material and sensible and end with the abstract and spiritual. Although the question of the relationship of these abilities to the higher mental faculties admitted a number of answers, the completion of suggested forms or recombination of sensory data came to be inextricably tied to the psychology of art. *Fantasia*, for example, having been successfully subjected to the rationalizing *virtus cogitativa* and judged by the prudent *virtus aestimativa*, progresses to the posterior ventricle, which is occupied by memory (*virtus conservativa et memorialis*). Here, too, nonsensitive impressions, those abstract concepts emanating from the soul, are preserved. When things imagined reach this point, the creative melancholic stands poised to begin the inspired quest for truth that will lead him back to the source from which we all descend and enable him to become one of the privileged, elite, and empowered: a creative genius.[39]

In its initial phase, that is until the visible sensation reaches the middle ventricle, melancholy and its somatic symptoms are not gender specific. Both sexes may experience the alternating states of hot and cold that result from a surplus of black bile. According to Hippocratic writers, who in contrast to the Pythagorean school and Aristotle did not ascribe on the basis of physiology a higher and positive value to one sex and a lower and inferior value to the other, any individual could experience fluctuations in temperature or fall victim to potentially fatal fevers. Galen bolstered this contention in his commentary on Hippocrates' *Epidemics:* "I know men and women who burned in hot love. Depression and lack of sleep overcame them. Then one day, as a result of their love sorrows, they became fevered."[40] But theories of sex difference, which

postulated physiological difference in terms of privilege and privation, predictably designated such enamored sufferings as an essentially female malady resulting from woman's inability to generate heat.

The issue of heat implies a connection between the *fuoco* of the creative mind and that of male *sperma,* a connection made clear in the definition of *concipere* as "to catch," as fire. Paradoxically, the mania of fantastic imaginings is associated with the female womb through a belief in the autonomy and errancy of both. Such associations, like the (pro)creation analogy, are selective and rife with gender inversions.[41] Although the male appropriates the fecund female body, he does not, because of his heat, acquire its maladies. His mind-womb remains healthy and productive and thus is receptive to inspired madness and sublime thoughts. By contrast, woman's excessively retentive mind-womb becomes unhealthy and unproductive. It is, therefore, susceptible to deranging and sometimes fatal hysteria. Indeed, the very qualities that make her fertile in body and receptive to his "design" — she is *humida, infreddatura,* and *lubrica* — make her sterile in mind.[42] Males, as male, are simply not subject to such positive–negative humoral alternations. *Calore, fervore,* and *ardore* contribute productively to both his physical and intellectual *potenze.* It is in this respect that melancholia becomes part of the ontological process *and* an aspect of the artistic temperament. Because "all things conceived by the artist, whether taken directly from the world of sense or from the autonomous workings of the imagination, were thought to take shape in the *fantasia,*" this faculty of the soul merged with the psychology of genius.[43] Together they formed the all-important psychic matrix of creative inspiration and invention. The Sappho-like Properzia De'Rossi of Lomazzo's *Libro dei Sogni* and Costa's *reppresentazione tragica* needs to be read in the context of the history of thought regarding this psychophysiological malady. Certainly, the actions and reactions of the poet and sculptor as depicted there have all the somatic effects of the negative form of the disease.

The object of sensation — Sappho's Phaon and De'Rossi's unnamed beloved — cannot be rationally evaluated by the afflicted lover. Moreover, because all mental powers are subject to the *aestimativa,* this corruption of estimation brings about the derangement of other faculties of the soul. Thus, rather than be gripped by divinely inspired madness or

the creative frenzy that came to be synonymous with genius, these melancholic women sink into the sluggish and despondent malaise of love melancholy. Intellectual concentration eludes them. Both are simply incapable of entering into a state of egoistical meditation on the higher celestial self that incites creativity. In other words, characterizations of Sappho and De'Rossi meld with a topos of the early medical tradition. Melancholia is more frequent in its occurrence and more positive in its effects in men, and more severe in its negative or pathological manifestations in women. "For the sixteenth-century physician John Weyer, melancholia's implicit masculinity makes it more harsh in women: 'They are cruelly used and violently disturbed by it, for melancholia being more opposed to their temperament, it removes them further from their natural constitution.'"[44] As Pietro Aretino explains, this particular pathological form of melancholy is a disease of the lovesick imagination: "poison at lunch, wormwood at dinner . . . your fancy is always fixed on one thing; until I am astonished that it is possible for the mind to be in so continuous a tempest without losing itself."[45]

It has been argued that

cultural ideals of rationality and self-control were [believed to be] threatened by erotic love, which overthrew reasonable governance of the body and mind . . . The poetry of Sappho and Ovid describes love's physical and psychological disruptions, while the tragic stories of Medea, Hippolytus, and Phaedra dramatize the threat to social order. When desire is doubled it becomes love; when love is doubled it turns to madness.[46]

If Sappho's poetry paints a vivid portrait of the lover tortured by ardent passion, then the poet's desperate leap from the Leukadian cliffs, no less than Medea's ravings and Thisbe's precipitously irrational suicide, demonstrates her madness and underscores her mere womanhood.

In Ovid's *Epistulae Herodium*, a collection of fictive amatory epistles addressed to men by women who have been seduced, betrayed, and abandoned, the *Epistula Sapphus* is both the longest and the only romance that deals with a historical figure with a prior literary existence.[47] But under the power of Ovid's pen, Sappho's historicity is denied as he assumes her voice and intricately blends fact with fiction. Because he does not indicate Sappho's nonfictive status, Ovid reduces the poet to

one more example of an icon of female abandonment whose tragic story is a creation of classical literature and legend.[48] As scholars have noted, Ovid not only "chose among contradictory interpretations of Sappho those that suited his overall intention and threaded those fragments together with a story line," he grafted the essentials of this tale onto her own writings. By constructing parallel passages to lines in her poems, advancing identical allusions, and using similar motifs in his *Epistula Sapphus,* Ovid appropriates her voice. So successful was he in this task that his *epistula* was accepted as the translation of a Sapphic original. As such, it became her "authorized" biography.

As the writings of Lomazzo and Costa demonstrate, it was possible to subject Properzia De'Rossi to a similar transmuting process. Certainly, parallels between the poet and sculptor are evident. Both are historically real, and both, whether by choice or commission, dealt in their art with the theme of love and rejection. More to the point, their lives and their art were made one and the same in such a way that both were simultaneously reduced to a stereotype and denied historicity. Virtually all authors interpreting the verbal and pictorial language of these two women reached the same conclusion. Creative females lose sight of their art as the "quasi disperata" mania that is induced by infatuation propels them toward actions with tragic consequences. At the midpoint of the *Epistula Sapphus,* the poet confesses to a failing of her poetic powers. She laments that that which you love makes you what you are — "sive abeunt studia in mores." Sappho — "alone," "abandoned," and "condemned" — is a woman devastated by erotic melancholy. The same may be said of Vasari's, Lomazzo's, and Costa's Properzia De'Rossi. Having made herself one with Saffira, the *scultrice* ceases to produce works for San Petronio. Indeed, she lays down her chisel altogether. This creative stasis is identical with that suffered by the poet from Lesbos. No longer in full possession of her literary powers but aware that her genius and towering poetic stature have diminished, Ovid's Sappho claims, "'My former power in song will not respond to the call; . . . mute for grief is my lyre.'"[49] Similarly, Costa's Properzia De'Rossi proclaims, "I no longer find pleasure in nature and art . . . Loosen me from this bothersome life."[50] According to Costa, who did no more than romanticize Vasari's life of the artist, her wish is granted.

Thus, like Ovid's Sappho, De'Rossi slides into the unhappy state of "love langor." Her life ends tragically. Indeed, suicidal tendencies induced by melancholy, whether overt as is the case with Sappho or suppressed as happened with De'Rossi, seem to take possession of only the creative female mind. Melancholic men, like Piero di Cosimo, find refuge in the rapture of creation or, like Andrea Feltrini, who was "tortured by a melancholic humor [and] was often at the point of taking his life," manage by varying means to be rescued from self-destruction.

In the final analysis, Sappho and De'Rossi were twin victims of two forces. First, both were artists initially empowered by creative genius. Ultimately, however, both women were divested of that power by men who denied them their love and thereby exerted a paralyzing effect on their art and had a destructive impact on their lives.[51] Second, both had their voices appropriated by mythmakers. Just as Ovid used the poetic language of Sappho against her, so did Vasari, Lomazzo, and Costa turn De'Rossi's imagery against her. The particular case studies of Sappho and Properzia are clear demonstrations of what is true of women's biography in general. "Subjects are viewed as products of predetermined forces, their life situations are usually reduced to essentialisms that relate to . . . their sexuality." This, in turn, makes "them ahistorical by universalizing them based on that essentialization."[52] That essentialization is, in fact, at work here can be demonstrated by the curious likeness of paradoxical images of the sculptor and poet presented by Vasari and Aelian. In *Varia Historia*, Aelian admits to some confusion concerning Sappho's identity. As is the case with the De'Rossi of Vasari's *Vite* and that of the criminal records, there were, it seems, two Sapphos. One was a "whore and an arrant strumpet." The other was "among such as were wise, learned, and skillful." The latter was also a victim of love.

Properzia De'Rossi's double personality (or Sapphic dualism) is particularly interesting when we consider yet another bit of conflicting evidence. Vasari places the sculptor during her final days in Bologna's Ospedale della Morte. Her name, however, appears in April 1529 on a patient list of the Ospedale di San Giobbe. In contrast to the plague-stricken patients of the Ospedale della Morte, those confined to San Giobbe were for the most part indigents and syphilitics. The different

patient populations of these hospitals takes on significance in light of the epitaph Vasari quotes in the first edition of the *Vite* but omits in the second.[53]

> Si quantum naturae artique Propertia tantum
> Fortunae debeat muneribusque virum,
> Quae nunc mersa iacet tenebris ingloria, laude
> Aequasset celebres marmoris artifices;
> Attamen ingenio vivido quod posset et arte
> Foeminea ostendunt marmora sculpta manu.

[However much Properzia owes to Nature and to art, she owes just as much to Fortune and to manly gifts [or gifts of men]. Whatever shameful reputation she had now lies sunken in shadow. The marbles sculpted by the hand of a woman show that in praise she has equaled the celebrated artists in marble and that she possessed loftiness both in her vivid talent and in her art.]

The epitaph cannot help but pique our curiosity. What, for example, constitutes *munieribus virum?* Does it mean she was blessed by Fortune with masculine capabilities or, in light of her criminal record and the reference to some now buried inglorious deed, with something more pedestrian, such as feminine wiles? Ultimately, it does not really matter. Vasari dropped the epitaph from the second edition, replacing it with a couplet from Canto 20 of Ariosto's *Orlando Furioso:* "Women have been seen to excel in those arts to which they have given care." Given the 1568 addition to De'Rossi's *vita* of commentary on a noblewoman, a nun, and an internationally renowned lady-in-waiting, the replacement of the ambiguous, but suggestive and individualized, epitaph with a generic tribute made sense. Moreover, other writers (except Lomazzo) seem to have preferred a more ladylike persona for the woman artist.

In *Il Riposo,* 1584, Raffaello Borghini not only refrains from advancing the Properzia—Potiphar's wife likeness, he quotes a different epitaph, this one reportedly penned by Vincentino di Buonaccorso Pitti.[54]

> Fero splendor di due begl'occhi accrebbe
> Gia marmi à marmi o stupor novo, e strano.
> Ruvidi marmi delicata mano
> Fea dianzi vivi, ahi morte invidia n'hebbe.

[The intrepid splendor of your two beautiful eyes increased from sculpture to sculpture, oh wonder both novel and strange. Before, her delicate hand made the rough stones come alive, alas death was jealous.]

Here, Properzia is praised with the language typically lavished on *gentildonne.* The splendor of her "two beautiful eyes [due begl'occhi]," for example, finds easy parallel with ideal feature number 5 on Domenico Bruni's list of the most desirable characteristics of feminine perfection as well as with lists in countless sonnets dedicated to ladies, such as Ridolfo Campeggi's "Occhi di bella Donna."[55]

So, which portrait of De'Rossi is the accurate one; Vasari's, Lomazzo's, Borghini's, Costa's, or Saffi's? In the final analysis, it is unimportant, since in all cases we are presented with a stereotype; the lovely and accomplished lady, the forlorn and lovesick woman, and the passionate and crazed creative female. Rather than attempt to determine which of these identities describes the real Properzia De'Rossi, we must be content with the composite portrait presented to us. This portrait was described best by Laura Ragg in 1907. "A lovely highly gifted woman, who is persecuted by professional jealousy, is unsuccessful in love, and dies at the height of her fame in the hey-day of her beauty — have we not here all the elements for melodrama and romance?"[56]

La Donnesca Mano

> In the congenial arts I see us still obliged to renounce sculp-
> ture and even painting . . . The "decency" that excludes us
> from studying the human form, everything in our ethos
> opposes our progress . . . Thus we are limited to music,
> dance, and banal versifying. Meager resources, which lead
> nowhere.
>
> —Mme Louise d'Epinay, 1771

A product of its maker, a work of art is at once self-reflexive and
self-revealing. Leonardo's aphorism "ogni dipintore dipinge se
[Every artist paints himself]" acknowledges the first of these held
truths. Vasari's commentary on Properzia De'Rossi's relief *Joseph Fleeing
Potiphar's Wife* recognizes the second.[1] Although reflexivity was frequently
described in early art criticism as a likeness between the character of the
artist and that of the subject he or she portrays – Castagno's Judas,
De'Rossi's Saffira – it was by no means restricted to presenting narrative
as artistic parable. As a signature of the artist, style was also described as
reflexive. This is implicit in the metaphorical language of art, specifically
that which explains the creative and procreative processes as alike and
therefore recognizes the artist and parent as that which determines the
appearance of the product and progeny. This raises two interrelated
questions. First, given the popularity of the (pro)creation metaphor in
early critical writing and considering the passive and indeterminate role
typically ascribed to the female in the (pro)creative process, can a
woman impress her individuating mark on the images she makes?
Second, assuming that she can, does her self-reflexive signature divulge
her sex? that is, does it reveal qualities specific to the female hand, *la*

donnesca mano? As the phrasing of these questions suggests, the answer to the second is contingent on that to the first.

Despite the reflection in early art criticism of an acculturated set of values that denied woman creative *potenza*, writers found it necessary to acknowledge facts. Women, like men, produce works of art. This unavoidable admission went hand in hand with a refocusing of the critical lens. Style, which is the artist's self-reflexive signature, was scrutinized for signs of strength and vigor (*ardito, furioso, pugnato, virile*, etc.) or indications of timidity and excessive care (*arrendevole, stento, tenero, femminile*, etc.). Malvasia's comparison of Elisabetta Sirani's style to that of her female forebears illustrates the qualitative difference between what may best be described as feminine and masculine styles. Sirani, whose style is described by Malvasia as *"virile"* and *"grande,"* "never left in her work signs of timidity or flattery, which is characteristic of the weaker sex [non lasciò mai una certa timidità e leccatura propria del debil sesso]."[2]

Malvasia's observation makes clear three points. First, masculine style is more commendable than feminine style. Second, feminine style typically reveals a female hand. Third, the gender of style, like that of *virtù*, is not necessarily determined by sex. Just as Malvasia sees virility in Sirani's style, so does Ferrante Carli, for example, view the paintings of Guido Reni as "womanly, Flemish, washed out and without force [da donna, fiaminga, slavata, senza forza]."[3] But despite the equivocal relationship of a gendered style to the artist's sex, one thing was certain. Within the semantic values of the critic's terminology, the concept of femininity was an effective rhetorical weapon, especially when deployed in combination with notions of inspiration and the (pro)creation metaphor.

According to Ficino, from the inspired *furor* of the *homo melancholis* comes the breath of life that vivifies art.[4] So defined, Platonic *furor* was designated by sixteenth-century art theorists as the inventive means to the desired aesthetic end, *la bella maniera*, and thus tailored to the values of *l'arte del disegno*. In something akin to a mathematical equation, the *furor* of the mind was added to the *furia* and *fierezza* of the hand. Combined, they imparted to the visible form a "quickness and liveliness of movement that eliminates any and all signs of labor and affectation [pron-

tezza e fierezza di moto senza stento e affettatione]."[5] Since, as Federico Zuccaro argues, "spirit is that *vivezza* and *fierezza di moto* in the glance and gesture," *furia* as a sign of decorum (or movement) corresponds to a transcendental reality.[6] In this respect, *furia* is associated closely with grace (*grazia*) and, at its highest level, is a hallmark of genius.[7]

Ideally and in practical terms, the *furor* of conception would not be lost nor diminished as it progressed from a labor of the spirit to a material product produced by the hand and presented to the eye. To insure that this was indeed the case, Francisco de Hollanda urged artists to place the "idea or concept . . . most quickly in execution before it is lost or diminished by some perturbation." Because any loss of "that divine furor and image that it bears in the *fantasia*" would inevitably reveal a weakness of talent, or *ingegno*, de Hollanda designated the quill pen the best instrument for this task.[8] Giorgio Vasari had argued the same point. "Pen or other drawing instruments or charcoal" are well suited to the "furor dello artefice," since they allow the artist to "express hastily" the spirit of an idea as it "occurs to him." These notations — *schizzi, bozze, macchie* — are an essential part of *disegno* in the broadest sense of the word. Not only do they reveal a learned hand: a "facilità del disegnare" that promotes "buona forma i disegni";[9] they define the art of drawing as a creative and cognitive process which, because of its conceptual basis and in keeping with a metaphorical system that connects the creative process to God's plan of creation, grants the artist a form of divinity. It is this nexus that ties *furia* to *grazia* and, by extension, to genius.

But the convergence of learned hands and concepts (*mani sapeva e concetti*) was not possible for all artists. Thus, Vasari advises anyone who "feels himself not strong enough" to visualize his own ideas to "try with all possible diligence [diligenza] to copy from life" as well as after masterpieces of art.[10] This method of making, however, carried a warning. Any "lingering too long" over a work "takes away all the good that facility [facilità] and grace [grazia] and boldness [fierezza] might do." In fact, "effort and labor [stento e fatica] . . . make things appear hard and crude; besides which, too much study" often "spoils" an image.[11] "It appears very often in sketches [bozze], born from a moment in the fury of art [nascendo in un subito dal furore dell'arte], that a man's

conception is expressed in a few strokes, while, on the contrary, effort and too great diligence [lo stento e la troppa diligenza] detract from the force and judgment" seen in works by excellent masters. Indeed, "whoever knows that the arts of design . . . are similar to poetry knows that, as the poems dictated by poetic furor are good and true and better than those that are labored, so the works of men excellent in design are better when they have been made at one stroke by the force of that furor [forze di quel furore]."[12]

Such prohibitions against too evident labor (*stento*) stand as warnings against the stylistic and mimetic affectation (*affettatione*) that can arise from painstaking diligence (*diligenza*) and assiduity of study (*l'assiduità dello studio*). They also point to a theoretical shift. Whereas Leon Battista Alberti believed that the perception of beauty on which the Idea depends is grounded in the observation and experience of nature, Vasari, Lomazzo, Armenini, Zuccaro, and others considered the Idea in more metaphysical terms. As the connection of *furor* and *grazia* in both a spiritual and stylistic sense suggests, the Idea that is "born" in the creative mind is of a purer and more perfect kind than that rooted solely in material reality.[13] Although all Renaissance theorists shared the goal of advancing art to ever higher levels of excellence, the shift in focus from the sensible to the conceptual necessitated changes in practice. This, in turn, required the development of a critical language that would allow writers to differentiate the origins and quality of works of art. And this fostered what may best be described as a symbiotic view of art, a view that made an artist's sex a factor of critical consequence.

According to theorists and critics, the finished product provides in its style insight into the process by which it came into being. In other words, the first visible notation of a composition has a perceptible impact on the completed image. This is true when the image, to use Armenini's words, records an Idea "which seems to be born in the mind" and drawn "velocemente" as well as when it is a painstaking working out of figures and compositions.[14] The finished image is, therefore, inseparable from the process. This necessarily makes it indivisible from its maker. Stated succinctly, art is self-reflexive.

As sixteenth-century writers began increasingly to review the relative merits of theory and practice in recognition of the qualitative differ-

ences among works by different artists, a two-tiered structure of critical evaluation took shape. In essence, this system distinguishes the *artista* from the *artigiano* and, ultimately, the inspired *pittore* from the proficient *pittrice*. It does so through the selective and systematic contextual application of critical terms which, not surprisingly, were structured into oppositional pairs: *affettatione — sprezzatura, ritrarre — imitare*, and so forth. Certain words — *furia, sprezzatura, grazia, imitare, invenzione* — recognize in a work the skilled hand and creative mind of the artist. Other words — *affettatione, stento, diligenza, ritrarre* — acknowledge the well-practiced but often uninspired hand and mind of the craftsman. As more and more critics assessed the merits of specific artists — both male and female — these terms absorbed current notions about gender. Works by men, who by reason of being male are susceptible to creative melancholia, typically evince the *fierezza* and *sprezzatura* of inspired *furor*. Works by women, who are "naturally" resistant to melancholy and physically fragile, often display not only the *troppa diligenza* of labored study but also reveal the "delicacy" and even the "affectation" of the feminine touch.

There are, of course, exceptions. A woman can sometimes rise above her femaleness, and a man sometimes falls to fill the void left by her ascension. In either case, an exception is a contradiction in terms and, as such, in no way alters perceptions of gender difference or changes the positive and negative values associated respectively with masculinity and femininity.[15] Indeed, by stressing the singularity of the masculine female (or oddity of the effeminate male) essentialist notions are reenforced. Thus, typically and at best, woman's work, because of an attention to detail, a preference for geometric pattern, a predilection for ornament, and a certain preciosity, was said to reveal *la donnesca mano*. Accordingly, Malvasia observed in portraits by the hand of Lavinia Fontana a certain "gentleness, diligence, and delicacy [gentili, diligenti e teneri]." And, "no less precious, as having come from the hand of a woman, are those few altarpieces by her seen in some of our churches."[16] Luigi Lanzi was to pick up where Malvasia had left off. Fontana's works, he claims, exhibit "without a doubt a certain feminine patience [femminil pazienza]."[17] Similar descriptive terms are used for works by other sixteenth-century *pittrici*. According to Paolo Morigia, Fede Galizia's works are marked by "delicacy" and, in the case of her portrait of Ercole

Ferraro's wife Camilla, betray in their attention to detail "diligenza grandissima."[18] Agostino Santagostino agreed. Galizia's portrait of Morigia, he claims, was "made with her usual diligence."[19] When these statements are read against earlier comments, such as Franco Sacchetti's satirical equation of woman's skill in portraiture with her application of cosmetics or Boccaccio's contemporaneous labeling of the latter of these activities as woman's attempt to overcome with "diligence" her "unfit- ness," the negative implications of *diligenza* are all too evident.[20]

This is not to say that critics never saw *diligenza* in a man's, indeed a master's, works.[21] According to Vasari, "In the attitude of each [the figures of Christ and John the Baptist in Raphael's *Madonna of the Gold- finch*] is a certain childlike simplicity that is wholly lovely, besides that they are so well colored and executed with such great diligence [tanta diligenza] that they appear as living flesh rather than worked by color and design; the Madonna likewise has an air truly full of grace and divinity."[22] This passage, like many in Raphael's *vita*, stresses the impor- tance of hard work but equally emphatically makes the point that it is not sufficient in itself. Innate talent is essential. Vasari's remarks about Sofonisba Anguissola make the same point. "With diligence and readi- ness [con diligenza e prontezza]" she creates images "that truly seem alive [che paiono veramente vive]" and thus evinces "more study and . . . greater grace than any other woman [più studio e . . . miglio grazia che altra donna]."[23] As the phrase "more than any other woman" discloses, the Cremonese *virtuosa* is exceptional among *artiste femminile*. In fact, excluding assessments of Anguissola's art, descriptions of Renaissance women's works, whether written in the late sixteenth or early twentieth century, never rescue *diligenza* with a string of positive aesthetic terms. Rather than neutralize a negative with a positive, as Vasari did by connecting Sofonisba's *diligenza* to her *prontezza*, critics have emphasized the negative by making it feminine. The strategy has been long-lived and effective.

In 1929, for example, Adolfo Venturi professed his ability to distin- guish the hand of Marietta Robusti not only from that of her father but also from those of her brothers and other members of the Tintoretto workshop. Certain passages in *The Baptism of Christ, The Miracle of Saint Agnes,* and *The Virgin in Glory with Saints George and Cecilia,* he states, display

a "sentimental femininity, a woman's grace that is strained and resolute [femminilità affettiva, una grazia mulierbre che si sforza e si determina]."[24] More recently, Vera Fortunati Pietrantonio has continued to voice the party line. Sounding remarkably like Nicola Pio and P. A. Orlandi, who in 1724 and 1753, respectively, noted that Lavinia Fontana "succeeded in things sweet [cosi dolce]," she observed that Fontana's early devotional panels were created "with somewhat oversweet familial sentiment."[25]

Equally typical, but worse and certainly more direct in its condemnation, *la donnesca mano* was said to lay bare artistic deficiencies. "The things of Lavinia," argued Giuseppe Maria Mazzolari, "do not have the excellence and valor to be found in such things by great men because they are, after all, by a woman who has left the usual path and all that which is suitable to their hands and fingers."[26] Baglione was more specific. Fontana's large-scale *istoria* in San Paolo fuori le Mura, Rome, which illustrates *The Martyrdom of Saint Stephen*, 1603–4, was "unsuccessful" (Figure 1). The *pittrice*, he contends, was quite simply incapable of meeting the awesome challenges of a monumental multifigural composition, which, as is well known, can only be produced by those endowed with "grand'ingegno." He therefore advised the artist to limit herself to painting portraits, "à quali col inclinava."[27]

Accepting the premise that the finished work reflects the manner in which it is made, comments such as these imply that women artists worked slowly and with painstaking care. Whether or not this is the case is impossible to tell. Drawings by Renaissance women are, to say the very least, rare. Although more than two dozen drawings have been attributed to Fontana, few have been given to Anguissola, and none have been securely established as the work of any other female hand. Of the identified drawings, a majority are portraits, which, by the very nature of portraiture, makes them replications of the visible rather than expressions of the conceptual. And as finished drawings rather than notational sketches, they naturally evince greater *assiduità dello studio* than *forze di . . . furore.* But does this necessarily translate into works made with obvious diligence? According to Pliny, at least one woman, who "painted chiefly portraits" – Marcia – worked with great speed. In fact, "no artist worked more rapidly than she did."[28] Given the analogies drawn be-

Figure 10. Lavinia Fontana, *The Vision of Saint Hyacinth*, 1599. Ascoli Chapel, church of Santa Sabina, Rome. (Photo: author.)

tween ancient and Renaissance women artists, Marcia's example should have provided early critics with the all-important precedent for recognizing a woman's *facilità* — but it did not. Whereas Malvasia, in 1678, was to compare Elisabetta Sirani's "virile" handling of the brush to Marcia's "speed . . . in painting," earlier writers refrained from making such comparisons.[29] The contention that a woman's work is marked by

Figure 11. Lavinia Fontana, *The Vision of Saint Hyacinth*, 1599. Detail. Ascoli Chapel, Church of Santa Sabina, Rome. (Photo: author.)

pazienza and *diligenza* was never really contested. Images, however, can be more eloquent than critical praise.

Although it is true that some of Sofonisba Anguissola's portraits of members of the Spanish court and royal family are so formal as to appear rigid, they must be seen as reflections of decorum rather than considered as evidence of a lack of technical and stylistic ease, or *disinvoltura*. Certainly, her drawings and paintings of family members, unfettered by courtly convention, exhibit, as both Vasari and Cavaliere note, a lively *vivezza*.[30] Baglione's attack on Fontana's *istorie* seems likewise to reflect inequitable critical selection. Unfortunately, her *Martyrdom of Saint Stephen* was destroyed by fire on 16 July 1823, making it impossible to read Baglione's censure of it in light of the actual image. But another monumental work painted a few years earlier, *The Vision of Saint Hyacinth*, 1599, in the church of Santa Sabina in Rome, raises real questions about the objective value of the critic's denunciation (Figures 10 and 11).[31] Seen *in situ*, the altarpiece, particularly the figure of the enraptured Hyacinth, gives visible expression to the essence of *furia* as both an impassioned state of mind and as an ideal aesthetic. Calculated but not contrived, the saint's body and limbs are symmetrically and three-dimensionally counterposed, reaching out of and extending into the pictorial space. As an example of a form arranged in a complex contrapposto, the figure of Hyacinth exhibits a balanced blending of *difficultà* and *facilità*. Indeed, Fontana's figure fits neatly the classical view expressed by Andrea Gilio which defines decorum as "that proportion, correspondence or conformity that style has with subject."[32] As such, it resists the frankly decorative energies that are often apparent in similar centrifugally inflected figures.[33] Detail is neither abundant nor precise, and "preciosity" is nowhere visible. The painting, unified by repetitions and modulations of color that subtly reenforce the shared *grazia* and *furia* of form and sentiment, is a masterful example of perspicuous formal devices placed in the service of a transcendental subject. If we accept Sir Joshua Reynolds's later definition of the artistic genius as one who extends his "attention at once to the whole," then Baglione's criticism of Fontana must be seen to be biased. Opinions expressed by others support this conclusion.[34]

Baldinucci calls *The Vision of Saint Hyacinth* a "miracle" "for having come from a woman's hand [per uscire da mano donnesca]," and even Baglione concedes that it has good coloring and is "just about the best work she made."[35] Others were more effusive in their praise of the *pittrice* and her altarpiece. Giambologna, a friend of the Fontana family, forwarded to the painter in a letter dated 1 January 1599 his assessment of a smaller version of the image. Above all, he marvels at Fontana's capacity to achieve naturalism in a picture depicting "the most holy of mysteries" and admires her ability to convey "great majesty" in a "small painting."[36] Moreover, he wants to "let [Fontana] know that in Florence no painter, neither great or small, has failed to stop to see it and that it has astounded and amazed everyone."

When the large-scale and final version of the image reached Santa Sabina in Rome it evoked a similar response. As Giambologna had done, Rosato Rosati, secretary to the cardinal of Ascoli and a longtime friend of the painter, informed Fontana of the altarpiece's reception.[37] In a letter of 4 March 1600, he professes his personal elation on viewing the work. His joy, he claims, is shared by all who enter the Ascoli Chapel. The altarpiece, he writes, "astounds all of Rome." Viewing Fontana's *Vision of Saint Hyacinth in situ* — that is, flanked by Federico Zuccaro's frescoes depicting scenes from the saint's life — apparently intensified his appreciation of the work. In comparison to Fontana's painting, Zuccaro's frescoes are, says Rosati, "an affront [smaccato]" (Figure 12). "If I were him, I'd whitewash them."

In contrast to Baglione's remarks about Fontana's *Martyrdom of Saint Stephen*, which subscribe to widely held truths concerning the general relationship of an artist's sex to her style, those by Giambologna and Rosati concerning *The Vision of Saint Hyacinth* suggest that the sex–style relationship was somewhat elastic. Women can excel and men can fail, or, more typically, a person of one sex can evince the abilities characteristic of the other. This, according to C. Torre, was the case with Fede Galizia, "a woman it is true, but a prodigious amazon of painting."[38] If Torre's aside implies a slippage from the oxymoronic to the androgynous, Paolo Pino explained the phenomenon in more explicit terms by drawing an analogy between female painters and stories he has heard of

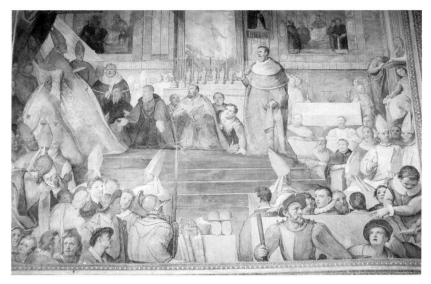

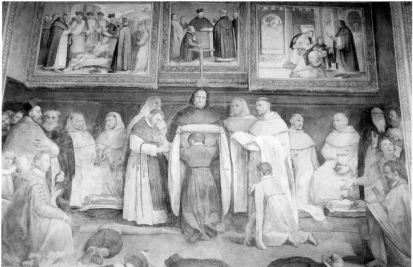

Figure 12. Federico Zuccaro, *Scenes from the Life of Saint Hyacinth,* 1599/1600. Ascoli Chapel, church of Santa Sabina, Rome. (Photo: author.)

hermaphrodites.[39] But such elasticity has its limits. Although a woman can distinguish herself by acting (or painting) like a man, and, conversely, a man can debase himself by acting like a woman, that which deserves commendation does not change. A good style is always masculine, or *virile*. This necessarily makes a so-called feminine style less than good. Pino also makes this point. Following his reference to hermaphrodite-like female artists, he condemns the "uomo effeminato" as "a vituperative thing."[40]

All of this needs to be seen in the context of a critical language rife with gender-based evaluative oppositions and associations. Castiglione, whose ideas on manners were incorporated into mannerist theory, provides a logical starting point.

This excellence which is opposed to affectation [affettazione] and which at the moment we are calling "nonchalance" [sprezzatura], besides being the real source from which grace springs, brings with it another ornament which, when it accompanies any human action however small, not only reveals at once how much the person knows who does it, but often causes it to be judged much greater than it actually is, since it impresses upon the minds of the onlookers the opinion that he who performs well with so much facility [facilmente] must possess even greater skill than this, and that, if he were to devote care and effort [studio e fatica] to what he does, he could do it far better.[41]

Applied to the artistic process, Castiglione's comments concerning *studio e fatica* came to be understood as the capacity to strike a carefully balanced equilibrium between hard work and seemingly effortless technique, or *sprezzata disinvoltura*. Images displaying *disinvoltura* enable the viewer to see the challenges in the process of making — such as foreshortening, variation in figural pose, gesture, and type, the ordering of parts within the whole — yet simultaneously blind the viewer to the efforts demanded by these challenges. Making the difficult appear easy thus is deemed a defining mark of a truly *miracoloso* and *sopra humano* talent. Because practice, once considered the source of theory, was now both its justification and realization, these terms spawned an associative oppositional pairing of others.

One of these pairs was *ritrarre* and *imitare*. As Vincenzo Danti explained and others corroborated, this pair, while not exactly antithetical, acknowledges nonetheless a qualitative difference in style similar to that

of *affettazione* and *sprezzatura*. The former (*ritrarre*) replicates meticulously and without alteration, thereby leaving the imperfect flawed. It demands *diligenza* and *pazienza*. The latter (*imitare*) is the process of imitating with an eye to perfecting any and all weaknesses inherent in the model. It requires *facilità* and *sprezzatura*. In terms of portraiture, the difference between these mimetic methods is, as Armenini states, the difference between *mediocre ingegno* and true, unqualified *ingegno*.[42] Nonetheless, imitation must be seen as a logical extension of replication. Copying what the eye sees prepares the hand to render that which the mind conceives. In other words, when it was conjoined with innate ability and thus not an end in itself, *studio e fatica* paved the way for *sprezzata disinvoltura.*

Academicians not only codified these theoretical terms into a pedagogical unity, they devised a practical course of study that would guarantee their perpetuation. Women, however, lacked full access to the newly established institutions that reviewed theoretical precepts as part of a program of *perfezionamento artistico*. Even an artisans' confraternity restricted the activities of female *confratelli*. The Roman Confraternity of San Giuseppe, which would in later years be known as the Congregazione dei Virtuosi del Pantheon, can serve as an example. Following her marriage to the architectural draughtsman Francesco da Volterra, Diana Scultori moved to Rome in 1575, secured a papal privilege for making and marketing her prints, and, together with her husband, joined the Confraternity of San Giuseppe. Diana's membership allowed her to participate only in religious services and in the process of dowering young girls.[43] Francesco, by contrast, was permitted full involvement in all professional and governing activities. Clearly, participatory privileges for women were limited.

The limitations imposed on women may be seen as one factor contributing to the establishment of informal *scuole* in which both instructors and pupils were female. According to Dionigi Atanagi, a group of ladies met regularly in the Venetian home of Irene di Spilimbergo in order to converse, play music, and draw. It was in this environment that Campaspe Giancarli extended to Irene artistic instruction.[44] A similar situation reportedly existed in Naples. At the request of "some ladies," Mariangiola Criscuolo ran a "scuola" for artistically talented girls.[45] Moderata Fonte's conclusion to *Il merito delle donne*, 1600, reveals the

effects of segregation. Like Christine de Pizan before her, Fonte creates a space for women apart from the world of men. Although Fonte's female society discusses at length the merits of women and ennumerates in detail the defects of men, when the assembled ladies came at last to listing "the best lawyers, the best doctors, the best writers, [and] the best artists" of cinquecento Venice, they surrendered all laurels to men.[46] Why? Is this the effect of typological thinking? Is Fonte giving voice to a belief in the concept of a "naturally" constituted man and woman? This seems unlikely, if for no other reason than that by writing a text Fonte was challenging the notion that the very act of self-expression was a violation of the spirit of domesticity and hence a transgression of feminine virtue. Francesco Barbaro spoke for many when he stated that women "should think that they shall obtain the glory of eloquence, if they adorn themselves with the famous ornament of silence."[47] But not all women were receptive to Barbaro's injunction. Certainly, Fonte was not silent. Neither were the nearly forty Renaissance women who chose the painter's brush or sculptor's chisel as their instrument for self-expression. To varying degrees, every one of them challenged the notion of femininity touted in the proliferation of emblems, like that in Andrea Alciati's *Emblematum libellus*, 1542, based on Plutarch's *Conjugalia praecepta* (142.31.C): "Phidias made Aphrodite of the Eleans with one foot on a tortoise to typify for women keeping at home and keeping silent. For a woman ought to do her talking through her husband . . . [for] she makes a more impressive sound through a tongue that is not her own" (Figure 13).[48] But a female challenge to the male-dominated "profession of gentlemen" did not necessarily mean overcoming the feminine. Art critics rarely acknowledged a female capacity to conceive *invenzioni* and never recognized a woman's ability to visualize *fantasie*. Similarly, all were reluctant to state that *la donnesca mano* can shed *femminilità affettiva*. Clearly, the sex of the artist matters.

Sixteenth-century writers devising the rhetoric and form of the new discipline of art history – Giorgio Vasari, Alessandro Lamo, Gian Paolo Lomazzo, Paolo Pino, and others – were the same writers intent upon codifying aesthetic values and evaluating artists according to canonical standards. Although they could not ignore the female presence, they

could define it. By describing style in relationship to practice and by then comparing it with the theoretical ideal of *la bella maniera*, early critics found an effective means of advancing typological difference. Social restrictions insured the accuracy of their critical suppositions. Unwelcomed in *accademie*, Renaissance women artists were forced to make do with existing structures of study or invent alternatives. They did both. Artists like Marietta Robusti and Fede Galizia worked in the family *bottega*. Diana Scultori, who, together with her brother Adamo, learned the art of engraving from her father, ultimately settled for limited participation in the Confraternity of San Giuseppe. Amilcare Anguissola, recognizing artistic potential in his fourteen-year-old daughter Sofonisba, sent her and her sister Elena to study with Bernardino Campi. Lucrezia Quistelli gained access to the works of Alessandro Allori, while Irene di Spilimbergo, who received some instruction from Campaspe Giancarli, studied works by Titian. Mariangiola Criscuolo, the daughter and sister of painters, reportedly established her own school. But regardless of which path the female artist chose as her route into the professional art world, she encountered barriers, the effects of which were duly noted by critics.

"It is against propriety for [women] to draw from the nude," Gian Lorenzo Bernini noted in 1665; "the best advice one can give them is to choose only the best examples to copy."[49] If earlier critics are to be believed, Bernini's recommendation was an established modus operandi. Renaissance women artists kept busy meticulously replicating a person's physical features and studiously reproducing extant images. Properzia De'Rossi, we are told, copied works by Raphael. Sofonisba Anguissola copied those of Bernardino Campi and "colored in oil" drawings by Michelangelo. Lucrezia Quistelli copied works by Alessandro Allori, Marietta Robusti "drew after her father," Irene di Spilimbergo reproduced images by Titian, and Suor Plautilla Nelli's "best works" are "those she derived from others."[50] As noted, critics recognized the effects of these laborious efforts when, with purposeful regularity, they described women's works with words like "patience" and "diligence." Examples are numerous. Borghini, for instance, describes De'Rossi's carved peach stones in the Grassi family crest as having been made with "grandissima patienza" and says that her angel carved in relief for San

Figure 13. Andrea Alciati, from *Emblematum libellus* (Paris, 1542), no. 106. (Photo: Biblioteca Apostolica Vaticana, Vatican City.)

Figure 14. Federico Zuccaro, *Artists Studying Michelangelo's Statues in the Medici Chapel*, ca. 1564. Louvre, Paris. (Photo: Louvre, Paris.)

Petronio exhibits "diligentemente lavorati". Such "patience" and "diligence," says Vasari, marked all of her works with a "delicatissima maniera."

Once again, it is important to remember context. The issue of propriety aside, the advice to copy masterpieces was not directed only at women. Academy curricula as well as numerous illustrations of artists at work, such as Federico Zuccaro's drawing of Florentine artists studying Michelangelo's sculptures in the Medici Chapel, ca. 1564 (Figure 14) make clear that copying was a practice recommended to all aspiring artists. But replication is never to be an end in itself. Instead, *ritrarre* is to promote *imitazione,* which in turn is to further the creation and recording of *invenzioni.* Replication is, in other words, the stepping stone enabling the artist gripped by *furor dello artefice* to record his ideas. If an artist fails to go beyond the initial stage of this progressive development – from *ritrarre* to *imitare* and *invenzione* – he is doomed to be inferior, since, says Vasari, "excessive study or diligence tends to produce a dry style," one that is presumably void of *vivezza.* This was held to be equally true of male and female artists. When artists "seek to do no more than copy the manner of their master, or that of some other men of excellence . . . and when they study these things only, they may with time and diligence come to make them exactly the same, but they cannot by these means attain perfection in their art."[51] They will, says Vincenzo Danti, end up with things just as they are, "whether good or bad [ò buono, ò tristo]."

As Vasari's remark, which was made in reference to Mino da Fiesole, demonstrates, it would be preposterous to suggest that only women were said to exhibit in their art the undesirable qualities that result from excessive study. It should be remembered, however, that this and several other examples of references to *pittori* lacking *sprezzatura,* such as Battista Franco, were more than balanced by literally dozens of references to male displays of *disinvoltura.* No such claim can be made about women's work. In the same vein, and as stated earlier in reference to Raphael, it must be stressed that female artists were not alone in exhibiting "diligence," "delicacy," and "sweetness" in their works. In a memorandum dated about 1490, the duke of Milan's Florentine agent distinguished Botticelli's style from that of Filippino Lippi. Botticelli's paintings have

"aria virile." Filippino's have "aria più dolce." Although it is true that it is difficult for us to know exactly what the agent meant by "virile" and "dolce," it is also true that he took care to differentiate them in terms of quality. Botticelli's works, which have "aria virile," "are done with the best method." As for Filippino's "aria più dolce," the agent concludes, "I do not think they have as much skill [non credo habiano tanta arte]."[52]

Defining the feminine in style and grounding it in practice challenged the woman artist, to use Hieronimo Mercuriale's words, "to prevail over the conditions of her sex."[53] This was not, according to Filippo Baldinucci, an impossible task. "It is neither impossible nor particularly unusual that the well-trained and talented woman can become marvelous in many areas, when, as occasionally happens, she is removed from those humble duties to which her sex is usually condemned."[54] In 1793, Francesco Maria Tassi was to support this contention. Celebrated are "the many who left behind natural weakness and vanity [naturali debolezze e vanitadi]" in order to study painting.[55] But despite Baldinucci's pronouncement and Tassi's corroboration of it, early critical commentary suggests it was rarely possible for a woman to put aside typical female activities. Indeed, the "humble duties to which . . . [the female] sex is usually condemned," it was thought, accounted for a woman's stylistic *diligenza* and *pazienza* as much anything else. When, for example, Mazzolari noted Fontana's stylistic deficiencies, he blamed their appearance on the decision of the *pittrice* to leave "the usual path and all that which is suitable to [a woman's] hands and fingers." Pino goes farther. He suggests that such departures are transgressions of natural law. "Art draws the feminine species away from that which is proper to it." A woman's hand, he says, should grasp only "the distaff and the spindle."[56] The metamorphosis of Alciati's 1542 emblematic tortoiselike Venus (Figure 13) into Johann van Beverwijck's 1643 portrait of the artist Anna Maria van Shurman poised on the same creature in front of a house in which a woman sits spinning (Figure 15) gives visual expression to Pino's ideological concerns and demonstrates just how hard it was for a woman to distance herself from her prescribed "humble duties."

Figure 15. Johann van Beverwijck, portrait of Anna Maria van Schurman. Frontispiece, *Van de Wtnementheyt des Vrouwelicken Geslachts* (On the excellence of the female sex), (1643). (Photo: author.)

At best, Pino's directive insured the continuance of the status quo. At worst, it quashed any chance a woman might have for displaying the *disinvoltura* so admired by critics. Stitching is a painstaking task that can only stifle *sprezzatura.* This, undoubtedly, is one of the reasons behind Caterina Ginnasi's later lament that "the needle and distaff are the mortal enemies of the painter's brush."[57] Even the most valiant attempt to cast the distaff and spindle in a favorable light fails. For example, Atanagi praises Irene di Spilimbergo for choosing to "flee idleness, the principal enemy of [the female] sex," by occupying herself with the needle. It was, he says, a judicious move on her part, for it prepared her for better things. "Departing from the common path followed by other girls," Spilimbergo, who was to be celebrated in dozens of *rime* for having vanquished Minerva with "the needle [l'ago]," soon set aside the needle and reached for the brush. Within six weeks, says Atanagi, she mastered color, foreshortening, *chiaroscuro*, anatomy, and the handling of drapery. He credits the *pittrice*'s prodigious display of painterly proficiency to two factors. First, from the practice of embroidery she had

acquired "great patience." Second, this *pazienza* enabled her to copy with "great diligence" "those most perfect things by Titian."[58]

In writings on women's works such critical observations are conspicuous by their omnipresence. In Fede Galizia's *piccoli ritratti* one sees, according to Paolo Morigia, a likeness of the sitter recorded with "diligenza grandissima."[59] Similarly, Ercole Basso notes that "the little picture" by Lavinia Fontana which he owns is "molto diligente" and, "as the work of a woman, praiseworthy."[60] Within the context of cinquecento critical theory it is impossible to read any of these remarks favorably, particularly since terms signifying a mastery of skill — *sprezzatura* and *facilità* — are absent. Indeed, there can be no doubt that *pazienza* and *diligenza*, when unsupported by innate talent, not only go hand in hand with *l'assiduità dello studio* and *stento*, they ultimately betray artistic stasis. "If," says Vasari, "Nature had made [Valerio Vincentino] excellent in *disegno* as well as diligent [diligente] and very patient [pazientissimo] in the execution of his works, [then] he would have surpassed the ancients . . . However, he used to copy the designs of others."[61] There is yet another side to these critical evaluations. Copying (*ritrarre*) figures prominently in the equation of *diligenza* and *stento*. Spilimbergo's *pazienza*, learned with the needle, enabled her to copy diligently works by Titian. That the *troppa diligenza* of sewing and embroidery prepares *la donnesca mano* for the demands of earnest and meticulous copying is, perhaps, best exemplified by Isabella Cattani Parasole.

The few facts known about Parasole's life and career come from Baglione's *Le vite de'pittori, scultori et architetteti*, 1642. Parasole apparently learned the art of intaglio from her husband Lionardo Parasole, Il Norcino, who, we are told, worked first in wood and then switched to the "più difficile" medium of copper. Isabella seems to have limited herself to wood. Baglione credits her with supplying woodcut illustrations to two books. The first book, of "her own invention," contained "diverse patterns for lace and other works for women" and was printed by Francesco Villamena. The second was "a book on herbs by Principe Cesi d'Acquasparte, *letteratissimo Signore*."[62] Of these, the first can be identified with certainty. Published by Lucchino Gargana in Venice in 1600 and dedicated to Gironima Colonna, *Libro della Pretiosa Gemma* is

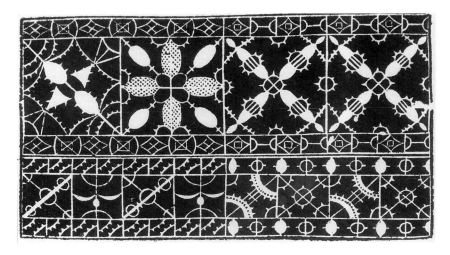

Figure 16. Isabella Parasole, lace pattern, from *Pretiosa gemma delle virtuose donne* (1600). Biblioteca Angelica, Rome. (Photo: Humberto N. Serra, Rome.)

acknowledged on the dedication page as "a collection of works by Signora Isabella Catanea Parasole." The following year a second *Libro della Pretiosa Gamma* was issued by the same press. It contains the following notice. "In the preceding year I presented . . . the first book of works by Signora Isabella Parasole." Presumably the second, like the first one, is by Parasole's hand. Each book contains twenty designs for *punto reale a reticella,* a combination of open and tight lace patterns, used typically in the making of liturgical vestments (Figures 16 and 17).[63]

It is more difficult to identify with precision the second group of works cited by Baglione, "gl'intagli nel Libro dell'herbe del Principe Cesi d'Acquasparte." Federico Cesi d'Acquasparte (1585–1630) was an influential and supporting member of the Accademia dei Lincei, an academy dedicated to the study of the natural sciences. A single bound volume, *Fabii Columnae Lyncei di Nardi Antonii Recchi* includes Cesi's *Phytosophicarum Tabulae,* 1628.[64] It is not an illustrated essay. Indeed, only one study among the collected treatises in *Fabii Columnae Lyncei* is illustrated. That one is a study of herbs (Figures 18 and 19). As is appropriate to a work of its kind, the illustrations in *Fabii Columnae Lyncei* are precise, recording observable differences in plant structure and surface

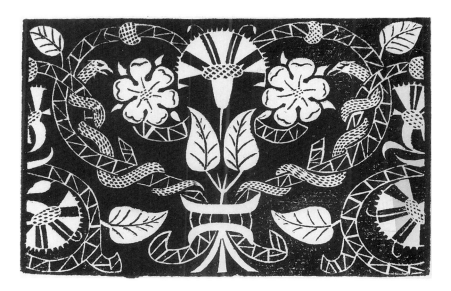

Figure 17. Isabella Parasole, lace pattern from *Secondo libro della pretiosa gemma delle virtuose donne* (1601). Biblioteca Angelica, Rome. (Photo: Humberto N. Serra, Rome.)

texture. These images are not decorative but, in keeping with the contemporary interest in the diversity of nature, documentary.[65] It would be wrong, therefore, to see Parasole at the beginning of a trend, a trend that would associate botanical illustration with the sensible and the beautiful, label it "craft," and ally it with the feminine hand. But having said this, it must be acknowledged that Parasole's move from lace design to studied plant illustration was precisely the kind of move that art history and criticism came to regard as appropriately female. Indeed, the painting of still lifes, like the painting of small devotional images and lifelike (albeit lifeless) portraits, became the proper venue for female talent like that of Fede Galizia.

One of the more interesting discussions of the association between still lifes and "feminine" space is found in an essay in Norman Bryson's *Looking at the Overlooked*.[66] Using Pliny's praise of Piraeicus's paintings of "barbers' shops, cobblers' stalls, asses, eatables and similar subjects" as a point of departure, Bryson reviews representations of the decidedly common in a multiplicity of compositional contexts as well as in

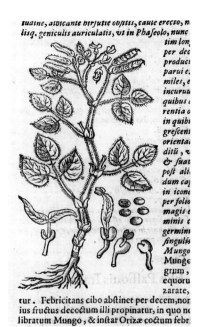

suaine, albicante hirsutie obsitis, caule erecto, n
lisq. geniculis auriculatis, vt in Phaseolo, nunc
sim lon,
per dec
product
parui e;
miles, e
incuruu
quibus i
rentia o
in quibi
grescent
orientai
ditü , c
& suat
post ali.
dum cap
in icone
per folio
magis c
minis c
germini
singulis
Mungo
Munge
grum ,
equoru
zarate,
tur. Febricitans cibo abstinet per decem,nor
ius fructus decoctum illi propinatur, in quo ne
libratum Mungo , & instar Orizæ coctum febr

repente , fractu facili , colore albicante ex pallido,sapo
natura Vitiginea, more Clematidis, sarmentis multis
GRANADILLA FLOS PASSIONIS.
terra
bus e;
demit
quæc
bores
singu
aut ai
imita
tibus ;
quoqi
sè inc.
nosis,s
binas
gis v
aliori
Xyrii
singul
ad A
iucun
mùm
foliof.
gusti
quino
rostra
tibus,
tur .
sili crassitudine , duplici ordine dissectæ, purpureis ma
dentur ,sanguineis guttis aspersa, quarum superiores
panduntur , inferiores verò rosæ longioribus,illisq. in

Figure 18. Isabella Parasole (?), bo-
tanical illustration, from *Fabii Col-
umnae Lyncei di Nardi Antonii Recchi.*
1628. Biblioteca Vaticana, Vatican
City. (Photo: Biblioteca Apostolica
Vaticana, Vatican City.)

Figure 19. Isabella Parasole (?), botani-
cal illustration, from *Fabii Columnae
Lyncei di Nardi Antonii Recchi.* 1628. Bibli-
oteca Vaticana, Vatican City. (Photo:
Biblioteca Apostolica Vaticana, Vatican
City.)

various value systems (monetary, aesthetic, etc.). Still lifes of the kind
painted by Galizia fall into the category of images represented "frankly
and on their own terms. There is no desire to inflate the scene beyond
itself" (Figure 20). Caravaggio's famed *Basket of Fruit* also falls within the
category of *cose inanimate* (Figure 21). But putting aside the similarity of
the blemished fruits and the absence of any indication of place in the
images by these two artists, these pictures are, says Bryson, strikingly
different. Although they share equally a "historical claim to invention
. . . the tone of ambition [visualized in Galizia's painting] is far less
strident." Caravaggio injects "into his scenes qualities of the heroic and
the extraordinary; mundane space is intensified to the point of theat-

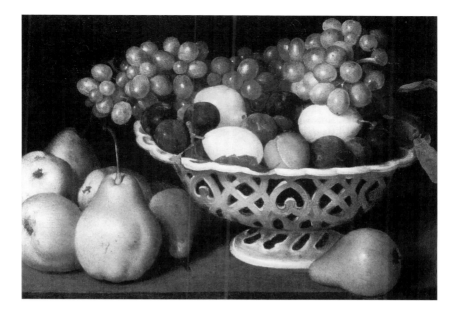

Figure 20. Fede Galizia, *Still Life*, 1602. (Photo: Silvano Lodi Collection, Campione d'Italia, Switzerland.)

Figure 21. Caravaggio, *Still Life of a Basket of Fruit*, ca. 1600. Pinacoteca Ambrosiana, Milan. (Photo: Alinari/Art Resource, New York.)

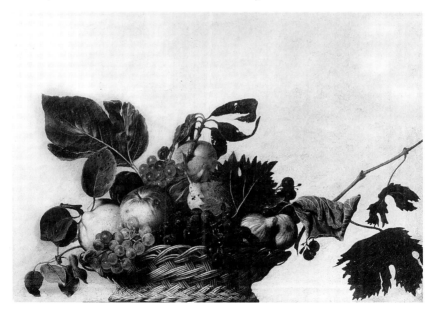

ricality and hyper-reality." By contrast, "Galizia's still-life is much closer to its subject." She "paints from within the same plane of existence as her subject," whereas he "paints his subject from on high." Here, as elsewhere, Bryson is sensitive to hierarchical constructs, including those involving gender. Yet in his comparison of still lifes by Caravaggio and Galizia he lets stand the juxtaposition of presentation and representation, high and low, art and craft. The former comes into being only inside the picture. It does so through the master's artifice. Indeed, as artifice, it is created. The latter already exists. It is merely replicated. At the very least, the distinction between presentation and representation points to the continued defining presence of Pythagorean contrarieties, replete with all of its positive and negative associations.

It would be inaccurate to claim that the hierarchies within the history and theory of art: copying versus invention, *diligenza* versus *disinvoltura*, still life versus history painting, and craft versus fine art, were fully realized in sixteenth-century critical discourse. It would, however, be accurate to say that this era sowed the seeds that would later bloom into clear-cut divisions that ultimately distinguished the artist from The Artist and typically reflected gendered notions concerning feminine versus masculine style. Early critics, for example, uniformly describe a woman's style as marked by "tanta pazienza" and "troppa diligenza." In several specific cases, these defining characteristics are tied directly to the needle, distaff, and spindle. And in an even greater number of instances, these tools are described as naturally proper to, yet artistically inhibiting of, *la donnesca mano.* The comparison of Scipione Delfinone with Caterina Cantona suggests that in the final analysis the difference between *ricamtori* and *ricamatrici* comes down to the issue of creating *istoria* replete with "nuova inventione" as opposed to the less difficult task of copying a likeness.[67] Indeed, by awarding Delfinone "the first place" in *ricamo,* Paolo Morigia and Gian Paolo Lomazzo make clear that even in art forms viewed as proper to the female mind and hand, woman remained secondary to man, feminine style the distant runner up to a masculine manner.

As Isabella Parasole's *Libro della Pretiosa Gemma* suggests and Morigia's concluding statement to Caterina Cantona's *vita* makes clear, women of all classes — "donne . . . della prima nobilità, . . . gentildonne, cittadine,

e artiste" — embroidered.[68] Noting that a majority of Parasole's lace patterns were for *punto reale a reticella* and considering that Cantona's works could be seen in chalice covers, liturgical vestments, and processional banners "ornamenting more than thirty churches" throughout Milan, one can assume that many of these pieces made their way into religious institutions. Such decorative objects were not the only type of art produced by women for churches and convents, nor were lay women the only ones making art works destined for these sites. Of the thirty-seven sixteenth-century women artists named in early texts, twelve were Dominican nuns.[69] Three — Suore Alessandra del Milanese, Felice Lupiccini, and Angiola Minerbetti — are identified as miniaturists.[70] Six — Suore Plautilla Nelli, Prudenza Cambi, Agata Trabalesi, Maria Ruggieri, Tommasa del Fiesca, and "Veronica" — are called painters.[71] Three — Dionisia Niccolini, Maria Angelica Razzi, and Vincenza Brandolini — are said to have "worked in *rilievo*" and modeled devotional terra-cotta figures.[72] Only Tommasa del Fiesca is referred to as an embroiderer, and only then in a note to Sopriani's *Vite.*[73] Indeed, although early writers indicate that convents were productive art institutions in their own right, providing instruction to novices and selling their works throughout Italy, no author identifies the embroiderer's needle as the instrument proper to *i benedetti mani* of *suore.* While it seems logical that nuns, like their secular sisters, were skilled with *l'ago,* it must also be assumed that the needle was not their sole source of study nor embroidery their preferred medium.

Conventual communities had long provided women with environments conducive to creative endeavors.[74] But such environments had their negative aspects. Opportunities for study were obviously far more limited for women in *clausura* than for either artist-daughters or *gentildonne* living at home. Yet life without men did not necessarily mean an artistic life without male instruction or influence. Just as Properzia De'Rossi copied works by Raphael and Marietta Robusti "drew after" those by Tintoretto, Suor Plautilla Nelli reportedly made "a picture of the Nativity of Christ, copied from one which Bronzino once painted for Filippo Salviati."[75] Moreover, the close affiliation of convents with monasteries, particularly after 1500, when attempts to restrict the liberating effects of Savonarolan reform on conventual communities were

especially intense, could work to the advantage of the nun-artist.[76] Whereas both Suor Caterina dei Vigri (1431–36), a Poor Clare and prioress of the convent of Corpus Domini in Bologna, Suor Tommasa del Fiesca (ca. 1448–1534), affiliated first with the Dominican convent of Santi Giacomo e Filippo in Genoa and later transferred with eleven others to assist in the reform of the convent of San Silvestro in Pisa, and the Dominican Tertiary Suor Caterina de'Ricci (1522–87), prioress of the convent of San Vincenzo in Prato, relied on their own mystical visions for artistic inspiration, Suor Plautilla Nelli (1523–87), prioress of the Dominican convent of Santa Caterina da Siena in Florence, had at her disposal a large cache of drawings by Fra Bartolomeo. These drawings were not only inspirational, they were instructive. The inventory drawn up on the Frate's death in 1517 lists "866 loose sheets of drawings, 12 sketchbooks, and an unspecified number of landscape drawings, colored as well as in pen and ink, pasted onto canvas rolls."[77] According to Vasari, Fra Paolino da Pistoia (ca. 1490–1547) was heir to Fra Bartolomeo's drawings.[78] Again according to Vasari, most of these drawings went from the monastery of San Marco to its sister convent Santa Caterina.[79] They did so, says Baldinucci, by way of the convent's prioress and student of Fra Paolino, Plautilla Nelli.[80] That the prioress-painter had at least some of them cannot be doubted.

Plautilla, we are told, was a prolific painter. Vasari lists more works by her hand than does any other critic about any Renaissance woman artist. She painted "large altarpieces [tavole grande]," "small devotional pictures [quadretti]," and miniatures. Her paintings graced "the homes of gentlemen throughout Florence" and adorned not only the walls and altars of her convent, but those of other churches in Florence, Pistoia, and Perugia. Both Fra Serafino Razzi, who walked nine hundred miles around northern Italy in search of documents in Dominican monasteries which he compiled into a biographical history of illustrious Dominicans, and Francesco Bocchi, author of the well-known guidebook *Le bellezze della città di Firenze*, confirm Vasari on this point. They also provide the specific locations of some images mentioned only in passing by the author of the *Vite*. Unfortunately, only two of her many paintings have been securely identified. The first of these is a large work representing the Last Supper (Figure 22). It is reported as hanging originally in

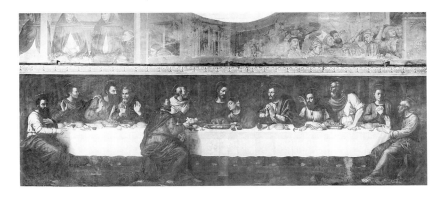

Figure 22. Suor Plautilla Nelli, *The Last Supper*, 1550s (?). Florence. (Photo: Alinari/Art Resource, New York.)

Santa Caterina's refectory, a typical location for depictions of this theme. When in 1853 Santa Caterina became the Galleria dell'Accademia, the image was moved to the chapterhouse of the Dominican church of Santa Maria Novella.[81] An early photograph of it, which was taken before 1930, shows it there, obscuring a large section of Andrea di Bonaiuto's fourteenth-century fresco of the life of Saint Peter Martyr. When Bonaiuto's fresco was restored to full view, Nelli's painting was moved. Unfortunately, I have only just learned its current location and therefore have relied on an old photograph as visual documentation of its appearance.[82] From this bit of evidence Nelli appears to have been a competent but not exceptional artist. The composition follows convention, and figural poses as well as gestures adhere to prescribed rhetorical types. Because of these features, and the absence of facial expressions, Nelli's *Last Supper* appears rigid and archaic. Fortunately, another work, a *Lamentation*, can be viewed in the Museo di San Marco in Florence. This makes possible a more accurate assessment of Plautilla Nelli's artistic abilities (Figures 23 and 24).

Like *The Last Supper*, Nelli's *Lamentation* relies on convention. In fact, aspects of its compositional structure are strikingly similar to the recently cleaned *Pietà* by Fra Bartolomeo (Figure 25), although one nineteenth-century source says it is "the invention of the celebrated painter Andrea del Sarto, which was carried out by Plautilla [L'invenzione del celebre pittore Andrea Sarto e di Suor Plautilla la es-

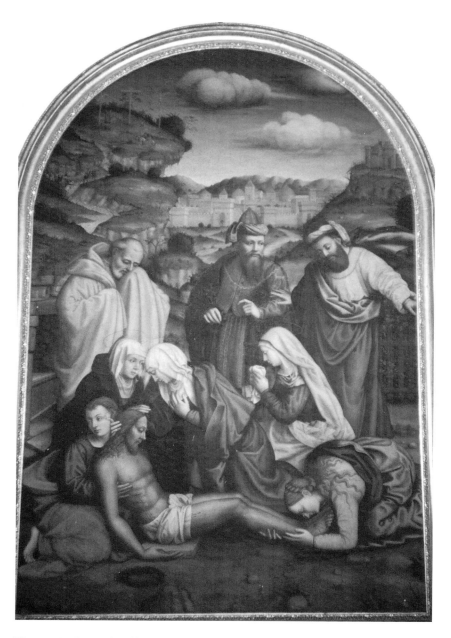

Figure 23. Suor Plautilla Nelli, *The Lamentation*, 1550s (?). Museo di San Marco, Florence. (Photo: author.)

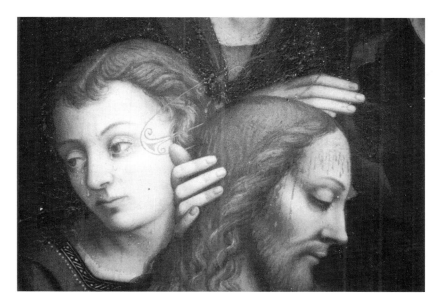

Figure 24. Suor Plautilla Nelli, *The Lamentation,* 1550s (?), detail. (Photo: author.)

ecuzione]."[83] The most notable likeness is between the Frate's Saints Peter and Paul and the prioress's two standing male figures, who, like those by Fra Bartolomeo, counterbalance one another through their closed and open postures. While it is possible to see this likeness of pose as a reflection of conventional compositional arrangement, the same cannot be said of the standing male figure on the left. Although cropped, the Frate's Peter leans forward so that he hovers over the grieving group surrounding Christ. His right hand, covered by a weighty mantle that sweeps around his entire form in broad and curving folds, clutches his identifying attribute, a key. Plautilla's corresponding figure is more erect. The cloak her figure wears hangs in folds more vertical than encircling, and his shrouded hands hold nothing. Like Fra Bartolomeo's weeping Saint Peter, Suor Plautilla's figure may be related to a figure study by Fra Bartolomeo drawn with black chalk and heightened with white, now in the Museum Boymans-van Beuningen in Rotterdam (Figure 26).

The drawing came to the Boymans-van Beuningen as part of "Vol-

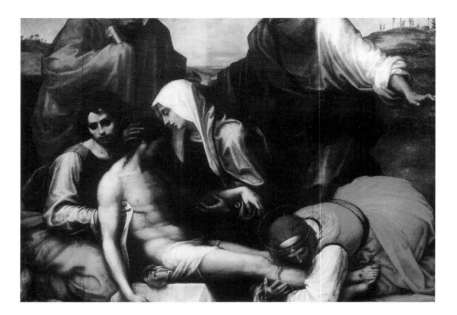

Figure 25. Fra Bartolomeo, *Pietà*, 1511–12. Galleria Palatina, Palazzo Pitti, Florence. (Photo: Archivio Fotografico dell'Opificio delle Pietre Dure di Firenze.)

ume M," a collection of 201 folios. The title page of Volume M reads in part as follows:

First Volume of Original Drawings by Fra Bartolomeo of San Marco, secularly called Baccio della Porta from Florence. See Giorgio Vasari, who talks about these drawings at the end of his Life of this famous painter . . . He says that on his death Fra Bartolomeo left these drawings to a nun called Sister Plautilla, a pupil of his, who was in the convent of Santa Caterina opposite San Marco. They remained in the said convent until the year 1727, when they were bought from the nuns to preserve them, . . . [since] for many years [they] were condemned to the inexperience of those Mothers and were wretchedly used for wrapping up coins.[84]

Despite the inaccuracies – Nelli, who was born six years after Fra Bartolomeo's death, could not have been either Fra Bartolomeo's pupil or his direct heir – the title page of Volume M supports the visual evidence. Plautilla Nelli had access to the Frate's drawings.

Nelli's *Lamentation* and Fra Bartolomeo's study provide us with a rare opportunity. Although the copying of men's work by women artists is

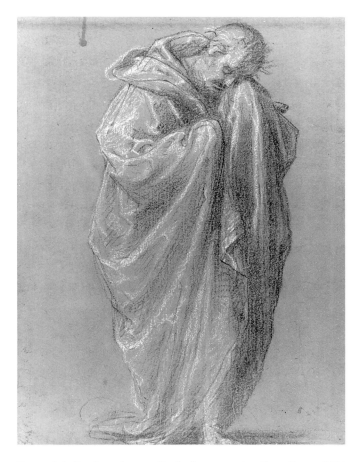

Figure 26. Fra Bartolomeo, Study for a weeping Saint Peter, 1511–12. Museum Boymans-van-Beuningen, Rotterdam. (Photo: Museum Boymans-van-Beuningen, Rotterdam.)

routinely mentioned and the effects of copying duly assessed, it is, except in this case, impossible to compare influencing and influenced images in light of critical commentary. Here we can do both.

According to Giorgio Vasari,

The best works from [Plautilla's] hand are those she has copied from others, wherein she shows that she would have done marvelous things if she had enjoyed, as men do, advantages for studying, devoting herself to drawing and

copying living and natural objects. And that this is true is seen clearly from a picture of the Nativity of Christ, copied from one [by] Bronzino . . . The truth of such an opinion is proved by this, that in her works the faces and features of women, whom she has been able to see as much as she pleased, are considerably better than the heads of the men . . . In the faces of women in some of her works she has portrayed Madonna Costanza de'Doni . . . painting her so well that it is impossible to expect more from a woman who, for the reasons mentioned above, has had no great practice in her art.[85]

Here, Vasari sounds familiar themes. As Boccaccio had done and as Bernini would do, he acknowledges decorum as an issue of consequence. Although the ancient painter Marcia, says Boccaccio, may have been able to choose either "to make men imperfect, or, by making them perfect, forget her maidenly modesty," Nelli could not.[86] She could "copy living and natural things" in only a limited sense. Therefore, to quote Bernini's later advice to women, the best thing for her to do "was to choose only the best examples [of works by others] to copy." Clearly, her options were limited in this regard as well. But although her options were few, drawings by Fra Bartolomeo in her possession were many. Nonetheless, having a rich source of visual material to copy (*ritrarre*) did not mean the prioress was able to imitate (*imitare*) the Frate's style, one in which classicizing idealism subsumes the immediate, personal, and introspective. The *Lamentation* makes this clear.

As it hangs in the Museo di San Marco, Nelli's painting appears quite different from the many contemporary Italian works around it, a majority of which reveal the influence of Fra Bartolomeo. Although the Frate and the best of his followers articulate intimate emotions with an extraordinary subtlety and expansive feeling that speaks universally, the Suor renders grief with an individualized intensity and precision more typically associated with northern Europe. Tears, each one meticulously defined, fall from red-rimmed eyes and streak pallid cheeks. Similarly, whereas Fra Bartolomeo amplifies, complicates, and unifies compositional structure using only the resources that reside in form, Suor Plautilla pushes her figures forward and spreads them across the picture plane in three tiers. To this, she adds copious detail. Stones littering the path to Calvary can be counted, as can the hairs on Mary Magdalene's head and the links in Joseph of Arimathaea's chain. Despite its monu-

mental scale, Plautilla Nelli's painting is not a monumental composition. The *difficultà* of painting an *istoria* is apparent; so too is the *diligenza* that comes from *assiduità dello studio*.[87]

Still, the prioress's *Lamentation* is a moving image. It is true that Plautilla Nelli's painting has stylistic weaknesses, such as the overcrowding of the foreground and the distractions of minutiae. As for the awkward rigidity of Christ's propped-up body, we can, if we accept popular tradition, credit it to her model: the corpse of "a dead nun [una monaca defuncta]."[88] But despite these weaknesses, the work has its strengths. These should not be ignored, nor should the power of the image to affect the viewer be denied. Vasari was right. "In [Nelli's] works the faces and features of women, whom she has been able to see as much as she pleased, are considerably better than the heads of the men." The accuracy of Vasari's observation, which points to Nelli's artistic strengths, is verified by a comparison of the three Marys in the *Lamentation* with the twelve apostles in *The Last Supper*. It is also confirmed by a comparison of the female and male faces within the San Marco painting itself (except that of the youthful John, who displays the same characteristics of sorrow seen in the grieving women). Here, the benefits of direct observation – Nelli's ability "to see as much as she pleased" the faces of women – are clearly visible. Indeed, here observation is combined with the painter's predilection for detail to a positive end. Not only are tearful eyes red, so are noses. Such signs of despair are familiar, the sense of loss inducing them comprehensible. To Nelli's credit, she did not sentimentalize these emotions. In fact, she captured and conveyed the very essence of grief – a commonly experienced sense of despair that ultimately cannot be shared. While outwardly showing signs of sorrow, each of these figures turns within to ease his or her pain.

Despite stylistic qualities that perhaps may be attributed to Plautilla's having had "no great practice in her art," such as her stylized rendering of drapery, there can be no doubt that works by this prolific prioress enjoyed popularity. According to Francesco Bocchi, not only is "the Church [of Santa Caterina] adorned with paintings made by her hand, as one can see, but others have also been sent to various locations with great praise to her name."[89] These "various locations" were private homes as well as religious institutions. Concerning the former, Vasari

reports that in the homes of Florentine gentlemen ("gentiluomini di Firenze") "there are so many pictures [by Nelli] that it would be tedious to speak of them all." Thus, he limits himself to two: "A large picture of the Annunciation belonging to the wife of the Spaniard, Signor Mondragone, and another [painting] like it which is owned by Madonna Marietta de'Fedini."[90] Regarding the latter, many a church within and outside of Florence's walls housed a painting made by this Dominican prioress. Vasari and Fra Serafino Razzi identify two non-Florentine locations: Santa Lucia in Pistoia and San Domenico in Perugia.[91] In fact, Plautilla's name, if not her paintings, had traveled far, as Karel van Mander's reference to her in *Het Schilder-Boeck*, 1618, makes clear.[92]

What was so appealing about Plautilla Nelli's work? We might begin to answer this question by asking who was attracted to her images. Here, we have the assistance of Vasari, Razzi, Bocchi, and van Mander. According to these writers, paintings by the prioress were admired and purchased by *gentiluomini*, women, the devout, and northern Europeans. Is there any way to connect this appreciative group to the little bit of visual evidence we have concerning Nelli's style? I suggest that Michelangelo's discourse on Flemish painting as recorded by Francisco de Hollanda provides the needed link. When Vittoria Colonna asked about Flemish painting, which she found "very devout," Michelangelo responded by contrasting the "boldness" and "vigor" of Italian art with the surfeit of detail in northern painting: "the fabrics and masonry, the green grass of the fields, the shadows of trees, and rivers and bridges . . . with many figures on this side and that."[93] Clearly, this description can be applied to Nelli's *Lamentation* just as easily as to a painting by Jan Mostaert or Jan van Scorel. More to the point, this style, says Michelangelo, "will please the devout" and "appeal to women, especially very old and very young women, and also to monks and nuns and to certain noblemen who have no sense of true harmony." If we assume that viewers are attracted to qualities in art that somehow mirror themselves, then what we have here is a definition of feminine taste.[94]

Michelangelo's critique of Flemish painting reflects an Italian bias structured on the conventional juxtaposition of penetrating masculine reason and substance with feminine irrationality and susceptibility to the superficial world of appearance.[95] As the list of miscellanea —

fabrics, masonry, grass, trees, rivers, bridges, and numerous figures — indicates, at least a part of Flemish painting's seductive appeal to women, monks, and nuns resides in its copious detail.[96] Nelli's *Lamentation,* filled with meticulously rendered stones, masonry, plants, fabrics, and figures, may be seen as the type of painting Michelangelo devalued. Does this explain van Mander's praise of Plautilla or account for the appearance of her work in convents, monasteries, and the homes of Signora Mondragone and Marietta de'Fedini? I suggest an alternative reason. Rather than credit the appeal of her images to the allure of the sensual and the superficial that are the reported results of an attention to detail, the attraction was in the "blessed hand [benedetta mano]" that put brush to panel. In other words (and with the aphorism "Every painter paints him/herself" in mind) appeal resides not so much in the virtuosity of the maker but rather in her virtue. As Paolo Morigia's admiration of Cantona's "divina mano" suggests, the virtue of the *virtuosa* was of no little consequence. Certainly, Domenici imparts this idea in his life of Mariangiola Criscuolo. "Some ladies who knew the goodness of her life, sent their daughters to her not so much that they should learn the virtuoso application of painting as learn by the good example of her Christian life."[97] At least one of her pupils learned her lessons well. After taking her vows, Luisa Capomazza went on to "make paintings for various chapels in the Church of Santa Chiara" in Naples, although "in drawing, to say the truth [she] is not perfect."[98]

Was Capomazza's reported weakness in drawing a reflection of Criscuolo's own deficiencies, a result of limited opportunities for study, or, in the mid-eighteenth century, was Domenici providing evidence of the continued presumption that women simply did not possess *forze di quel furore?* The question raises a final point about nun-artists and their source of inspiration. Conventual communities were sympathetic to mystical visions. Recording them, it seems, kept many a *benedetta mano* busy. Caterina dei Vigri, Tommasa del Fiesca, and Caterina de'Ricci all had mystical visions which informed their work and that of those around them.[99] In the case of Caterina dei Vigri, poems and prayers sprang from experiences of spiritual ecstasy.[100] Presumably, these entranced visions also provided the prioress of the Poor Clares of Bologna's convent of Corpus Domini with rich source material for her

paintings. According to Raffaello Sopriani, this was true of Tommasa del Fiesca.[101] Caterina de'Ricci's work, such as a small devotional *Man of Sorrows* painted for Charles Borromeo, may have come from a similar source. Certainly, Caterina de'Ricci's visions were many – and many were the devout hands that recorded them in word and image. Indeed, the prioress apparently recognized a good thing when she encountered it. According to Fra Serafino Razzi's *Historia de gli Huomni illustri*, 1596, San Vincenzo was home to "many sisters competent in painting." Encouraged by Caterina, nuns expressed their reverence to God and fealty to their superior sister by painting devotional images that ultimately made their way to "tutta Italia" because "they came from the holy monastery where there were one hundred and fifty noble handmaids of God."[102]

Translations of the verbal into the visual seem to have been commonplace in convents. Maria di Reggio, who took her vows in 1508, reportedly led a group of nuns into the woods to pray at a wooden cross erected "in memoria della Passione di Nostro Signore." While gazing at the cross, Maria, with "open eyes" and "in estasi di spirito," saw the suffering and blood-stained Christ. Recovering her senses, she described her vision to her companions. They, in turn, painted it.[103] Lacking any works associated specifically with such mystical visions, it is impossible to assess whether one woman's divine *furor* could metamorphose into another woman's *furor dello artefice.* However, because all sixteenth-century discussions of *furia* and *fierezza* bind the perceiving eye to the visualizing hand, the separation of the mystic from the painter suggests, at least theoretically, that this did not occur. In fact, for one person to visualize the visions of another may be seen as a form of copying and thus susceptible to all the stylistic weaknesses that inhere in the practice. The *furor* of conception, or more properly in these instances perception, must inevitably be lost or diminished as it progresses from an image of the spirit to a marketable material product.

CHAPTER SIX

Misplaced Modifiers

Ideal clay, o marvel, woman's flesh!

—Victor Hugo

I N *Dialogo delle bellezza donne*, 1548, Agnolo Firenzuola defines six
qualities of female beauty. Three — *leggiadria* (elegance), *vaghezza* (allur-
ing charm), and *grazia* (grace) — refer generally to the visible body, its
form and the way it moves.[1] The remaining three — *venustà* (loveliness),
aria (air, or demeanor), and *maestà* (majesty) — are more transcendent,
referring to qualities that inspire spiritual love. To varying degrees, all
six qualities are elusive. They "arise mysteriously from the composition,
union, and conjunction of several diverse and different parts," are "ar-
ranged and joined together by Nature in an inexplicable relationship,"
and cause the lover to be attracted to the beloved through an "indefin-
able something."[2] Art has this same "non so che."[3] For Giorgio Vasari,
it is "that graceful and sweet ease [quella facilità graziosa e dolce]"
which hovers "between the seen and unseen [fra 'l vedi e non vedi]."[4]
For Ludovico Dolce, who quotes from one of Petrarch's sonnets in
which the poet sees "in [Laura's] eyes an indefinable something," it is
that "certain charm" that makes him "fall in love" with Parmigianino's
paintings.[5]

Although the ineffable qualities shared by women and art do not
make the appeal of the latter contingent on the representation of the
former, coupling a beautiful subject with a beautiful style could work to
the advantage of both. Through a mastery of style, the artist enhances
the grace and elegance of the model. Conversely, the beauty of the
model provides the artist with the perfect vehicle for demonstrating
stylistic *grazia* and *leggiadria*. But for the woman who painted an image of

herself, such reciprocity became mired in reflexivity. Because model, maker, and image are, or reflect, one and the same thing, the use of the same terms to describe alternatively all three blurs the distinctions between one and the others. Critics, poets, and many of those expressing a desire to own a woman's self-portrait took full advantage of the flexibility, thus leaving the reader to determine what it is that the writer admires and desires: the artist as model, the artist as image, or the artist as artist. The most effective way to sort through this quagmire of muddled modifiers is to define the "indefinable something" that is *grazia*.

Grace. What is it, who or what has it, and where did he, she, or it get it? The answer is an evasive but nonetheless accurate, "It depends." A Grace is one of the three sister goddesses generally associated with the nine Muses and usually in attendance on Venus. Grace is a short prayer of thanksgiving typically offered in exchange for a divine blessing. Grace is a prerogative of mercy, a pardon or a reprieve. Grace is a charming or attractive endowment, a manner of acting or a comeliness of appearance. Grace is a condition of being in favor or the privilege of being counted among the elect. One can live in a state of grace, enjoy the benefits of a grace period, fall from grace, be in the good graces of another, grace an occasion with one's presence, go forth in grace, or, by the grace of God, be spared suffering. One can be grateful, gracious, or graceless. One can be physically gracile or technically graceful. Often the two are combined in such a way as to elicit admiration, as when, for example, a figure skater gracefully glides across or pivots on the ice. So, what is grace? Grace is a prayer, a blessing, a favor, a disposition, a manner of acting or of appearance. Who has it, and where did they get it? It depends.

As the question suggests, all definitions of grace imply some sort of relationship. Someone or something attributes, gives, or offers grace. Someone or some other thing takes, receives, or accepts it. Grace defined as a prayer is graciously offered to God. If the prayer is answered, the grateful supplicant, having received God's blessing, may be said to dwell in a state of grace.[6] Grace defined as a condition of being can be extended to include grace defined as a charming or attractive endowment. Beauty and talent are typically acknowledged as God-given gifts. Of course not all grace is divine in origin. An individual might act in an effusively gracious manner in order to ingratiate him- or herself with

another who is in a position to bestow special favors or grant dispensation. In some cases an individual blessed by God with some special talent, such as an artist, might place those talents at the service of another, such as a prince, with the hope of securing tangible favors rather than spiritual rewards. This type of reciprocity — an exchange of grace (the demonstration of unusual talent) for grace (the benefits of patronage) — significantly alters the nature of the relationship. In addition to the one who gives and the one who takes or receives, there is an object: the work of art. Complicating matters further is the subject depicted in that object, particularly when, as is often the case in sixteenth-century painting, the represented subject is a woman who embodies the *non so che* that is Firenzuola's *grazia*.

When considering images of this kind, determining who or what has grace and figuring out its origin depends on what precisely is under scrutiny. If the focus of attention is the woman depicted in the image, then Nature must be credited with endowing her with beauty. If, however, the image itself elicits the viewer's admiration, then the artist who made it deserves commendation. Because imaged female beauty became, during the course of the cinquecento, a synecdoche for the beauty of art, thereby causing words like *grazia*, *leggiadria*, and *vaghezza* to become critical commonplaces describing both a beautiful woman and an individual artistic style, answering these questions is challenging.[7] Then, as in current usage, *grazia* and myriad associated terms could be used in both an objective and subjective sense. Similarly, then as now relationships are always implicit. But in contrast to now, sixteenth-century writers took full advantage of the possibilities afforded by semantic slippage. In some instances the subject–object (model–maker) opposition is collapsed, whereas in others (maker–model/image) it is reasserted.

Semantic shifts between the object(ive) and the subject(ive) are in part the result of word choices by authors, who, although concerned with different topics, share the same vocabulary. In the name of aesthetics, writers of treatises on feminine beauty as well as authors of theoretical tracts on art describe the beautiful as a thing of grace and elegance. The potential for confusion is obvious. In the case of the former, that which is beautiful is woman. In the case of the latter, it is a work of art. If the beautiful work of art has as its subject a beautiful woman, then

deciding what – object or subject – is being appreciated for its aesthetic appeal is open to discussion. Rudolf Wittkower summed up the difficulty of determining who or what has grace when he rightly observed that this often elusive term not only contains but critically depends upon a certain element of 'I don't know what,' *un non so che*. Whereas now it is possible to resolve some of these difficulties through careful critical analysis, in the sixteenth-century aesthetic concepts and notions of woman were so inextricably tied into a knot that separating one from the other was virtually impossible. For the Renaissance woman artist, such complexities proved an extraordinarily difficult bind – especially when she imaged herself.

Self-portraits by sixteenth-century women are numerous. For example, more than a dozen are attributed to Sofonisba Anguissola, at least a couple are given to her sister Lucia, and four have been credited to Lavinia Fontana. Although Anguissola's self-portraits are distinguished by their number, the practice of self-imaging was not gender specific. Baccio Bandinelli, Titian, and Vasari, among others, also produced self-portraits.[8] Indeed, the sixteenth-century penchant for painting self-portraits, regardless of the sex of the artist who produced them, may be seen to be wholly consonant with what has been described as "an increased self-consciousness about the fashioning of human identity as a manipulable and artful process."[9] Moreover, it may be viewed as a logical response to the still somewhat unfixed identity of the artist. Just as the discursive fiction of artists' lives was emerging from the fusion of history with biography, so was the artistic "type," as a consciously constructed identity, taking visible form. Self-portraits allowed artists to imagine and image what that form might be. The self-fashioned image, however, did not advance without resistance.

The process of reinscribing artists on lists of illustrious men had been initiated in the fourteenth century, but only in the sixteenth had the practice gone beyond the occasional textual commendation to include visual representation. Increasingly, images became the visual counterparts to biographical histories of art, such as Vasari's *Vite*, and biographies of famous men, like Paolo Giovio's *Eloqia Virorum Illustrium*.[10] Like the assemblage and presentation of biographies into a chronologically ordered corpus of lives, portraits of *uomini famosi*, which now included

artists, began to be collected and displayed in "musei" designed specifi-
cally for that purpose. Two of Titian's self-portraits, for example, en-
tered Philip II's portrait collection.[11] Titian's works were not unusual in
this regard. In a reply letter to Alonso Chacon, dated 3 May 1579,
Lavinia Fontana expresses her willingness to supply Chacon with "a
small self-portrait [retratino piccolo]" that was to be engraved, along
with images of "five hundred illustrious men and women," including
"that of Sofonisba," then being assembled for Archduke Ferdinand of
Austria.[12] As a group, these and other self-portraits constitute a collec-
tive construction that identifies the artist as a person of *virtù* and
nobilità.[13] But if these portraits were generated by self, the image of the
artist they projected was not wholly fashioned by that self, for self-
fashioning was not an act of autonomy.[14]

It was during the sixteenth century that "fashion," a term long used
to signify "the action or process of making, . . . seems to come into
wide currency as a way of designating the forming of self."[15] Yet, in
reality, fashioning was a process of articulating the current "mode of
perceiving and behaving." The fashioning of self thus entailed accom-
modating existing concepts about what a thing is or should ideally be.
Like any defining process, this one involved defining and evaluating one
thing in relation to something else – the *artigiano* versus the *artista* as
compared to the *uomo famoso*, or a "feminine" versus a "virile" style. The
"mode of perceiving" reflected in self-portraits may be seen, therefore,
as a dialectic between self (artist) and authoritative forces situated
outside of self (cultural spokesmen, including critics and patrons). In
this regard sixteenth-century notions of portraiture and *grazia* are alike.
A relationship, in which inheres a given set of expectations, is always
present. This is implicit in any patron's request for an artist's self-
portrait just as it is evident in definitions of grace. At issue, then, is the
question of who has the greater say in the process of self-fashioning: the
self or the forces outside the self?

Alonso Chacon's letter to Lavinia Fontana is unusual among requests
for self-portraits to women artists. All he has apparently asked of her is
that she fashion herself as a "personaggio illustro." Far more typical are
requests obscuring the distinction between the maker and model, those
in which the object and subject are collapsed into one. On 23 December

1559, for example, Annibale Caro wrote to Amilcare Anguissola requesting Sofonisba's self-portrait. "There is nothing I desire more," he wrote, "than an image of the artist herself, so that in a single work I can exhibit two marvels, one the work, the other the artist [l'una dell' opera, l'altra della Maestra]."[16] The same desire seems to have inspired Mutio Manfredi's letter of 6 June 1591 to Lavinia Fontana. Like Caro, Manfredi requests "a portrait by the hand of the same" (i.e., sitter) in order that he might have "un esempio di bella, e raramente virtuosa donna."[17] And in a letter of thanks to an unnamed woman artist (probably the Flemish miniaturist Levina Teerlinc, ca. 1520–76) for her self-portrait, the miniaturist Giulio Clovio expresses his delight in having "the grace of your countenance, the liveliness of your spirit, and your excellence in the art which I profess [la gratia del vostro volto, la vivezza del vostro spirito, et l'eccellenza di quell'arte de la quale io fo professione]."[18] As these letters imply, when a collector's desire was met he could eat his cake and have it too. He could proudly claim, as does Clovio, his possession of two prizes and tout his ownership of two types of *grazia*: the beauty of the artist, and an example of the artist's beautiful style.

All three letters point to the problems inherent in a language critically dependent upon *un non so che*, "that indefinable something." Caro, Manfredi, and Clovio, it seems, consciously collapsed the subject–object opposition, thereby equating the maker with the model. In all three cases, artist and image-of-artist are the "esempio," the "miracolo," a manifestation of "gratia." This is never the case when the maker is a male. Indeed, it cannot be, since in metaphorical terms it was feminine and not masculine beauty that has the special connection to art.[19] Clearly, this placed women artists in a problematical position. If they imaged themselves in a manner accommodating the desires of forces outside the self, they ran the risk of subjecting themselves to critical commonplaces that would inevitably rob them of their professional identity while stressing their sexuality. Thus any response, including a refusal to respond, was a significant one. Because the two aspects of a woman artist's self — her sex and her profession — were, according to Renaissance concepts of each, diametrically opposed, it could not be otherwise. Both Anguissola and Fontana appear to have recognized the

situation for what it was. If what Caro and Manfredi truly desired was an example of the artist's distinctive manner, evidence of a singularity of style (*di mano di*), proof of stylistic rather than feminine *grazia*, then a painting of any subject would have sufficed. This, however, does not seem to have been what either man sought. Caro wanted two marvels, one of which was the artist. Manfredi desired an example of beauty as well as the "virtuosa donna". Anguissola and Fontana would have none of this. Both painters responded favorably to requests for self-portraits by other patrons, but neither satisfied the longings of these specific men, despite inducements to do so.[20] In fact, Manfredi's inducement may have made Fontana more steadfast in her resistance to his overtures.

Professing his desire to "secure at all costs" Fontana's self-portrait, Manfredi wrote to the *pittrice* in 1591, claiming not only to have composed a madrigal in her honor but also to having "printed it with my other one hundred [gli altri cento {madrigali} miei], . . . believing with certainty to receive in response the desired portrait, but I did not get anything except a new promise."[21] The letter is revealing, yet curious. Did Fontana turn a deaf ear to Manfredi's pleas – and threats – or was she chronically slow to respond to requests for her work?[22] Hieronimo Mercuriale suggests, in a letter to the duke of Urbino of 18 June 1588, that the painter was not always prompt. "Even though I used every diligence so that you [the duke] would be served quickly, . . . I wasn't able before now to see the completion [of a "ritratto"], because this painter, who, to speak in truth, is excellent in every way, took advantage of the condition of her sex and rarity of her person."[23] Why Fontana failed (or refused) to honor her promise to give Manfredi her self-portrait may never be known. It is possible, however, that Manfredi was disingenuous when he proposed an exchange of his madrigal for her portrait. Manfredi's reference to "gli altri cento [madrigali] miei" must refer to either his *Cento Donne Cantate*, 1580, a corpus of neo-Petrarchan poems that celebrates specifically named *gentildonne*, or *I madrigali*, a similar collection of poems published in 1606. If this is the case, then Manfredi's claim that he sent the poem to be published with the book[s] is false. Neither text contains a *rime* dedicated to the Bolognese *pittrice*. Although the promised poem seems never to have made it into print, the

proposal, considering the book for which it was intended, discloses much about attitudes toward fashioning and suggests another reason for Fontana's recalcitrance.

There is nothing particularly unusual about Manfredi's *cantate*. Hippolita Baglioni Bonarelli is admired for her "celestial grace" [*gratia celeste*]; Signora Anna, Viscountess Panigarola, is praised for her "eyes that are like stars" and the radiance of her face, which obscures the sun, and so forth. The interesting thing about *Cento Donne Cantate* is the concluding poem, addressed to Manfredi by Angelo Ingegneri. Casting the author of *Cento Donne* as the painter Zeuxis, Ingegneri writes, "As Zeuxis assembled five beautiful nudes in order to form his perfect image, you, Mutio, have gathered together one hundred clothed ladies variously endowed by heaven with wisdom and loveliness."[24] The analogy between painter and poet and the comparison between past and present are common enough in sixteenth-century literature. Many a Renaissance painter was regarded as having bested the classical best when he was praised as the "new Zeuxis," and many a Renaissance poet earned the *paragone* laurels when he applied Zeuxis's compositional methods to the literary arts. But apart from its usefulness in the *paragone* debates, the analogy had special import for the metaphorical use of words like *grazia*, an import that was to have a significant impact on women artists.

Stated simply, the author–Zeuxis analogy broadened the field of players participating in the game of reciprocity that inheres in all definitions of *grazia* and is part and parcel of virtually all representations of Renaissance women. Pen in hand, writers, no less than artists, could create "images" or "portraits" of a particular ideal of womanhood. They did so, as Ingegneri's poem to Manfredi states explicitly, by appropriating the creative means of Zeuxis. In accordance with a preconceived notion of ideal woman, they would extract body parts from many different models and then unite them in a single perfected form. This was, after all, a male prerogative, within the Pythagorean system of classification and association in which female is formless matter and male is that which gives form to matter. One can safely assume that Manfredi, who used this selective method of composing to poetically portray Hippolita Bonarelli, Anna Panigarola, and the other ninety-

eight *gentildonne* praised in *Cento Donne Cantate* would have created his image of Fontana destined for a corpus of *madrigali* by like means.

Manfredi's assumption of Zeuxis's creative powers can only be seen as a potent reaffirmation of the status quo, since it aligned him with all the positive principles of Pythagorean polarities: male, active, intellective, and, above all, that which fashions *materia*. This placed him opposite *artiste femminile*, just as Zeuxis had stood opposite the five Crotonian maidens whom he deemed worthy of serving (at least in their parts) as models. As the famous story goes, Zeuxis, ambitious to make his painting of Helen of Troy "contain within itself the preeminent beauty of the female form [formae pulchritudinem]," yet cognizant that Nature never "gave everything to one," took from each woman the most "perfect and finished" parts. These he refashioned into "the picture I have promised you, so that reality may be transformed from the living example to the mute image."[25] What Zeuxis had done, argued Alberti, was to go in quest of the "idea of pulchritude" [idea delle bellezze].[26] Manfredi was to do likewise. Equipped with his concept of the ideal woman who just happened to be an artist, he would put his pen to paper and portray Fontana, just as Zeuxis had put his brush to panel in order to transform an imperfect plurality into the flawless one: Helen.

Writers and artists clearly understood the implications of the Zeuxian legend. Not only did authors advance the analogy – artists like Vasari and Rubens depicted it within and on the facades of their homes. But despite its popularity as a sign of virtuosity, two hundred years would pass before a woman artist would challenge the masculine monopoly on the Zeuxian method (Figure 27). It would take another two hundred years before the challenge, carefully masked to avoid social criticism, would be recognized for what it was.[27] Significantly, Angelica Kauffmann's *Zeuxis Choosing his Models for the Painting of Helen of Troy* painted in the late 1770s, was not the only image by this painter to participate, albeit subversively, in the dominant conventions of patriarchal structures in order to claim intellectual and professional rights. In *Angelica Kauffman Hesitating between the Arts of Music and Painting*, 1791–2, she casts herself as a female Hercules. Flanked by two beautiful women (personifications of Art and Music), the equally beautiful Herculean artist slips into the

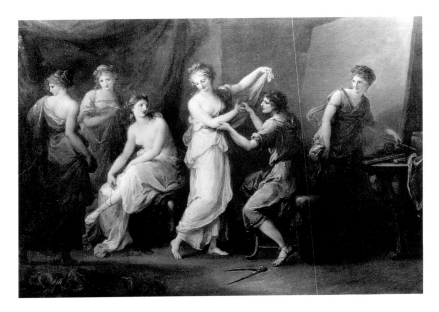

Figure 27. Angelica Kauffmann, *Zeuxis Choosing His Models for the Painting of Helen of Troy*, late 1770s. Brown University, Providence, Rhode Island. (Photo: Brown University Library, Providence, Rhode Island.)

guise of the third Grace. She does so with conscious self-effacement, balancing "the pictorial themes of Hercules and the Three Graces [in order] . . . to make palatable what on first sight seems inappropriate for her as a female artist."[28] But what was possible for Kauffman in the late eighteenth century was not viable for women artists of the late sixteenth century. Zeuxis was a male, and, as analogical references make clear, men alone were the rightful heirs to the compositional methods of this classical master.[29]

Much of the early literature celebrating Renaissance women artists suggests that Manfredi's strategy was shared. Repeatedly the distinction between the image of and by the artist and the artist herself was distorted by a haze of misplaced modifiers. Determining who or what has grace, identifying what precisely that grace is — a sign of stylistic virtuosity or a mark of feminine virtue — and establishing its source of origin comes down to a single question: Who is creating whom or what? If there is but one question, there are at least two answers, each of which

is complicated by the issues of authorial intent and intended audience. On the one hand, there is the author creating a poetic or critical portrait of the perfect *pittrice*. On the other hand, there is the *pittrice* imaging herself. In both cases, but to varying degrees, stylistic grace is enmeshed with feminine grace, since both writers and artists address the same cultural expectations of what "woman" and "artist" ideally are. There is, however, another way of looking at this situation. This one focuses on which persona – woman or artist – is to be stressed and hence determines (or is determined by) the principal literary model informing the creation of the portrayal.

As noted, "the most amenable of all the professions to the transformation of biography into history was the arts."[30] It was so in part because Cicero, Quintilian, Pliny, and Marcus Varro, who reportedly went so far as to place artists next to philosophers and poets, provided a precedent. It was so also because more recently Filippo Villani raised the respectability of artists by designating them *viri illustres*. Combining Diogenes Laertius's scheme of historical periodization with the Suetonian–Plutarchan form of biographical writing, Renaissance writers now had the means to promote the arts by fashioning a composite portrait of the artist. The goal was to make this portrait commensurate with the recent admission of artists into the exalted company of illustrious men of arms and letters. With this objective motivating their endeavors and relying on the genre of epideictic rhetoric in its classical and Christianized form, Renaissance critics made the Renaissance artist a man endowed with supernatural powers, one who gives prodigious evidence of divine favor, a man who eschews worldly goods and graciously assists his fellow artists. As fashioned, this ideal artist, or *virtuoso*, stands "somewhere between the merely mortal and the divine."[31] The Renaissance woman artist did not stand by his side. In contrast to him, she is never credited with supernatural powers, nor is she said to have evinced any prodigious proofs of virtuosity.[32] Still, the heavens bestowed on her their blessings – beautiful eyes, delicate hands, a lovely body, a sonorous voice, and so forth. She, unlike he, is not saintlike. She is instead ladylike, for she embodies those very qualities cherished most and enumerated often by men. Thus, while the *virtuoso* stands "somewhere between the merely mortal and the divine," the *virtuosa* assumes a

position somewhere between the real and the fabricated ideal. Indeed, she is Baldassare Castiglione's perfect lady, an ideal which "I have fashioned to my taste [formata ch'io l'avero a modo mio]."[33] Given the principal sources informing early writings on women artists — biographies of the illustrious, ancient histories of art, and treatises defining woman — it is no wonder that references to *grazia* and questions about who gives it to whom or what merge into a metaphorical quagmire.

Vasari's observations concerning the *grazia* of two women artists, Sofonisba Anguissola and Properzia De'Rossi, prove the point. The author of the *Vite* concludes his assessment of Anguissola by observing that her works exhibit "greater grace [miglior grazia] than those by other women."[34] Considered by itself, this statement is clear enough. *Grazia* refers to the Cremonese painter's distinctive style. Her stylistic *grazia* demonstrates her technical uniqueness among women, just as her ability to vivify images reflects her remarkable capacity to create. The clarity of this statement is not repeated when Vasari discusses the *grazia* of De'Rossi's *Joseph Fleeing Potiphar's Wife*. Because Vasari equates Properzia with Potiphar's wife, seeing the image of the latter as a self-portrait of the former, and because of the syntax of this passage — De'Rossi "represented the wife of Pharoah's Chamberlain, who, burning with love for Joseph, and almost in despair after so much persuasion, finally strips his garment from him with a *womanly grace* that defies description" [con una donnesca grazia e più che mirabile]" — the "donnesca grazia" of Saffira stripping Joseph is equated with the "donnesca grazia" of De'Rossi carving the relief of him.[35] Here the active maker — passive model distinction is totally collapsed. Indeed, Vasari's qualification of *grazia* as *donnesca* may be seen as underscoring this lack of difference. Artist and artist's subject are one and the same and thus act in a like manner. But Vasari's qualification of De'Rossi's *grazia* as feminine has another function. It stresses the difference between the *virtuoso* and the *virtuosa*. To my knowledge there is not in Vasari's text, nor for that matter in anyone else's, a "manly grace" to counter Properzia's "womanly grace."

When the artist herself is described, some of the haze of ambiguity dissipates, leaving her the clear object of visual pleasure. Assuming the creative powers of Pygmalion and Zeuxis, writers typically fashion their

portraits of the Renaissance *virtuosa* in accordance with lengthy lists of beautiful features provided by Giovan Giorgio Trissino, Agnolo Firenzuola, Domenico Bruni, and others. Predictably, these authors, following the example of Zeuxis, dissect their subjects, carefully detailing specific body parts worthy of commendation. Vasari, followed by Raffaello Borghini, admires the small, ivorylike, and delicate hands of Properzia de'Rossi, or what Trissino, in *I Ritratti*, 1524, describes as "le mani bianchi" in his enumeration of desired female features and Paolo Pino's Fabio, in the *Dialogo*, admires as "le mani delicate."[36] Similarly, in his epitaph for the *scultrice*, Vincenzo di Buonaccorso Pitti adds that her "two beautiful eyes shone with splendor," a *splendore* Firenzuola says was "like two sparks of fire" and a feature that Bruni, in *Difese delle Donne*, 1559, cites as ideal number 5 on his list of about 25 perfect feminine attributes.[37] For Alessandro Lamo, who, like Vincenzo Danti and Borghini, recognized the body as the soul's signifier, Sofonisba Anguissola is "belle di spirito [e] vaghe di corpo," a woman who should be counted as one of the celestial Graces.[38] Numerous poets, such as Lodovico Dolce, Battista Pigna, and Celio Magno, memorialize Irene di Spilimbergo in a like manner (Appendix Two, Section 6). Her splendor obscured the stars and sun, winning her a place in heaven. Her coloring rivaled the "purple rose, the white lilies, and the pale violets." And just as Ridolfo Campeggi hailed Lavinia Fontana as "the true ornament of our era," so did Cesare Malvasia lament the premature death of "la bella Irene, l'ornamento, la gloria, e lo splendore del secolo nostro."[39] If Spilimbergo's biographer is to be believed, this may be understood as a reflection of "the beauty of her body . . . and the graciousness [graziosa] seen in her face and in her every movement." Indeed for Atanagi, Spilimbergo's "beauty and grace was visible in all her aspects," for she had "una certa venusta," a certain chaste virtuousness that comes from Heaven.[40] Such purposeful ambiguity has deep roots.

Ancient texts reveal grace to have long had a similarly wide range of meaning. The Latin *gratia*, which is a translation of the Greek *charis*, means essentially favor given, received, or possessed. As in sixteenth-century texts, the word could be applied objectively or subjectively. Not only did grace signify the gracious granting of favor to one by another, it also described visible and undeniably appealing beauty. This was

possible because *charis*, in addition to being translated as *gratia*, became the Latin *venustas*. As *venustas*, the meaning of grace was extended to imply a pleasant, charming, or lovely appearance of a form or the manner of an action. Both meanings — outward grace, or beauty, and inward grace, or disposition — are implicit in the analogy Homer draws between the "skilled craftsman . . . [whom] Hephaistos and Athena have taught . . . [and who] brings to perfection pleasing works of art" and Athena, who "pour[s] forth grace on [Odysseus's] head and shoulders."[41] If, in the context of this particular passage, we ask who has grace and what is its source, answers come easy. Grace understood as artistic perfection comes from the craftsman. Grace understood as artistic skill comes from the gods. Grace understood in a more general sense as divine favor or blessing is likewise god-given. But when the subject depicted by the artist is factored into the equation, as happens in Pliny's discussion of the relationship between the painter Apelles, Alexander the Great, and Campaspe, who is Alexander's mistress and Apelles' model, the potential for and effects of misplaced modifiers becomes apparent.

When the imaged model is the focus, *gratia* is most often associated with the undeniable appeal of *venustas*, or visible beauty, and *comitas*, or an elegant and charming manner. Such beauty and charm may be apprehended in the sweetness of a smile, the prettiness of a face, the delicate and rhythmic movement of body and limbs, and the symmetry and harmony of parts to the whole. So defined, *gratia* can be applied readily to the human form (the model) and to a work of art (the painting of the model). Moreover, the two can be and often are combined. When this occurs, as happens when an artist re-creates a beautiful (*venustas*) thing with a pleasing (*comitas*) style, one form of *gratia* augments the other. In the case of the former, that is when *gratia* means "favor given, received, or possessed," grace signifies a gracious act of kindness such as a patron might bestow on a painter for having demonstrated creative *ingenio* and stylistic *gratia.*

Obviously, the two meanings of *gratia*, like *venustas* and *comitas*, are often interrelated. *Gratia*, understood as beauty, has the capacity to elicit *gratia*, understood as favor. A clear example of this union is found in Pliny's account of the relationship between Alexander the Great and

Apelles. "A graceful [venustas] beauty," he contends, "was particularly distinctive in [Apelles'] art." And "even though there were very great painters active in the same period, . . . they lacked his quality of charm [venus], which the Greeks call *charis.*"[42] Indeed, so great was "the charm of his style [comitas]" that the painter "won the favor [gratior] of Alexander the Great."[43] This princely largess took two forms. First, Apelles gained favored status among all of the artists eager to place their talents in the service of the Macedonian ruler. Not only did Alexander "forbid any one else to paint his portrait"; he also, as "a signal mark of his regard, commissioned Apelles to paint a nude figure of his favorite mistress, Campaspe," who herself was an image of seductive beauty. The second form of Alexander's "favor" was a direct result of the Campaspe commission. "Perceiving that Apelles had fallen in love with [his mistress], with great magnanimity . . . [Alexander] gave her to him as a present."[44] For his part, Alexander gained Apelles' enduring gratitude. This, in turn, ensured him continued access to the "graceful beauty" of the artist's style. In other words, whether real or imaged, given or received, grace was possessable. Apelles possessed a graceful [comitas] style. Alexander possessed both the judgment to recognize a graceful style and the authority to reward it by dispensing favor [gratior]. And, finally, Campaspe possessed beauty [venustas], which was first possessed by Alexander and then by Apelles.

The story of Alexander, Apelles, and Campaspe had particular appeal for sixteenth-century poets and art theorists.[45] First, it exemplified the ideal reciprocity of the prince–artist relationship. For this reason, the story was reenacted with contemporary players. Just as Apelles had been deeply honored by Alexander's magnanimity, so too was Raphael when, says Fabio Chigi, Agostino Chigi gave his concubine to the painter.[46] Second, it identifies the nature of the artist's special God-given talents by pointing to the definition of grace as a gift of knowing, or, to use Vincenzo Danti's phrase, which he borrowed from Quintilian, "a particular gift of talent and judgment" [un dono particolare dell'ingegno e del giudizio]."[47] Castiglione's retelling of the tale emphasizes this very aspect of the story. Alexander, he says, gave his mistress to Apelles in recognition of the painter's ability to discern true beauty. Of course, it is the magnanimous Alexander who has the superior *giudizio,* since it is he

who discerns Apelles' capacity to best feminine beauty and grace with stylistic *grazia,* a quality equated with the ineffable beauty of *la bella maniera*.[48] This points to the third reason underlying the popularity of the story. In essence it was a verification of the artist's creative capacity, in the broadest possible sense. When the artist unites his ability to perfect nature with his capacity to vivify that which he creates, the need to have the real thing is no longer essential.[49] Artistic *grazia* supplants natural *grazia*. Not only does this underscore the artist's creativity, it explains Alexander's (or any patron's) willingness to relinquish a beloved mistress for an image of her. Indeed, "when the sense of *charis* transferred from Campaspe to Apelles himself, the history of looking at women became an integral part of the larger history of thinking about beauty" – including the beauty of art.[50] The effects of this transference found two distinctive but closely related forms of expression, one in verse, the other in image.

Neo-Petrarchan poets diverged from Petrarchan convention on a significant issue.[51] Whereas Simone Martini's painting of Petrarch's Laura cannot reply to the poet's supplications – "if only she could reply to my words" – portraits of beloved beautiful women by sixteenth-century artists, say neo-Petrarchan poets, can and do converse with the beholder. Antonio Brocardo's marble lady, for example, "speaks with me, and I with her."[52] In one sense Brocardo's lady is a prosopopoeia, "the fiction of an apostrophe to an absent, deceased, or voiceless entity, which posits the possibility of the latter's reply and confers upon it the power of speech."[53] Yet this power of speech cannot be credited to her own voice any more than can the words spoken by Evangelista Maddaleni Capodiferro's Cleopatra be heard as her own.

A humanist at the court of Julius II, Capodiferro composed a number of verses in response to the Vatican statue called the *Sleeping Nymph,* to whom he gives the voice of Cleopatra. The implications of historical and political narrative of subjugation aside, it is Cleopatra's prosopopoeic identity as aesthetic and erotic object that is most intriguing. "As much as Caesar, ruler of the world burned for me when I was alive, so much the other Julius loves me in marble."[54] Brocardo's poem and others like it reflect Capodiferro's point of view. These are decidedly one-sided dialogues. The prosopopoeic voice confirms imaged female

beauty as a synecdoche for the beauty of art and acknowledges the possessibility of both. As "the fiction of an apostrophe" to the absent, such images diminish the distinction between the representation of beauty and the beauty represented to the point where the identity of the female model becomes immaterial. This gave rise to a special class of paintings that may be most accurately described as "portraits" of ideal beauty rather than portraits of identifiable beautiful women.[55] Put simply, one type of beauty is exchanged for another, since, to use Raphael as an example, a beautiful painting rendered beautifully demonstrates just "how much grace [grazia], in company with art [l'arte]," could be accomplished by a creative and technically skilled master.[56] It also demonstrates, as the author of *Della nobilità et eccellenza della donne*, 1544, so aptly put it, that "man is the work of nature, and woman is the artifice of the Idea."[57]

As this brief foray into neo-Petrarchan sensibilities and the prosopopoeic voice demonstrates, the sixteenth-century preoccupation with the concept of grace — determining what it is, identifying who or what has it, and defining its origins — became increasingly convoluted and complex. This may be due to the variety of new voices commenting on the aesthetics of beauty and grace. There is the poet-lover's hyperbolic praise of his mistress's charms — the appeal of her delicate, womanly beauty. There is also the critical theorist's praise of a painter's style — an artist's ability to impart Nature's motion (*moto*) to his own creations, which, to quote Lomazzo, was to attain "eccellenza dell'arte."[58] And there is the authoritative writer of treatises defining ideal female beauty — an elusive perfection of features and a "certain harmony and order among parts" that, claims Firenzuola, delight the beholder and "has the power to draw the mind to a desire for heavenly things."[59] Complicating matters further is Christianity, its notion of grace and designation of the loving Mary as the embodiment of *grazia*.

Although expanded to incorporate Christian concepts of divine grace and embellished to accommodate the theoretical concerns of academicians, classical *gratia* retained both its essential and extended meanings when it became Renaissance *grazia*. For Baldassare Castiglione *grazia* is not so much a particular quality as a modality; a courtier's ability to "correct [his] natural defects" by tempering "his every action with a

certain good judgment and grace [un certo buon giudizio e grazia]" so that "at first sight [he is] pleasing and lovable to all who see him," "worthy of the company . . . of every great lord," and deserving of "that universal favor which is so greatly prized."[60] For Benedetto Varchi and Vincenzo Danti, *grazia* is very much a quality. Defined by both as "vera bellezza dell'anima," grace is spiritual beauty and the perfection of the intellective soul made visible. As such, it is an outward expression of inner disposition, "a personal *ambiente*, which emanates . . . and also encompasses."[61] It is the nexus binding external senses to internal sense.[62] It is the proportional correspondence of parts to the whole, joined to a sweetness (*dolcezza*) and suavity (*soavita*) of color, and, says Varchi citing Gianfrancesco Pico della Mirandola, "it is seen every day in women." Leone Ebreo agrees. *Grazia* is everywhere — "in the objects of sight, as are beautiful forms and shapes and beautiful painting, and the beautiful order of the parts among themselves to the whole, and beautiful and proportionate instruments and beautiful colors and beautiful clear light and the beautiful sun and beautiful moon, beautiful stars and beautiful heaven." Most importantly, through its sensible appeal *grazia* can "delight and move the soul to proper love."[63] In other words, *grazia* is a powerful catalyst. Depending on the form it takes, beauty can prompt admiration, inspire feelings of love and devotion, or promote spiritual enlightenment. All of this underscores *grazia* as a relationship while implying a connection between beauty and virtue as well as style and virtuosity.

The best way to describe these relationships as they relate to art objects and the means by which these objects come into being is, perhaps, to compare the sixteenth-century concept of *grazia* to a circle of dominoes. One domino falls, impacting on the next, until the process eventually ends at the point from which it began. The way in which *grazia* moves from maker to image to viewer follows a similarly inevitable course.[64] An artist, favored by God-given gifts, or what Vasari describes as a "a truly celestial gift," confers beauty on that which he makes.[65] The beauty or grace of the man-made but divinely inspired object has, in turn, the power to draw the viewer's mind, through its appeal to the eye, to a meditation on and an appreciation of heavenly, that is perfect, things. Vasari's commentary on Leonardo da Vinci, a virtuous *virtuoso*

without "equal in giving grace [grazia] to figures and in the [depiction of] movements [moti]," illustrates specifically the nature of these closely interrelated relationships.[66] "Many men and women," he says,

are born with various remarkable qualities and talents; but occasionally . . . a single person is marvelously endowed by nature with beauty [bellezza] and grace [grazia] and virtuosity [virtù in una maniera] in such abundance that he leaves other men far behind, . . . [because] everything he does clearly comes from God rather than from human art. Everyone acknowledged that this was true of Leonardo, . . . an artist of outstanding physical beauty [la bellezza del corpo], who displayed infinite grace [grazia più che infinita] in all of his actions.[67]

These actions included the making of works of art. Vasari then goes on to explain by example how the reflexive relationships between the intrinsic and the extrinsic, between God and artist, and between artist and work of art operate. In his *Madonna and Saint Anne*, Leonardo bestowed on Mary "all of the simplicity [simplicità], and beauty [bellezza], and grace [grazia] that can be conferred on the mother of Christ."[68] This is only fitting, since the Virgin presents the most efficacious of models for *grazia* in its expanded sense.[69] Blessed with grace by the Father, Mary is herself a source of grace. As such, argued Niccolo Franco, she, or an image of her, provides the artist with a vehicle for the expression of his grace. Her *bellezza* and *grazia* become his source of inspiration. He, in turn, uses all of his God-given virtue/virtuosity, which includes *grazia*, to capture all that she embodies. When his *virtù* is conjoined with her *grazia*, the image of grace presented to the viewer has the power to move the soul toward the divine. What is true of a beautifully rendered image of the Madonna is also true of a beautifully painted image of a beautiful woman. Writings on Leonardo make this point as well. When, says Bernardo Bellincioni, Leonardo re-created with his characteristic infinite grace the "supremely beautiful" features of Cecilia Galleriani, the resultant image moved her lover's soul.[70] Ludovico Sforza's response justified the *grazie*, or favors, the enamored duke bestowed on the painter.

On one level the difference between the two paintings is insignificant. Both may be seen as demonstrations of Castiglione's advice. "That certain grace which we call an air" not only makes Leonardo "at first sight pleasing . . . to all who see him," it also "informs and attends all

his actions." Here the action is putting his brush to panel and canvas. But on another level the difference between the two images is great. Cecilia's *grazia* is not the same as Mary's. The viewer's response to these images, therefore, cannot be the same. Although it may be argued that both paintings have a pictorial rightness – a beauty and grace expressed in the harmony of interrelating planes, colors, and lights – Cecilia's beauty is possessable, whereas the Virgin Mary's is not.[71] As a product of an age when the fashion for Petrarchan lyric verse was at its height, Bellincioni's sonnet grants the artist the power to impart eternal life and beauty to his subject. "Whoever sees [Cecilia] like this, though it may be too late to see her alive, will say: This is enough for us to understand what are Nature and Art." As other poets (including Petrarch himself) make clear, an artist of this caliber has inherited the potency of Pygmalion. Because the Renaissance accepted Cicero's claim that Pygmalion gave his statue of Galatea "greater beauty than any girl could have," any invocation of the classical sculptor's name was a reminder of the reciprocal nature of *grazia*. Pygmalion's *grazia* flows into the material he carves, transforming malleable matter into a form of feminine *grazia*. Then, through divine favors or *grazie*, the graceful form is given life. In his memorial verse to Irene di Spilimbergo, Ludovico Dolce makes Titian Pygmalion's heir. Although dead, the Venetian *pittrice* lives in Titian's portrait of her. "With the greatest care [Titian] unites color, art, and talent, painting a living likeness with life-giving design in order that you [Irene] are not taken by bitter and harsh death."[72]

Aside from its usefulness in confirming the vivifying virtuosity of the *virtuoso*, the story of Pygmalion enriched by example the familiar and often repeated topos that an artist's mistress is his art and that his paintbrushes, to use Aretino's metaphor are the arrows of Cupid or, more crudely, his penis.[73] Castiglione makes this clear. Not only is his ideal lady "fashioned to my taste"; he, "like Pygmalion, will take her for my own."[74] Many embraced the idea, transforming the real into the fabricated ideal. Bellincioni's sonnet is but one example. Although Ludovico Sforza, unlike Alexander the Great, refrained from giving his beloved mistress to his much-admired painter, Bellincioni's poem and Pliny's prose convey a similar message. Both authors bind so tightly a woman's beautiful form to an artist's beautiful style that it is difficult to

separate one from the other. But even if one can successfully extricate the living woman from her inanimate yet animated image, the effort expended in doing so is unnecessary on two counts. First, the image allows its owner to have two forms of beauty — stylistic and feminine — for the price of one. Second, because the image is so lifelike — *più vivo che vivere* — possessing the real thing becomes less critical. The artist's recognized ability to make the absent present or to present the beautiful as possessable simultaneously highlights the creative capacities of the *virtuoso* while obfuscating still more the distinction between woman and image. Ultimately this allows a poet like Giovanni Della Casa to profess an inability to distinguish the image from the imaged, as is the case of Titian's portrait of Elisabetta Quirini Massola:

> Clearly I see, Titian, in a new form my idol, who
> opens and turns her lovely eyes on your living canvas,
> and talks and breathes as if alive, and moves her
> sweet limbs, and it pleases me that my heart should
> find double comfort, from that at which it sometimes
> sighs, and while it gazes at one face and the other,
> it longs to find the true one, yet knows not where.[75]

The dilemma facing Della Casa — gazing "at one face and the other" and unable to discern which is "the true one" — is a dilemma Annibale Caro and Mutio Manfredi want to share, the only difference being that they want to deny the distinction even more by having image, model, and maker all in one.

Manfredi seems to have had his wish granted by Fede Galizia (or her artist-father Nuntio), if not by Lavinia Fontana.[76] Included in *I madrigali* are six poems to two women artists; three commemorate Barbara Longhi — "Signora Barbara Lunghi eccellentissima pittrice, e perpetua virgine" — and three are dedicated to Fede Galizia — "Signora Fede Galitia, Fanciula nell'Arte della Pittura eccellentiss" (Appendix Two, Section 3b).[77] In the case of the latter, the artist's name, "Fede" or "Faith," provides Manfredi with the perfect vehicle for the poet's version of hide-and-seek. While he does not expressly refer to an image, he does ask us to gaze upon "due forme." But what are these "two forms" — an image of the artist or the artist herself? And who produced these forms —

Fede or her artist–father, Nuntio? Obviously, the recognized similarity of artistic creation to biological procreation complicated the game of who creates what. Ultimately, identities are of little importance as Manfredi urges us to contemplate, first with our "minds, then with [our] eyes, and finally with desire" one and then the other. As is characteristic of highly stylized neo-Petrarchan verse, Manfredi plays with ambiguity. Following a tradition that equates the artful application of cosmetics with the artful placement of paint on canvas, he observes that both images of beauty have painted lips. Both are like "goddesses." Although Nuntio, Fede's father, can tell him which of the *due forme* is real, he will still need Fede, faith.

Manfredi's poems (and Ingegneri's poem to Manfredi) must be seen in the context of the burgeoning literature dedicated to defining woman and ideal femininity, for only in this way can questions be answered about who or what has *grazia*. When, for example, Agnolo Firenzuola's Mona Selvaggio commends il Celso's "picture" of the ideal woman as something "made by the hands of a master [questa vostra dipintura stia come quelle che son di mano di buon maestro]" at the conclusion of *Dialogo delle bellezze delle donne,* 1548, we see the distinction between model and image diminished in the context of a viewer's desire. "If I were a man," she confesses, "I should be constrained, like a second Pygmalion, to fall in love with her."[78] The method by which Firenzuola's il Celso composed his "picture [dipintura]" of the perfect lady points to the ever widening gulf separating the real from the fabricated ideal. Firenzuola's young gentleman has, as he announced he would at the beginning of the *Dialogo,* verbally dismembered the lovely ladies accompanying him on a stroll through the Tuscan hills. From their fragments he has created a new and flawless whole. "'The gods,'" he says, quoting Homer and the Carthaginian Maharbal,

"have not given everything to everyone, but to some they have given intelligence, to others beauty. . . to a few grace, and virtue to hardly anyone." Thus I will take from each one of the four of you and will do like Zeuxis, who chose the five most elegant girls of Croton and, taking from each her most exquisite feature, painted such a beautiful picture of Helen of Troy that in all of Greece one spoke of nothing else . . . In the same way I will try to make, from our four beautiful women, a perfect beauty.[79]

As Firenzuola admits, he is not alone in recognizing the efficacy of this compositional method. Trissino's Vincenzo Macro had set an influential precedent.[80] Others, like Federico Luigini, would similarly recognize the advantages of this technique of assemblage.[81] With "five brushes" in hand, the five *signori* in Luigini's dialogue spend three evenings contemplating, and thereby creating, "la bella e leggiadria donna." Firenzuola's polylogue is especially significant, both for the placement of the references to Zeuxis and Pygmalion within the structure of the text and for the use of the word *dipintura*. Coming as they do at the beginning and end of the *Dialogo*, the examples of Zeuxis and Pygmalion indicate the way in which the portrayal of a beautiful woman came to function as a synecdoche for the beauty of painting and sculpture. The fact that Firenzuola's il Celso makes reference to Zeuxis's painting of Helen immediately following his stated intention to "see what elegance [leggiadria] consists of, what is charm [vaghezza], what we mean by grace [grazia] or by loveliness [venusta], what it is to have an air about you [aria] . . . [and] what is that quality which people call majesty [maestà] in you women," and that Luigini's Vincenzo Macro follows his reference to the same Zeuxian image with a list of ideal female features based in part on Petrarch's descriptions of his beloved Laura solders the binding chain. The beauty of art and the beauty of woman are the same.

It should be noted that the models for such composite portraits of ideal woman could be, as is the case with Luigini's beauty (and Pygmalion's Galatea), totally fictive or, as is true of Firenzuola's lovely lady (and Zeuxis's Helen) extractions from the real, such as "the noble and beautiful women of Prato" to whom the *Dialogo* is dedicated. They also, as is the case with Mutio Manfredi's *Cento Donne Cantate* and the earlier *Donne Romane*, 1575, purportedly represent specific individuals. But whether real or fictive in her origin, the woman emerging from these texts is ultimately a product of the author's imagination. He has, as Castiglione's Il Magnifico so readily admits, "fashioned her to my taste." Her individuality, indeed her reality, is of little consequence. Instead her *grazia* and *leggiadria* are the manifestations of *his* stylistic excellence, *his* ability to unite separate parts so that, to use Lomazzo's words, "the comeliness and grace in the proportion and disposition of a picture" demonstrates "eccellenza dell'arte." She is, moreover, made to be possessed.

145

If descriptions of synthetic beauty "reveal the potential consequences of being female matter for male oratory," or fragmented fodder for the *virtuoso*, then what can be said of the *virtuosa?*[82] Does she possess *grazia* and *leggiadria*, and, if so, can she, like her male peers, exhibit it by the same means? *Rime, madrigali,* and *vite* memorializing women artists suggest a difference in kind and means. In *vite*, terms like *grazia* and *leggiadria* are conspicuously scarce, and although they appear with greater frequency in *rime*, they typically describe the artist rather than refer to the works she has made. The best example of this is the corpus of poems dedicated to Spilimbergo. Before her untimely death at the age of twenty-one, Spilimbergo seems to have produced few if any art works.[83] In fact, to date none has been attributed to her with any degree of surety, and although Atanagi has much to say about her musical talent, education in letters, and overall loveliness, he remains mute on the topic of her art. Thus, any and all references to her grace are references to her person and virtuous behavior rather than to her art and *maniera*. It is fair to say that the *virtuosa* when fashioned by the contributors to *Rime di diversi . . . autori* is metamorphosed into Zeuxis's Helen, the ideal beauties of Firenzuola and Luigini, or, more appropriately, the apparently real but fictively perfect woman of Manfredi's *cantati*.

Time after time differences in the descriptive praise of male and female artists are apparent. According to Raffaello Borghini, Tintoretto endowed his figures with "fiery energy and grace, and a loveliness of color [fiero e grazioso nelle attitudini, e vaghissimo nel colorito]."[84] By contrast, Tintoretto's daughter, Marietta Robusti, is herself described as "bellezza e grazia." Despite the proposed connection between the feminine hand and a feminine style, that which Marietta physically possesses curiously does not transfer to that which she produces. Robusti, says Borghini, "painted very well and made many fine works [dipingne benissimo, e ha fatto molte bell'opere]."[85] Moreover, in accordance with Danti's Neoplatonic contention that external beauty reveals a beautiful soul, Carlo Ridolfi, elaborating on Borghini's life of the Venetian *pittrice*, declares Marietta's "womanly virtue [donnesca virtù]" to be "the true ornaments of femininity [i veri ornamenti feminili]."[86] But Robusti has more than a resplendent soul and beautiful body. In addition to being able to make "many fine works," she "knows how to play the clavichord,

lute, and other instruments."[87] In this respect, Marietta Robusti matches the *gentildonna* whom Castiglione "fashioned to my taste." "I wish this lady to have a knowledge of letters, music, of painting, and know how to dance and how to be festive, adding a discreet modesty . . . to herself."[88]

Robusti was not alone among sixteenth-century women artists in meeting these criteria. Properzia De'Rossi, says Vasari, was not only learned in the sciences and proficient in household matters but "played and sang in her day better than any other woman of her city."[89] Borghini concurs. Similarly, Dionigi Atanagi reports that Irene di Spilimbergo was quite accomplished in the musical arts. Blessed with "soavità di voce," she studied music with the lutanist Bartolomeo Gazza and the composer of *frottole*, Bartolomeo Tromboncino. In fact, she became so proficient that she, together with her sister Emilia, sang for Queen Bona Sforza of Poland, for which she received a gold chain in thanks.[90] Many of the contributors to *Rime di diversi . . . autori — in morte della Signora Irene delle Signore di Spilimbergo* take note of this, commenting that "now the learned Irene sings with Apollo and the Muses."[91] And if images of self by Sofonisba Anguissola and Lavinia Fontana are to be believed, these *pittrici* were also musically inclined.[92]

That musical talent, so long as it was kept within proper bounds, was considered on a par with artistic ability cannot be questioned, at least as far as women artists were concerned.[93] As Kauffmann's *Angelica Kauffmann Hesitating between the Arts of Music and Painting*, 1791–2, suggests, high levels of accomplishment could come down to making a professional choice. This was apparently the case with Mariangiola Criscuolo. According to Bernardo De Domenici, Criscuolo "as a young girl already had a particular gift for painting . . . By her adolescence she delighted in music to such a degree that she balanced playing with singing . . . [But] after a while her love [of painting] became foremost."[94] Criscuolo's decision, while in all probability no more difficult than that of Kauffmann, must be viewed as a choice that put her between the proverbial rock and hard place. Music no less than painting could lead to trouble. Thus, Pietro Bembo, in apparent agreement with Aretino's warning that music is a "key that opens the doors of modesty," reacted negatively to his daughter's request that she be given leave to study music. In a letter

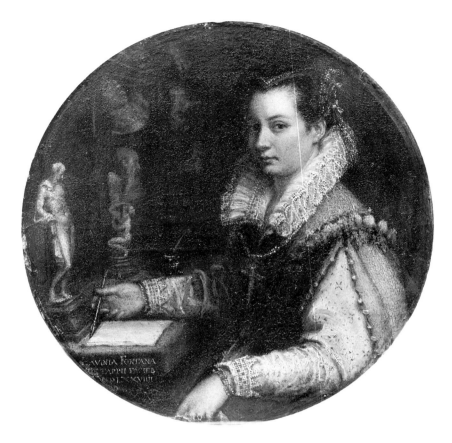

Figure 28. Lavinia Fontana, *Self-Portrait,* 1579. Galleria degli Uffizi, Corridoio Vasariano, Florence. (Photo: Alinari/Art Resource, New York.)

dated 10 December 1541, he says, "I can understand that because of your tender age, you cannot know that playing the monochord is a vain and frivolous thing." He therefore counsels her to be a "gentle, chaste, and modest woman," one who is "content in the skills of letters and sewing."[95] Yet given a choice between imaging themselves as accomplished in either the visual or musical arts, women artists seem to have viewed the latter as more socially acceptable.

The self-portrait sent by Lavinia Fontana in 1579 to Alonso Chacon (Figure 28) has little in common with that sent in 1577 to Severo

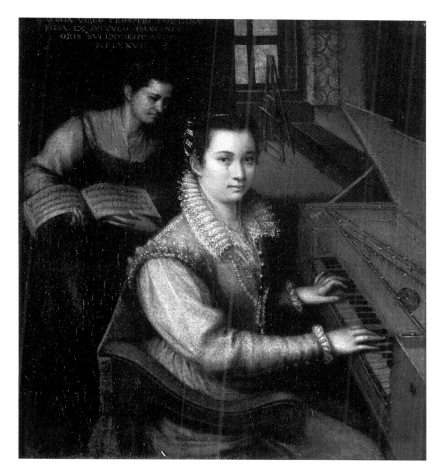

Figure 29. Lavinia Fontana, *Self-Portrait*, 1577. Galleria dell'Accademia di San Luca, Rome. (Photo: Galleria dell'Accademia di San Luca, Rome.)

Zappi on the occasion of her marriage to his son, Gian Paolo (Figure 29).[96] In the former we see a *personaggio illustro*, a woman renowned in *arti nobili*; in the latter, a *gentildonna*, or, as the inscription informs us, "LAVINIA VIRGO PROSPERI FONTANAE/FILIA SPECULO IMAGINEM." In the earlier of the two images, Fontana sits at a clavichord, her hands poised on the keys. An attentive maidservant, who lends an air of propriety to the scene, which is appropriately set within the confines of the home, stands ready

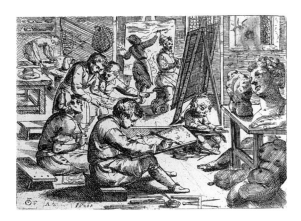

Figure 30. Odoardo Fialetti, *The Artist's Studio*, from *Il vero mondo per dissegnare tutte le parti et membre del corpo humano* (Venice, 1608). (Photo: The New York Public Library, Astor, Lenox, and Tilden Foundations, Print Collection.)

to supply her mistress with a bound volume of music. Other than the image itself, the only thing alluding to Fontana's involvement in the pictorial arts is an easel in the background. Significantly, it stands empty. Two years later this self-image had changed considerably. Gone is the attendant maidservant, absent are all references to music. Stylus in hand and paper before her, Fontana, not unlike the artists in Odoardo Fialetti's *The Artist's Studio,* 1608 (Figure 30) now sits before a table and shelves laden with replicas of classical sculpture and fragments.

Although it might be tempting to see the 1577 self-image as reflective of forces outside self and that of 1579 as consciously reflective of self, neither can be seen as wholly self-fashioned. What had changed was the audience, and with it expectations and function. Zappi's Fontana is Castiglione's virtuous lady, a proper vision of a daughter-in-law. She has, as the portrait suggests and Castiglione advises, "knowledge of music [and] of painting." Possibly she also "knows how to dance," and certainly she is capable of "the giving of a good impression of herself."[97] Chacon's Fontana, though different, is no less an appropriate vision. As he desired, she has pictured herself in a style appropriate to Chacon's already collected images of two hundred famous individuals, including

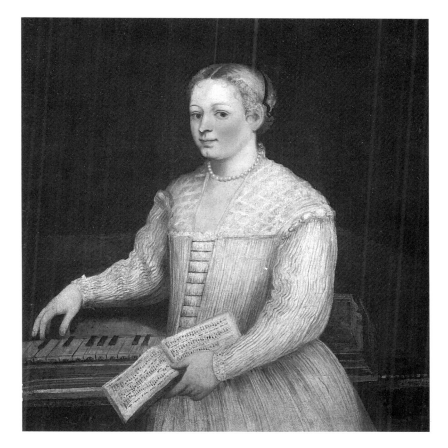

Figure 31. Marietta Robusti, *Self-Portrait* (?) ca. 1580. Galleria degli Uffizi, Corridoio Vasariano, Florence. (Photo: Soprintendenza per I Beni Artistici e Storici, Florence.)

those accomplished in "the noble arts."[98] Indeed, the art objects cluttering the table and shelves before her signify impending success, thereby verifying the rightness of Chacon's choice of Fontana as one of the illustrious elect. As Vasari, Danti, Armenini, and other theorists note, the artist who studies the "faultless antique" will come "to make the finest possible figure."[99] Alas, the accuracy of the persona put forth in both self-images cannot be checked. Although it is safe to assume that Fontana studied classical works, none of the drawings given to her indicate this was her modus operandi. Her musical prowess is even more

problematical. None of her early biographers — Mancini, Baglione, Malvasia — state explicitly that she was instructed in music.

Of the two self-portraits, the one sent by Fontana to Zappi adheres to what appears to be a prescribed type. More than a decade before the Bolognese *pittrice* cast herself as a lady proficient in music, Sofonisba Anguissola had positioned herself before the keyboard and, as Fontana was to do, placed herself in the company of a maidservant. In an earlier example in Naples, ca. 1556–7, the keyboard is again prominent. Marietta Robusti's supposed self-portrait, ca. 1580, follows suit (Figure 31). The pictorial type even appears north of the Alps, as Caterina van Hemessen's frequently cited *Portrait of a Young Woman at the Virginals,* 1548, illustrates.

The prominent and often repeated inclusion of a keyboard instrument in sixteenth-century Italian women's self-portraits implies, as do the many textual references to the musical talents of the *virtuosa,* that the harpsichord, virginals, or *spinetta* was invested with symbolic meaning. Yet as Mary Garrard has rightly noted, as a signifier this instrument had polyvalent meaning.[100] On the one hand, it was connected with the female body and associated sexual performance.[101] Titian's *Venus and Cupid with an Organist,* ca. 1550, and *Venus, Cupid, and Lute Player,* 1560, are recognized as examples of the lascivious connotations conveyed by instruments. On the other hand, as Bernardino Campi's *Saints Cecilia and Catherine of Alexandria,* 1568, shows, the "musical model link[ed] the organ or spinet with female chastity" through its association with virgin martyrs.[102] It was also, therefore, "a well-tempered instrument whose harmony was not disturbed by the distempering influence of sexual intercourse." Although pictorial meaning depends ultimately on the viewer's choice of association, as metaphorical attributes the instruments in women's self-portraits may be understood to symbolize the "total creative potential" of the *pittrice.*

In the fully secular and contemporary contexts in which [Anguissola and Fontana] join their self-images with musical instruments, [they] emphasize not the form and shape of the instrument but their own act of playing it, thus conveying the idea of self-possession and self-management. At the same time, they extend the range of the synecdoche so that the virginals represent not only body but also mind, talent, and abilities.[103]

Robusti's self-portrait seems to challenge this reading.

In contrast to Fontana, Robusti's musical skill was widely acknowledged by her early biographers. According to Borghini, she played the "harpsichord, lute, and other instruments."[104] Some sixty years later, Ridolfi, who identified her music teacher as the Neapolitan Giulio Zacchino, cited her musical ability as one of her "many virtuous qualities [molte virtuose qualità]."[105] But if her supposed self-portrait may be seen as a visualization of these skills, it can also be seen as sexually evocative. The title of the music she holds, Philippe Verdelot's madrigal composed for four voices, "Madonna per voi ardo," is clearly legible. Its opening lines, "My lady, I burn with love for you, and you do not believe it," makes Marietta the object of adoration. The inclusion of the provocative text is, to say the least, curious, unless Robusti made the image for her husband. The fact that no other woman's self-portrait can be read in a like manner raises, I would argue, the question of authorship. If, in fact, this portrait was painted by Tintoretto's daughter, as has been claimed since Marco Boschini in 1675 persuaded Cardinal Leopold de'Medici to buy it for his "museo" of renowned artists, then there is a problem. Why would someone purportedly so skilled in playing the instrument pictured here make the conspicuous mistake of incorrectly grouping the keys? As represented, the proper sequence of black and white keys is interrupted at G and A.[106] The error can only be explained if the authorship of the painting is given to someone ignorant of music, someone other than Marietta Robusti.[107] If this is the case, then once again the question of who is imaging whom, or to what degree a woman's self-fashioning can be accepted as an act of autonomy, comes to the fore.[108]

Francesco Salviati, perpetuating the cultural construct of the male as principal creator, provided an answer to the query in a letter written to Anguissola's first teacher and dated 28 April 1554. "From the works by the hand of the beautiful Cremonese painter [Anguissola], your [Campi's] creation, which here I am able to view with amazement, I am able to understand your beautiful intellect."[109] Like Ingegneri, who casts Manfredi as Zeuxis, Salviati invests Campi with the creative powers of Pygmalion. Anguissola, Campi's "creation" [vostra fattura], is nothing more than malleable material given form by his "bell'intelletto." On first

viewing, Anguissola's double portrait *Bernardino Campi Painting Sofonisba Anguissola,* late 1550s, appears to record deferential acceptance of Salviati's characterization of her as Campi's *fattura* (Figure 32).[110] Here, Anguissola is presented as Campi's vision of her. With his right hand steadied by a mahlstick, he seems to pause from his work just long enough to acknowledge the presence of the unseen artist painting him. Of the two figures presented to the viewer, Campi is clearly the more active. Indeed, fashioned as an image of an image, Anguissola could not be more passive. But "although Campi is shown as the creative agent in one sense, in other respects it is he who is diminished, and even used transactionally" to validate Anguissola's position of control in this painting about the art of painting.[111]

The clearest indication of this transactional relationship is revealed when an answer to the question "Who is imaging whom?" is put forth. *Bernardino Campi Painting Sofonisba Anguissola* suggests that it is Campi who is imaging Anguissola. Yet this double portrait ultimately locates agency outside of the picture and behind Sofonisba's unseen easel. She, not he, is responsible for the image we see. This painting is indeed her *fattura.* This is true in more than just the most obvious sense. No portrait of Anguissola by Campi is known. By contrast, the *pittrice* produced many self-portraits, of which approximately five may be dated prior to this image. Generically, these self-portraits bear a striking resemblance in style to Campi's supposed portrait of his student seen here. Thus, the painting to which Campi adds finishing touches "is likely to represent a work by Anguissola herself."[112] What, then, may be said of Campi's portrait? Is it too a self-portrait? By the time Anguissola painted this work, her mentor had long departed from Cremona for Milan. He was therefore not available to model for her in person. What she could and apparently did do was appropriate a portrait or self-portrait of Campi, possibly the one later engraved as the frontispiece to the first volume of Zaist's *Notizie istoriche de'pittori, scultori, ed architettori,* 1774.[113] If this is the case, which seems probable, then Anguissola's act of appropriation was a conscious declaration of her progression from copying (*ritrarre*) to imitating (*imitare*). By adapting a bust-length picture of Campi to a wholly new context of her own making — a three-quarter length portrait of Campi at work painting her — Anguissola authoritatively refashioned

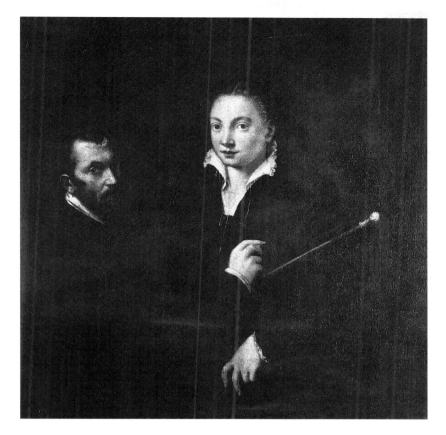

Figure 32. Sofonisba Anguissola, *Bernardino Campi Painting Sofonisba Anguissola,* late 1550s. Pinacoteca Nazionale, Siena. (Photo: Alinari/Art Resource, New York.)

her source in accordance with her tastes and intent. This demanded *invenzione,* a hallmark of *imitazione* and that which vivifies an image and imparts *grazia* to it. Accordingly, *Bernardino Campi Painting Sofonisba Anguissola* may be viewed as a verification of Vasari's contention that Sofonisba's works exhibit "greater grace than those by other women," since "those who do not possess *grande invenzione* are always poor in *grazia.*"[114]

Metaphorically speaking, here the giving and receiving of *grazia* is a game between a *virtuosa* and a *virtuoso* and his literary allies. Anguissola

played it well, filling her composition with visual clues that undermine Salviati's praise of Campi's "bell'intelletto" and refute Lamo's contention that Campi knew how to "form beauty," specifically the beauty seen in Anguissola's style and image.[115] In comparison to what is presented as Campi's portrait of her, Anguissola's image of him is the one *più vivo che vivere*. He is pictured as the active artist, she as passive paint. Yet paradoxically, it is Bernardino and not Sofonisba who must depend on the mahlstick, a device condemned by Paolo Pino as the crutch of a weak and uncertain copyist.[116]

Thus, it is Campi who is relegated to Armenini's category of the copyist as an artist of "mediocre ingegno." Simultaneously, Anguissola, who is both the real and implied perceptual center of this scene, is made the master of *l'arte del disegno*. As Aristotle had advised, she has brought the "design" of her *fattura* under her conscious control. In light of this self-defining statement, her roughly contemporaneous rejection of Annibale Caro's request for her self-portrait "so that in a single work [he] can exhibit two marvels, one the work, the other the artist" is predictable. On the eve of her departure for the Spanish court, a moment marking her rise to international fame, she had surpassed anything Campi would achieve. She could easily refuse to let herself be objectified as the epitome of feminine grace, readily resist attempts by others to reduce her to a vision "fashioned to [their] taste." Here she is not Alessandro Lamo's "phoenix" rising from Campi's ashes; she is the *virtuosa* who has risen above the *virtuoso*. If *grazia* may be understood as a reciprocal relationship between artist, model, and image, then Sofonisba Anguissola is on both the giving and receiving end.

CHAPTER SEVEN

Femmina Masculo
e Masculo Femmina

O madness of discourse, That cause sets up with and against itself!

—Shakespeare

WHO among Renaissance *artiste femminile* is a *virtuosa,* and, more importantly, what does the title signify? The answer to the first of these questions is easier to ascertain than the second. We need only consult the texts. According to early critics, Sofonisba Anguissola, Suor Plautilla Nelli, Lavinia Fontana, Marietta Robusti, Fede Galizia, and Irene di Spilimbergo were *virtuose.* Determining what exactly this title means is far more difficult, since the critics who use the term employ it in discriminating and nuanced ways. Vasari, for example, calls Anguissola a "virtuosa vergine." He also draws attention to her capacity to impart life to the images she makes and takes note of her ability to exhibit in these creative works "miglior grazia" than any other female artist.[1] Vasari's assessment of the Cremonese *pittrice* suggests that a *virtuosa* is an artistically talented variant of Torquato Tasso's *donna donnesco.* She is a woman endowed with "le virili virtù," which in this context may be understood as masculine virtuosity.[2] But Vasari's comments concerning Plautilla Nelli, a "revered and virtuous sister [veneranda e virtuosa suora]," suggest a different definition.[3] In contrast to Anguissola, Nelli is not credited with the capacity to vivify the figures populating her panels, nor is she commended for her stylistic *grazia.* In fact, her artistic abilities are decidedly limited by reason of her principal profession. Her representation of the faces and features of women, "whom she has been able to see as much as she pleased," are, as Vasari says and we can see, far superior to her depictions of men, particularly

seminude males like the dead Christ in her *Lamentation*.[4] In her case, therefore, *virtuosa* seems to refer more to religious vocation, or pious virtue, than to artistic virtuosity.

Critical assessments of Properzia De'Rossi present an altogether different scenario. Although she too is called a "virtuosa" and is said to have "capricious talent [capriccioso ingegno]," she, in contrast to Anguissola, is never commended for her creative *potenza*.[5] And certainly this woman, identified as a "concubine" in the records of Bologna's criminal tribunal, failed to demonstrate the piety and propriety of Plautilla, the "veneranda e virtuosa suora."[6] The *scultrice* seems to have earned the title *virtuosa* by reason of her choice of a "masculine" medium. Still, De'Rossi's choice of a "masculine" medium did not mean she made art like a man, or even like a *virtuosa* blessed with "le virili virtù." As Vasari makes clear, the "donnesca grazia" of her relief depicting Joseph's flight from Potiphar's wife does not correspond with the vivifying *grazia* seen in portraits painted by Sofonisba Anguissola.

And what about Lavinia Fontana, the *pittrice* whom Mutio Manfredi celebrates as "an example of beauty and rare womanly virtue [un esempio di bella, e raramente virtuosa donna]"?[7] In Fontana's case the label *virtuosa* comes close to signifying the qualities of Castiglione's lady. She possesses the attributes of cultural refinement, and she gives a good, that is, virtuous, impression of herself. Moreover, she is pretty. In two out of three of these characteristics, Fontana is like De'Rossi, who is also celebrated for her "beautiful body," praised for her purported musical skill, and admired for her artistic abilities.[8] For the same reasons, but with feminine propriety added back in, she is like Marietta Robusti. Tintoretto's daughter likewise is prized by Borghini for her "beauty and grace [bellezza e grazia]" and lauded by Ridolfi for musical talents, which "one sees united with her many other virtuous qualities [si vedero unite molte virtuose qualità]."[9] She also bears comparison with Anguissola, Gratiano's "beautiful and wise painter [bella e saggia dipintrice]," renowned for her "exemplary ways [costumi illustri]" (Appendix Two, Section 5).[10]

So, who is a *virtuosa*? Less than a quarter of the nearly forty *artiste femminile* active in Italy during the sixteenth century received this title. And what does this label mean? As the foregoing statements indicate, in

a majority of cases a *virtuosa* is a talented, attractive, and properly behaved woman. Her artistic ability, like her musical accomplishment and *bellezza,* is merely one more ladylike quality making her a "gemma, un ornamento." But in one case, that of Sofonisba Anguissola, *virtuosa* clearly signifies something more than an artistic proficiency suggestive of dilettantism. Here, *virtuosa* means exceptional, that is, unique, in the full sense of the word. Vasari implies as much by crediting her with abilities he otherwise gives solely to male artists. And what Vasari implies, others state explicitly. For Gratiano, "the noble Sofonisba from Cremona . . . [is] alone in [her] art, [which is] so perfect and good that, if I may be permitted to say of her . . . , I see no other person or painter who comes forth with a brush as lovely in color" (Appendix Two, Section 5). Others, like Baldinucci, modified only slightly Gratiano's hyperbolic praise. "Fu Sofonisba nell'arte del dipignere singolare."[11] Her uniqueness, as he goes on to explain, is specific to her sex, for in *ritarre del naturale* she is like Titian. Both Sopriani and Zaist would agree.[12] Her talent exceeds that of other women.

The praise lavished on Sofonisba Anguissola provides us with the clearest definition of *virtuosa.* It also reveals an adherence to a long-lived ideology. The excellence of woman depends on whether she can rise above the condition of her sex and act (or paint) like a man. Returning to Plutarch's question, which was introduced at the beginning of this study — "If, conceivably, we asserted that painting on the part of men and women is the same . . . , would anybody reprehend us?" — we now have an answer.[13] But this declaration, inasmuch as it reflects critical commentary, which is itself a reflection of cultural practices, still leaves us with an evaluative system rife with gender bias. Within this system, *virtuosa,* understood as a woman endowed with masculine abilities, becomes a relational term. Margaret King's description of the learned woman of the early Italian Renaissance is equally appropriate to the *virtuosa* of the sixteenth century: "not quite male, not quite female, [she] belonged to a third amorphous sex."[14] What, we should ask, does this mean in the context of sixteenth-century concepts of art and artists?

As discussed in Chapter Two of this study, the table of ten paired Pythagorean opposites conveyed to the Renaissance by Aristotle ignored notions of moderation that would allow a component of any pair to be

evaluated contextually. It was a hierarchical, dualist scheme that paired opposites but did so asymmetrically, evaluating the first of each set — male–female, one–plurality, and so forth — as superior to the second. The passage of time subjected the system to numerous associative additions that revealed its flaws. The result, as Jacopo Zabarella's *Tabulae logicae* shows, was the establishment of a middle category of being, or intermediates. An intermediate recognizes a middle ground between contrarieties. It acknowledges, for example, the gray between black and white. An intermediate may also be understood as an antinomy. Rather than simply recognize a middle ground, it admits contradictions between principles that have been obtained by correct reasoning. An example of this type of intermediate is a hermaphrodite, someone "not quite male, not quite female." Acknowledging the hermaphrodite facilitated explanations of the origins of sex difference and proposed a rationale for womanly males and manlike women. The uterus, or so the theory first proposed by the anatomist Mondino de'Luzzi (1275–1326) goes, has seven cells or cubicles. Three are on the right, three on the left, and one is in the center.[15] The sex of the fetus depends on its position in one of these cells. If it develops in the warmer, righthand cubicles, it is a boy; if in the cooler lefthand cells, it is a girl. Assigning hermaphrodites to the middle cell allowed physicians like Jacopo da Forli in the early fifteenth century to go beyond medieval gender dichotomies.[16] Similarly, it prompted Guilhelmus de Mirica to include explanatory chapters on "womanly males and hermaphrodites" and "manlike women and hermaphrodites" in his *Physionomia*.[17] For Zabarella it allowed a logical and medical explanation for a bisexual child.[18]

So where does this leave the *virtuosa* or, to put it another way, the women painters, who, says Paolo Pino, bring to mind stories told about hermaphrodites?[19] If the sex of the artist is visible in the works she, he, or some remarkable combination thereof makes, as critiques of *la donnesca mano* suggest, then a *virtuosa*, understood as a parallel to Tasso's *donna donnesco*, should rightly be a "master." Indeed, the confused gender of the *virtuosa* (a woman with masculine virtuosity) should make her the best master of all, since *grazia*, a stylistic quality exemplifying virtuosity, was perceived by some to be a similar combination of the masculine and the feminine.

Grazia, in addition to being a prayer, a blessing, a favor, and a disposition, and in relation to its being a manner of appearance, is, as Mario Equicola suggests in *Libro di natura d'amore,* 1526, an intermediate between a Pythagorean pair. Having just retold the tale of Zeuxis's ingenious creation of the ideal woman in his painting of Helen and reiterated Vitruvius's notions of perfect and harmonious proportion as they relate to *grazia,* Equicola turns his attention to the human face. "The countenance of a woman is praised if it has the look of a man; the face of the man if it has the look of femininity, hence the proverb: for almost everyone the female-male and the male-female have grace [quasi per ciascun luogo femmina masculo e masculo femmina hanno grazia]."[20] That Equicola's *grazia* can, indeed, be understood to be an intermediate, or antinomy, is reenforced by the sylleptic constructions in the quoted proverb. In constructs that come close to the definition of a hermaphrodite as a union of male and female characteristics, *femmina* and *masculo* combine while remaining separate. This suggests that in some instances *grazia* is, in addition to other things, an aesthetic of indeterminacy, a virtuosic combination of the feminine and the masculine. Critical commentary lends support to this idea.

In a letter of 1542 to Guidobaldo della Rovere, Pietro Aretino appears to recognize in two works by Michelangelo the essence of *grazia* as explained by Equicola.[21] Having commended the "softness of the flesh," the "loveliness of the limbs," and the "suavity of their place-ment" in an image of Leda, the critic turns his attention to the overall *grazia* of the form. For Aretino, the figure's grace is a result of the union of "parti de lo ignudo" (male) in such a way that when combined they create "tanta grazia ignuda" (female). He reiterates this idea when he turns to look at Michelangelo's Venus, in which "sentimenti virili e donneschi" are conjoined in a tour de force demonstration of "vivacità d'artificio." What Aretino saw in Michelangelo's female figures of Leda and Venus, Ludovico Dolce saw in Titian's male figure of Adonis. "Grazioso ed in ogni parte sua leggiadro" and "delicatissimo," Adonis is a testament to the artist's ability to demonstrate a "certain beauty and grace that partakes of femaleness yet does not draw away from maleness [questo unico maestro ha cercato di esprimere certa graziosa bellezza che, partecipando della femmina, non si discostasse però dal virile]."[22]

Theoreticians, like connoisseurs, similarly see *grazia* as an aesthetic of indeterminacy, albeit not one that always involves gender. The *grazia* of the *figura serpentinata*, for example, involves the merging of two seemingly antithetical concepts: *furia,* or inspired creative frenzy, and *giudizio,* or calculated critical judgment. Because the resultant form spirals in a way that reveals at the same time both the front and back of the figure, it demonstrates, says Aretino, "the virtue of easy force and . . . the grace of unforced ease." It is this juxtaposition of opposing points of view rendered with seemingly antithetical skills that allows an image to act as a "magnet to the eye."[23] Such oppositional couplings are, perhaps, to be expected, given the Renaissance perception of itself as an era that is at once "anciently modern and modernly ancient [anticamente moderna e modernamente antica]."[24] In a manner paralleling the double-directional *figura serpentinata,* the *rinascita* simultaneously embraces the past and reaches for the future.

But perhaps the best example of oppositional plays — and one that does pivot around gender — is found in the prescriptives for *imitazione.* As all sixteenth-century theorists make clear, the objective of the imitation game was not wholesale copying. At the very least, dependency should be masked. At best, existing masterpieces — both ancient and modern — should function as springboards from which painters and sculptors begin the inventive process of creation. To this end, Armenini advises artists to alter their sources "in such a manner that the figures do not appear to be borrowed." A good way to do this, he continues, is to "reverse members, change the head slightly, raise an arm, or take away or add drapery."[25] Examples of the *Spinario,* which depart from the original by crossing the right leg over the left, illustrate the pervasive adoption of this mimetic method.[26] So do variations on the *Laocoon,* which transform the Trojan priest into Christ at the Flagellation or recast him as Marsyas grimly awaiting his fate.[27] But raising the right arm instead of the left or draping a nude figure were not the only ways of appropriating an image. As the metamorphosis of the *Spinario* into a thorn-pulling Venus suggests, the artist could simply change the sex of the model.[28]

To be sure, both methods of *imitazione* were facilitated by the fact that much of the classical sculpture that began to reappear in the late fifteenth century was in mutilated and fragmented condition.[29] Since

one cannot copy something that is not there to be seen, the method of appropriating antiquity advanced by Armenini was necessarily, in such cases, an inventive task. In fact, the Greek verb *mimesthai* points to ambiguity, since it refers both to the imitation of a preexisting work and the creation of a new one. As for altering the sex of the model, a work's state of preservation, combined with the fact that many of the represented subjects were unknown to the library of ancient literature such as was available in 1500, meant that much — including gender — was up for interpretive grabs.[30] A monumental pair of seated knees, generally understood today to be a fragment of *Jupiter Enthroned*, for example, was completed in a drawing by Amico Aspertini as a woman with a mirror. Even works in perfect condition, like the bronze *Camillus*, which was included in Sixtus IV's 1471 donation, was known interchangeably throughout the sixteenth century as either a serving boy (Fulvio, 1527) or a gypsy girl (Aldrovandi, 1557).[31]

If one accepts the definition of *grazia* as an intermediate or an aesthetic of indeterminacy, then switching the sex of a prototype seems wholly logical. If, however, one considers not only the then current sciences of anatomy and physiognomy, both of which rested on the premise that outwardness expresses inwardness, as well as the adoption by Renaissance writers of the all-important defining relationship of sex to demeanor put forth by Aristotle, Galen, Hippocrates, and others, then this mimetic method seems illogical, if not impossible to follow. After all, gender difference is visible in ways other than the physiologically obvious, as Castiglione makes clear.

In her ways [modi], manners [maniera], words, gestures [gesti], and bearing [portamenti], a woman ought to be very unlike a man; for just as he must show a certain solid and study manliness [virilità], so it is seemingly for a woman to have a soft and delicate tenderness, with an air [maniera] of feminine sweetness [dolcezza feminile] in her every movement.[32]

As is true of other statements of Castiglione, this one found practical application in the visual arts. Artists, says Vasari, "ought to distinguish between different movements and characteristics [i gesti e l'attitudini], making women with a sweet and beautiful air [aria dolce e bella]."[33] A comparison of the geometric construction and precise proportionality

of Vitruvian man that is visible in the well-known woodcut illustration to Cesare Cesariano's 1521 edition of Vitruvius with those of ancient vases showing "the manner in which the [female] body is formed" in the second dialogue of Firenzuola's *Dialogo delle bellezze delle donne* demonstrates just how impossible such confusion should be, at least in theory.[34] As the juxtaposition of the two suggests, proofs of the dignity of the human male form were geometric, if not arithmetical; those of the female form were not. Accordingly, Cennino Cennini claims male beauty is the more regular, female "non a nessuna perfetta misura" or, to use Pomponius Gauricus's words in *De sculptura*, 1504, "delicatiorem negligentioremque."[35]

Although Cennini's and Gauricus's ideas about human form gave way during the sixteenth century to the belief that a beautiful woman has "a grace that is born of right proportion and propriety [una grazia che di proporzione e di convenenza nasce]," to mistake "feminine proportions" for those that are "masculine" in a classical statue, even a mutilated one, still seems surprising.[36] The fact is, however, that not only were such confusions possible, as evinced by the varied designations of the *Camillus* as a serving boy and gypsy girl; such purposely ambiguous male–female conflations were laudable, as proved by the praise bestowed on Michelangelo's Leda and Titian's Adonis.

I would argue that all of this had an impact on notions about exceptionality. For at least a brief period during the sixteenth century, exceptionality could be understood as incomparability. If an intermediate is a contradiction in a contrariety, then it cannot be defined against an opposite: it does not have one. This makes an intermediate a unique and incomparable variation on other things. Sofonisba Anguissola perfectly fits this description. Unfortunately, a recognition of Anguissola's uniqueness did much to underscore just how homologous in their femaleness were all of the other *virtuose*, to say nothing of *artiste femminile*. Identifying a feminine style and, according to its merits or lack thereof, establishing an ahistorical place for women artists in the history of art thus became a defensible position that was to have long-term repercussions.

A Roster of Sixteenth-Century Italian Women Artists

The following list of women artists departs from the text by including women recognized as artists by nineteenth-century authors. Otherwise the bibliographic references included have been restricted to sixteenth- and seventeenth-century published sources. There is, of course, some difficulty in distinguishing "amateurs" from "professionals," particularly in the case of nun-artists. Some, like Suor Caterina de Ricci and Marietta Robusti's younger sister Ottavia, an embroiderer in the Benedictine Convent of Santa Amia di Castello, have been omitted since they are neither acknowledged as artists in early texts nor has any work been identified with them.

Quintilia Amaltea (ca. 1572–after 1611). Painter and sculptor, Friuli(?), daughter of Pordenone. Cited in Luigi Lanzi, 1789.

Lucia Anguissola (ca. 1540–ca. 1565). Painter, Cremona. Cited in Giorgio Vasari, 1568; Alessandro Lamo, 1584; Antonio Campi, 1585; Filippo Baldinucci, 1681.

Sofonisba Anguissola (1532/35–1625). Painter, Cremona and Madrid. Cited in Marco Gerolamo Vida, 1550; Giorgio Vasari, 1568; Alessandro Lamo, 1584; Gian Paolo Lomazzo, 1584; Antonio Campi, 1585; Ludovico Cavitelli, 1588; Giulio Cornelio Gratiano, 1636; Raffaello Sopriani, 1674; Filippo Baldinucci, 1681.

(Giorgio Vasari, 1568; Alessandro Lamo, 1584; Antonio Campi, 1585, cite the artistic activities of other Anguissola sisters: Europa, Minerva, and Anna Maria.)

Margarita Barza (n.d.). Embroiderer, Milan. Cited in Paolo Morigia, 1595.

Suor Vincenza Brandolini (n.d.). Sculptor, convent of Santa Caterina da Siena, Florence. Cited in Richa, 1754–64.

Suor Dorotea Broccardi (n.d.). Miniaturist, Convent of San Lino, Volterra. Signed manuscript, Libro dell'Ordine di Santa Chiara," Biblioteca Guarnacci, Volterra.

Suor Prudenza Cambi (n.d.). Painter, convent of Santa Caterina da Siena, Florence. Cited in Fra Serafino Razzi, 1596.

Barbara Cantona (n.d.). Painter and embroiderer, Milan, daughter of Caterina Cantona. Cited in Paolo Morigia, 1595.

Caterina Leuca Cantona (d. 1605). Embroiderer, Milan. Cited in Gian Paolo Lomazzo, 1584, 1587; Paolo Morigia, 1595; Benedetto Sociacco, 1612.

Mariangiola Criscuolo (1584?–?). Daughter of Giovan Filippo Criscuolo, teacher of Luisa Capomazzo, Painter, Naples. Cited in Bernardo De Domenici, 1742.

Teodora Danti (1498–1573). "Disegnatrice" and painter, Perugia, daughter of Vincenzo Danti. Cited in Giorgio Vasari, 1568; Lione Pascoli, 1730.

Vittoria Farinato (1565–?). Painter, Verona, daughter of Paolo Farinato. Cited in Zannandreis, 1871.

Suor Tommasa del Fiesca (ca. 1448–1534). Painter and embroiderer, Genoa and San Silvestro, Pisa. Cited in Raffaello Sopriani, 1674.

Lavinia Fontana (1552–1614). Painter, Bologna, daughter of Prospero Fontana. Cited in Raffaello Borghini, 1584; Gian Paolo Lomazzo, 1591; Lutio Faberio, 1603; Ridolfo Campeggi, 1620; Giulio Mancini, 1620; Celestino Colleoni da Bergamo, 1622; Giambattista Marino, 1630; Pompilio Totti, 1638; Gaspare Celio, 1638; Francisco Pacheco, 1638; Giovanni Baglione, 1642; Antonio Masini, 1666; Filippo Titi, 1675; Carlo Cesare Malvasia, 1678; F. de los Santos, 1681; Filippo Baldinucci, 1681.

Fede Galizia (ca. 1578–ca. 1630). Painter, Milan, daughter of Annunzio Fontana. Cited in Gian Paolo Lomazzo, 1591; Paolo Morigia, 1595; Mutio Manfredi, 1606; Cesare Rinaldi, 1609; Giovanni Baglione, 1642; Francesco Scanelli, 1657; Agostino Santagostino, 1671; Giulio Cesare Malvasia, 1678; Filippo Baldinucci, 1681.

Campaspe Giancarli (n.d.). Painter, Venice. Cited in Dionigi Atanagi, 1561; Giulio Cornelio Gratiano, 1636.

Barbara Longhi (1552–1638). Painter, Ravenna, daughter of Luca Longhi. Cited in Giorgio Vasari, 1568; Mutio Manfredi, 1606.

Suor Felice Lupiccini (n.d.). Miniaturist, convent of Santa Caterina da Siena, Florence. Cited in Giuseppe Richa, 1754–64.

Isabella Mazzoni (n.d.). Second wife of and assistant to Guido Mazzoni, sculptor, Modena(?) and Naples(?). Mazzoni's daughter also reportedly worked in the *bottega*. Cited in Pomponio Guaricus, 1504; Lodovico Vedriani, 1662.

Suor Alessandra del Milanesi (n.d.). Miniaturist, convent of Santa Caterina da Siena, Florence. Cited in Paolo Mini, 1593.

Suor Angiola Minerbetti (n.d.). Miniaturist, convent of Santa Caterina da Siena, Florence. Cited in Giuseppe Richa, 1754–64.

Suor Plautilla Nelli (1523–88). Painter, convent of Santa Caterina da Siena, Florence. Cited in Giorgio Vasari, 1568; Francesco Bocchi, 1591; Fra Serafino Razzi, 1596; Giuseppe Richa, 1754–64.

Suor Dionisia Niccolini (n.d.). Modeler of clay, convent of Santa Caterina da Siena, Florence. Cited in Fra Serafino Razzi, 1596; Giuseppe Richa, 1754–64.

Isabella Cattani Parasole (active 1594–1620). Print maker – woodcut, Rome, wife of Lionardo Norsino Parasole, mother of Bernardino Parasole. Cited in dedication, *Pretiosa gemma delle virtuose donne,* a book of lace patterns, Venice, 1600; Giovanni Baglione, 1642.

Caterina Pepoli (n.d.). Cited as learning to paint from Lavinia Fontana, Bologna. Cited in Gaetano Giordani, 1832.

"Prudenza" (n.d.). Identified only as the painter-daughter of Valerio Profondavalle di Lovania, Milan(?). Cited in Gian Paolo Lomazzo, 1591.

Lucrezia Quistelli (n.d.). Painter, Florence. Cited in Giorgio Vasari, 1568.

Suor Maria Angelica Razzi (n.d.). Modeler of clay, convent of Santa Caterina da Siena, Florence and Perugia(?). Cited in Fra Serafino Razzi, 1596; Giuseppe Richa, 1754–64.

Cecilia Ricci (1549–93). Painter, Verona, daughter of Il Brusacorci, sister of Felice Ricci. Cited in Luigi Lanzi, 1789.

Marietta Robusti (ca. 1552 or 1560–90). Painter, Venice, daughter of Tintoretto. Cited in Raffaello Borghini, 1584; Giulio Cornelio Gratiano, 1636; Carlo Ridolfi, 1648.

Properzia De'Rossi (ca. 1490–1530). Sculptor, Bologna. Cited in Giorgio Vasari, 1550, 1568; Raffaello Borghini, 1584; Pompeo Vizani, 1608; Giulio Cornelio Gratiano, 1636; Gio. Nicolò Pasquali Alidosi, 1621; Giovanni Antonio Bumaldi, 1641; Luigi Vedriani, 1662; Antonio Masini, 1666; Carlo Cesare Malvasia, 1678.

Suor Maria Ruggieri (n.d.). Painter, convent of Santa Caterina da Siena, Florence. Cited in Fra Serafino Razzi, 1596.

Veronica Sala (n.d.). Embroiderer, Milan. Cited in Paolo Morigia, 1595.

Diana Scultori [Mantuana] (ca. 1545/50–1612). Engraver, Mantua and Rome. Cited in Giorgio Vasari, 1568; Giovanni Baglione, 1642; Carlo Cesare Malvasia, 1678; Filippo Baldinucci, 1681.

Irene di Spilimbergo (1541–59). Painter, Venice. Cited in Dionigi Atanagi, 1561 (a life of the artist and a collection of 279 Italian and 102 Latin

poems by 109 named contributors and a substantial number of "incerto");
Giulio Cornelio Gratiano, 1636.

Suor Agata Trabelesi (n.d.). Painter, convent of Santa Caterina da Siena, Florence. Cited in Fra Serafino Razzi, 1596.

"Suor Veronica" (n.d.). Painter, convent of Santa Caterina da Siena, Florence. Cited in Fra Serafino Razzi, 1596.

Unnamed daughter of Valerio Vincentino (n.d.). Engraver. Cited in Giorgio Vasari, 1568.

"Many sisters" in the convent of San Vincenzio, Prato. Cited in Fra Serafino Razzi, 1596.

Rime, Madrigali, and Other Early Writings on Artists and Art

In addition to *vite, rime* are major sources revealing early concepts about Renaissance women artists. The following extracts from collections of poems are representative examples. The translations are neither literal or poetic. With the assistance of Mary Gallucci, I have attempted to strike a balance between the two, while keeping in mind the language of critical discourse. The selected *rime* by Campeggi and Marino provide an opportunity to juxtapose writings about women and women's work with those about men and their images.

I Ridolfo Campeggi, *Delle Poesie del Signor Conte Ridolfo Campeggi,* Venice, 1620

a. Alla Signora Lavinia Fontana Pittrice famosa

Celeste man, che di Natura a l'opre
 Leggiadre, e rare, involi i primi honori,
 Ch'in emulando il Ciel piu bei splendori,
 (O dolce inganno) il tuo penel discopre.
Se per fare altro Mar tua forza adopre,
 Vere son l'onde, odi quei lor fragori,
 O s'humana belta formi, e colori,
 Un vivo corpo, un muto spirito copre.
O de la nostra eta vero ornamento
 Mentre il foco ad Amor disegni, e pingi,
 L'imprimi altrui nel sen piu ardente, e vago.
L'occhio (quando non scopri) e che non fingi
 Divini oggetti, a l'hor via piu contento
 S'appaga poi ne la tua bella imago.

(Part I, p. 101)

[Celestial hand, which steals first honors
 from Nature for rare and graceful works

169

that imitate Heaven (O sweet deception),
discovers with your brush the most beautiful splendors.
If you reveal your power to create another Sea,
the waves sound true – hear them crashing.
Or if you form and color human beauty
the body is alive, though it is clothed in a mute spirit.
Of if you draw and paint the true ornament
of our era as the fire of Love,
you imprint it upon another, more ardent and lovely bosom.
The eye, when it does not detect or imagine
Divine objects, is now more content
and satisfied in your beautiful image.]

b. Al Sig. Guido Reni Pittore Eccellentiss.

Guido pompa maggior de la Pittura,
 A'cui di gloria il crin la Fama cinge,
 Rende tua dotta man mentre dipinge
 Vittrice l'Arte, e vinta la Natura.
Fatta Imago da te d'Alma non cura,
 Che tanto viva se medesma finge,
 E con si chiare prove il guardo astringe,
 Che il finto al vero ogni credenza fura.
Ne tuoi divi colori (oltre l'esterno)
 Mostra un volto il desio mentre contrasta,
 Discopre un atto immoto il moto interno.
Contra il tempo, e l'oblio, che rode, e guasta
 I nomi, e i gesti, per far altri eterno
 Del tuo penello un'aureo tratto basta.

<div align="right">(Part I, p. 100)</div>

[Guido, greatest splendor of painting,
 Fame crowns your temples with glory
 in recognition of your learned hand. When you paint,
 Art is victorious and Nature is vanquished.
An image by you doesn't need a Soul,
 for you have fashioned her so alive
 and with such obvious veracity that the gaze is compelled
 to see the replication as robbing truth of any credence.
Your divine colors, which go beyond the visible,
 reveal invisible thoughts by making them visible
 yet resistant to desire.

Against time and oblivion, which consume
 and devastate names and actions,
 a stroke from your golden brush
 is enough to make them eternal.]

2. Giambattista Marino, *La Galeria Distinta in Pitture & Sculture* (1619/20) (Venice 1630)

a. La Decollatione di San Giovanni Battista, di Titiano

Crudel fù ben colui,
 Che vivo, e ver, dal busto
 la sacra testa al buon Giovanni sciolse.
 Pietoso è ben costui,
 che finto in campo angusto
 Nel opra istessa illustre tela accolse,
 Quei già di vita il tolse,
 Quasi in atto più pio l'armi severe
 Alzasì, ma non fere.

(p. 82)

[He was most cruel
 who severed from its breast the head
 of the good John while still alive and breathing.
 But he is most pious
 who [with reverence] painted this vile scene.
 In this same illustrious work,
 which is true to life, he,
 in an even more pious act,
 raises his arms,
 severe but not cruel.]

b. Herodiade con la testa di San Giovanni Battista, di Lavinia Fontana

Mentre in giro movendo il vago piede
 La Danzatrice Ebrea. Ciò, ch' a pena potea
 Soffrir con gli occhi, con la lingua chiede;
 Ebro il Re Palestino
 Di lascivia, e di vino,

Le dona pur, dal giuramento astretio,
Il capo benedetto,
O più perfida assai, che ciò concede,
D'ogni perfidia altrui perfida fede.

(p. 67)

[While moving her dainty foot aloft, the feverish dancer,
 she, who could hardly
 suffer with her eyes, requested with her tongue
 that the king of Palestine, who was
 drunken with lasciviousness and wine,
 give her the blessed head
 with his solemn oath.
 Oh, more perfidious, who conceded it
 with every perfidy, or perfidious faith.]

3. Mutio Manfredi, *I Madrigali* (Venice: Roberto Meglietti, 1606)

a. Pittrice Barbara

Per la Signora Barbara Lunghi eccellentissima pittrice, e perpetua
virgine.

I

La Barbara pittrice,
cui di vincer, pingendo, altrui non lice,
Se disegna, ò colora,
La Natura de l'Arte s'innamora:
E sol, ch un tratto tiri,
A' pena che si miri;
Quel, ch esser deve, al mirator predice.
Pinger la vidi un fiore,
E non finito ancor, spirò l'odore.

[Barbara the painter
Conquers by painting — a gift not granted to many.
When she draws or paints,
Nature falls in love with Art;
The merest line she traces predicts,
to one just beginning to admire
what the picture will be.

172

I once saw her painting a flower, and before
she finished, I inhaled its fragrance.]

<center>II</center>

La Barbara pittrice,
E sì perfetta d'arte,
Che per lei cede la Natura à l'Arte:
Anzi si tien felice,
Poiche da man sì rara,
D'abbellir ciò, che fà, gioiosa, impare:
E già si ne l oprar fatta è secura,
Ch'esser si crede insieme Arte, e Natura.

[Barbara the painter
is so perfect in skill
that for her Nature cedes to Art:
Indeed, Nature finds happiness
when, with a hand so rare
in embellishing her, joyously
Nature learns what to do;
and she is so certain about the work done
that she believes it is both Art and Nature.]

<center>III</center>

La Barbara pittrice,
O' dipinga, ò disegni,
Par, ch'a Natura d'operare insegni;
E l'insegna, e le dice,
Che non sarà mai come lei felice.
Risponde la Natura;
Altri, che tu mai non mi fè paura:
Ma sei Donna, e Donzella;
E ti fò mia compagna, e mia sorella.

[Barbara the painter,
whether she paints or draws,
seems to teach Nature what to do,
she teacher her, and tells her
that she will never be as happy as she is.
And Nature responds,
"None but you will ever cause me fear;

<center>173</center>

but you are a woman, a virgin;
and I shall make you my companion and my sister."]

b. La Fede

Per la Signora Fede Galitia, Fanciula nell'Arte della Pittura eccellentiss.

I

Mirai due forme, e di beltà celeste,
E Nuntio n'hebbi in sicurtà del vero;
Ma mentre col pensiero,
L'una, e l'altra, e con gli occhi, e col desio
Centemplava, vid'io,
D'ambe le labbra, benche finte, aprirsi;
E ciascuna per Dea meco scoprirsi.
Allor forte gridai. chi ne fà fede?
Echo rispose. FEDE.

[Once I admired two forms of celestial beauty;
I had Nuntio assure me of the true one;
but while I contemplated them,
now one, now the other, first with my mind then with my eyes,
and finally with my desire, I saw
both their lips, although painted, open;
and each was discovered by me to be a goddess.
At that I cried aloud. Who would believe me, by faith?
Echo answered, "Faith."]

II

Queste, ch'io miro qui bellezza finte,
Da virginella man, dotta, dipinte,
Esser non pon terrene;
Che troppo rare son, troppo perfette:
E sol paiono elette
A' render vana l'amorosa spene.
Ma pur creder si dè, se ne fà fede
La purissima FEDE.

[Those two of false beauty, whom I admire here,
painted by a virginal, learned hand,
are beings not of this earth;
They are too rare, too perfect;

they seem to have been chosen
to render amorous hopes vain.
But indeed, one must believe, one must have faith.
Most pure Faith.]

<div align="center">III</div>

Angeli son, non donne,
Le due, c hor miro, finte nò, ma vive;
O' ch almeno sono Dive.
Ma pur son Donne, e finte,
E da donzella pinte.
Credalo ogni hu[m]o (?), s'io 'l credo, e chi nol crede:
Se fede ce ne fà l'istessa FEDE?

[Angels they are, not women,
those two, whom I admire, not false, no, but alive;
Oh, they are divas at least.
But really they are women, and false, and painted by a young girl.
Let every man believe it, if I believe it, and whoever doesn't:
Who else will have faith, but Faith?]

4. Mutio Manfredi, Comments concerning Barbara Longhi from a lecture delivered to the Accademia de'Confusi, Bologna, 4 February 1575

Sappiate, che in Ravenna è una fanciulla di età 18 anni, figliuola di Maestro Luca Longhi eccellentissimo pittore, la quale in quest'arte è si maravigliosa che il padre stesso comincia a maravigliarsi di lei, e massime nella parte de'ritratti, ch'elle appena dara un'occhiata a una persona, che meglio la finge di chiunque altro più che mediocremente esercitato, avendola tuttavia dinanzi, non sarebbe: il suo nome e Barbara.

[You should know that in Ravenna there is a young girl eighteen years old, the daughter of the most excellent painter Luca Longhi, who is just as remarkable in this art, especially the painting of portraits, which she captures with only a single glance. Even her father marvels at her, for she paints better than those who practice this art in a mediocre fashion. Her name is Barbara.]

5. Giulio Cornelio Gratiano, *Di Orlando Santo vita, et morte con venti mila Christiani uccisi in Roncisualle Cavata dal Catalogo de Santi* (Ascoli: Maffio Salvioni, 1636).

O che belle pittrice antiqui veggio
 Seguir la schiera de li dotti maestri,

Er in arte si degna non far peggio.
Ch'a tesser veli, ò bianche gonne, o nastri
Timarete, che tenne il primo seggio.
Che pinse loggie, gease, asse, e pilastri,
Irenua figlia di Cratino, & anco
Aristarete di saper non manco.
Ma, che dirò di queste nostre adesso
Donne, che fan profesione tale,
Che adoprano il color lo stilo, e l'gesso,
E spiegan poi de la lor fama l'ale
Ben sono certo à quelle antiche appresso
Et alcuna di lor molta più vale,
Credo del Tentoretto esser la figlia,
Che dal valente padre l'arte piglia.
De Spilimbergo la signora Hirene,
Tutta gentil, tutta famosa, e regia,
Che con Pittori, e con Poeti tiene
Il pregio, e'l vanto d'ogni virtù egregia,
E Campaspe Iancarli, che si bene
Honora col sapere tutta Vinegia,
Propertia Bolognese, che'l pennello
Adopra, e sculpe, e intaglia di scalpello.
Ecco la bella e saggia dipintrice
La nobil Sofonisba da Cremona.
Che ben hoggi si può chiamar felice,
Sendo ne l'arte sol perfetta, e buona,
Se l' dir di lei, se l'ragionar me lice
(Dirò) c'hora non veggio altra persona,
Nè Pittor, che l'avanza con pennello
Si vago ha l'color, polite, e bello.
E se giovine tal hoggi la corte,
Dal Sacro Rè Filippo orna, e rischiara,
(Come ha voluto la benigna sorte)
Per la beltà, per la vertute rara,
Maraviglia non è ch'anco le morte,
Che fassi contra noi cotanto avara
Vinta sara da suoi costumi illustri,
E viverà ben più de mille lustri.

(pp. 93–4)

176

[Oh what beautiful, ancient women painters I see
 following the ranks of learned masters and
 doing no worse in art than others of their era
 instead of weaving veils or white gowns of ribbons,
 as you might fear would take first place.
The one who painted loggias, panels, and columns
 is Irene, daughter of Cratinus. And
 Aristarete is of no small skill.
But what shall I say of them now,
 our women, who assume this profession and
 who adopt paint, pen, chalk
 and then explain the flight of their fame?
 I am well certain that at least one of them
 is to be valued more than those ancient women.
 I believe she is the daughter of Tintoretto,
 she who plucked the skill from her worthy father.
The Signora Irene of Spilimbergo, who is
 very genteel, very famous, and regal,
 holds the prize with painters and poets,
 for she boasts every outstanding virtue;
 and Campaspe Giancarli, who well
 honors all of Venice with her knowledge, and
 Propertia Bolognese, who took up the
 brush and sculpted and did intaglio with the scalpel.
Behold the beautiful and sage painter,
 the noble Sofonisba from Cremona,
 whom we may call happy even today,
 is alone in art so perfect and good that,
 if I may be permitted to say of her or consider,
 that now (how shall I say?) I see no other person
 or painter who comes forth with a brush
 as lovely in color as she has, so lustrous and beautiful.
This young woman adorns and illumines
 the court of the sacred King Philip,
 (as benign fortune would have it)
 with beauty and with her rare virtue.
 It is no wonder that even death,
 always so avaricious toward us,
 will be vanquished by her illustrious ways.
 She will live more than a thousand centuries.]

6. *Rime di diversi nobilissimi, et eccellentissima autori — in morte della Signora Irene delle Signore di Spilimbergo,* ed. Dionigi Atanagi
(Venice, 1561)

a.

Mentre IRENE gentil, essempio vero
 Di quella IRENE antica, in ogni parte
 Cercò in se unir le sue eccellenze sparte
 Col buon pennello, e col giudicio intero;
Fè con tanto artificio, e magistero
 Spirar piu forme vere in vive carte;
Che portò invidia la natura a l'arte:
 Ne dal finto si vide il ver sincero.
Hor sdegnando si humili oggetti, e frali,
 è salita a la sfera piu sublime,
 Che risplende d'un foco, e lume eterno;
Ove nel specchio del motor superno
 Contempla, e mira l'alte Idee immortali,
 E quelle ancor la su pingendo esprime.

(Federico Frangipane, p. 36)

[While gentle Irene, true exemplar
 of her ancient namesake, always sought
 to unite in herself many disparate gifts,
 made many true forms come alive on paper,
with a good brush and complete justice,
 and with such artifice and majesty
 that Nature envied Art.
 Nor could one distinguish the true from the false.
Distaining now such humble and frail objects,
 Irene has ascended to a more sublime sphere
 which glows with a fire, with an eternal fire.
Thus, in the reflection of the eternal mover
 she contemplates and admires the high, immortal Ideas;
 whereas here below she expressed them in paint.]

b.

Mentre la bella, & giovenetta IRENE
 Col canto, & col pennel leggiadro, & raro,

Di Zeusi, & de le Muse andando a paro,
 Di meraviglia empia le nostre arene;
Invida Morte, & rea, che non sostene
 Lunga stagion un vivo lume, & chiaro;
 L'ancise, ohimè, sul fior de gli anni: e'l caro
 Viso oscurò del secol nostro spene.
Felice un tempo, a cui quel Sol lucente
 Soura le notti sue fosche, & erranti
 Bel giorno aprì d'alma virtute ardente:
Ma suenturato a pieno hoggi tra quanti
 Godon quest'aria, in cui lo stral pungente
 D'Amor passò da que begliocchio santi.

<div align="right">(Giacomo Tiepolo, p. 51)</div>

[While the beautiful and youthful Irene
 with her song and with her delicate and rare brush,
 filled our shores with marvels;
 competing with Zeuxis and the Muses,
envious and evil Death, who does not suffer
 long a living and clear luminary,
 smote her, oh me, in the flower of her years, and
 obscured her dear visage from our earthly hopes.
Happy the time when the luminous Sun
 dawned one beautiful day, full of dear and ardent virtue
 over dark and treacherous nights,
but most unfortunate is the man among those today
 who still breathe, in which the pungent arrow
 of love passed from those beautiful and holy eyes.]

<div align="center">c.</div>

Qui sepolta non è la bella IRENE;
 Ma le gratie, le muse, il suono, e'l canto:
 Et l'arte, ond'hebbe Zeusi, e Apelle il vanto,
 Et quella ancor, ch'Aragne in pregio tene.
Che più? Morta costei, lasso, convene,
 Ch'estinta sia beltà, che fredda a canto
 Le dorma l'honestà, lugubre quanto
 Chi riman privo, & fuor d'ogni suo bene.
Breve spatio di terra, & picciol sasso
 Hor copre quel, cui poco era gia il mondo,
 Et non capiva in questo centro basso.

Sò ben, che'l ciel ne và lieto, & giocondo:
 Ma chi può star a fren, ne mover passo,
 Se posti siam de le miserie al fondo?

<div align="right">(Gioseppe Betussi, p. 72)</div>

[Here lies not the beautiful Irene,
 but the Graces, the Muses, Song, Music,
 and Art, of which Zeuxis and Apelles could not vaunt,
 and she who held Arachne in praise.
Who else? Since she has died,
 beauty must be extinct; honesty, cold,
 sleeps next to her, as lugubrious as
 one who remains deprived and apart from any good.
Brief span on earth, and small stone
 you now cover one who was barely in this world
 and one who never came to this sad place.
Well I know that the heavens go happy and jocuse,
 but who can remain still or move one step,
 if we are paralyzed by misery within?]

<div align="center">d.</div>

Se la Vergine è 'n ciel, se gira il volto
 Al chiaro lume de l'Esperio Atlante,
 Per esser l'opre sue leggiadre, & sante,
 Ne l'haver con bilance il giusto accolto;
Perche questa non v'è? perche rivolto
 Al medesmo splendor non ha'l sembiante;
 S'è colma di virtù si rare & tante?
 Se piu raggi, che l'altra ha da lui tolto?
Da lui tolse l'ingegno, e ogn'arte egregia
 De la man, de la lingua, & del concetto,
 Et Venere, & Minerva, & le tre Gratie.
Et benche l'altra hebbe la verga regia;
 Quest'ha d'alma gentil tutte le gratie:
 E'l degno albergo suo mostrò l'aspetto.

<div align="right">(Gio. Battista Pigna, p. 74)</div>

[If the virgin is in Heaven and if she turns her face
 to the bright light of the Atlantic Hesperis,
 her works will be happy and holy,
 because she has taken justice in her scales.

<div align="center">180</div>

Why isn't she there? Why has she not returned
 to the same splendor that has no parallel,
 if she is filled with such rare and countless virtues
 and emanates more radiantly than any other?
From him she took genius and every outstanding art
 of the hand, of speech, and of conceit
 and Venus, Minerva, and the three Graces.
And although the other had the royal staff,
 this one has all the graces of the gentle soul,
 and her worthy place showed this aspect.]

e.

EGREGIA poteras spirantes fingere uultus
 Pictura, & quod deest addere sola decus,
Ante diem tibi ni IRENE vitalia nentes
 Stamina soluissent tenuia fila Deae.
Dixerat illacrymans prisco Titianus Apelle
 Exprimere artifici doctior ora manu:
Cum mors caelum, inquit, pictura ornarier huius
 Dignum est: orbi unus tu Titiane sat es.

 (Titianvs Vecellivs, *Diversorum praestantium poetarum*
 carmina In obitu Irene Spilimbergo [Venice, 1561], p. 55)

["Excellent Irene, you fashion breathing faces in your pictures,
 and you alone could add the decorum that is lacking,
if the Fates spinning out your slender vital thread
 had not loosed it before its time,"
a weeping Titian said, "then you with your artist's hand
 would have expressed faces in a more learned way than the ancient
 Apelles."
Then Death said, "It is right that heaven be decorated with your
 painting.
 You, Titian, are enough for the world."]

f.

Quella, che co'i soavi almi concenti,
 Onde fermar potea dal corso i fiumi,
 E render queto il mar, placidi i venti,
 Dolci fè spesso alpestri acri costumi;

Quella, che co'i suoi chiari, & santi lumi
 Tosto liete facea d'afflitte menti,
 E spargea gratie tali infra le genti,
 Che di terra fean ciel, d'uomini numi,
Quella, che con la man; più ch'altra mai
 Leggiadra, Apelle, & Pallade vincea;
 Et con la dotta penna ogni alto ingegno;
 Morte ne'nvola. Ahi ciel, come tu'l fai;
 Che donna tal, anzi verace Dea
 Di quell'empia soggiaccia al fero sdegno.

<div align="right">(Ippolita Gonzaga, p. 98)</div>

[She, with soft, nurturing harmonies,
 can halt the waves from the river's course,
 calm the sea and subdue the winds, and
 temper the often harsh alpine ways.
She, who often brought relief to afflicted minds,
 spread so much grace among the people
 that she made Earth a Heaven, and angels of men.
She, with her hand more elegant
 than any other, vanquished Apelles and Pallas,
 and with her learned brush conquered every other talent.
Death stole her. Oh Heaven, how could you allow
 such a woman, indeed a veritable goddess,
 to be subjected to so cruel an offense by that impious one?]

Notes

1. INTRODUCTION

1 King, 1991, xiii. As King notes of her study, "Much is dared here, but there are some tasks that could not be assumed. Eastern Europe and the rest of the world are neglected, as are female painters and musicians." I am hopeful that the present study will fill in part of the gaps. In addition to King's informative *Women of the Renaissance*, for a general discussion of Renaissance women see Natalie Zemon Dvis and Arlette Farge, eds., *A History of Women, Renaissance and Enlightenment Paradoxes* (Cambridge, MA, 1993).

2 As Lisa Tickner, "Feminism, Art History, and Sexual Difference," *Genders*, 3 (1988), 99, rightly advised nearly a decade ago, it is time to reformulate "the old question (why are there no great women artists?) as the new: how are the processes of sexual differentiation played out across the representations of art and art history (How and to what effect?)."

3 Svetlana Alpers, "Art History and Its Exclusions: The Example of Dutch Art," in *Feminism and Art History: Questioning the Litany*, ed. Norma Broude and Mary D. Garrard (New York, 1982), p. 184, states it succinctly. "The rhetoric, the very language with which we talk about a painting and its history is . . . Italian born and bred."

4 Vasari, 1906 vol. 4, pp. 315–16,

in Raffaello facesse chiaramente risplendere tutte le più rare virtù dell' animo accompagnate da tanta grazia, studio, bellezza, modestia ed ottimi costumi, quanti sarebbono bastati a ricoprire ogni vizio, quantunque brutto, ed ogni macchia ancor che grandissima. Laonde si può dire sicuramente, che coloro che sono possessori di tante rare doti, quante si videro in Raffaello da Urbino, sian non uomini semplicemente, ma, se così e lecito dire, Dei mortali.

5 Vasari, vol. 3, p. 93, "Fu veramente sempre cosa lodevole e virtuosa la modestia, e l'essere ornato di virtù che agevolmente si riconoscono nell' ornate azioni d' Antonio Rossellino scultore; il quale fece la sua arte con tanta grazia, che da ogni suo conoscente fu stimato assai più che uomo, ed adorato quasi per santo, per quelle ottime qualità ch'erano unite alla virtù sua." Unless otherwise stated, all translations are mine.

6 In some cases, such as that of Castagno, artistic virtuosity rescues an artist from a life of vice. See Vasari, vol. 2, p. 668.

7 Vasari, vol. 5, p. 75.

8 See, for example, Vasari, vol. 4, p. 17, on Leonardo.

9 Vasari, vol. 5, p. 80.

10 Razzi, p. 369.

11 Domenici, vol. 2, p. 348.

2. PROBLEMS OF PRAISE AND PYTHAGOREAN CONTRARIETY

1 Parker and Pollock, p. 3; T. S. R. Boase, p. 138.

2 Charles Hope, "Can You Trust Vasari?", *New York Review of Books*, vol. 42, no. 15, 5 October 1995, p. 11. In his review of Patricia Rubin's *Giorgio Vasari: Art & History*, Hope argues for Pierfrancesco Giambullari's authorship of the first preface and the influence and assistance of others in the composition of the second and third prefaces.

3 Vasari, 1906, vol. 2, p. 97.

4 Plutarch, *Mulierum virtutis* 243A.

5 Aristotle, *Rhetoric* 1.8.1366a35, describes *virtù* as "a faculty of providing and preserving good things." In *Nicomachean Ethics* 4.2.1122a35–1122b5, he associates the virtuous man with the artist. For a discussion of art as *virtù* see Mendelsohn, pp. 47–52.

6 Maclean, pp. 47–67.

7 According to McLeod, pp. 20–1, Plutarch promises in the introduction to *Mulierum virtutis* "not only to praise women but also to do so within an essentially public frame, just as for men. In combination these two approaches delineate a starkly new stance in the catalog tradition." Plutarch, says McLeod, allows the heroine to "occupy a variety of roles far beyond [her] biological function" yet to do so without having her femininity denied. I would argue otherwise. If, as McLeod claims, the femininity of the heroine is not denied, in some cases, such as the Argive maidens and Cloelia, it is brought into question. Any change Plutarch may have effected was not necessarily long-lived, as Vespasiano da Bisticci's life of Alessandra De'Bardi demonstrates. Although Vespasiano, writing in the 1480s, admits his debt to Plutarch, "that most exact of writers" who "also wrote lives of illustrious Greek Women to save them from oblivion," he praises Alessandra for her fidelity to her husband. Vespasiano da Bisticci, *Renaissance Princes, Popes, and Prelates,* trans. William George and Emily Waters (New York, 1963), pp. 441–62.

8 Plutarch, *Mulierum virtutis* 250F. This, he says, makes "her worthy of a gift fitting for a warrior," such as an equestrian monument.

9 Plutarch, *Mulierum virtutis* 254D–F. As a postscript to the story, Plutarch (245F) notes that the Argive women coupled "with the best of their neighboring subjects." Although these subjects were made Argive citizens, "the women

showed disrespect and intentional indifference to those husbands, . . . wherefore the Argives enacted a law, the one which says that married women having a beard must occupy the same bed with their husbands!'

10 Other texts among the *loci classici* included Plato's *Laws* 7, *Republic* 5, *Meno* 71–5, and Aristotle's *Politics* I.13.1260a20ff., *Economics* I.3.1344b30ff., and *Metaphysics* A.3.986a21ff. See Maclean, pp. 47–67.

11 Torquato Tasso, *Discorso delle virtù femminile e donnesca* in *Opere*, 1724, vol. 3, pp. 321–6. Tasso, p. 322, duly acknowledges the authority of Plutarch's essay on illustrious women. As Maclean, pp. 62–3, notes, "The difference between the sexes [in this essay] is . . . subjugated to the social or conventional expectations which, according to Tasso, regulate moral behavior. It is clear that such an argument was bound to attract refutation." For women writers dealing with these issues, see Ginevra Conti Odorisio, *Donna e societa' nel seicento, Lucrezia Marinelli e Arcangela Tarabotti* (Rome, 1979).

12 Tasso, 1724, vol. 3, p. 324.

13 Aristotle, *Physics* 188a.19–30 and *Metaphysics* 1004b.29–1005a, 1075a.28, 1087a.29–1087b.

14 Aristotle, *Metaphysics* 986a.31–986b. Also see G. E. R. Lloyd, *Polarity and Analogy: Two Types of Argumentation in Early Greek Thought* (Cambridge, 1971); Maclean, especially pp. 28–46; and David Summers, "Form and Gender," *New Literary History*, 24 (1993), 243–71. The emergence of modernism has been traced to a similar "cascade of antinomies" – west/east, active/passive, masculine/feminine. See Peter Wollen, "Fashion/orientalism/the body," *New Formations*, 1 (Spring 1987), 29.

15 The Hippocratic system of polarities provides the exception. Perhaps because of the importance of moderation to good health, Hippocratic polarities are not hierarchical. Heat, for example, is usually valued more highly than cold, yet excess heat (fever) can be fatal. See Cadden, pp. 15–17.

16 Plato, *Phaedo* 80b.

17 R. Howard Bloch, "Medieval Misogyny" in *Misogyny, Misandry and Misanthropy*, ed. R. Howard Bloch and Frances Ferguson (Berkeley and Los Angeles, 1989), p. 11. Also see *Three Medieval Views of Women*, ed. and trans. Gloria K. Fiero, Wendy Pfeffer, and Mathè Allain (New Haven, 1989).

18 Maclean, pp. 41–62.

19 Plutarch, *Mulierum virtutis* 243B–C.

20 Zabarella, *Tabulae logicae*, in *Quibus summa cum facilitate ac brevitate ea omnia explicantur, quae ab aliis prolixè declarari solent*. The *Tabulae* is appended to *Apologiae* in *Opere logica*, pp. 99–174. See especially p. 106, a ten-tiered system that defines "homo" as both rational and irrational, mortal and immortal, and p. 146, which diagrams the merging of the "active" and the "passive" in the "irrational," which then combines with the "rational" as "potentia."

21 Caro, vol. 2, pp. 332–3, letter no. 565. For Sangallo, who expressed this in his

letter to Benedetto Varchi concerning which art – painting or sculpture – was superior to the other, see Barocchi, 1960–2, vol. I, p. 77.

22 Using these terms in reference to women artists was a common practice. For examples of each, see Caro, vol. 2, pp. 308–9, in reference to Sofonisba Anguissola, and, also on Anguissola, see Lomazzo, 1974, vol. I, p. 95.

23 Vasari, vol. I, p. 91.

24 See Rudolf Wittkower, *The Artist and the Liberal Arts* (London, 1952); P. O. Kristeller, "The Modern System of the Arts" in *Renaissance Thought* (New York, 1965), vol. 2, pp. 163–227. For resistance to the altered status of artists, see the position of the *artigiano* in the Tarocchi in Jay A. Levenson, Konrad Oberhuber, and Jacquelyn L. Sheehan, *Early Italian Engravings from the National Gallery of Art* (Washington, DC, 1973), p. 92, cat. no. 15. The lives of three artists – Leonardo, Michelangelo, and Raphael – were included by Paolo Giovio in *Elogia Virorum Illustrium*. These, however, were not published with the text until 1772. See G. Tiraboschi, *Storia della letteratura italiana* (Parma, 1772), vol. 9, pp. 254–5.

25 According to Villani,

> The ancients, who wrote admirable records of events, included in their books the best painters and sculptors of images and statues along with other famous men. The ancients poets too, marveling at the talent and diligence of Prometheus, represented him in their tales as making men from the mud of the earth. These most wise men thought, so I infer, that imitators of nature who endeavored to fashion likenesses of men from stone and bronze could not be unendowed with noble talent and exceptional memory, and with much delightful skill of hand. For this reason, along with other distinguished men in their annals they put Zeuxis, . . . Phidias, Praxiteles, Myron, Apelles of Cos, . . . and others distinguished in this sort of skill. So let it be proper for me, with the mockers' leave, to introduce here the excellent Florentine painters who have rekindled an art that was pale and almost distinguished.

> For a review of Villani's chapter on painters, see Michael Baxandall, *Giotto and the Orators* (Oxford, 1971), pp. 70–2.

26 For the impasse in historiography, see Eric Cochrane, *Historians and Historiography in the Italian Renaissance* (Chicago, 1981), pp. 393–422. For Leonardo, see Jean Paul Richter, *The Literary Works of Leonardo Da Vinci* (London, 1939); and Martin Kemp, "From Mimesis to 'Fantasia': The Quattrocento Vocabulary of Creation, Inspiration, and Genius in the Visual Arts," *Viator* 8 (1977), 347–98. For Michelangelo, see Rudolf Wittkower and Margot Wittkower, *Born under Saturn* (New York, 1969); and Paul Barolsky, *Michelangelo's Nose: A Myth and Its Maker* (University Park, PA, 1990).

27 As Garrard, 1984, pp. 335–50, Mendelsohn, pp. 47–52, and others note, the liberal arts and the virtues were so deeply connected in Renaissance thought that their identities were fused. Fusion permitted the word *virtù* to carry both traditional and new meanings, as Lomazzo's *Trattato dell'arte*, 1584, demonstrates. For

two examples among many, see Vasari, vol. 3, p. 93, on Antonio Rossellino, and for the effects of less than virtuous morals on virtuosity, see Vasari on Castagno, vol. 2, p. 668.

28 Plutarch, *Mulierum virtutis* 243A.

29 Pino, p. 36.

Lauro: Mi spiace udir ragguagliar le femine con l'eccellenza dell'uomo in tal virtù, e parmi che l'arte si denigri, e che si tiri la specie feminile fuori del suo proprio, perchè alle femine non si vi conviene altro che la conocchia e l'arcolaio. Fabio: Voi dite bene, ma queste tali celebrate per diverse virtù furono femine che partecipavano dell'uomo, sì come favoleggiando si dice d'uno ermafrodite, le quali appresso di me mertano esser apprezzate come quelle che, vista l'imperfezion loro, tentano istraendosi dal suo proprio imitar il più nobile, ch'e l'uomo. In opposito poi veder un uomo effeminato è una cosa vituperosa, ma tal integrità nelle femine appaiono di raro, et è detto come miracolo in natura.

30 Vasari, vol. 5, p. 75.

31 Cicero, *Brutus* 70; and *De Oratore* 3.26; Quintilian, *Institutio oratoria* 10.1.54 and 12.10.2–9. Also see J. J. Pollitt, *The Ancient View of Greek Art* (New Haven, 1974).

32 Pliny, *Natural History* 35. 147–8.

There have also been women artists – Timarete the daughter of Micon who painted the extremely archaic panel picture of Artemis at Ephesus, Irene daughter and pupil of the painter Cratinus who did the Maiden at Eleusis, Kalypso, who painted an Old Man and Theodorus the Juggler, and painted also Alcisthenes the Dancer; Aristarete the daughter and pupil of Nearchus, who painted an Asclepius. When Marcus Varro was a young man, Iaia (Marcia) of Cyzicus, who never married, painted pictures [probably encaustic] with the brush at Rome (and also drew with the *cestrum* or graver on ivory), chiefly portraits of women, as well as a large picture on wood of an Old Woman at Naples, and also a portrait of herself, done with a looking-glass. No one else had a quicker hand in painting, while her artistic skill was such that in the prices she obtained she far outdid the most celebrated portrait painters of the same period, Sopolis and Dionysius, whose pictures fill the galleries. A certain Olympias also painted; the only fact recorded about her is that Autobulus was her pupil.

H. Rackham, the translator of the text quoted here, notes that the passage about "Kalypso" may be read as referring to either an artist by that name or a painting with a Kalypso as its subject. Jex-Blake, who provides an alternative translation for Pliny's paragraph on women artists, reads "Kalypso" as referring to an artist. *The Elder Pliny's Chapters on the History of Art*, trans. K. Jex-Blake (Chicago, 1968), p. 171.

33 It should be noted that in contrast to his review of male artists, Pliny provides no dates to help the reader insert these women into the chronological sequence that determines the order of the rest of his history. Similarly, when he discusses their fathers he fails to mention these artist-daughters. This is not the case with artist-sons.

34 Cicero, *Brutus* 18. Also see E. H. Gombrich, "Vasari's *Lives* and Cicero's *Brutus*," *Journal of the Warburg and Courtauld Institutes*, 23 (1960), 309–11.

35 Quintilian, *Institutio oratoria* 12.10.1–9.
36 Pliny, *Natural History* 35.79–80; 35.65; and 35.54.
37 Vasari, vol. 2, pp. 94–107.
38 Vasari, vol. 2, p. 96.
39 Vasari, vol. 4, pp. 11–12, 13.
40 Vasari, vol. 7, p. 726.
41 Lomazzo, 1587, bk. II, p. 91. Separate *rime* for the individual artists follow.
42 Lomazzo, 1587, bk. II, p. 115. The dancer Alkisthenes (Alcestine), not a woman artist, was the subject of one Kalypso's paintings.
43 The notion of stylistic advancement that typically inheres in analogical constructs of this kind is not only decidedly absent from Pliny's remarks on women, it may be said to work in reverse. Since Pliny was indisputably the Renaissance's source for this genealogy, the single critical comment he makes concerning the style of an image painted by a woman is worth noting. Timarete's Artemis at Ephesos is "antiquissimae." Although this term may refer to a conscious affecting of an archaic style, as sometimes happens when a new painting is made to replace another lost or damaged work, the adjective still stands by itself.
44 Cantaro, p. 319, no. 5b2.
45 Ridolfi, vol. 2, p. 78.
46 Domenici, vol. 2, p. 347.
47 See note 29 to this chapter.
48 Lomazzo, 1974, vol. I, p. 95. Also see Chapter Five in the present volume, "La donnesca mano."
49 Boccaccio, 1963, p. 145.
50 Malvasia, vol. 2, p. 385.
51 Viewing a woman with a masculine style in a positive light has not been agiven in the annals of art criticism. Jean Dominique Rey, for example, approved of Berthe Morisot's refusal to adopt the "falsely masculine toughness" of Suzanne Valadon.
52 Tassi, vol. I, pp. 224–5, is confused. He makes Marcia, or Iaia, two different people.

3. (PRO)CREATIVITY

1 See Summers, 1993; Jacobs, 1994; Sohm, 1995.
2 Castiglione, bk. III, chap 15, p. 182, has Gasparo explain it this way: "Man is as the form just as woman is as matter, and therefore, just as form is more perfect than matter, indeed gives it its being, so man is more perfect than woman [L'omo s'assimiglia alla forma, la donna alla materia, e però, cosi come la forma è più perfetta che la materia, anzi le da l'essere, cosi l'omo è più perfetta assai che la donna]."
3 Aristotle, *De generatione animalium* I.20.729a10–729b25.

4 Pietro Aretino, *Sei giornate. Ragionamento della Nanna e della Antonia* [1534], ed. Giovanni Aquilecchia (Bari, 1969), pp. 17–20. See Sohm, pp. 798–800.

5 John Ruskin, *Sesame and Lilies*, 1867, in Parker and Pollock, p. 6. "The man's power is active, progressive and defensive. He is eminently the doer, the creator, the discoverer. His intellect is for invention and speculation. But the woman's intellect is not for invention or creation but sweet ordering, arrangement, and decision."

6 Aristotle, *Physics* 1.9.192a 20–25.

7 Galen, *On the Natural Faculties* 2.3.

8 Thomas Aquinas, *Summa theologica* (New York, 1947), pt. 3, question 32, "De conceptione Christi quoad Activum Principium," article IV.

9 Plato, *Theatetus* 150B–151.

10 A similar distinction is made in *Symposium* 208E–209A. Those who are "pregnant in body" go to midwives and beget children, while those who are "pregnant in soul" conceive and bear that which is proper to the soul. Also see Joseph Needham, *A History of Embryology*, 2nd ed. (New York, 1959), p. 43, and J. S. Morrison, "Four Notes on Plato's *Symposium*," *Classical Quarterly*, 14 (1964), 42–55.

11 Filarete, vol. I, p. 39. The analogy is fitting, given the stated purpose of book II of the *Trattato:* "Come si genera l'edificio appropriato d'esso corpo umano."

12 Kemp, pp. 381–2 and 396.

13 See S. K. Heninger, Jr., "A World of Figures: Enargeiac Speech in Shakespeare," in *"Fanned and Winnowed Opinions"*: *Shakespeare Essays Presented to Harold Jenkins*, ed. John W. Mahon and Thomas A. Pendleton (London, 1987), pp. 216–30.

14 See, for example, *Astrophil and Stella*, as cited in Katharine Eisamen Maus, "A Womb of His Own: Male Renaissance Poets in the Female Body" in Turner, p. 275.

15 For a list of editions, translations, and commentaries on Aristotle's *De generatione animalium*, see F. Edward Cranz, *A Bibliography of Aristotle's Editions, 1501–1600*, 2nd ed. (Baden-Baden, 1984).

16 Aristotle, *De generatione animalium* 1.20.729a 1–20, 2.4.738b 20–23; *De partibus animalium* I.639b 11–25; and *Metaphysics* 1029a 6 and 1046a 9–26.

17 Aristotle, *De generatione animalium* 1.20.729a 30–35. Also see Aristotle, *De anima* 412a. Matter is "that which in itself is not 'a this,' and in the sense of form or essence . . . is called 'a this' . . . Now matter is potentiality, form actuality."

18 Aristotle, *De generatione animalium* 2.3.736b 13.

19 Aristotle, *Metaphysics* 9.1.1046a 20–30, and *De generatione animalium* 1.20.729a 25–34; 2.3.737a 25–30; and 2.5.471a 10–16. Plato suggests a similar distinction when he contrasts those "pregnant in body" with those "pregnant in soul."

20 Aristotle, *De generatione animalium* 2.3.736a25–736b30. Also see Summers, 1987, pp. 110–24.

21 Vasari, 1906, vol. 4, p. 350.

22 Aristotle, *Physics* 194b 24.

23 Aristotle, *De generatione animalium* 1.21.729b 12–15.

24 Zuccaro, p. 184. "come concetto di tutti i concetti, forma di tutte le forme, Idea di tutti i pensieri, per lo quale tutte le cose sono nell'anima nostra, come di già habbiamo provato, & questo intendiamo noi essere quella virtù, & potenza. Zuccaro is building on Aristotle, *De anima* 432a.

25 Aristotle, *De anima* 432a5. "Since according to common agreement there is nothing outside and separate in existence from sensible spatial magnitudes, the objects of thought are in the sensible forms, viz. both the abstract objects and all . . . sensible things."

26 Aeschylus, *Eumenides,* lines 658–60.

27 Euripides, *Orestes,* lines 552–5.

28 Galen, *On Seed* in *Opera Omnia,* vol. 4, p. 519. Also see Richard J. Durling, "A Chronological Census of Renaissance Editions and Translations of Galen," *Journal of the Warburg and Courtauld Institutes,* 24 (1961), 230–305.

29 For a discussion of challenges to Aristotle, see Anthony Preus, "Galen's Criticism of Aristotle's Conception Theory," *Journal of the History of Biology,* 10 (Spring 1977), 65–85, and Michael Boylan, "The Galenic and Hippocratic Challenges to Aristotle's Conception Theory," *Journal of the History of Biology,* 17 (Spring 1984), 83–112.

30 Pliny, *Natural History* 7.66.

31 Tertullian, "On the Apparel of Women," quoted in R. Howard Bloch, "Medieval Misogyny: Woman as Riot" in *Misogyny, Misandry, and Misanthropy,* ed. R. Howard Bloch and Frances Ferguson (Berkeley and Los Angeles, 1989), pp. 11–12.

32 Cornelius a Lapide, *In omnes divi Pauli epistolas commentaria,* quoted in Maclean, p. 11.

33 Saint Ambrose, *Expositio Evangeliis secundum Lucan* in *Patrologica latine,* 15.1844. Concerning the alternative choices, Isidore of Seville suggests the former in *Etymolgiarum sive originum libri XX,* ed. W. M. Lindsay (Oxford, 1911), 11.2.17–20. Pope Innocent III, *De miseria humane conditionis,* ed. Michele Maccarrone (Lugano, 1955), I.6, is among many who propose the latter course of (in)action. See Vern L. Bullough, "Medieval Medical and Scientific Views of Woman," *Viator,* 4 (1973), 485–501.

34 Jerome, *Commentariorum in Epistlam ad Ephesios libri III* in *Patralogica latine,* 26.533.

35 Giovanni Marinello, bk. III, p. 236r. "dal calore dello sperma, aiutato da quello della matrice alcun spirito, ò vapore, ò fumo, che vi piaccia di chiamare: il quale è instrumento à generar tutta la creatura."

36 See Summers, 1993, p. 245.

37 In a well-known passage, Petrarch noted this in the context of literary imitation. Rather than copy precisely the style of a venerated author, a writer must imitate freely in a manner "our painters call air [*aerem*]." Such stylistic imitations parallel

family resemblance and explain why "seeing the son . . . recalls to our mind the memory of the father." Petrarch, *Prose* (Milan, 1955), p. 1,018.

38 Kemp, p. 396.

39 Zuccaro, p. 227.

40 Juan Huarte, *Examen de Ingegnios* (1575), quoted in N. Chomsky, *Cartesian Linguistics* (New York, 1966), pp. 78–9. Also see Robert J. Bauer, "A Phenomenon of Epistemology in the Renaissance," *Journal of the History of Ideas*, 31 (1970), 281–8.

41 Varchi, *Due Lezzioni* in Barocchi, 1960, vol. I, p. 45.

42 Vasari, vol. I, p. 103.

43 Varchi, *Opere*, vol. I, pp. 6–7.

44 Galeazzo Landrini, *De naturali humani corporis formatione, & usu* (Ferrara, 1633), tractatus I, p. 7; "ita pater ille est, qui movet semen, semen movet materiam id est sanguinem menstruum, & quem modum in cera imprimatur figura, aut in alba pagina littere imprimumtur."

45 According to Doni, in a letter to the sculptor Giovann'Angelo Montorsoli in Barocchi, 1971–6, vol. 2, pp. 1906–7, "L'disegno è padre della pittura e della scultura." For Lamo, *Intorno alla scoltura, e pittura* in Zaist, vol. I, p. 13, "La Scoltura e la Pittura fra l'arti liberali il primo grado, come virtù nobili, e nascono da gli intelletti de gli uomini liberi."

46 "Il rilievo è il vero padre, che la scultura, e la pittura è un de' sua figliuoli." Cellini, *Discorso sopra l'arte del disegno* in Barocchi, 1971–6, vol. 2, p. 1,932.

47 A further extension of the analogy is reflected in the structure of art history. According to Vasari, vol. I, p. 243, "The nature of this art is similar to that of others, which, like human bodies, have their birth, their growth, their growing old, and their death [il nascere, il crescere, lo invecchiare ed il morire]." Like the child–art object analogy, biological metaphors of this kind, refined by Darwin and his colleagues, survived well into the nineteenth century, when terms such as "evolution" or "life" of style entered into the art historical vocabulary.

48 The viewing of works of art as progeny has enjoyed a long life. Recalling a conversation with Jackson Pollock, Tony Smith comments on Pollock's perception of children. "Did they seem a part of you, an extension of you? . . . It was almost as if he thought you could have control over what they would be like . . . even as babies. It must have been the way he thought about art." See Judith Wolfe, "Jungian Aspects of Jackson Pollock's Imagery," *Art Forum*, 11 (1972), 67.

49 Vasari, vol. 6, p. 502.

50 Boccaccio, 1836, chap. LV, p. 152.

51 Vera Fortunati Pietrantonio in *The Age of Correggio and the Carracci, Emilian Painting of the Sixteenth and Seventeenth Centuries*, exhibition catalogue (Washington, DC, 1986), p. 132.

52 Baglione, pp. 143. He notes, moreover, that following her arrival in Rome she

painted portraits "of the greater part of Roman ladies." Men also sought her talents, including the "king of Persia," the "Persian ambassador," and Pope Paul V. Also see Mancini, vol. I, p. 234.

53 Destroyed by fire in 1823, Fontana's painting is preserved in an engraving by Jacques Callot, ca. 1611.

54 See Stefano Bottari, *Fede Galizia pittrice (1578–1630)* (Trento, 1965), and Caroli, 1989.

55 Morigia, bk. V, chap. iii, p. 467, "e nelli miracolosi suoi ritratti; e pur presente ella ha fatto il ritrattato di me presente autore di quest' Opera, di tanta eccellenza, rasomigliando talmente al natural."

56 The fee charged by the Pinacoteca Ambrosiana, where the portrait now is, makes reproduction of the image here impossible. I refer the reader to Harris and Nochlin, p. 115, fig. 8.

57 Ridolfi, vol. 2, p. 72. Borghini, vol. 2, pp. 91–2, reports the Strada commission.

58 Malvasia, vol. I, p. 177. The time lapse between Vasari's use of the word *virtù* and Malvasia's should be kept in mind, especially since, as noted, he credits (vol. 2, p. 385) her style with qualities seen typically in women's work: weakness and excessive flattery.

59 Harris and Nochlin, p. 113.

60 Cantaro, p. 129.

61 Armenini, bk. III, chap. xi, p. 190.

62 Armenini, bk. I, chap. iv, p. 37, and bk. I, chap. v, p. 43.

63 Danti, *Il primo libro del trattato delle perfette proporzioni* in Barocchi, 1960, vol. I, p. 241.

64 Vasari, vol. 4, p. 9.

65 John Pope-Hennessey, *The Portrait in the Renaissance* (Princeton, 1979), p. 3.

66 For an example of the effects of these treatises, see David Summers, "David's Scowl" in *Collaboration in Italian Renaissance Art*, ed. Wendy Stedman Sheard and John T. Paoletti (New Haven, 1978), pp. 113–20. In his essay in the 1994 exhibition catalogue *Sofonisba Anguissola e le sue sorelle*, pp. 55–6, Flavio Caroli notes the impact of studies on physiognomy as they relate to portrait painting. For recent discussions of the issue, see Jennifer Montagu, *The Expression of the Passions: The Origin and Influence of Charles Le Brun's "Conférence sur l'expression générale et particulière,"* (New Haven, 1994); and Flavio Caroli, *Storia della Fisignomica, arte e psicologia da Leonardo a Freud* (Milan, 1995).

67 Danti in Barocchi, 1960, vol. I, p. 265.

68 See Rogers, pp. 291–305.

69 Cennini, chap. xxvii, Ghiberti, p. 40, and Vasari, vol. 4, p. 17.

70 See David Summers, "*Aria II:* The Union of Image and Artist as an Aesthetic Ideal in Renaissance Art," *Artibus et historiae*, 20 (1989), 17. Also see Aristotle, *De anima* 414a15–25, and Robert Klein, "Spirito peregrino" in *Form and Meaning: Essays on the Renaissance and Modern Art* (Princeton, 1981), pp. 62–85.

71 Aristotle, *Metaphysics* 1032b15–25 and 1034a20–25.

72 Cadden, p. 18.

73 Aristotle, *De generatione animalium* 728a 18.

74 Aristotle *De generatione animalium* 3.3.737a 25–30; 2.5.741a 20–33; 4.2.766b 35; 4.2.767a 13–27; 4.3.767a 24–768a 8. Also see Anthony Preus, "Biomedical Techniques for Influencing Human Reproduction in the Fourth Century B.C.," *Arethusa*, 8 (1975), 237–63.

75 Aristotle, *De generatione animalium* 4.1.766b 15–26; 4.3.768a 6–7.

76 Jacobus Forliviensis, *De generatione embrionis* (Venice: Bonetus Locatellus, 1502), fol. 9vb. As Cadden, pp. 196–201, explains, Jacopo da Forli's list of ten causes that determine a child's sex is an eclectic synthesis of many sources. Huarte, pp. 320–1 and 341, makes much of the causal relationship between diet and type of progeny. Too much red meat produces dark and brooding sons. The consumption of fowl will produce a son who is affable in temperament and fair in complexion.

77 Marinello, bk. III, chap. iii, p. 248r.

78 Varchi, 1549, fol. 33.

79 Danti in Barocchi, 1960, vol. I, p. 236.

80 Danti in Barocchi, 1960, vol. I, p. 264.

81 Leja's recent explanation for the reappearance of the female figure in the works of Willem De Kooning reveals that the association of the material with the female still persists. "In defiance of his effort to compose a modernist, abstract painting . . . [the female figure] personifies the forces against which the act of painting . . . is performed." Michael Leja, *Reframing Abstract Expressionism, Subjectivity, and Painting in the 1940s* (New Haven, 1993), p. 265.

82 De Hollanda, 1928, p. 64.

83 Heliodorus, *Aethiopian Tale about Theagenes and Charicleia*, bk. 5, chap. 9, cited in David Freedberg, *The Power Images: Studies in the History and Theory of Response* (Chicago, 1989), p. 2.

84 See Guido Ruggiero, *Binding Passions: Tales of Magic, Marriage, and Power at the End of the Renaissance* (New York, 1993). For majolica, see Franco Crainz, *La tazza da Parto* (Rome, 1986). For the nineteenth-century saying, see Giuseppe Bernoni, *Credenze popolari Veneziane* (Venice, 1874), pp. 14–15.

85 Klapisch-Zuber, pp. 317–19.

86 Leon Battista Alberti, *On the Art of Building in Ten Books*, trans. J. Rykwert et al. (Cambridge, 1988), p. 299.

87 A. W. A. Boschloo, *Annibale Carracci in Bologna: Visible Reality in Art after the Council of Trent* (The Hague, 1974), vol. I, p. 115.

88 Mancini, vol. I, p. 143. In extending imaginative power to the male parent, Mancini follows Ficino's *Liber de Vita*. Marsilio Ficino, *The Book of Life*, trans. Charles Boer (Irving, TX, 1980), p. 143. In his life of Bartolomeo Cesi, Malvasia, vol. I, p. 242, also notes the effectiveness of placing "lascivie" in bedrooms

to assist the formation of "concetti." For a discussion of *bambini* as aids to the production of handsome children, see Klapisch-Zuber, pp. 310–29.

89 Juan Luis Vives, *Linguae Latinae Exertitatio* (Basel, 1555), pp. 30–1.

90 Vasari, vol. 6, pp. 498–9.

91 Vincentino di Buonaccorso Pitti's epitaph for Properzia is in Borghini, bk. III, p. 428.

92 Beroqui, *Tiziano en el Museo del Prado* (Madrid, 1927), p. 106.

93 In her notes to the exhibition catalogue *Sofonisba Anguissola e le sue sorelle,* pp. 190–1, Rossana Sacchi identifies the figures in the painting and relates their gestures to rhetorical types.

94 The power of this image cannot be denied, indeed, its communicative qualities seemed all the more amazing given the circumstances under which I first saw it. Moved with the rest of the Borghese Collection to temporary and cramped housing in Trastevere while the villa was undergoing restoration, the work was exhibited hanging on a prefabricated wall cluttered with images that often were stacked five and six deep. Commanding and holding a viewer's attention in this environment was no mean feat, yet Fontana's study of the smiling youth did just that.

95 Vasari, vol. 5, p. 81.

96 Cavalieri's letter is quoted in Italian and in translation in Charles De Tolnay, "Sofonisba Anguissola and Her Relations with Michelangelo," *Journal of the Walters Art Gallery,* 4 (1941), 117 and 119. Perlingieri, p. 12, has published a letter to the duke from Averardo Serristori as a further confirmation.

97 Tolnay, p. 116.

98 As Della Porta's *De humana physiognomia,* 1586, illustrates, this interest concentrated more on permanent character traits than on momentary stresses.

99 Leon Battista Alberti, *Della pittura,* ed. L. Mallè (Florence, 1950), p. 94. It should be remembered that Alberti's treatise was republished in 1540.

100 Leonardo da Vinci, *Treatise on Painting* [*Codex urbinas latinas*], trans. A. Philip McMahon (Princeton, 1956), vol. 1, p. 155.

101 Most recently the image as well as similar depictions of the theme by Vincenzo Campi and Jacob Bos, who was active in Italy from 1549 to 1563 and made an engraving after Anguissola's *Old Woman Studying the Alphabet and a Laughing Girl,* has been linked to Aesops fable "The Boy and the Scorpion," published in Gabriele Faerno, *Fabulae centum ex antiquis auctoribus delectae et carminibus,* 1563, and to the challenges of rendering a type realistically. See the exhibition catalogue for *Sofonisba Anguissola e le sue sorelle,* cat. no. 39, pp. 274–7. Anguissola's drawing is in the Uffizi, Gabinetto Disegni e Stampe, inv. no. 13936F, and Bos's engraving is in Amsterdam, Rijksmuseum, Rijksprentenkabinet.

102 Lomazzo, 1974, vol. 2, p. 97. "Onde vediamo che per non incorrere in cosi notabil diffetto, tutti I grandi inventori, per il piú, sono stati sottilissimi investigatori de gl'effetti naturali col dilettarsi, come ho detto, di vedergli spesso e

continumamente stare occupati in questa pratica col soprapensarvi e studiarvi. Dal che se ne viene l'uomo ad acquistar poi una pratica cosi fatta che se ne vale come d'un'altra natura, rappresentando vivamente tutti gl'atti e moti che gli tornano a proposito."

103 Baldinucci, 1692, p. 21.

104 Vasari, vol. 5, p. 80.

105 Vasari, vol. 5, p. 78.

106 Atanagi, 1904, p. 145.

107 Zaist, vol. I, p. 233.

108 Vasari, vol. 5, p. 81. My emphasis.

109 Lomazzo, 1974, vol. I, p. 332; Sangallo, letter to Varchi, in Barocchi, 1960, vol. I, p. 71; and Armenini, bk. I, chap. v, p. 43, and bk. II, chap. i, p. 82.

110 Vasari, vol. 5, p. 358.

111 Vasari, vol. 3, p. 115.

112 Armenini, bk. I, chap. ix, p. 70.

113 Dolce in Barocchi, 1960, vol. I, p. 171.

114 Vasari, vol. 5, p. 81.

115 Vasari, vol. 3, p. 107. "Grandissimo obbligo hanno al cielo e alla natura coloro che senza fatche partoriscono le cose loro con una certa grazia, che non si puo dare alle opere, che altri fa, ne per istudio ne per imitazione."

116 Baglione, p. 394.

117 Ridolfi, vol. 2, p. 79.

118 Morigia, bk. V, chap. xviii, pp. 494–6.

119 Lanzi, vol. 2, p. 322.

120 Morigia, bk. V, chap. xviii, p. 495. "Fra il gran numero de'Ricamatori Milanesi Scipione Delfinone tiene il primo luogo & e degno di molte lodi . . . vede si ancora la famosissima Caccia de'huomini, e d'animali, ch'egli fece al Re d'Inghllterra, & un' altra di nuova inventione ch'ei fece al nostro gran Re Filippo, oltre alla Tapezzaria de' Satiri, e Centauri, ch'ei fece al medesimo Re." The subject of Delfinone's fantastic *invenzione* leaves no room to confuse *imitazione*, an inventive form of mimesis, with pure invention. This was no accident. Whereas Cristofano Landino described Masaccio as "optimo imitatore di natura," editors preparing his text for publication in 1564 changed his status to "optimo inventore."

121 Summers, 1981, pp. 111–43, discusses these and numerous other writers responsible for developing the Renaissance idea of fantasy.

122 Philostratus, *Life of Apollonius of Tyana*, 6.19, quoted in Summers, 1981, pp. 110–11.

123 Marsile Ficin, *Thèologie platonicienne de l'immortalitédes ames*, ed. and trans. R. Marcel (Paris, 1964), vol. 2, pp. 12–18.

124 For an excellent in-depth discussion of what Dante called *l'alta fantasia*, see Summers, 1981, pp. 103–43.

125 Katharine E. Maus, "A Womb of His Own: Male Renaissance Poets in the Female Body" in Turner, p. 276. Also see *The Passions of the Mind in General* (1604), ed. Thomas O. Sloan (Urbana, IL, 1971); Lisa Jardine, *Still Harping on Daughters: Women and Drama in the Age of Shakespeare* (Brighton, UK, 1983), pp. 103–40.

126 Huarte, p. 300; "Ma il membro, il quale è più partecipe delle alterationi dell'utero, dicono tutti i medici essere il cervello, se bene non trovano ragione, in cui fondino tanta corrispondenza."

127 Lomazzo, 1974, vol. I, pp. 371–2.

128 Lomazzo, 1587, bk. II, p. 114, and 1974, vol. I, p. 371.

4. MELANCHOLIA

1 Vasari, 1906, vol. 5, p. 81.

2 Vasari, vol. 5, pp. 75 and 78. Raffaello Borghini, bk. III, p. 428, does not call her a *virtuosa*, but he does say that Clement VII, having heard of "the *virtù* of this rare woman," tried to meet her.

3 Pomponius Guaricus, p. 249, and Lanzi, 1968, vol. 2, p. 62.

4 Sangallo's statement, which appears in a letter to Benedetto Varchi, is one of eight responses solicited by Varchi. The other respondents were Vasari, Tribolo, Pontormo, Tasso, Michelangelo, Cellini, and Bronzino. For Sangallo's comment, see Barocchi, 1960–2, vol. I, p. 77. Paolo Pino agreed with Sangallo on this point. For a discussion of the *paragone*, see Mendelsohn.

5 Comments concerning the lives and works of Suor Plautilla Nelli, Lucrezia Quistelli, and Anguissola were appended to her *Life*. Additional information on the Anguissola sisters also appears in a discussion of Bernardino Campi. Moreover, the *Vite* was now introduced by Giovanbattista Adriani's survey of ancient art, which includes a recapitulation of remarks on five of the six women painters mentioned by Pliny.

6 See Hope, as cited in Chapter Two, note 2, to the present volume.

7 Lomazzo, 1974, vol. I, pp. 155–6. The comparison appears in "Libro dei Sogni," which has been assigned an ante quem date of 1564. It was not, however, among the author's published works.

8 See Goldstein, pp. 641–52. Vasari's use of literary convention has been much discussed. See, for example, C. M. Soussloff, "*Lives* of Poets and Painters in the Renaissance," *Word & Image*, 6 (1990), 154–62; Rubin; and W. Kallab, *Vasaristudien: Quellenschriften für Kunstgeschichte und Kunsttecknik des Mittelalters*, vol. 15 (Vienna, 1908). For the uses of epideictic rhetoric, see John W. O'Malley, *Praise and Blame in Renaissance Rome: Rhetoric, Doctrine, and Reform in the Sacred Orators of the Papal Court, c. 1450–1521* (Durham, NC, 1979).

9 See Michelangelo Gualandi, "Memorie intorno a Properzia de'Rossi," *Osservatore Bolognese*, nos. 33, 34, 35 (1851), pp. 167–87.

10 Nicolò Pasquali Alidosi, p. 147, claims Properzia's family was from Modena, there is no evidence to support this.

11 Vasari does note in the second edition his possession of "some very good [pen] drawings" by Properzia's hand "copied from works by Raphael." While he does not specify the subject of the drawing, it is tantalizing to speculate that it represented Joseph's escape, since her relief is very close to Raphael's depiction of the story in the Vatican Logge, which was subsequently engraved by Marcantonio Raimondi.

12 Fortunati, 1994, pp. 180–1, cites and illustrates a second carving of this kind that has been given to De'Rossi, now in the Museo degli Argenti, Palazzo Pitti, Florence. Such carvings were among the marvels collected in European Kunst- and Wunderkammern. See Kenseth, cat. no. 44a, pp. 268–9, for a Flemish example.

13 For attributions to De'Rossi on this project, see Vera Fortunati Pietrantonio, "Per una storia della presenza femminile nella vita artistica del cinquecento bolognese: Properzia De Rossi 'Schultrice,'" (1981), 167–77; M. V. Brugnoli, "Le porte minori" in *La Basilica di S. Petronio*, (Bologna, 1984), vol. 2, p. 83.

14 Vasari, vol. 5, pp. 76–7.

15 See Mazzoni Toselli, vol. 2, pp. 66–159.

16 Lovesickness, though not always suffered only by females, is nonetheless a feminine illness, as Shakespeare's Achilles in *Troilus and Cressida*, III.iii.237–8, demonstrates; "I have a woman's longing, An appetite that I am sick withal." Huarte, p. 161, describes these mood swings as characteristic of the malady. As an interesting aside, it should be noted that in *Varia historian* Aelian says there are two Sapphos, one learned and wise, the other an errant strumpet.

17 In adopting this method, Vasari modified for his own purposes the classical prescription for evaluating character and accomplishments that is set forth in *Rhetorica Ad Herennium*, a standard textbook on rhetoric. For a discussion of Vasari's reliance on classical rhetoric, see Rubin.

18 See Barolsky, 1990, pp. 23–30.

19 Vasari, vol. 2, p. 678.

20 As many have noted, Vasari's lives reflect the hagiographic tradition. See Kris and Kurz; T. Hampton, *Writing from History: The Rhetoric of Exemplarity in Renaissance Literature* (Ithaca, NY, 1980); Carl Goldstein, "The Image of the Artist Reviewed," *Word & Image*, 9 (1993), 9–18; H. Delehaye, *The Legends of the Saints* (New York, 1962); and D. Weinstein and R. M. Bell, *Saints & Society: The Two Worlds of Western Christendom, 1000–1700* (Chicago, 1982).

21 Borghini, bk. III, p. 428.

22 Another example of a nineteen-century romantic play that includes a tragic tale of love about a Renaissance woman artist is Luigi Marta's *Il Tintoretto e sua figlia; dramma in sei quadri*, staged in Milan in 1845 and published the following year.

George Sand's *Les maitres mosaistes*, 1838, was Marta's source for the unhappy love of Marietta Robusti and Valerio Zuccati. See Anna Laura Lepschy, *Tintoretto Observed: A Documentary Survey of Critical Reactions from the Sixteenth to the Twentieth Century* (Ravenna, 1983), p. 83.

23 Saffi, pp. 6–7.

24 Costa, vol. 3, pp. 24–64. The story of Joseph and Potiphar's wife is in Genesis 39:1–23.

25 Saffi, pp. 19–20. Despite these objections, the identification persisted. The Joseph panel is included as De'Rossi's self-portrait in *Five Hundred Self-Portraits*, ed. Ludwig Goldscheider (Vienna, 1937), fig. 94.

26 The translation is from Jane McIntosh Snyder, *The Woman and the Lyre: Women Writers in Classical Greece and Rome* (Carbondale, IL, 1989), pp. 18–19. An alternate translation is offered by Beecher and Ciavolella: "Yea, my tongue is broken, and through and through me / 'Neath the flesh, impalpable fire runs tingling; / Nothing see mine eyes, and a noise of roaring / Waves in my ears sounds: / Sweat runs down in rivers, a tremor seizes / All my limbs, and a paler than grass autumn. / Caught by pains of menacing death, I falter, / Lost in the love trance." For the complete poem, as well as Longinus's commentary on it (*On the Sublime*), see Ferrand, p. 40.

27 "Gli Dei fermo uguaglia, anzi si gode / Gaudio più che divin quei che sedente / Al tuo cospetto te rimira ed ode / Dolce ridente. / Che se l'altra ventura unqua mi tocca / D'esserti appresso, o mio soave amore. / Non io ti guardo ancor che su la bocca / La voce muore; / Fassi inerte la lingua, il pensier tardo. / Un sottil fuoco va di vena in vena, / Un gelido sudor tutta m'innonda, / Mi trema il cor, rabbrivida ogni membro; / Mancami il fiato, e pallida qual fronda / Morta rassembro." Costa, vol. 3, p. 34.

28 Hippocrates, *De natura hominis* in *Hippocrates*, ed. W. H. S. Jones (Cambridge, MA, 1962), 1.4. Also see *Epidemics*, 3.17b, and *Aphorisms*, 5.23.

29 Lucretius, *De rerum natura*, trans. W. H. D. Rouse (Cambridge, MA, 1975), 4, 1058–70, describes the "madness" and the "tribulation" of consuming love.

30 Aristotle, *Problems*, 30.953a 1–30. Also see *Problems* 4.884a30: "Why are the melancholic inclined to sexual intercourse? Is it because they are full of breath, and semen is an emission of breath?"

31 See Beecher's and Ciavolella's critical introduction to Ferrand, p. 61. Their introduction provides a detailed review of the history of lovesickness.

32 Aristotle, *De Anima* 1.4.408b 1–15 and 3.10.433a 15–16.

33 Aristotle, *On the Parts of Animals* 2.4.651a12. Not all authors agreed that the heart was the seat of melancholy. Effects of blood and the appetitive part of the liver were alternative suggestions.

34 Aristotle, *De anima* 3.3.429a.

35 Aristotle, *Metaphysics* 8.1050b 2.

36 Ficino, *Opera omnia*, 1576, pp. 286–7. Also see *Marsilio Ficino and the Phaedran*

Charioteer, ed. M. J. B. Allen (Berkeley and Los Angeles, 1981), pp. 65–129, and Schiesari, pp. 112–41.

37 Ficino, quoted in Schiesari, pp. 130–1.

38 Michelangelo Buonarroti in *Poesia Italiana del Cinquecento,* ed. G. Ferroni (Milan, 1978), p. 150.

39 Discussions of the "disease" and commentaries on the texts describing it are numerous. See, for example, Andre DuLaurens, *A Discourse of the Preservation of the Sight; of Melancholik Diseases; of Rheumes, and of Old Age,* trans. Richard Surphlet (London, 1599); Mario Equicola, *Libro di natura d' amore* (Venice, 1526); Marsilio Ficino, *Commentary on Plato's Symposium on Love,* trans. Sears R. Jayne (Dallas, 1985); R. Klibansky, E. Panofsky, and F. Saxl, *Saturn and Melancholy* (London, 1964); Ruth A. Fox, *The Tangled Chain: The Structure of Disorder in the Anatomy of Melancholy* (Berkeley and Los Angeles, 1976); Bernard Gorceix, "La melancholie au XVIe et XVIIe siècles: Paracelse et Jacob Böhme," *Recherches germaniques,* 9 (1979), 18–29; Ruth E. Harvey, *The Inward Wits: Psychological Theory in the Middle Ages and the Renaissance* (London, 1975); Stanley W. Jackson, *Melancholia and Depression from Hippocratic Times to Modern Times* (New Haven, 1986); Michel Foucault, *Madness and Civilization: A History of Insanity in the Age of Reason,* trans. Richard H. Howard (New York, 1965); Robert S. Kinsman, "Folly, Melancholy, and Madness: A Study in Shifting Styles of Medical Analysis and Treatment, 1450–1675" in *The Darker Vision of the Renaissance* (Berkeley and Los Angeles, 1974), pp. 273–320; John Charles Nelson, *Renaissance Theory of Love: The Context of Giordano Bruno's "Eroici fuori,"* (New York, 1963); Mario Pozzi, *Trattati d'amore del Cinquecento* (Rome, 1975); Hubert Tallenbach, *Melancholy: History of the Problem, Endogeneity, Typology, Pathogenesis, Clinical Considerations,* trans. Erling Eng, (Pittsburgh, 1980); and Juliana Schiesari, *The Gendering of Melancholia: Feminism, Psychoanalysis, and the Symbolics of Loss in Renaissance Literature* (Ithaca, NY, 1992).

40 Wack, p. 8. Also see Cadden, pp. 15–17.

41 During the nineteenth century the selective nature of these disorientations would become pronounced, prompting Mary Wollstonecraft, among others, to take issue with the alliances. "Wollstonecraft did not dispute the medical orthodoxy that decreed 'People of genius have very frequently impaired their constitutions.' But she refused to infer from this that 'men of genius have commonly weak, or, to use a more fashionable phrase, delicate constitutions.' Bodily strength and mental strength go together – in both men and women." See Battersby, p. 97.

42 Marinello, bk. III, chap. ii, p. 59r.

43 Summers, 1981, p. 116.

44 John Weyer, *De praestigiis daemonum,* 1563, cited in Schiesri, 1992, p. 14.

45 Aretino, quoted in Ferrand, p. 12.

46 Wack, p. 6.

47 Ovid, *Heroides and Amores,* trans. Grant Showermann (Cambridge, MA, 1986), 15.

48 See Howard Jacobson, *Ovid's "Heroides"* (Princeton, 1974); Sarah B. Pomeroy,

Goddesses, Whores, Wives, and Slaves: Women in Classical Antiquity (New York, 1975); Judith P. Hallet, "Sappho and Her Context: Sense and Sensuality," *Signs,* 4 (1979), 447–64; Eva Stehle Stigers, "Romantic Sensuality, Poetic Sense: A Response to Hallet on Sappho," *Signs,* 4 (1979), 265–71; Linda Kauffman, *Discourses of Desire: Gender, Genre, and Epistolary Fictions* (Ithaca, NY, 1986); and Joan DeJean, *Fictions of Sappho, 1546–1937* (Chicago, 1989).

49 DeJean, 1990, p. 67.

50 Costa, vol. 3, p. 34.

51 Ovid is explicit on this point, having Sappho, as she is poised to leap to her death, say, "My genius had its powers from him; with him they are swept away." *Heroides* 15.206.

52 Kathleen Barry, "The New Historical Syntheses: Women's Biography," *Journal of Women's History,* 1 (1990), 75–6.

53 I am grateful to Sheryl Reiss for informing me of the difference between these patient populations. The epitaph is in Giorgio Vasari, *Le vite de'più eccellenti pittori scultori e architetti nelle redazioni del 1550 e 1568* (Florence, 1976), vol. 4, p. 404. If De'Rossi's epitaph was here, it was not the only memorial to an artist placed here. A monument to Agostino Carracci was also destined for this site.

54 Borghini, bk. III, p. 428.

55 Bruni, bk. II, p. 72. *Delle Poesie del Signor Conte Ridolfo Campeggi,* pt. I (Venice, 1620), p. 2. *Splendore* was, after all, associated specifically with Aglaia, one of the three Graces, and thus with Venus, the paradigm of feminine *grazia.*

56 Ragg, p. 167.

5. LA DONNESCA MANO

1 The same auto-mimetic principle applies to architecture. "In paintings and buildings the wisdom and skill of the artist shines forth. Moreover we can see in them the attitude and the image, as it were, of his mind; for in these works the mind expresses itself not otherwise than a mirror reflects the face of a man who looks into it." Ficino, 1576, p. 229.

2 Malvasia, vol. 2, p. 385.

3 Carli quoted in Sohm, p. 794. The reference to Flemish style in this context echoes Michelangelo. See de Hollanda, 1928, p. 15. For an excellent discussion of gendered style applied to schools of painting and techniques (oil versus fresco), see Sohm, pp. 773–98.

4 Ficino, 1576, p. 1365.

5 See, for example, Zuccaro, p. 234. As Sohm, p. 790, points out, fresco painting was gendered masculine because "it demands decisiveness and prompt action." The same may be said of drawing. Indeed, while Pietro Testa tried to reconcile rather than polarize *disegno* and *colorito,* gender continued to inform critical language. For a transcription of and commentary on Testa's remarks, see Cropper, 1984, no. 61.2, pp. 252–3.

6 Zuccaro, p. 234. Also see Summers, 1981, p. 61.

7 The equation of grace with movement and *vivezza* as a sign of artistic excellence was nothing new. See Alberti, 1950, pp. 89–90.

8 De Hollanda, 1921, p. 59.

9 Vasari, 1906, vol. I, p. 174.

10 Vasari, vol. I, p. 174.

11 Vasari, vol. 6, p. 577. This idea was long-lived. See Pliny, *Natural History* 34.92: Callimachus's "attention to detail knew no limit . . . Also by this artist are the Laconian Dancers, a flawless work, but one in which attention to detail has taken away its charm [*gratiam omnem diligentia abstulerit*]."

12 Vasari, vol. 2, p. 171. This theme runs throughout the *Vite*. For Vasari, vol. 7, pp. 426–8, drawing was an inventive process, one which "fills the mind with good ideas."

13 Prior to the mid–sixteenth century, the term *divino* is, according to Kemp, p. 397, "applied to art or artists in a few spectacular instances – Marsuppini's epitaph for Brunelleschi and the assertions of the divine power of painting by Alberti and Leonardo – but only Giustiniani fully equates painting with poetic ideals of divine inspiration."

14 Armenini, bk. I, chap. ix, p. 75.

15 For an interesting twist on this, see June Wayne, "The Male Artist as a Stereotypical Female," *Art Journal*, 32(1973), 414–16.

16 Malvasia, vol. I, pp. 177–8.

17 Lanzi, vol. 3, p. 33.

18 Morigia, bk. V, chap. iii, p. 467. Attention to detail was believed to have particular appeal to certain audiences – women and nuns. Michelangelo's denigration of Flemish painting, as reported by de Hollanda, falls into this category.

19 Santagostino, p. 71.

20 In Sacchetti's *Trecento Novelle*, ca. 1390, the sculptor Alberto Arnaldo refutes the contention of other artists that "this art [painting] has grown and continues to grow worse day by day." He argues that excellent painters, "the Florentine women, whose skill in cosmetics corrects the defects of the greatest painter of them all, God," are at work as he speaks. Sacchetti is quoted in Millard Meiss, *Painting in Florence and Siena after the Black Death* (New York, 1951), p. 3. I am grateful to Paul Watson for directing my attention to this citation. For later negative connotations of the relationship between cosmetics and painting, see Jacqueline Lichtenstein, "Making up Representations: The Risks of Femininity," *Representations* 20 (1987), 77–87.

21 The terms *diligens* and *diligentia* were used in ancient art criticism to imply precision, often in terms of the application of some theoretical precept and sometimes in order to contrast a style that reflects a scrupulous adherence to rules with stylistic subjectivism. See Pollitt, pp. 351–7.

22 Vasari, vol. 4, pp. 321–2.

23 Vasari, vol. 6, p. 498, and vol. 5, p. 81.

24 Venturi, vol. 4, pp. 684–6.

25 Nicola Pio, *Le vite di pittori, scultori et architetti*, ed. Catherine Enggass and Robert Enggass (Vatican City, 1977), p. 206, and P. A. Orlandi, p. 334. Pietrantonio's remark is in *The Age of Correggio and the Carracci* (Washington, DC, 1986), p. 132.

26 Mazzolari, as quoted in Malvasia's *vita* of Fontana, vol. 1, p. 180. Pino, p. 36, identifies the suitable tools: the distaff and the spindle (*la conocchia e l'arcolaio*).

27 Baglione, pp. 136–7.

28 Pliny, *Natural History* 35. 148.

29 Malvasia, vol. 2, p. 389.

30 The same dichotomy is visible in Moroni's portraits, as may be seen by anyone looking at those hanging together in the Galleria Palatina, Palazzo Pitti, Florence.

31 Fontana's Santa Sabina altarpiece, like Ottaviano Leoni's in Santa Maria Maggiore, Rome (1598), was clearly influenced by Ludovico Carracci's 1594 painting of this theme, now in the Louvre. See *Ludovico Carracci*, ed. Andrea Emiliani (Bologna: Museo Civico Archeologico – Pinacoteca Nazionale, 1993), pp. 87–8. Fontana's composition is her own, differing from Ludovico's formally and in ethos.

32 For Gilio's ideas as they relate to contrapposto, see Summers, 1977, p. 343.

33 For the rules governing the construction of "la figura piramidale, serpentinata e moltiplicata," see Lomazzo, 1974, vol. 1, pp. 29–30. Also see John Shearman, *Mannerism* (Harmondsworth, UK, 1967), pp. 165–6; David Summers, "*Maniera* and Movement: The *Figura serpentinata*," *Art Quarterly*, 35 (1972), 269–301; and David Summers, "*Contrapposto*: Style and Meaning in Renaissance Art," *Art Bulletin*, 59 (1977), 336–61.

34 As Cantaro, pp. 194–5, and 310–12, nos. 5a17–20, notes, there is much extant documentation concerning Fontana's *Vision of Saint Hyacinth*.

35 Baldinucci, vol. 5, pp. 96–7; Baglione, p. 136. Both statements are reprinted in Cantaro, p. 326, no. 5b13 and p. 323, no. 5b11, respectively.

36 Given Giambologna's description of the work as "a small painting," he must have seen a finished study. According to Cantaro, p. 194, "del bozzetto purtroppo non vi e più traccia." For the full text of Giambologna's letter, see Cantaro, p. 310, no. 5a17.

37 For the full text of Rosati's letter, see Cantaro, pp. 311–12, no. 5a20.

38 C. Torre, *Il Ritratto di Milano* [1714], quoted in Caroli, 1989, p. 21.

39 Pino, p. 36. See note 29 to Chapter Two in the present volume.

40 Pino, p. 36.

41 Castiglione, bk. I, chap. 26, p. 35.

42 Armenini, bk. III, chap. xi, p. 190.

43 For information on Diana Scultori, see Massari, 1980 and 1993, pp. 141–66; Bellini, 1991; and Pagani, 1992.

44 Ananagi, 1904, p. 44.

45 Domenici, vol. 2, p. 350.

46 Moderata Fonte (Modesta da Pozzo), "Il merito delle donne" in *Donne e società nel seicento: Lucrezia Marinelli e Arcangela Tarabotti*, ed. Ginevra Conti Odoriso (Rome, 1979). Also see Patricia Labalme, "Venetian Women on Women: Three Early Modern Feminists," *Arte veneto*, ser. 5, 197 (1981), 89, and King, 1991, pp. 228–32.

47 Francesco Barbaro, *De re uxoria*, 1416, quoted in Jordan, p. 45.

48 Andrea Alciatus, *Emblematum libellus* (Paris, 1542), p. 106. Also see Alciati, *Emblems in Translation*, ed. Peter M. Daly (Toronto, 1985), emblem no. 196. Daly publishes four variations of the emblem, from different editions (Paris, 1536; Paris, 1542; Lyon, 1549; and Lyon, 1551). Christian writers could easily meld Plutarch's comment with biblical passages, such as I Timothy 2:11–12.

49 Paul Freart de Chantelou, *Diary of the Cavaliere Bernini's Visit to France*, trans. Margery Corbett (Princeton, 1985), p. 285.

50 For De'Rossi, Quistelli, and Nelli, see Vasari, vol. 5, pp. 78 and 80. Also for Nelli, see Lanzi, vol. 2, p. 87, and Orlandi, p. 436. For Robusti, see Ridolfi, vol. 2, pp. 71–2. For Anguissola, see Perlingieri, 1992, pp. 47–8. For Spilimbergo, see Atanagi, 1904, p. 144; Lomazzo, 1974, vol. I, p. 95; and Zaist, pp. 232–3.

51 Vasari, vol. 3, pp. 115–16.

52 Baxandall, 1972, p. 26.

53 Mercuriale's statement, made in reference to Fontana, is in a letter to the duke of Urbino, 18 June 1588. See Cantaro, pp. 308–9, no. 5a13.

54 Baldinucci, vol. 8, p. 208. The statement appears in his introduction to Sofonisba Anguissola: "ma io, che so che non solo non è cosa impossibile, nè anche cosa punto nuova, che un ben coltivato ingegno d'una femmina si renda in ogni facoltà maraviglioso, ogni qual volta, tolto da quelle umili applicazioni, alle quali per lo più vien condennato quel sesso, egli sia posto nella sua libertà."

55 Tassi, vol. I, pp. 224–5.

56 Pino, p. 36.

57 Domenici, vol. 3, p. 93.

58 Atanagi, 1904, p. 144.

59 Morigia, bk. V, chap. iii, p. 467.

60 Basso's letter, dated 1585, is quoted in Cantaro, p. 308, no. 5a11.

61 Vasari, vol. 5, p. 379.

62 Baglione, pp. 394–5. Also see Girolamo D'Adda, "A l'essai bibliographique des anciens modèles de lingerie, dentelles et tapisseries publiès en Italie aux XVI et XVII siècles," *Gazette des beaux-arts*, 17 (1864), 430–6, Dèsire Guilmard, *Les maitres ornemanistes* (Paris, 1880–1), vol. I, p. 298, and M. Jourdain, "The Lace Collection of Mr. Arthur Blackborne," *Burlington Magazine*, 5 (1904), 557–69. Guilmard, followed by Jourdain, confuses the identity of Parasole with "Lucrezia Romana" as the Florentine Lucrezia Quistelli.

63 I found the book in the Biblioteca Angelica, Rome, I.I.3. Perhaps Caterina Cantona, the Milanese "Minerva" of her time, used this technique in the many vestements she made for some thirty churches in and around her native city.

64 Biblioteca Vaticano, Barberini M.IV.28. Since the publication of this book it has come to my attention that the project is most probably an illustrated version of Francisco Hernandez's treatise on Mexican plant life. See Evelyn Lincoln on Parasole in *Dictionary of Women Artists*, ed. D. Gaze, London, 1997, vol. 2, p. 1069.

65 See *La natura morta al tempo di Caravaggio*, exhibition catalogue (Naples, 1995).

66 Norman Bryson, *Looking at the Overlooked* (Cambridge, MA, 1990), pp. 136–78, especially p. 64.

67 Morigia, bk. V, chap. xviii, pp. 495–6; Lomazzo, 1974, vol. I, p. 371; and Lomazzo, 1587, pp. 114–15.

68 Morigia, bk. V, chap. xviii, p. 496.

69 Nineteenth-century authors expanded the list. See, for example, Tommaso Trenta, vol. 8, pp. 122–3, for the following additions: Suor Aurlia Fiorentini,"who came to light in 1595"; Suor Lodovica Carli, "che esercitavasi nella pittura decorosamente verso il 1579"; Suor Brigida Franciotti, who assumed the habit at San Giorgio in 1532.

70 Mini, p. 108; Richa, vol. 8, p. 283.

71 Razzi, p. 369, refers to Cambi, Trabalesi, and Ruggieri as "pupils of the Prioress Plautilla [discepole della prefeta suor Plutilla]."

72 Razzi, p. 369; Richa, vol. 8, p. 283.

73 Sopriani, vol. I, p. 25, note b.

74 Those headed by Hildegard of Bingen (1098–1179) and Herrade of Landesberg (d. 1195) are two of the better-known medieval examples. One wonders what happened to Uccello's daughter. According to Vasari, vol. 2, p. 217, the painter taught her how to draw. In his notes to the *Vite*, Milanesi identifies her as Antonia (1456–91), a Carmelite nun.

75 Vasari, vol. 5, p. 80, and Razzi, p. 369.

76 See Lorenzo Polizzotto, "When Saints Fall Out: Women and the Savonarolan Reform in Early Sixteenth Century Florence," *Renaissance Quarterly*, 47 (1993), 486–525.

77 Chris Fischer, *Fra Bartolomeo, Master Draughtsman of the High Renaissance* (Seattle, 1990), p. 12.

78 Vasari, vol. 4, pp. 200–1.

79 Vasari, vol. 4, p. 195.

80 Baldinucci, vol. 2, pp. 589–90. Baldinucci claims Fra Bartolomeo left the drawings directly to Plautilla Nelli – an impossibility, since he died six years before her birth. As Fischer, p. 13, notes, this inaccuracy has been repeated.

81 See Milanesi's notes in Vasari, vol. 5, p. 79.

82 Since the writing of this text I have learned that the painting is in the Caserma adjacent to Sta. Maria Novella. My thanks to Andrée Hayum for this informa-

tion. In addition, a *Pentecost,* 1554, remains in situ, San Domenico, Perugia. Padre Serafini Siepi, *Descrizione topologico-istorica della città di Perugia,* ii, Perugia, 1822, pp. 516–17.

83 Marchese, vol. 2, p. 265.

84 Fischer, pp. 18–19.

85 Vasari, vol. 5, p. 80.

86 Boccaccio, p. 145.

87 According to Richa, vol. 8, p. 283, Nelli "è commendata particolarmente per la diligenza grande."

88 Marchese, vol. 2, p. 266.

89 Bocchi, pp. 8–9.

90 Vasari, vol. 5, p. 79.

91 Vasari, vol. 5, p. 79, describes the Santa Lucia painting as a Madonna and Child with multiple saints. Today this small church exists only as an apartment building at Via de'Rossi, 3. Razzi, p. 369, also mentions a painting (presumably the same one) at Santa Lucia. He is the source for the San Domenico reference.

92 Van Mander, 1618, fol. 116a.

93 De Hollanda, 1928, p. 15, and Sohm, p. 775–6.

94 For the art historical repercussions of this see Svetlana Alpers, "Art History and Its Exclusions: The Example of Dutch Art" in *Feminism and Art History: Questioning the Litany,* ed. Norma Broude and Mary Garrard (New York, 1982), pp. 183–200.

95 Sohm, pp. 775–84, relates this to the *colorire–disegno* debate. Also, see Patricia L. Reilly, "The Taming of the Blue: Writing out Color in Renaissance Theory" in *The Expanding Discourse, Feminism and Art History,* ed. Norma Broude and Mary Garrard (New York, 1992), pp. 87–100.

96 For a discussion of the aesthetics of detail, see Naomi Schor, *Reading in Detail: Aesthetics and the Feminine* (New York, 1987).

97 Domenici, vol. 2, p. 350.

98 Domenici, vol. 3, p. 93.

99 Although not an issue addressed by earlier writers on art, the relationship between melancholia, visions, and creativity is one deserving investigation. A point of departure would be the visionary Hildegard of Bingen, who discussed melancholy in relation to gender. See Schiesari, 1992, pp. 141–59.

100 See Zuan Antonio, *Vita della Beata Catherina Bolognese de lordini de la diva Clare Donne* (Bologna, 1502). The first biography of Caterina Vigri, *Specchio di Illuminazione,* which was written by her close friend Illuminata Bembo in 1469, specifically cites Caterina's visions as a source for her imagery. It was not published until 1787 (*Le Armi necessarie alla battaglia spirituale, opperetta composta da S. Catarina da Bologna alla quale si aggiunge lo Specchio di Illuminatzione sulla vita della medesima santa* [Bologna, 1787]).

101 Sopriani, vol. I, p. 25.

102 Razzi, p. 369. Also see P. Guglielmo M. Di Agresti, *Santa Caterina De'Ricci*, vol. I (Florence, 1963), and vol. 4 (Florence, 1966).

103 Masetti Zannini, pp. 131–2.

6. MISPLACED MODIFIERS

1 Written in 1542, *Dialogo* was published in 1548. Defining beauty is not, as Firenzuola notes, his true task, "Because when speaking with women it is necessary to speak a little more plainly." He will, therefore, "explain" rather than "define precisely." Firenzuola, 1992, p. 14.

2 Firenzuola, 1802, p. 54. "Questo splendor nasca da uno occulat proporzione e da una misura che non e ne nostri libri, la quale noi non conosciamo, anzi non pure imaginiamo, ed e, come si dice delle cose che noi non sappiama esprimere, un non so che."

3 See Cropper, 1976, pp. 374–94. Cropper's articles of 1976 and 1986 on artistic/feminine beauty are invaluable resources on the subject. They do much to sharpen the focus of all viewers looking at Renaissance paintings of women. More recently, Sohm, 1995, has extended the discussion into the areas of gender, criticism and technique.

4 Vasari, 1906 vol. 4, p. 9.

5 Dolce, 1910, p. 127. Petrarch's poem reads as follows: "E un non so che negli occhi, che in un punto / può far chiara la notte, oscuro il die, / E 'l mèle amaro, ed addoleir l'assenzio." For the reference to Parmigianino, see p. 135.

6 Firenzuola, 1992, p. 35, argues the same point in a different context. "Il Celso: grace is another thing I wanted to talk about with you, that grace is part of beauty, not of those who are handmaidens to Venus. Metaphorically, those Graces signify nothing more than the combined rewards given by grateful people in return for benefits already received . . . In affairs of the heart and matters of love many benefits accumulate between lovers, and they reward each other for them."

7 See Cropper, 1976, pp. 374–94.

8 Bandinelli's painted self-portrait is in the Isabella Stewart Gardener Museum, Boston; Vasari's self-portrait is in the Uffizi, Florence; Titian's are in the Gemäldegalerie, Berlin, and the Prado, Madrid. *Allegory of Prudence* is also a self-image by Titian. Bandinelli carved as well as painted his portrait. The images cited here are all formal in the manner of self-presentation. Self-portraits included in narratival programs, such as Vasari's self-portrait on the ceiling of the Sala del cinquecento, Palazzo Vecchio, Florence, belong in a separate category. Still, all forms of self-presentation, including the autobiographies of Vasari and Bandinelli, can be viewed as productions of identity.

9 Greenblatt, p. 2.

10 Although Giovio's text included lives of Leonardo, Michelangelo, and Raphael, these were not included in the published *Elogia* until 1772. See Paolo Giovio,

Opere, ed. Renzo Meregazzi (Rome, 1972), vol. 8, pp. 229–32. Giovio's Galleria dei Ritratti, in his villa facing Lake Como, contained multiple rooms dedicated to the exhibition of specific objects (antiquities, books) or images (portraits, *fantasie*). His *ritratti* were as much "portraits" of an artist's virtuosity as they were portraits of a specific sitter. See *Collezioni Giovio le immagini e la storia* (Como, 1983), pp. 40–8. The addition of portraits to the second edition of Vasari's *Vite* is the best example of the union of portrait and biography. In addition, Vasari included portraits of artists in the fresco cycles decorating his home. See Elizabeth McGrath, "The Painted Decoration of Rubens's House," *Journal of the Warburg and Courtauld Institutes,* 41 (1978), 245–77; Fredrika H. Jacobs, Vasari's Vision of the History of Painting: Frescoes in the Casa Vasari, Florence," *Art Bulletin,* 66 (1984), 399–416.

11 One was sent to Spain in 1550. A second painting, in which Titian portrayed himself with an image of Prince Philip (later Philip II), followed in 1552. See *Titian: Prince of Painters* (Venice, 1990), p. 338.

12 Cantaro, pp. 86–7. In 1713 the painting, signed and dated 1579, became part of Ferdinando de'Medici's collection, which in 1773 was transferred to the Galleria degli Uffizi, Florence.

13 For a concise review of the relationship between virtue and art, see Mendelsohn, pp. 47–52. That virtuosity could earn an artist noble rank is well known by the example of Titian. Vasari cites nearly twenty cases in which artists were rewarded for their talents through an elevation in social rank or by acquiring the material pleasures associated with it.

14 Greenblatt, p. 1.

15 Greenblatt, pp. 2–4.

16 Caro, vol. 2, pp. 308–9, no. 543.

17 Bottari-Ticozzi, vol. 5, p. 44. Manfredi's letter is also in Cantaro, p. 309, no. 5a14.

18 Campbell, p. 39.

19 A humorous and lascivious example which incorporates the (pro)creation metaphor is Pietro Aretino's *Ragionamento della Nanna e della Antonia* (Venice, 1534).

20 According to Vasari, vol. 6, p. 499, Pope Julius III and the archdeacon of the Cathedral of Piacenza had Anguissola self-portraits. Self-portraits by later women artists indicate that the popularity of these images continued to have special appeal. For example, more than a dozen self-portraits by Angelica Kauffmann (1741–1807) are extant.

21 Cantaro, p. 309, no. 5a14.

22 Manfredi threatens the artist with legal action: "se io, per essere finalmente sodisfatto, ricorrero con più aspra petizione a più rigoroso tribunale, che quello non e della cortesia."

23 Cantaro, pp. 308–9, no. 5a13: "questa Pittrice Eccellente per dire le vero in ogni conto si prevale della condizione del sesso, e della rarità della persona." Also see

Mercuriale's earlier letter of 30 April 1588, Cantaro, p. 308, no. 5a12. By attributing Fontana's tardiness to the condition of her sex, Mercuriale adopts the essentialist belief that femaleness and retentiveness go hand in hand.

24 Manfredi, 1580, p. 234.

25 Cicero, *De inventione rhetorica* 2.1.1–3. The story is recounted by numerous Renaissance writers, including Petrarch, *Africa* 4; Ariosto, *Orlando Furioso*, bk. XI, line 71; Castiglione, *Il Cortegiano*, bk. I, chap. 54, p. 69; Borghini, *Il Riposo*, bk. II, p. 32; Armenini, *De'veri precetti*, bk. III, chap. xv, p. 208.

26 Alberti, 1950, pp. 107–8.

27 Angela Rosenthal, "Angelica Kauffmann Ma(s)king Claims," *Art History*, 15 (1992), 38–59.

28 Rosenthal, p. 47.

29 See the discussion of analogy and (a)historical place in Chapter Two of the present volume.

30 Cochrane, p. 400. Cochrane, pp. 393–422, provides a concise and informative discussion of history and biography in the Renaissance and explains how art historical writing fused the two disciplines. Also see Charles Stinger, *Humanism and the Church Fathers: Ambrogio Traversari* (Albany, 1977), p. 77, for the influence of Diogenes.

31 Goldstein, 1991, especially pp. 646–7, provides a concise overview of the characteristics of the artist. As Goldstein points out, not all artists demonstrate these lofty virtues. Those who do not nonetheless serve the same didactic function. Their weaknesses, moral and/or artistic, underscore the strengths of the ideal artist, personified by men such as Donatello and Michelangelo. For overviews on the epideictic, see T. C. Burgess, *Epideictic Literature*, University of Chicago Studies in Classical Philology, no. 3 (Chicago, 1902), pp. 89–261; and O. B. Hardison, *The Enduring Monument: A Study of the Idea of Praise in Renaissance Literary Theory and Practice* (Chapel Hill, 1962).

32 The closest one gets is Vasari's remarks about the third of the Anguissola sisters, "called Europa, [who] is still a child in age. To her, a girl full of grace and talent [tutta grazia e virtù], I have spoken this very year, and, in so far as one can see from her works and drawings, she will be in no way inferior to Sofonisba and Lucia." Vasari, vol. 6, p. 501.

33 Castiglione, bk. III, chap. 4, p. 172.

34 Vasari, vol. 5, p. 81.

35 Vasari, vol. 5, p. 77. Emphasis added.

36 Trissino, vol. 2, p. 272. Trissino's list follows first his review of the Zeuxis story and then Petrarch's description of Laura. Pino, p. 27.

37 Firenzuola, 1992, p. 26. Bruni, bk. II, pp. 72–3.

38 Lamo in Zaist, vol. I, p. 39.

39 Campeggi, p. 101. Malvasia in Atanagi, 1561, p. 25.

40 Atanagi, 1904, pp. 147–8.

41 Pollitt, pp. 297–9, 380–1. The passage from Homer, which is cited by Pollitt, is *Odyssey* 6.232.

42 Pliny, *Natural History* 35. 79.

43 Pliny, *Natural History* 35. 95.

44 Pliny, *Natural History* 35. 86.

45 For Castiglione and the problems raised by the complexities of this triad, see Cropper, 1986, pp. 181–2.

46 G. Cugnoni, "Agostino Chigi il Magnifico," *Archivio della Società romana di storia patria*, 2 (1879), pp. 62 and 486–7. Also see David Cast, *The Calumny of Apelles: A Study in the Humanist Tradition* (New Haven, 1981), pp. 189–91.

47 Danti, *Il primo Libro del trattato delle perfette Proporzioni* in Barocchi, 1960, vol. 1, p. 230. Quintilian, *De institutio oratoria*, 12.10.6.

48 As Sohm, p. 770, notes, "Vasari mentions [grazia] twelve times in [the] short preface [to Part III of the *Vite*] in relation to sixteenth-century art, but never in relation to fifteenth-century art."

49 Cropper, 1986, pp. 179–81.

50 Patricia Emison, "Grazia," *Renaissance Studies*, 5 (1991), 436. Also see Marina Warner, *Monuments and Maidens: The Allegory of the Female Form* (New York, 1985).

51 See Amedeo Quondam, *Il naso di Laura, lingua e poesia lirica nella tradizione del classicimo* (Ferrara, 1991), especially pp. 83–95 ("Classicismo e imitazione nell 'ut pictura poesis'") and pp. 153–79 ("1529: le *Rime* di Giovan Giorgio Trissino").

52 Rogers, pp. 292, 300–3.

53 The definition of "prosopopoeia" is that of Paul de Man (*The Rhetoric of Romanticism*, 1984), quoted in Barkin, p. 144. John Shearman, pp. 46–50, discusses the conversational relationship between speaking statues (*statue parlanti*) and spectators.

54 Barkin, p. 146.

55 Cropper, 1986, pp. 175–90. Rogers, pp. 291–305.

56 Vasari, vol. 6, p. 349.

57 *Della nobilità et eccellenza della donne* (Venice, 1544), p. 8r. "Si che l'huomo è l'opera della natura, & la donna l'artificio d'Iddio."

58 Lomazzo, 1974, vol. 2, pp. 35 and 97.

59 Firenzuola, 1992, pp. 14 and 11.

60 Castiglione, bk. I, chap. 14, p. 23, and bk. I, chap. 21, p. 31. Also see Eduardo Saccone, "*Grazia, sprezzatura, affettazione* in the *Courtier*" in *Castiglione: The Ideal and the Real in Renaissance Culture*, ed. Robert W. Hanning and David Rosand (New Haven, 1983), pp. 45–68.

61 Leo Spitzer, *Classical and Christian Ideas of World Harmony* (Baltimore, 1963), p. 62.

62 Varchi, "Discorso della bellezza e della grazia" in *Opere*, 1834, vol. I, p. 294. Danti in Barocchi, 1960, vol. I, p. 229.

63 Leone Ebreo, *Dialoghi d'amore*, ed. S. Caramella (Bari, 1929), pp. 226–7. Also see Summers, 1987, pp. 215–16.

64 Plato, *Ion* 535b–536a, uses the power of a magnet attracting iron rings to itself as the metaphor to explain this.

65 Vasari, vol. 3, p. 108.

66 Vasari, vol. 4, p. 373.

67 Vasari, vol. 4, p. 17.

68 Vasari, vol. 4, p. 38.

69 On this point the Virgin's inspiring appearance to Saint Luke deserves consideration. Having painted his vision, Saint Luke went on to become the patron of painters. A favorite subject of painters, the Vision of Saint Luke was full of metaphorical significance for all who painted it. In the spirit of *ut pictura poesis*, poets also found the theme appealing. Campeggio, for example, wrote a series of poems on Saint Luke's portrait of the Virgin Mary. See Ridolfo Campeggi, *Delle Poesie* (Venice, 1620), pp. 253–63.

70 For Bernardo Bellincioni, "On Leonardo da Vinci's Portrait of Cecilia Galleriani," see Rogers, pp. 300–1.

71 See Alberti, 1972, p. 88. The distinction resides in Firenzuola's division of beauty into six qualities: three refer generally to the visible body and three to a more transcendent beauty.

72 Atanagi, 1561, p. 121. In Dolce's poem, Spilimbergo, if not displaced as the subject being honored, has been reduced to an object (Titian's painting of her) that proves Titian's artistic virtuosity.

73 Aretino, *Ragionamento della Nanna e della Antonia*, [1534], quoted in Sohm, p. 799. "Placing his paintbrush, which he first moistened with spit, in her tiny color cup, he made her twist and turn as women do in the birth throes [Nol consumò miga: che posta il suo pennello nello scudellino del colore, umiliatolo prima con lo sputo, lo faceva torcere nella guisa che si torceno le donne per le doglie del parto o per il mal della madre]." Vigée Lebrun (1755–1842) saw the rapport between portraitist and sitter from a different perspective. "As soon as I observed any intention on their part [a male sitter] of making sheep's eyes at me, I would point them looking in another direction." Marie Louise Vigée Lebrun, *Memoirs of Madam Vigée Lebrun* (New York, 1903), p. 12.

74 Castiglione, bk. III, chap. 4, p. 172.

75 For the complete poem, see Rogers, p. 302.

76 According to Galli, pp. 8–9, Manfredi made similar "usurious" exchanges with Baubet of Mantua and Francesco Longhi of Ravenna.

77 Manfredi, 1606, pp. 202–3 and 228–9.

78 Firenzuola, 1552, pp. 45v–46r.

79 Firenzuola, 1552, p. 10r and 1992, p. 13.

80 Trissino, vol. 2, p. 271.

81 Luigini, p. 8. Also see Summers, 1981, pp. 186–99.

82 Naomi Yavneh, "The Ambiguity of Beauty in Tasso and Petrarch" in Turner, p. 139.

83 Paintings attributed to her, primarily on the basis of anecdotal evidence, include a Saint Sebastian for the Church of S. Mauro in Izola, or Isola d'Istria, in the former Yugoslavia, which has been rejected by Zotti on grounds of decorum; a baccanal; and various treatments of the story of Noah and the Flood. See Ruggiero Zotti, *Irene di Spilimbergo* (Udine, 1914), pp. 33–7. An alleged self-portrait is in storage at the Museo Civico, Padua.

84 Borghini, bk. III, p. 86.

85 Borghini, bk. III, p. 91.

86 Ridolfi, vol. 2, p. 80.

87 Borghini, bk. III, p. 91. Also see Ridolfi, vol. 2, p. 79.

88 Castiglione, bk. III, chap. 9, p. 177.

89 Vasari, vol. 5, p. 75.

90 Atanagi, 1904, p. 144. Also see Anne Jacobson Schutte, "Irene di Spilimbergo: The Image of a Creative Woman in Late Renaissance Italy," *Renaissance Quarterly*, 44 (1991), 42–61, especially pp. 50–1.

91 For example, Gradinico da Padoa in Atanagi, 1561, p. 98.

92 The most frequently illustrated Anguissola at the keyboard is in the Collection of Earl Spencer, Althorp, UK. A version of it from the Anguissola sister circle is in Goodwood House, Goodwood, UK. The image may depict Sofonisba's artist sister Lucia. A third self-portrait, minus the maidservant, is in Gallerie di Capodimonte, Naples.

93 This is not to say that all male artists were one-sided in their talents. According to Vasari, vol. 4, p. 92, Giorgione "was extremely fond of the lute, which he played so beautifully to accompany his own singing that his services were often used at music recitals and social gatherings." Also, says Vasari, vol. 4, p. 18, Leonardo "for a little while attended to music, and then he very soon resolved to learn to play the lyre, for he was naturally of an elevated and refined disposition; and with this instrument he accompanied his own charming improvised singing." It should be noted that similar images were painted by *pittori*, as Domenico Brusasorci's *Self-Portrait* (Verona: Museo del Castelvecchio, 1560s) demonstrates.

94 Domenici, vol. 2, pp. 347–8.

95 Bembo as quoted in David Rosand, "*Ermeneutica Amorosa*: Observations on the Interpretations of Titian's Venuses" in *Tiziano e Venezia. Convegno Internazionale di Studi, Venezia* (Vicenza, 1976), pp. 379–80. "che io sia contento che tu impari di sonar di monacordia, ti fo intender quello che tu forse per la tua troppo tenera età non puoi sapere: che il sonare è cosa donna vana et leggera. Et io vorrei che tu fossi la più gentile e la più casta et pudica donna che viva . . . e contentati nell'essercitio delle lettere et del cucire."

96 A second version, copied after the one in the Galleria dell'Accademia di San Luca, is in the Corridoio Vasariano, Galleria degli Uffizi, Florence. See Cantaro, p. 74. The existence of several versions suggests the image may have been used to

publicize Fontana's abilities. It has been argued that Amilcare Anguissola used his daughter's self-portraits for promotional purposes. See *Sofonisba Anguissola: A Renaissance Woman* (Washington, DC, 1995, p. 46).

97 Castiglione, bk. III, chap. 9, p. 177.

98 For Chacon's letter, see Cantaro, p. 305, 5a5.

99 Vasari, vol. 4, p. 8.

100 Garrard, 1994, pp. 589–97.

101 For the sexual symbolism of musical instruments, see E. Winternitz, *Musical Instruments and Their Symbolism in Western Art: Studies in Musical Iconography* (New Haven, 1979), pp. 48–56.

102 Garrard, 1994, p. 591.

103 Garrard, 1994, pp. 591–5.

104 Borghini, bk. III, p. 91, "saper sonare di gravicembolo, di liuto, e d'altri strumenti."

105 Ridolfi, vol. 2, p. 72.

106 My thanks to Jessie Ann Owens and John Guillory for discussing this aspect of the painting with me.

107 Garrard, 1994, p. 596, note 78, also expresses reservations concerning the attribution of the painting but does so for other reasons.

108 The question, I would argue, is all the more valid in view of Tintoretto's painting of *Venus, Vulcan and Cupid*, Galleria Palatina, Palazzo Pitti, Florence. The similarity in face and hair style between Venus and Marietta is unmistakable.

109 Salviati's letter, which appeared in Baldinucci's *Notizie de'professori del disegno da Cimabue in Qua*, is quoted in Caroli, 1987, p. 36: "se dall'opere che vegghiamo qui, con meraviglia, di mano della bella pittrice cremonese vostra fattura, si può fare congettura del bell'intelletto vostro." The idea is also found in Lamo, p. 35.

110 For an in-depth discussion of this work, see Garrard, 1994, especially pp. 556–66. Her reading of this painting within the context of women's self-portraits is critical to any discussion of fashioning.

111 Garrard, 1994, p. 564.

112 Garrard, 1994, p. 565.

113 Garrard, 1994, p. 566.

114 Vasari, vol. 5, pp. 81 and 358.

115 See note 100 to this chapter.

116 Garrard, 1994, p. 564, citing Pino, sees the mahlstick as a revealing sign, for it "sometimes connoted artistic timidity or preoccupation with detail." Given Malvasia's contention that timidity is characteristic of a feminine style, Anguissola's decision to give Campi this tool is an inversion of the association. Garrard extended this inversion by pointing to Anguissola's choice of black clothing, but in a lecture at the National Museum of Women in the Arts (Washington, D.C., 6 May 1995), Martha A. McCrory identified Sofonisba's "smock" as a fashionable *sopra veste.*

7. FEMMINA MASCULO E MASCULO FEMMINA

1 Vasari, 1906, vol. 6, p. 501, refers to Anguissola as a "virtuosa"; vol. 6, pp. 498–9, he admires her capacity to create images "that seem truly alive"; vol. 5, p. 81, he credits her with stylistic grace unmatched by other women artists.

2 Tasso, 1724, vol. 3, p. 324.

3 Vasari, vol. 5, p. 80.

4 Vasari, vol. 5, p. 80.

5 Vasari, vol. 5, p. 75.

6 Vasari, vol. 5, p. 75, calls her a "virtuosa"; Mazzoni-Toselli, vol. 2, p. 102, cites the designation in criminal records.

7 Bottari-Ticozzi, vol. 5, p. 44, and Cantaro, p. 309, 5a14.

8 For references to Properzia's "beautiful body," see Vasari, vol. 5, p. 75, and Borghini, bk. III, p. 427.

9 For Robusti's beauty, see Borghini, bk. III, p. 91; for her musical virtuosity, see Ridolfi, p. 79.

10 Gratiano, bk. IV, pp. 22–3. Also see Morigia, bk. III, chap. 3, p. 467, on the "gentilissima e virtuosissima" Fede Galizia, "virtuosa" and "figlia del virtuoso."

11 Baldinucci, 1811, vol. 8, p. 226.

12 Sopriani, vol. I, p. 412; Zaist, vol. I, p. 233.

13 Plutarch, *Mulierum virtutis* 243A.

14 Margaret I. King, "Book-Lined Cells: Women and Humanism in the Early Italian Renaissance," in Labalme, p. 75. Lisa Tickner considers similar issues in the context of "the tangled relations between modernism and sexual difference." See her "Men's Work? Masculinity and Modernism" in *Visual Culture, Images and Interpretations*, ed. N. Bryson, M. A. Holly, and K. Moxey (Hanover, NH, 1994), pp. 42–82.

15 Although some sixteenth-century theorists, like Colombo, mocked the theory, claiming that Mondino "might as well have called them porches or bedrooms," others did not. See Matteo Renaldo Colombo, *De re anatomica* (Venice, 1559), II.16, pp. 447–8.

16 For a discussion of medieval ideas on this subject, see Cadden, pp. 198–202.

17 Guilhelmus de Mirica's chapters (Bodleian Library, MS canon. misc. 350, fols. 94v–96v) are cited in Cadden, p. 202.

18 As Evelyne Berriot-Salvadore, "The Discourse of Medicine and Science," notes in Davis and Farge, vol. 3, pp. 357–8, self-determination, or a female's desire to attain the virile perfection she lacked, was also factored into the equation of sex origin. "In 1624 Guy Patin wrote a thesis on the subject 'Can woman transform herself into man?' and although his answer was negative, it implied that the question remained open."

19 See note 29 to Chapter Two of the present volume.

20 Equicola, *Libro di natura d'amore* in Barocchi, 1971–6, vol. 2, p. 1617.

21 Aretino, 1945, p. 137.

22 Dolce, 1910, p. 209, expresses this in a letter to Alessandro Contarini.

23 Aretino, 1957, vol. I, p. 175.

24 Vasari uses this phrase in his life of Giulio Romano in the first edition of the *Vite.* Vasari, 1986, p. 828.

25 Aretino, 1957, vol. I, p. 175.

26 Given the ambiguity of the Greek *mimesthai*, which refers to the creation of a new object and the copying of a preexisting one, this is logical. See G. Gebauer and C. Wulf, *Mimesis: Culture, Art, Society* (Berkeley and Los Angeles, 1995).

27 For variations as well as replications of *Laocoon* and *Spinario* see Bober and Rubinstein, pp. 154–5 and 236.

28 An example is the anonymous bronze figure in the Museo Nazionale del Bargello, Florence, inv. no. 60.

29 See Bober and Rubinstein for an indispensable census of classical works known in the Renaissance.

30 See Barkin, pp. 133–66.

31 See Francis Haskel and Nicholas Penny, *Taste and the Antique* (New Haven, 1981), p. 169.

32 Castiglione, bk. III, chap. 4, p. 172. The only two illustrations of undissected forms, "Nude Male" and "Nude Female," in Vesalius's *Epitome*, visualize the difference Castiglione describes.

33 Vasari, vol. I, p. 173.

34 Firenzuola, 1992, p. 63. Also see Cropper, 1976, pp. 379–82. *De L. Vitruvio Pollione de architectura libri dece, traducti de latino in vulgare, affigurati, commentati da C. Cesariano* (Como, 1521). Ingrid Rowland notes the relevance of Vitruvius to human form in Raphael's fresco *Fire in the Borgo*, Stanza dell'Incendio, in "Raphael, Angelo Colocci, and the Genesis of the Architectual Orders," *Art Bulletin*, 76 (1994), 95–6.

35 See Emison, pp. 438–9.

36 The description is that of Pietro Bembo, *Gli Asolani*, bk. III, p. 467. Also see Giorgio Santangelo, *Il Petrarchismo del Bembo e di altri poeti del '500* (Rome, 1962), p. 99; and Emison, p. 438.

Bibliography

All references to Plato and Aristotle are to the Loeb Classical Library editions, Cambridge, MA, 1959–75.

Alberti, Leon Battista. *The Family in Renaissance Florence.* Trans. Renee New Watkins. Columbia, SC, 1969.

"On Painting" and "On Sculpture." Ed. and trans. Cecil Grayson. London, 1972.

Alidosi, Nicolò Pasquali. *Instruttione delle cose notabili della città di Bologna.* Bologna, 1621.

Allen, Jeffner and Iris Marion Young, eds. *The Thinking Muse: Feminism and Modern French Philosophy.* Bloomington, 1989.

Amorini, A. *Vite dei pittori ed artefici bolognese.* Bologna, 1843.

Aretino, Pietro. *Lettere.* Ed. Sergio Ortolani. Turin, 1945.

Aretino, Pietro. *Lettere sull'arte.* Ed. E. Camesasca. Milan, 1957.

Sei giornate. Ragionamento della Nanna e della Antonia. [1534]. *Dialogo nel quale la Nanna insegna a la Pippa.* [1536]. Ed. Giovanni Aquilecchia. Bari, 1969.

Armenini, Giovambattista. *De'veri precetti della pittura.* Ravenna, 1586.

L'Atanagi da Cagli. Ed. D. A. Tarducci. Cagli, 1904.

Atanagi, Dionigi, ed. *Rime di diversi nobilissimi, et eccellentissimi autori – in morte della Signora Irene delle Signore di Spilimbergo.* Venice, 1561.

Autoritratti dagli Uffizi da Andrea del Sarto a Chagall. Florence, 1990.

Baglione, Giovanni. *Le vite de'pittori, scultori, architetti ed intagliatori. dal Pontificato di Gregorio XIII. del 1572. fina a' tempi di Papa Urbano VIII. nel 1642.* Naples, 1733.

Baldinucci, Filippo. *Lezione di Filippo Baldinucci.* Florence, 1692.

Notizie de'professori del disegno da Cimabue in qua. In *Opere di Filippo Baldinucci.* 14 vols. Milan, 1808–12.

Barkin, Leonard. "The Beholder's Tale: Ancient Sculpture, Renaissance Narratives." *Representations,* 44 (1993), 133–66.

Barocchi, Paola, ed. *Scritti d'arte del cinquecento.* 3 vols. Milan, 1971–6.

Trattati d'arte del cinquecento fra manierismo e Contrariforma. 3 vols. Bari, 1960.

Barolsky, Paul. *Giotto's Father and the Family of Vasari's "Lives."* University Park, PA, 1992.

Michelangelo's Nose: A Myth and Its Maker. University Park, PA, 1990.

Battersby, Christine. *Gender and Genius: Towards a Feminist Aesthetic.* Bloomington, 1989.

Bauer, Robert J. "A Phenomenon of Epistemology in the Renaissance." *Journal of the History of Ideas,* 31 (1970), 281–8.

Baxandall, Michael. *Giotto and the Orators.* Oxford, 1971.

Painting and Experience in Fifteenth Century Italy. Oxford, 1972.

Bellini, Paolo, ed. *L'opera incisa di Adamo e Diana Scultori.* Vicenza, 1991.

Bembo, Pietro. *Prose della volgar lingua, Gli Asolani, rime.* Ed. Carlo Dionisotti. Turin, 1966.

Benson, Pamela Joseph. *The Invention of the Renaissance Woman: The Challenge of Female Independence in the Literature and Thought of Italy and England.* University Park, PA, 1991.

Bianconi, Giovanni Giuseppe. *Descrizione di alcuni minutissimi intagli di mano di Properzia De'Rossi.* Bologna, 1829.

Boase, T. S. R. *Giorgio Vasari: The Man and the Book.* Princeton, 1979.

Bober, Phyllis Pray and Ruth Rubinstein. *Renaissance Artists and Antique Sculpture.* London, 1986.

Boccaccio. *De claris mulieribus.* Naples, 1836.

Concerning Famous Women. Trans. G. Guarino. Princeton, 1963.

Bocchi, Francesco. *Le bellezze della citta Fiorenza.* Florence, 1591.

Bonafede, C. *Cenni biografici e ritratti d'insegni donne Bolognese.* Bologna, 1845.

Bonetti, G. "Nel centenario di Sofonisba Anguissola." *Archivio istorico lombardo,* 55 (1928), 285–306.

"Sofonisba Anguissola, 1531–1625," *Bolletino storico cremonese,* 2 (1932), 109–52.

Borghini, Raffaello. *Il Riposo.* Reggio, 1826.

Borsieri, Girolamo. *Il supplemento della nobilità di Milano.* Milan, 1619.

Bottari, Giovanni Gaetano and Stefano Ticozzi. *Raccolta di lettere sulla pittura, scultura ed architettura scritti da'più celebri personaggi dei secoli XV, XVI, e XVII.* 8 vols. Milan, 1822–5.

Boylan, Michael. "The Galenic and Hippocratic Challenges to Aristotle's Conception Theory." *Journal of the History of Biology,* 17 (1984), 83–112.

Brown, Peter. *The Body and Society.* New York, 1986.

Bruni, Domenico. *Difese delle donne.* Milan, 1559.

Bullough, Vern L. "Medieval Medical and Scientific Views of Women." *Viator,* 4 (1973), 485–501.

Bumaldi, Giovanni Antonio. *Minervalia bonon. Civium anademata seu Biblioteca Bononiensis.* Bologna, 1641.

Cadden, Joan. *Meanings of Sex Difference in the Middle Ages.* Cambridge, 1993.

Campbell, Lorne. *Renaissance Portraits: European Portrait-Painting in the Fourteenth, Fifteenth and Sixteenth Centuries.* New Haven, 1990.

Campeggi, Ridolfo. *Delle Poesie del Signor Conte Ridolfo Campeggi.* Venice, 1620.

Campi, Antonio. *Cremona fedelissima citta.* Cremona, 1585.

I Campi e la cultura artistica cremonese del Cinquecento. Milan, 1985.

Cantaro, Maria Teresa. *Lavinia Fontana bolognese "pittora singolare."* Milan, 1989.

Caro, Annibale. *Lettere familiare.* Ed. Aulo Greco. Florence, 1959.

Caroli, Flavio. *Fede Galizia.* Turin, 1989.

Sofonisba Anguissola e le sue sorelle. Milan, 1987.

Storia della fisiognomica, arte e psiologia da Leonardo a Freud. Milan, 1995.

Castiglione, Baldassare. *Il Cortegiano.* Florence, 1854.

Cavatelli, Lodovico. *Annales. Quibus res ubique gestae memorabiles à Patria.* Cremona, 1588.

Celio, Gaspare. *Memorìa delli nomi dell'artefici delle pitture, che sono in alcune chiese, facciate, e palazzi di Roma.* [1638]. Milan, 1967.

Chadwick, Whitney. *Women, Art and Society.* London, 1990.

Cheney, Liana DeGirolamo. "Barbara Longhi of Ravenna." *Women's Art Journal,* 9 (1988), 16–20.

Choulant, J. L. *A History and Bibliography of Anatomic Illustrations.* New York, 1962.

Cochrane, Eric. *Historians and Historiography in the Italian Renaissance.* Chicago, 1981.

Colleoni da Bergamo, Celestino. *Breve ragguaglio del tempo in cui vennero a Bergamo I Cappuccini.* Brescia, 1622.

Collezioni Giovio le immagini e la storia. Como, 1983.

Comanini, Gregorio. *Il figino, overo del fine della pittura.* Mantua, 1591.

Conti Odorisio, Ginevra. *Donna e società nel seicento. Lucrezia Marinelli e Arcangela Tarabotti.* Rome, 1979.

Costa, Paolo. *Opere complete.* Florence, 1839.

Crespi, Luigi. *Vite de'pittori bolognese.* Rome, 1769.

Cropper, Elizabeth. "On Beautiful Women, Parmigianino, *Petrarchismo,* and the Vernacular Style." *Art Bulletin,* 58 (1976), 374–94.

 "The Beauty of Women: Problems in the Rhetoric of Renaissance Portraiture." In *Rewriting the Renaissance: The Discourses of Sexual Difference in Early Modern Europe,* ed. Margaret W. Ferguson, Maureen Quilligan, and Nancy J. Vickers, pp. 191–205. Chicago, 1986.

 The Ideal of Painting: Pietro Testa's Dusseldorf Notebook. Princeton, 1984.

Dardano, Luigi. *La bella e dotta difesa delle Donne in verso, e prosa.* Venice, 1554.

Davis, Natalie Zemon and Arlette Farge, eds. *A History of Women in the West.* Vol. 3, *Renaissance and Enlightenment Paradoxes.* Cambridge, MA, 1993.

De Los Santos, F. *Descripcion del real Monasterio de S. Lorenzo del Escorial.* [1681]. Ed. F. A. Ximenez. Madrid, 1764.

Dolce, Ludovico. *Dialogo della pittura.* [1557]. Florence, 1735.

Dolce, Ludovico. *L'Aretino, Dialogo della pittura con l'aggiunta di varie lettere.* Florence, 1910.

Domenichi, Lodovico. *La nobilità delle donne.* Venice, 1551.

Domenici, Bernardo De. *Vite de'pittori scultori ed architetti Napoletani.* [1742]. Naples, 1843.

Delle donne illustri italiane dal XIII al XIX secolo. Rome, 1855.

Dunstan, G. R., ed. *The Human Embryo: Aristotle and the Arabic and European Traditions.* Exeter, 1990.

Emison, Patricia. "Grazia," *Renaissance Studies,* 5 (1991), 427–60.

Faberio, Lutio. *Il funerale di Agostino Carraccio in Bologna sua patria da gli Incamminati. Accademia del Disegno. Oratione di Lutio Faberio Accademico Gelato in Morte di Agostin Carraccio.* Bologna, 1603.

Ferrand, Jacques. *A Treatise on Lovesickness.* Trans. and ed. Donald A. Beecher and Massimo Ciavolella. Syracuse, NY, 1990.

Ficino, Marsilio. *The Book of Life (Liber de vita)*. Trans. Charles Boer. Irving, TX, 1980.
 Opera omnia. Basel, 1576.

Filarete. *Trattato di architettura*. Ed. Maria Finoli and Liliana Grassi. Milan, 1972.

Firenzuola, Agnolo. *On the Beauty of Women*. Trans. and ed. Konrad Eisenbichler and
 Jacqueline Murray. Philadelphia, 1992.
 Dialogo delle bellezze delle donne. [1548]. Venice, 1552.
 Opere. Pisa, 1816.

Fortunati, Vera, ed. *Lavinia Fontana, 1552–1614*. Milan, 1994.

Fortunati Pietrantonio, Vera. "Per una storia della presenza femminile nella vita
 artistica del cinquecento bolognese: Properzia De Rossi 'Schultrice.'" *Il Carrobbio*,
 7 (1981), 167–77.
 Pittura bolognese del '500. Bologna, 1986.

Freedberg, David. *The Power of Images: Studies in the History and Theory of Response*. Chicago,
 1989.

Freedberg, Sidney J. *Painting in Italy, 1550–1600*. Harmondsworth, UK, 1970.

Fumerton, Patricia. *Cultural Aesthetics, Renaissance Literature and the Practice of Social Ornament*.
 Chicago, 1991.

Galante, Gennaro Aspreno. *Guida sacra città di Napoli*. [1873]. Ed. Nicola Spinosa.
 Naples, 1985.

Galen. *On the Natural Faculties*. Trans. A. J. Brock. Cambridge, 1963.
 Opera omnia. Ed. C. G. Kuehn. Hildesheim, 1964.

Galli, Romeo. *Lavinia Fontana pittrice, 1552–1614*. Imola, 1940.

Garrard, Mary. *Artemisia Gentileschi*. Princeton, 1988.
 "Artemisia Gentileschi's Self-Portrait as the Allegory of Painting." *Art Bulletin*, 62
 (1980), 97–112.
 "Here's Looking at Me: Sofonisba Anguissola and the Problem of the Woman
 Artist." *Renaissance Quarterly*, 47 (1994), 556–622.
 "Leonardo da Vinci: Female Portraits, Female Nature." In *The Expanding Discourse:
 Feminism and Art History*, ed. Norma Broude and Mary Garrard, pp. 58–85. New
 York, 1992.
 "The Liberal Arts and Michelangelo's First Project for the Tomb of Julius II (with a
 Coda on Raphael's *School of Athens*)." *Viator*, 15 (1984), 335–76.
 Review of Laura M. Ragg, *Women Artists of Bologna* (1907). In *Women's Art Journal*, I
 (1980–1), 58–64.

Gauricus, Pomponius. *De Sculptura seu statuaria libellus*. [1504]. Ed. A. Chastel and
 R. Klein. Geneva, 1969.

Giordani, Gaetano. *Notizie sulle donne pittrici di Bologna*. Bologna, 1832.

Giovio, Paolo. *Elogia virorum illustrium*. In *Opera*. 8 vols. Ed. Renzo Meregazzi. Rome,
 1972.

Goldstein, Carl. "Rhetoric and Art History in the Italian Renaissance and Baroque."
 Art Bulletin, 73 (1991), 641–68.

Gozzadini, Giovanni. "Di alcuni gioielli notati in un libro di ricordi nel secolo XVI e

di un quadro di Lavinia Fontana." *Atti e memorie della R. Deputazione di Storia Patria per le Provincie di Romagna.* 1982–3.

Grafton, Anthony and Lisa Jardine. *From Humanism to the Humanities: Education and the Liberal Arts in Fifteenth- and Sixteenth-Century Europe.* London, 1986.

Grasselli, Giuseppe. *Abecedario biografico dei pittori, scultori ed architetti cremonesi.* Milan, 1827.

Gratiano, Giulio Cornelio. *Di Orlando Santo vita, et morte con venti mila Christiani uccisi in Roncisualle Cavata del Catalogo de Santi.* Ascoli, 1636.

Greenblatt, Stephen. *Renaissance Self-Fashioning from More to Shakespeare.* Chicago, 1980.

Greene, Thomas M. *The Light in Troy: Imitation and Discovery in Renaissance Poetry.* New Haven, 1982.

Greer, Germaine. *The Obstacle Race.* New York, 1979.

Gregori, Mina. *I Campi e la cultura artistica cremonese nel cinquecento.* Cremona, 1985.

Gualandi, Michelangelo. *Memorie originali italiane rigardanti le Belle Arti. Ser. 4. Bologna, 1840.*

Hanning, Robert W. and David Rosand, eds. *Castiglione: The Ideal and the Real in Renaissance Culture.* New Haven, 1983.

Hollanda, Francisco de. *Four Dialogues on Painting.* Trans. Aubrey Bell. London, 1928.
De la pintura antigua por Francisco de Hollanda, versión castellana de Manuel Denis [1563]. Ed. E. Tormo. Madrid, 1921.

Horowitz, Maryanne Cline. "Aristotle and Woman." *Journal of the History of Biology,* 9 (1976), 183–213.

Huarte, Juan. *Essame de gl'ingegni de gl'huomini, per apprender le scienze.* Venice, 1586.

Hulse, Clark. *The Rule of Art, Literature and Painting in the Renaissance.* Chicago, 1990.

Jacobs, Fredrika H. "The Construction of a Life: Madonna Properzia De'Rossi 'Schultrice' Bolognese." *Word & Image,* 9 (1993), 122–32.

"Woman's Capacity to Create: The Unusual Case of Sofonisba Anguissola." *Renaissance Quarterly,* 47 (1994), 74–101.

Jordan, Constance. *Renaissance Feminism: Literary Text and Political Models.* Ithaca, NY, 1990.

Kelly, Joan. *Women, History and Theory.* Chicago, 1986.

Kelso, Ruth. *Doctrine for the Lady of the Renaissance.* Urbana, IL, 1978.

Kemp, Martin. "From 'Mimesis' to 'Fantasia': The Quattrocento Vocabulary of Creation, Inspiration and Genius in the Visual Arts." *Viator* 8 (1977), 347–98.

Kenseth, Joy, ed. *The Age of the Marvelous.* Hanover, NH, 1991.

King, Margaret L. *Women of the Renaissance.* Chicago, 1991.

King, Margaret L. and Albert Rabil, Jr. *Her Immaculate Hand.* Binghampton, NY, 1983.

Klapisch-Zuber, Christine. *Women, Family and Ritual in Renaissance Italy.* Trans. Lydia G. Cochrane. Chicago, 1985.

Klein, Robert. *Essays on the Renaissance and Modern Art.* Princeton, 1981.

Kris, Ernst and Otto Kurz. *Legend, Myth and Magic in the Image of the Artist.* [1934]. Reprint, New Haven, 1979.

Kristeller, P. O. "The Modern System of the Arts." In *Renaissance Thought,* vol. 2. New York, 1965.

Kusche, Maria. "Sofonisba Anguissola en España retratista en la corte de Felipe II

Junto a Alonso Sànchez Coello y Jorge de la Rua." *Archivio Espanol de arte*, 62 (1989), 391–420.

Labalme, Patricia H., ed. *Beyond their Sex: Learned Women of the European Past.* New York, 1980.

Lamo, Alessando. *Intorno alla scoltura, e pittura.* [1584]. Appended to G. B. Zaist, *Notizie istoriche de'pittori, scultori, ed architetti cremonesi*, vol. I. Cremona, 1774.

Lancetti, Vincenzo. *Biografia cremonese.* Milan, 1819.

Landrini, Galeazzo. *De natural humani corporis formatione, & usu, nec non de auditus sensu, Tractatus duo, in guibus rebus propositis difficilimis guidem sed pulcherrimis.* Ferrara, 1633.

Lanzi, Luigi, *La storia pittorica della Italia inferiore o sia delle scuole.* Florence, 1792.
 Storia pittorica della Italia. [1789]. 3 vols. Florence, 1968.

Leone de Castris, Pierluigi. *Pittura del cinquecento a Napoli, 1573–1606 l'ultima maniera.* Naples, 1991.

Lepschy, Anna Laura. *Tintoretto Observed: A Documentary Survey of Critical Reactions from the Sixteenth to the Twentieth Century.* Ravenna, 1983.

Levine, Laura. *Men in Women's Clothing: Anti-theatricality and Effeminization, 1579–1642.* Cambridge, 1994.

Lichtenstein, Jacqueline. "Making up Representation: The Risk of Femininity." *Representations*, 20 (1987), 77–87.

Lomazzo, Gian Paolo. *Rime.* Milan, 1587.
 Scritti sulle arti. 2 vols. Ed. Roberto Paolo Ciardi. Florence, 1974.

Luigini, Federico. *Il libro della bella donna.* Venice, 1554.

Maclean, Ian. *The Renaissance Notion of Woman.* Cambridge, 1980.

Malvasia, Carlo Cesare. *Felsina pittrice. Vita de pittori bolognese.* [1678]. Reprint, Bologna, 1841.

Mancini, Giulio. *Considerazioni sulla pittura.* [1620]. Rome, 1956.

Mander, Carel van. *Dutch and Flemish Painters.* Trans. Constant van de Wall. New York, 1936.
 Den grondt ter edel vry schilder-const. Amsterdam, 1618.

Manfredi, Mutio. *Cento Donne Cantate.* Parma, 1580.
 Lettere. Venice, 1606.
 Lettione del Signor Mutio Manfredi il Vinto. Da lui publicamente reculeta nella illustre Accademico de Confusi in Bologna, Feb III 1575. Bologna, 1575.
 I madrigali. Venice, 1606.

Manfredi, Mutio, ed. *Donne Romane – Rime di diversi autori.* Bologna, 1574.

Marchese, P. Vincenzo. *Memorie dei più insigni, pittori, scultori e architetti domenicani.* Florence, 1854.

Marinello, Giovanni. *Delle medicine partenenti all'infermità delle donne.* Venice, 1574.

Marino, Giambattista. *La Galleria. Distinta in pittura & scultura.* [1619–20]. Venice, 1630.

Marshall, Sherrin. *Women in Reformation and Counter-Reformation Europe: Private and Public Worlds.* Bloomington, 1989.

Martines, Lauro. "A Way of Looking at Women in Renaissance Florence." *Journal of Medieval and Renaissance History,* 4 (1974), 15–28.

Masetti Zannini, Gian Ludovico. *Motivi storici della educazione femminile (1500–1650).* Bari, 1980.

 Stampatori e librai a roma nella seconda meta del cinquecento. Rome, 1980.

Masini, Antonio. *Bologna perlustrata.* Vol. I. Bologna, 1666.

Massari, Stephania. *Giulio Romano pinxit et delineavit. Opere grafiche di collaborazione e bottega.* Rome, 1993.

 Incisori Mantovani del '500, Giovan Battista, Adamo, Diana Scultori e Giorgio Ghisi. Rome, 1980.

Mazzoni Toselli, Ottavio. *Racconti storici estratti dall'archivio criminale di Bologna.* Bologna, 1868.

McLeod, Glenda. *Virtue and Venom: Catalogs of Women from Antiquity to the Renaissance.* Ann Arbor, 1991.

Mendelsohn, Leatrice. *Paragoni: Benedetto Varchi's "Due Lezzioni" and Cinquecento Art Theory.* Ann Arbor, 1982.

Migiel, Marilyn and Juliana Schiesari, eds. *Refiguring Woman: Perspectives on Gender and the Italian Renaissance.* Ithaca, NY, 1991.

Mirollo, James V. *Mannerism and Renaissance Poetry: Concept, Mode, Inner Design.* New Haven, 1984.

Mini, Paolo. *Discorso della Nobilità di Firenze, e de Fiorentini.* Florence, 1593.

Morigia, Paolo. *La nobilità di Milano.* [1595]. Milan, 1619.

Muraro, Michelangelo. "Il memoriale di Zuan Paolo da Ponte." *Archivio veneto,* 44–5 (1949), 77–88.

Murphy, Caroline P. "Lavinia Fontana: An Artist and Her Society in Late Sixteenth Century Bologna. PhD diss., University College, London, 1995.

Della nobilità et eccellenza della donne. Venice, 1544.

Orlandi, Pellegrino Antonio. *Abecedario pittorico.* Venice, 1753.

Pacheco, Francisco. *Arte de la pintura.* [1638]. Ed. Sanchez Canton. Madrid, 1956.

Pagani, Valeria. "Adamo Scultori and Diana Mantovani." *Print Quarterly,* 9 (March, 1992), 72–87.

Panofsky, Irwin. *Idea: A Concept in Art Theory.* New York, 1968.

Parker, Rozsika and Griselda Pollock. *Old Mistresses: Women, Art, and Ideology.* New York, 1981.

Pascoli, Lione. *Vite de'pittori, scultori, ed architetti moderni.* Rome, 1730.

Passi, Giuseppe. *I donneschi diffetti.* Venice, 1599.

Perlingieri, Ilya Sandra. *Sofonisba Anguissola: The First Great Woman Artist of the Renaissance.* New York, 1992.

 "Sofonisba Anguissola's Early Sketches." *Women's Art Journal,* 9 (1988–9), 10–14.

Pino, Paolo. *Dialogo della pittura.* [1548]. Milan, 1954.

Pliny the Elder. *Naturalis historia.* Trans. H. Rackham. Cambridge, MA, 1956–66.

Plutarch. *Mulierum virtutes.* In *Moralia,* 3 vols. Trans. Frank Cole Babbitt. Cambridge, MA, 1961.

Pollitt, J. J. *The Ancient View of Greek Art: Criticism, History, and Terminology.* New Haven, 1974.

Pollock, Griselda. "Agency and the Avant-Garde." *Block,* 15 (1989), 4–15.

Preus, Anthony. "Galen's Criticism of Aristotle's Conception Theory." *Journal of the History of Biology,* 10 (1977), 65–85.

Quondam, Amedeo. *Il naso di Laura. Lingua e poesia lirica nella tradizione del classicismo.* Ferrara, 1991.

Ragg, Laura M. *The Women Artists of Bologna.* London, 1907.

Rando, Flavia. "The Essential Representation of Woman." *Art Journal,* 50 (1991), 48–52.

Razzi, Fra Serafino. *Historia de gli Huomini illustri dell'Ordine de'Predicatori.* Lucca, 1596.

Rice, Eugene F., Jr. *The Renaissance Idea of Wisdom.* [1958]. Reprint, Westport, CT, 1973.

Richa, Giuseppe. *Notizie istoriche delle Chiese Fiorentine devise ne'suoi quartiere.* Florence, 1754–64.

Richter, Jean Paul. *The Literary Works of Leonardo da Vinci.* London, 1939.

Ridolfi, Carlo. *Delle maraviglie dell'arte.* Venice, 1648.

Rogers, Mary. "Sonnets on Female Portraits from Renaissance North Italy." *Word & Image,* 2 (1986), 291–305.

Rose, M. B., ed. *Women in the Middle Ages and the Renaissance: Literary and Historical Perspectives.* Ithaca, NY, 1986.

Rubin, Patricia Lee. *Giorgio Vasari: Art and History.* New Haven, 1994.

Ruggiero, Guido. *Binding Passions: Tales of Magic, Marriage, and Power at the End of the Renaissance.* New York, 1993.

Saffi, Antonio. *Discorso all'Accademia di belle arti, Bologna, 22 Giugno 1830, della vita, e della opere de Maria Properzia de' Rossi.* Bologna, 1832.

Sacchi, Federico. *Notizie pittoriche cremonese.* Cremona, 1872.

Santagostino, Agostino. *L'immortalità e gloria del pennello. Catalogo delle pitture insigni che stanno esposte al pubblico nella città di Milano.* Milan, 1671.

Saslow, James M. *Ganymede in the Renaissance: Homosexuality in Art and Society.* New Haven, 1986.

Scannelli, Francesco. *Il Microcosmo della pittura.* Cesena, 1657.

Schiesari, Juliana. *The Gendering of Melancholia: Feminism, Psychoanalysis, and the Symbolics of Loss in Renaissance Literature.* Ithaca, NY, 1992.

Schutte, Anne Jacobson. "Come costruirsi un corpo di santa." *Studi storici,* 33 (1992), 127–39.

"Irene di Spilimbergo: The Image of a Creative Woman in Late Renaissance Italy." *Renaissance Quarterly,* 44 (1991), 42–61.

Shearman, John. *Only Connect . . . Art and the Spectator in the Italian Renaissance.* Princeton, 1992.

Singer, Charles. *A Short History of Anatomy from the Greeks to Harvey.* New York, 1957.

Sociacco, Benedetto [Benedicti Sociaci]. *Silvae & Opuscula Sacra.* Mediolani, 1612.

Sofonisba Anguissola e le sue sorelle. Exhibition catalogue. Cremona, 1994.

Sohm, Philip. "Gendered Style in Italian Art Criticism from Michelangelo to Malvasia." *Renaissance Quarterly,* 48 (1950), 759–808.

Sopriani, Raffaello. *Vite de pittori, scultori ed architetti Genovesi.* [2nd ed., 1674]. Genoa, 1768–9.

Struever, Nancy S. *Theory as Practice: Ethical Inquiry in the Renaissance.* Chicago, 1992.

Summers, David. "*Aria* II: The Union of Image and Artist as an Aesthetic Ideal in Renaissance Art." *Artibus et historiae,* 20 (1989), 15–31.

 The Judgement of Sense: Renaissance Naturalism and the Rise of Aesthetics. Cambridge, 1987.

 Michelangelo and the Language of Art. Princeton, 1981.

Sutherland Harris, Ann and Linda Nochlin. *Women Artists: 1550–1950.* New York, 1976.

Tassi, Francesco Maria. *Vite dei pittori, scultori e architetti Bergameschi.* Bergamo, 1793.

Tasso, Torquato. *Opere.* Florence, 1724.

 Prose filosofiche. Florence, 1847.

Thieme, Ulrich and Felix Becker. *Allgemeines Lexicon der Bildenden Künstler.* Leipzig, 1911.

Tiraboschi, Girolamo. *Notizie de'pittori, scultori, incisori e architetti.* Modena, 1786.

 Storia della letteratura italiana. Parma, 1772.

Titi, Filippo. *Descrizione delle pitture, sculture e architetture esposte al pubblico in Roma.* Rome, 1763.

Tolnay, Charles De. "Sofonisba Anguissola and Her Relations with Michelangelo." *Journal of the Walters Art Gallery,* 4 (1941), 115–19.

Totti, Pompilio. *Ritratto di Roma Moderna.* Rome, 1638.

Trenta, Tommaso. *Memorie e documenti per servire all'istoria del Ducato di Lucca.* Lucca, 1822.

Trissino, Giovan Giorgio. *I ritratti* (1524). In *Tutte le opere,* 2 vols. Verona, 1729.

Turner, James Grantham, ed. *Sexuality and Gender in Early Modern Europe.* Cambridge, 1993.

Varchi, Benedetto. *Due lezzioni di M. Benedetto Varchi, nella prima delle quali si dichiara un Sonetto di M. Michelagnolo Buonaroti, nella seconda si disputà quale sia più nobile arte, la scultura o la pittura, con una lettera d'esso Michelagnolo e più altri eccellentissimi pittori, et scultori, sopra la quistione sopradetta.* Florence, 1549.

 Opere. Milan, 1834.

Vasari, Giorgio. *Le opere.* Ed. Gaetano Milanesi. Florence, 1906.

Vasari, Giorgio. *Le vite de'più eccellenti architetti, pittori, et scultori italiani, da Cimabue insino a' tempi nostri.* Ed. Luciano Bellosi and Aldo Rossi. Turin, 1986.

Vecchi, Alberto. *Con mano devota. Mostra delle imaginette spirituali manufatte.* Padua, 1985.

Vedriani, Lodovico. *Raccolta de' pittori, scultori, et architetti Modenesi più celebri.* Modena, 1662.

Venturi, Adolfo. *Storia dell'arte italiana.* Milan, 1901–40.

Vida, Marco Gerolamo. *Cremonensium Orationes III adversus Papienses in controversia Principatus.* Cremona, 1550.

Vizani, Pompeo. *I due ultimi libri delle historie della sua patria.* Bologna, 1608.

Wack, Mary Francis. *Lovesickness in the Middle Ages: The Viaticum and Its Commentaries.* Philadelphia, 1990.

Wethey, Harold E. *The Paintings of Titian.* 3 vols. London, 1971.

Wiesner, Merry E. *Women and Gender in Early Modern Europe.* Cambridge, 1993.

Wittkower, Rudolf. *The Artist and the Liberal Arts.* London, 1977.

Wittkower, Rudolf and Margot Wittkower. *Born under Saturn.* [1963]. Reprint, New York, 1969.

Wood, Jeryldene M. "Breaking the Silence: The Poor Clares and the Visual Arts in Fifteenth Century Italy." *Renaissance Quarterly* 48 (1995), 262–86.

Zabarella, Jacopo. *Opere Logicae.* Cologne, 1603.

Zaist, Giovambattisa. *Notizie istoriche de'pittori, scultori, ed architetti cremonesi.* Cremona, 1774.

Zannandreis, Diego. *Le vite dei pittori, scultori, e architetti veronesi.* Verona, 1891.

Zonta, G. *Trattati del cinquecento sulla donna.* Bari, 1913.

Zuccaro, Federico. *Scritti d'arte di Federico Zuccaro.* Ed. Detlef Heikamp. Florence, 1957.

Index

Adam, 12, 13

Adriani, Giovambattista, 19, 65

Aelian, 82

a Lapide, Cornelius, 34

Alberti, Leon Battista, 8, 88, 131; on physiognomy, 57

Alciati, Andreas 99, 103, fig. 13

Aldrovandi, Ulisse, 50–51, 163

Allori, Alessandro, 6, 100

Amaltea, Quintilia, 44, 64, 165

androgyny, 159–60; *see also* hermaphrodite

Anguissola, Elena, 100

Anguissola, Europa, 23–24, 165, 208n32

Anguissola, Lucia, 126, 165, 208n32, 211 n.92

Anguissola, Sofonisba, 2, 6, 23–24, 38–39, 64, 73, 94, 100, 134, 153, 157, 158–59, 164, 165, 176–77; and invention, 58–60; and Michelangelo, 56–57; as a portrait painter, 51–58, 90; figs. 3, 4, 6, 32; self-portraits, 126, 127, 128–29, 147, 152, 154–56

Apelles, 8, 17–18, 20, 21, 22, 23, 179–80, 181, 182, 186n25; and Alexander's mistress, 136–38

Aretino, Pietro, 27, 80, 147, 161, 162, 207n19

Ariosto, 83

Aristarete, 19, 23–24, 25, 176–77

Aristotle, 8, 11, 12, 40; on humoral disposition, 75, 76–77; on making, 27, 31; on *fantasia*, 61, 62; on (pro)creativity, 27, 28, 29, 31–35, 48, 49, 78, 156; on Pythagorean contrariety, 11–12, 159

Armenini, Giovambattista, 88, 151, 156; on

imitation, 162–63; on invention, 58–59; on portraiture, 44–45, 98

Aspertini, Amico, 67, 69, 70, 163

Atanagi, Dionigi, on Giancarli, 98, 166; on Spilimbergo, 60, 104–5, 135, 146, 147, 167–8

auto-mimesis, 17, 66, 71–72, 85–86, 200n1; and gendering of style, 88; *see also* portraiture (self), Rossi

Baglione, Giovanni, on Fontana, 91, 94, 95, 152, 166, 191–92n52; on Parasole, 59, 105–6, 167

Baldinucci, Filippo, 57–58, 103, 112; on Anguissola, Sofonisba, 159, 165; on Fontana, 95, 166; on Galizia, 166; on Scultori, 167

Boccaccio, 25, 40–41, 90, 118

Barza, Margarita, 165

Brandolini, Suor Vincenza, 165

Battiferri, Laura, 65

Bembo, Pietro, 147–48

Bocchi, Francesco, 7, 112, 119, 120, 167

Borghini, Raffaello, 19; on Fontana, 166; on Robusti, Marietta, 3, 146–47, 153, 167; on Rossi, 72, 83–84, 100, 158, 167

Brandolini, Suor Vincenza, 111, 165

Broccardi, Suor Dorotea, 165

Bruni, Domenico, 84, 135

Cambi, Suor Prudenza, 7, 111, 166

Campeggi, Ridolfo, 84, 135, 166, 169–71, 209–10n69

Campi, Bernardino, 100, 152, 153, 154–56

Cantona, Barbara, 166